Turning to Art in Wood

A CREATIVE JOURNEY

A PUBLICATION CELEBRATING 25 YEARS

OF THE WOOD TURNING CENTER

WITH CONTRIBUTIONS BY

GLENN ADAMSON

ELISABETH R. AGRO

GERARD BROWN

RICHARD R. GOLDBERG, ESQ.

MICHELLE HOLZAPFEL

ALBERT LeCOFF

ROBIN RICE

THE
CENTER
FOR ART
IN WOOD

4880 Lower Valley Road • Atglen, PA 19310

Dedicated to:

Artists everywhere,

All staff and volunteers, and

Supporters who financially and spiritually make it happen.

CONTENTS

This publication utilizes three image numbering systems. Figure images are numbered sequentially within each essay that they appear. Plate numbers are used to classify objects from the collection that are included in the anniversary exhibition. Object numbers are used in the complete collection section to identify every object contained in the collection. Note that some of the objects in the collection will have both an object number and a plate number.

INTRODUCTION

Richard R. Goldberg, Esq.

BALLARD SPAHR, LLP

PRESIDENT, BOARD OF TRUSTEES

THE CENTER FOR ART IN WOOD

PHILADELPHIA

On the surface, this publication and the accompanying exhibition—*Turning to Art in Wood: A Creative Journey*—are a celebration of the nonprofit Wood Turning Center's 25 years of enthusiastically promoting artists working in wood and putting their art before the public. This project is also a celebration of Albert LeCoff's 35 years of working tirelessly to stimulate, show, and enjoy the work of emerging and established artists. Albert's work, along with his brother Alan, in the first 10 years is what made the next 25 years possible and so successful. Alan has worked behind the scenes all these years, and now serves on the board of trustees. In 2011, the Center marches on to a new era, a new name and a new location for its works.

This publication is also a flashback on all the small and large things that have been accomplished, utilizing the Center's unique library and archives and Albert's personal papers and files. Both resources document and track the letters, drafts, edits and final products for over 92 exhibits, 18 publications and 35 conferences, organized from 1976 by Albert and later by him and the Wood Turning Center after it incorporated in 1986.

> ## Albert's interest has always been to stimulate [artists'] creativity and give them ways to show it to the public.

A cross-section of individuals partnered with the Center's Exhibitions and Publications committees to conceive and execute this exhibit and this publication. Thanks to Robin Rice of Philadelphia, the chair of the Exhibitions Committee, and editor Judson Randall of Oregon, the Publications Committee chair, for their leadership. This publication documents the Center's museum collection of more than 1,000 objects and 25,000 books, papers and artists' files to track and demonstrate the evolution of the art form from pure wood turning to diverse variations as the artists expanded their universes and those of viewers. Albert's interest has always been to stimulate their creativity and give them ways to show it to the public.

The exhibition has been curated by Gerard Brown, Foundations Department. Chair at Tyler School of Art, Temple University in Philadelphia. Gerard is serving as the Center's 2011 resident scholar. He spent numerous joyous hours studying the Center's collection, resource library, and visiting other substantial wood collections, and interviewing collectors and artists concurrent with his teaching workload in the studio craft programs at Temple. His interpretations and insights in this publication provide a very fresh lens on the artists who work in wood and the impacts the Center has had in exhibiting these items.

This exhibition launches the Center's newly designed interactive research website, originally funded by Ron Wornick of California. The new database has been developed with a significant grant from the William Penn Foundation of Philadelphia and the Windgate Charitable Foundation. In this publication's collections section, the work is organized in acquisition order, but the database allows users to sort by their personal priorities.

Authors here reflect on the past and future roles that Albert and the Center have played and will play. Albert writes his personal memories of his career and life. Thanks to curator Glenn Adamson of London, artist Michelle Holzapfel of Vermont, curator Elisabeth Agro of the Philadelphia Museum of Art, and Robin Rice of Philadelphia, who share their personal and global insights.

Thanks to Peter Schiffer at Schiffer Publishing, Ltd. for publishing the trade edition of this publication.

And finally, special thanks to Ron Humbertson, Director of Exhibitions & Collections, the shepherd of all our efforts to create this exhibition and publication.

Generous funding has been provided by the Windgate Charitable Foundation; The Center for Art in Wood, Fleur Bresler Publications Fund; Friends of The Center for Art in Wood; and Collectors of Wood Art.

During this anniversary year, the Center changes its name to The Center for Art in Wood, a name that catches up with Albert's and the Center's ongoing mission, as it moves to its new location in Old City Philadelphia at 141 N. 3rd Street. ▪

Albert LeCoff

CO-FOUNDER AND EXECUTIVE DIRECTOR

THE CENTER FOR ART IN WOOD

PHILADELPHIA

"W hat's past is prologue" from Shakespeare's *The Tempest* is an oft-quoted line that conveys that the past sets the context for today. While that is obviously true of The Center for Art in Wood, it also might overlook the contributions of the people who established and governed the organization over its history. They were absolutely crucial in promoting the development of the Center and permitting me and our committees to run full range with ideas on how to establish contemporary wood art as an important movement in the art world.

A key group provided early structure and governance to the Center. In 1986, an organizing committee was formed, consisting of notable artists, educators, collectors and curators. When the first Board of Directors was formed in 1989 (fig. 1), Bruce Kaiser was elected the first President. Bruce served from 1989 to 1999. Many of the present institutional activities were developed during Bruce's leadership, including the World Turning Conferences and the International Turning Exchange (ITE). Bruce was already an avid collector and was instrumental in developing the Center's relationships with many of the key artists, collectors and galleries engaged in wood art. Bruce also led the Center through its first strategic planning, which helped formulate policy for his ten-year tenure (fig. 3). Bruce, indeed, laid the foundation for the Center's future success.

Also during this formative period, significant guidance was provided by Charles Hummel (fig. 2), presently Curator Emeritus at the Winterthur Museum. Charles' vast experience in museum practices and decorative arts, as well as his complete willingness to be available to me, the trustees and the committees, was instrumental. He helped establish the academic content of the World Turning Conferences, the initial collection policy of the Center and the role of the museum store. He helped refine the Center's goals and objectives to position it as a major force helping artists working in wood.

Bruce was succeeded by Fleur Bresler who served as President from 1999 to 2003. Fleur is one of the world's major collectors of wood art, famous for her donations and exhibitions at the Renwick Gallery/Smithsonian American Art Museum, and the Mint Museum of Craft + Design. During Fleur's tenure, *Wood Turning in North America Since 1930*, the collaborative exhibit and publication between the Center and the Yale University Art Gallery, was developed and executed. This event was seminal in establishing wood art as an important

FIG. 1

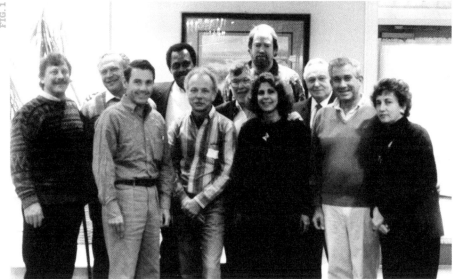

FIG. 2

and persistent part of the decorative arts. It also established the reputation of the Center as a major force in the discipline. While Fleur was President, the Center moved from my home to a new site at 501 Vine Street in Philadelphia establishing its permanence in the world of museums and galleries. Fleur also furthered the growth of the Center through strategic planning efforts.

Fleur, along with her late husband Charles, and Bruce have also been major contributors to the museum collection of the Center. They have impeccable taste and have donated some of the finest pieces in the Center's already note-worthy collection.

The next President was Terry Moritz, who served from 2003 to 2006. Terry built on the excellent base developed by his predecessors. He promoted the expansion of the Center's role to highlight wood art as art in its fuller breadth and depth, rather than as simple reflections of the turning process. Terry also was the first President to deal with the proposed John Grass Wood Turning Company building acquisition and helped to guide the Center's planning in that regard. Terry was a stabilizing force in the strategic planning process, a generous supporter and he fostered relationships with artists, collectors and galleries.

Next in line was Greg Rhoa who served from 2006 to 2009. Greg, who with his wife Regina is a well known collector, continued the planning process. In particular, when it became clear that the John Grass building acquisition and development was too ambitious a project for the Center in its then financial position, Greg was President when an opportunity was made available to the Philadelphia United Brotherhood of Carpenters and Joiners. They stepped in

FIG. 1 Center's first board of directors, 1989, left to right: Albert LeCoff, Arthur Mason, Charles Stamm, Frank E. Cummings, Ron Fleming, Rude Osolnik, William Hunter, Janis Wetsman, Dr. Irv Lipton, Bruce A. Kaiser, and Joanne Rapp.

FIG. 2 *Wood Turning in North America Since 1930* installation at Yale University Art Gallery, with oversight by Charles Hummel (second from right) and Patricia Kane.

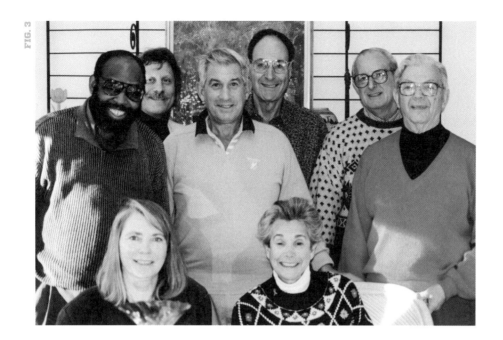

FIG. 3 1997 Strategic Planning Retreat. Left to right, front: Connie Mississippi and Fleur Bresler; back: David Stephens, Albert LeCoff, Bruce A. Kaiser, Lincoln Seitzman, Charles Hummel, and Ed Bosley.

and bought the John Grass building and its valuable machinery tools and work samples for historic preservation. Greg persevered through the continued search and planning for a new home for the Center.

The fifth President is Richard R. Goldberg who has served since 2009. Initially involved as counsel to assist in the John Grass acquisition process, he joined the Board in 2008 and served as Vice President under Greg. His accomplishments include overseeing the development of a three-year strategic business plan that resulted in the largest amount of financial aid ever received by the Center, totaling approximately $750,000. The plan also led to renaming the Center as The Center for Art in Wood, to acknowledge the breadth of the Center's programs and the changing nature of the art form. Dick also negotiated and supervised the lease and renovations of the Center's new home at 141 N. 3rd Street. The new name and the new location will promote and publicize the Center's continuing mission to foster global appreciation of art made from wood.

In 2011, to build on the strategic business plan, the Center adopted a new logo through a branding process facilitated by Finch Brands, Philadelphia. The logo captures the Center's mission to promote the endless potentials of the evolving art form.

The Center and I owe an incalculable debt to its past leaders and to the people who served and currently serve on the Board of Trustees. Their efforts have sealed the Center's accomplishments to date and have laid the groundwork for its future accomplishments. I am humbly grateful to all of them. ◼

THE MAKERS' GAME

Michelle Holzapfel

ARTIST, WRITER, TEACHER

MARLBORO, VERMONT

This is the story of a territory whose inhabitants match wits with materials and tools, forms and time. They spin and gouge, stack and saw: create objects. They survey the terrain and work to the rhythm of its cycles. Think, make. Think, make. Think, make, sell? ℭ In business, under construction or in performance, sellers, collectors and commentators cultivate markets and the marketplace of ideas.

In the heartland of our field stands the Wood Turning Center. Its founders and staff, Board and supporters maintain our flesh-and-blood domain.

I'll explore the Center's role in my working life, grab a big rough chunk of its history and work from the outside in.

I'll examine the forces that knocked off my corners: ambition, class and gender.

Then, the shapers who cultivate the field: colleagues, teacher and friends.

To the heart of the story: the axis of the Wood Turning Center.

From the inside out, Patrons support and lubricate the process.

And as the players collaborate, the Wood Turning Center changes.

Yet it remains a fit vessel to contain the past and transport us to the future.

ALICE SOON CAME TO THE CONCLUSION THAT IT WAS A VERY DIFFICULT GAME INDEED. —LEWIS CARROLL

Makers' equipment and materials cost! The need for capital sent me to rural craft fairs and urban art galleries. At the Wood Turning Center's 1993 World Turning Conference, I anticipated the discussion about Woodturning and Art with Stephen Hogbin and Mike Darlow. I became annoyed as Darlow admonished us: "Don't play the Game of Art, it'll break your heart!"

I played the game and explored the land of the Next Big Thing—where novelty gets attention but repetition is reputation—and each return to my shop and my work was all the sweeter. The Game of Fame is a slippery place, where Aspiration can trip on Ambition. I mostly played 'hide and seek' and learned that laurels can chafe. But my heart is intact.

I admire Makers who can take it on the chin and come back chuckling. At that same 1993 World Turning Conference, I met Bill Daley, ceramist, scholar and teacher. He introduced me to a fresh notion—"the aristocrat of skill." It describes many Makers: my calloused peers whose first fealty is to form.

DOMESTIC VIOLENCE

Some Makers play where Craft jostles Art and Art looks askance: "Those little bastards, playing with mud and sticks." The Wood Turning Center has provided many venues for a good joust on this disputed territory.

The *Curators' Focus: Turning In Context* exhibit of 1997 generated some resistance from makers. The curators' choices seemed arbitrary, their criteria cryptic. One response was the on-line 'salon des refusés' "Out of Focus," that sprang from the vision of Virginia Dotson. At the exhibit's symposium, the panel discussion heated up. One curator opined that the 'problem' with wood-turning was its 'baggage,' the tendency to take refuge in technique and the beauty of materials. When Craft asked 'why?' Art replied 'because I said so.' But Craft is not Art's understudy. It's the ancestor who holds all Makers on its ancient and capacious lap.

I first encountered James Prestini at the Wood Turning Center's "Turner's Challenge III" symposium in St. Louis in 1989. He captured my loyalty by saying, "I learned more from being poor than I ever did at Yale." He knew that Craft *is* native, but *is not* naïve. It's ironic that our blue-collar friendship would ultimately confer legitimacy on my work.

The Outsider-ness of Craft carries a feminine valence that begets a compensatory urge in some Makers—"Hey, we're still men!" Tool/technique loomed large in wood-turning's 20th century history. The confetti of flying chips celebrated technical prowess. Performance became a tease: what will it take to make her explode?

In 1994, I attended the Turning Plus exhibit and conference at Arizona State University. Albert LeCoff asked me to submit a review. I overcame my reluctance to speak to the whiff of the locker-room that I had encountered in Tempe. This struggle to illuminate my world still raises the question of its abiding powerlessness. So I conjure courage every time I write. Fortunately, I am not alone. At the Wood Turning Center's 1997 World Turning Conference, Merryll Saylan invited me to join a panel of colleagues. As a group of tomboys, we seemed like the logical bridge between bravado and aesthetics. The proof that we provided food for thought: an ally reported grumbling in the men's room.

We all make things: forms, collections, essays and exhibits. It's a scavenger hunt for the appropriate storage for our stories, and process is the game we share. Sibling rivalries may rage, but this wrestle is a proxy for a collegial embrace. We work at our centers, struggle with our humanness, in Yeats' "... foul rag and bone shop of the heart."[1] There's plenty of poetry here if you don't mind getting dirty.

Whether turned or chain-sawn, our forms are rarely monumental. The purse before the bank, the home before the skyscraper, the chalice before the cathedral. Our vessels or spindles strive to " ... evade functional necessities, or surpass them, even while satisfying them."[2] They make us who we are: objects of attention, scorn or admiration.

We converse with our material and the force of its nature. This dialogue becomes a force of habit that shapes our relationships with colleagues. I thank the Wood Turning Center for the opportunities to encounter a community of siblings. My favorite Wood Turning Center exhibit was a makers' mash-up: the *Cabinets of Curiosities* show in 2003. It began with a modest idea I floated to Albert. It grew into the opportunity to propose an exhibition with the Furniture Society.

To make our cabinet (fig. 1), my husband David and I worked with a local bookmaker, cabinetmaker, logger and sawyer. My essay for the catalogue offered the Makers' context. We even sold the piece, with difficulty and many thanks to Ursula Ilse-Neuman and Albert LeCoff. They knew when to put their thumbs on the scales in the Makers' favor.

FIG. 1

FIG. 1 Michelle Holzapfel, David Holzapfel, Donna C. Hawes, Dan MacArthur, Kim Thayer, Steve Smith, & Brown & Roberts Hardware, *Story Book*, 2002. Created for *Cabinets of Curiosities* Exhibition.

FIG. 2 Co-curators Christopher Tyler and Michelle Holzapfel confer during *Challenge VI* exhibition at Philip and Muriel Berman Museum, Ursinus College, PA, 2001.

The Wood Turning Center hosts the world of Makers in its most vivid form at the International Turning Exchanges. These events have borne a robust harvest of objects, texts, images and relationships. The scribes—a patternmaker-scholar, journalist-filmmaker, teacher-farmer—have found many points of connection. Their words and images remind us of the tenderness and terror of our interdependent Game.

I dedicate this essay to the memory of Chris Tyler (fig. 2), ITE's 2000 resident scholar. We co-curated the *Challenge VI—Roots: Insights & Inspirations in Contemporary Turned Objects* exhibit in 2001, and savored the freshness of each other's viewpoint. In Chris' own words: "The artists were 'speaking' to us ... both as a collective babble and as two hundred and thirty individual statements. ... [W]e were able to edit, to orchestrate silences, and to bring out rhythms so that the babble became words, then sentences, and then debates where both the roars and the whispers could be heard."[3]

Our enthusiasm for the Makers counterbalanced our focus on their Objects, and we lobbied to help shape the catalogue to reflect this. Editor Judson Randall's patience supported me in the many iterations of the voice-poem I made from makers' statements. This verbal patch-work found re-incarnation as a short film by videographer Ron Kanter (ITE 2003).[4] And, as always, Albert found the funds to realize our vision.

FIG. 2

Impresario, pain-in-the-ass, visionary, juggler: Albert LeCoff. Most of all, he is a gifted Matchmaker. Our first contact was the 1981 *Turned Objects: The First North American Turned Object Show*, when the Wood Turning Center was just a glint in his eye. Albert knows what he likes: to be at the axis where the growth of the Center is fuelled by the passion of the Makers' Game. With Tina LeCoff's fine dowry of complementary skills, they make a dynamic team.

Thanks to their dedication, the Wood Turning Center, today The Center for Art in Wood, is a well-wrought container: collaborative by design and built to last.

HOME ECONOMICS

Approximately 2 percent of artists live solely off the sale of their work in the commercial marketplace.[5]

Our 'field' is fertilized by employed spouses and pensions, trusts and windfalls, teaching gigs and sheer luck. The shimmering oasis of stability is a mirage. Markets blow hot and cold and *this* climate is *not* going to change. A friend once asked, 'What would you make if you didn't have to sell it?' Perhaps the answer is found in a favorite craft show joke: "Did you hear about the wood-turner who won the lottery? Yeah, she kept doing craft shows until the money ran out."

For better or for worse, the consumer fuels the Makers' Game. And the Wood Turning Center, with Albert as matchmaker, has provided a lively salon for both Makers and Patrons. Its population is multi-lingual: Collector-Writers, Patron-Makers, Boardmember-Curators. This is a bittersweet realm of jealousy and flattery, triumph and rejection. It is the inescapable 'ante' to play the Makers' Game. The collectors' consumption can conserve, encourage or devour. Their taste may congeal around hollow forms or painted surfaces. Risky work is often orphaned. Our works are seen by many, but taken home by few. But the ever-present danger is that the cycle will be broken.

Perhaps the truer question is: What would you make if no one bought it?

WILL THIS CIRCLE BE UNBROKEN??

In 2001 to 2002 the Wood Turning Center undertook an ambitious project with the Yale University Art Gallery, *Wood Turning in North America Since 1930*. The catalogue's scholars were enriched by their residencies at the

International Turning Exchange. Ned Cooke's (ITE 1996) experience was "a demystification of process"[6] that imbued his essay with an insider's empathy. Glenn Adamson's (ITE 1997) residency set him "in the experience but not of the experience."[7] His intimately informed viewpoint "from the wings"[8] complemented Ned's to yield a document with a stereoscopic depth-of-field.

As I attended these events, however, I couldn't suppress my anxiety that the apex of the wheel was passing. Which museums will shelter the Makers' stories as well as their Objects? Will the next generation of curators and scholars replace the History of Great Men with 'A People's History of the United States of Makers?' This rougher terrain could challenge scholars and tempt a wider public through their museums' doors.

P.S. TRUE TO FORM

We now inhabit a strange land: the local is exotic, the exotic is banal. Globalism seems at once robust and extinct. Some day, the Wood Turning Center—or simply the Center?—may host the interactive Makers' Game, 'Gravity + Levity = Longevity.' Choose your avatar: starving genius or discriminating patron? stressed-out promoter or avid amateur? Dominate the market ... or pay the bills. Master difficult skills ... or hire help. Find the choicest material ... or recycle refuse. Then go outside, grab a chunk of life and "make the road by walking."[9]

My ambition is to be one of the Center's guardian angels—like Charles Hummel and the late Palmer Sharpless—and to encourage another generation of Makers.

I'll abide in my field and, like a leaf to the sun, reach for those warm souls whose presence sustains me.

Our work is a prayer of deep thanks and brute luck. Don't put it on a pedestal, or hang it on a cross.

Just keep it in mind and show it to someone who may take its pulse and find it still very much alive. ▪

ENDNOTES

[1] William Butler Yeats. *The Circus Animals' Desertion*, from *Last Poems*. 1939.

[2] Robert Harbison. *The Built, Un-Built & the Unbuildable*. 1993.

[3] *Hearing the Artists' Voices.* Chris Tyler in *Challenge VI—Roots: Insights & Inspirations in Contemporary Turned Objects.* 1997. p. 9.

[4] Ron Kanter CD, *Connections: Sweet Possibilities and Grave Self-Doubts.* 2005.

[5] Columbia University Research Center for Arts and Culture. *Information on Artists III* report. 2007. Joan Jeffri, Program Coordinator.

[6] From Robin Rice essay in *Connections: International Turning Exchange 1995–2005.* Wood Turning Center. 2005. p. 32.

[7] Ibid.

[8] Ibid.

[9] Educator Paulo Freire's quote: "We make the road by walking."

WITH MANY THANKS TO MY FAVORITE FIRST READER, DAVID.

A LETTER OF RECOMMENDATION

Glenn Adamson

HEAD OF GRADUATE STUDIES, RESEARCH DEPARTMENT

VICTORIA & ALBERT MUSEUM

LONDON

I wasn't there in 1976, when the country's top lathe turners gathered at the George School near Philadelphia for the first Wood Turning Symposium. If I had been I wouldn't have been too much use, as I was only four at the time. But I've seen pictures and talked to many of the participants. On the basis of this evidence, I imagine the scene like this: a group of 50 people stand tightly huddled in a workshop, taking turns at the lathe. Almost all are amateurs. There are denim jackets, corduroys, and floor-mop hairdos. And plenty of muttering, as they observe one another's techniques, even simple things like how to get the wood screwed on to the face-plate, and the use of cutting gouges instead of flat-edged scraping tools. Bowls spin into being one after the other. Shavings pile up on the floor. The group is particularly impressed by the skilled production turners who have come to the symposium, like Manny Erez and the manager of the George School shop, Palmer Sharpless. These professional turners, already a rare breed by the 1970s, are able to fashion a mighty stack of stair balusters in the course of a single day. And then there is Albert LeCoff, co-host of the event (together with his twin brother Alan, and Sharpless), who sports a rakish moustache and talks enthusiastically to everyone, already imagining a national organization, a net-work of mutually supportive turners, and—why not? An art movement.

...I was on a collision course with the Center.

Did the other attendees take Albert's ambitions seriously? I'm not quite sure about that, but certainly he found allies soon enough, for within a short five years his objectives had already been largely realized. The Wood Turning Center was established in 1986, and turners were exchanging their ideas via further symposia, exhibitions, and publications (notably *Fine Woodworking*, which launched just as the turning movement was getting underway). They exchanged tools, timber, finished objects, and vintage how-to books, slowly reconstructing and extending the tricks of their trade. Older turners like Rude Osolnik, Mel Lindquist, Ed Moulthrop, and Bob Stocksdale were embraced as founding fathers, and younger figures were beginning to define the aesthetic parameters of the emerging field. Factions and rivalries developed, a sure sign of maturity in any field of creative practice. There were exacting techni-cians like David Ellsworth, concerned with turning elegant thin-walled hol-low vessels; expressionists like Mark Lindquist (son of Mel), who looked to the

FIG. 1

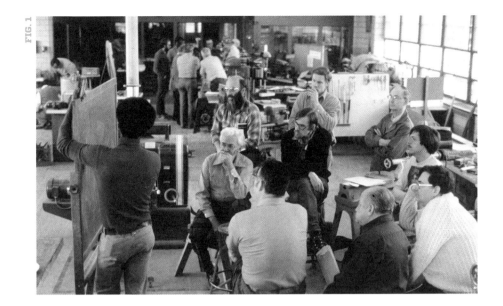

FIG. 1 Frank E. Cummings explains design elements during the March 1978 Symposium.

arenas of ceramics and sculpture for inspiration; constructionists like Philip Moulthrop (son of Ed) who assembled complex laminated or resin-bonded blocks before turning them, so as to realize dynamic graphic patterns; and even a few *enfants terribles* like Giles Gilson, who decorated their vessels with bright paint in accordance with the outrageous postmodern style coming out of Milan.

These leading lights of the field forged a sometimes-uneasy alliance with the Center, whose activities were increasingly falling to one side of the fault line between professional and amateur turners. Determined to elevate the status of the field and to sow the seeds of artistic achievement, LeCoff (with unflagging support from his staff, and his extraordinarily patient and generous wife Tina) sought out connections to museums and galleries. He encouraged the specialist wood art collectors who now began appearing at events, attracted to the vibrancy, diversity, and relative affordability of lathe-turned objects. He forged links to other disciplines—notably pottery and metal-spinning, two other centrifugal crafts, and furniture, the other primary area of woodworking. He built a library and a collection, and explored the deep history of the craft of turning through preservation initiatives. Through it all the Center retained the gleeful do-it-yourself spirit with which it had begun back in '76, festooning its projects with pun-laden titles, exhibiting broadly comic work alongside elegant forms, and generally conveying the impression that turning—despite its perfectly circular geometries—can be a charmingly eccentric pursuit.

Meanwhile I was busy growing up, completely ignorant of what was happening in the crafts. Eventually I discovered my own interest in the subject (initially via ceramics) and then found myself at Yale University studying under

the material culture historian Edward S. (Ned) Cooke, Jr. I didn't know it at the time, but like so many other people I was on a collision course with the Center. In my case, the connection came through Ned, who had been swept up into one of LeCoff's many schemes—the International Turning Exchange (ITE), a summer residency program that annually brings together a handful of turners and other artists, photojournalists and scholars from around the world to the University of the Arts to cohabitate and collaborate. The ITE is an explicit restaging of the first Wood Turning Symposium's spirit. It is all about building connections and exchanging ideas. Because many participants come from places with little in the way of an established turning community—or perhaps one with a very distinctive orientation within the field, such as Australia or France—the situation is bound to produce sparks.

There is no such thing as a typical encounter with the Center—its activities are too varied for that.

Ned's 1996 experience at the ITE was so positive that it led to ongoing discussions with LeCoff. I myself was the "resident scholar" at ITE the following year. Before I knew it, while still a graduate student, I was working with the Wood Turning Center and the Yale University Art Gallery on a major retrospective, entitled *Wood Turning in North America Since 1930* (figs. 2, 3). The project was pioneering in many respects. The first substantive history of the field, it gathered together 132 key works and was accompanied by a major catalogue, to which I contributed an essay. For me it was a sort of baptism. This was my first experience of exhibition-based research, and it was an ideal introduction in many respects. The field was small enough to grasp, but big enough to be fascinatingly diverse. The timing was perfect: turning had reached a point of maturity in both an artistic and commercial sense, but had not become saturated by marketplace forces (as arguably had happened in studio glass and ceramics by then—and might happen to turning soon enough, if artists and their supporters aren't careful). And above all there was LeCoff, who was a trove of information and ideas and even more importantly connected me to the turners themselves, many of whom have become lifelong friends.

FIG. 2

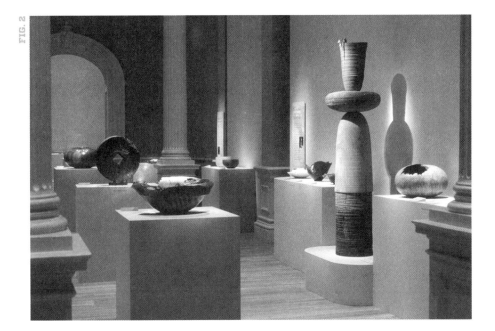

FIG. 3

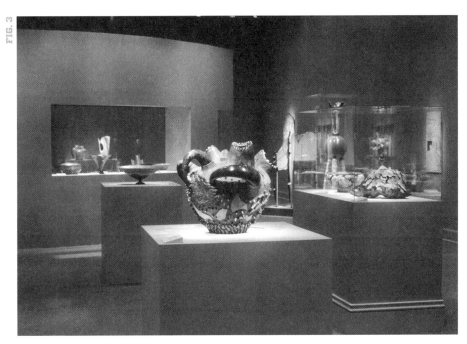

FIGS. 2 & 3 *Wood Turning in North America Since 1930* exhibition installed at the Renwick Gallery/Smithsonian American Art Museum, 2002.

There is no such thing as a typical encounter with the Center—its activities are too varied for that. But I think the dramatic impact that this exhibition had on me, and the opportunities it afforded me as a young scholar, are paralleled by the experiences that many others have had as a result of working with them. Over its history, the Center has been remarkably non-judgmental in its dealings with artists. It has been brave enough to do things that might seem foolhardy from a distance, like trusting an untried graduate student with writing the history of its field of endeavor. In this respect it differs from many arts organizations, who pride themselves on rigorous evaluation. "Quality" is the means by which an overcrowded art world divides the proverbial wheat from the chaff. But that is not the only definition of success. In fact, the single-minded pursuit of excellence sometimes results in an inadvertent replication of the status quo, rather than discovery of something truly new. LeCoff often

says of the ITE program that he would be entirely satisfied if a summer ended with nothing but a pile of wood shavings on the floor (and here one thinks of the long-ago inaugural symposium of 1976), so long as the participants had forged new relationships and discovered new directions in their work. This is the spirit of the Center. It does often make possible the creation of wonderful objects; but it is the people in the field that are its true concern.

When all is said and done, turning is really a small province within the grand landscape of the arts. This is the only reason that an organization of this relatively small size can achieve such comprehensive coverage of the field. Especially in today's post-disciplinary environment, when artists can fully be expected to direct a film one day, make a painting the next, and go on to write a play over the weekend, an exclusive focus on turning seems anachronistic. The Center is well aware of this, and has become ever more ecumenical in its activities. As it moves to Old City Philadelphia at 141 N. 3rd Street, it changes its name to The Center for Art in Wood. Nothing excites LeCoff more than a "turning" show that includes cinematic, painterly and dramatic elements (as did one of the Center's recent projects, *Challenge VII: dysFUNctional*). But even accounting for such broadmindedness, its tight focus will always be its strength.

Craft in general derives its potency from the specificity of tools, materials, and processes, all worked out over many years and by many hands. The same is true of the Wood Turning Center. You never quite know what you'll get from this little dynamo of an organization. It may never be a large and powerful organization, but it will always be an interesting one; and that's what really counts. ■

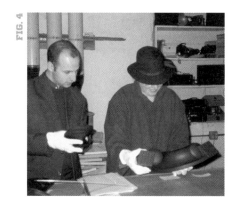

FIG. 4 Glenn Adamson and Patricia Kane examine objects stored in preparation for *Wood Turning in North America Since 1930* exhibition, 2000.

WITHOUT A DIVINING ROD AT HAND...

Elisabeth R. Agro

THE NANCY M. MCNEIL ASSOCIATE CURATOR FOR

AMERICAN MODERN AND CONTEMPORARY CRAFTS AND DECORATIVE ARTS

PHILADELPHIA MUSEUM OF ART

Finding it difficult to predict the future without a divining rod at hand, I am struck with ironic thoughts about the daily word choices we use in attempting to communicate about the past or, in this case, the future. As a human race we tend to dwell on the past, predict and anticipate the future. Some are able to live in the moment thereby engaging in the act of reflection. This reflection—or "foresight strategy" as it is called in business—on the past and present provides key insights that act as markers that lead the way. Reflecting on the future of The Center for Art in Wood, formerly the Wood Turning Center, we only have to look back in order to understand this moment and the new direction it will soon take.

...the Center became the catalyst for catapulting the field into the art arena and onto the national stage.

Wood turning was a latecomer to the field of contemporary craft. Much of the significance that surrounds the field of art in wood is in large part due to Albert LeCoff's devotion to and promotion of this art form and his unwavering vision for the Center, steadfast engagement with artists, collectors and museums. By embracing centuries-old wood turning tradition merged with the application of age-old and new techniques to traditional and uncommon materials; and establishing a network between artists, collectors, scholars and museums, the Center became the catalyst for catapulting the field into the art arena and onto the national stage.

One of LeCoff's initiatives was the exhibition program called *Challenge*, which was initiated in 1987. This series would prove to be vigorous and provocative. The first challenge and exhibition was entitled *Works off the Lathe: Old and New Faces*. The goal of this exhibition and two subsequent *Challenges* was to represent self-imposed demands that artists placed on themselves and their work. In other words, the artists were charged to make work they were truly inclined to make regardless of the marketplace. *Challenge VII: dysFUNctional* (2008) and *Magic Realism: Material Illusions* (2010) were pivotal exhibitions, which established a broader context and altered assumptions of wood turning as an art form. While *Magic Realism: Material Illusions* was not part of the challenge series, the two exhibitions provided both a portal and an emerging platform from which the Center could evolve. In an uncanny way,

the conceptual underpinnings of the *Challenge* series are echoed in the Wood Turning Center's next chapter as The Center for Art in Wood and its refocused mission.

As a participant in the development of the Center's three-year strategic business plan (2010–12), I was struck by the committee's willingness to think outside of the box and be visionary about what its organization should and could be regionally, nationally and internationally. The plan was never to abandon the foundation but to build upon it, thrive and, what I identified at the time as a key element, to be relevant in this moment. The new mission that was developed embraces "leading the growth, awareness, appreciation and promotion of artists and their creation and design of art in wood and wood in combination with other materials." This speaks to many artists today who are exploring their unique voices in a multitude of materials—wood being one of them—utilizing limitless processes resulting in new directions in their work. As in art in wood, I can say with certainty that it is an invigorating time to be an artist working in craft materials.

Invigorating as it may be, we can all agree that there is a huge shift occurring in the world of art. I am referring not to the things we always bemoan but the change in society and its relationship to art. In an increasing world of the virtual, where do tangible objects stand and will they continue to be valued? Will tangible objects, in this case art in wood, be relevant in the years ahead? This challenge is what many art organizations—large and small, focused or broad—are facing in this emerging virtual world. Relevancy equates to living in this very moment, taking the pulse of what is going on around you and striking a balance between the past, present and the future.

Using strategic planning as a lens, the Center has uniquely positioned itself to educate, promote, preserve and present art in wood in all of its manifestations, from historical to present day to tomorrow. Building upon and embellishing the vehicles it already has in place such as the permanent collection, exhibitions, seminars, publications, educational outreach, the International Turning Exchange (ITE), the Center will have the ability to make art in wood visible to the broader public. This will be done while continually engaging with artists, scholars, collectors, museums and galleries.

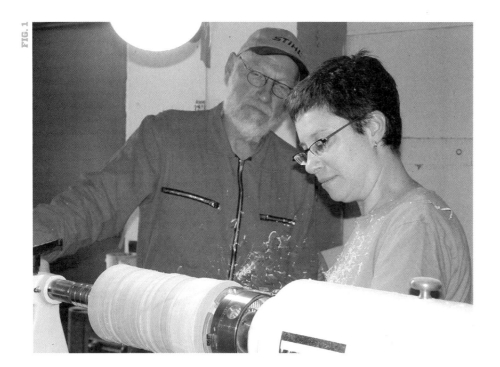

FIG. 1

FIG. 1 Siegfried Schreiber, Germany, instructs Elisabeth on the elementary aspects of wood turning during their 2007 ITE residency in Philadelphia.

With visibility and connectivity to the public, the Center can be a beacon in the field. It will have the potential to galvanize all the branches: artists, hobbyists, scholars, curators, collectors, and gallerists in a truly unique way and be extremely influential. As a central hub or national center for art in wood, it will act as a place of exchange, transmission, deposit for ideas, techniques, objects, scholarship, education, etc. But more importantly, it will act as a place for all these branches of our community to celebrate and elevate the art form itself. No matter what branch we represent, this commonality speaks to the core of our mission as art advocators.

The Center as "beacon" represents an enormous opportunity for the field of art in wood but also could be used to set an example for the field of contemporary craft. The five fields of concentration (glass, ceramics, fiber, wood, metal) are traditionally set apart as if in silos. There is a need to come together and sit tall at the table. Ironically, contemporary craft is on a steady upswing. It seems that new curatorial appointments dedicated to craft are being created in museums, interest in the study of craft at the graduate level is increasing, artists who work in customary materials are creating work in craft materials, the world of industrial design is giving more consideration to materials, and although some are needlessly threatened by the burgeoning movement of unschooled crafters who identify themselves as part of DIY (Do-It-Yourself) they are proof of our society's need to create and surround ourselves with handmade objects. This tells me that the need for tangible objects is ever present. But what I find most intriguing is the great extent of exchange of techniques, processes, and idea generation within this group of hip crafters. It very much mirrors earlier

days of the American studio craft movement itself where out of necessity budding artists relied on each other for direction in their process and creativity. Imparting knowledge of "how-to" is one of the tenets of craft that set it apart from others. Unlike the other endeavors, the fields of art in wood and DIY share a similar beginning. Studio wood turning came to be a hobby for interested individuals and was also taught through manual instruction in schools around the 1930s. Like DIY, there was a strong tradition of exchange. Now a celebrated field of art, this practice of transmission continues today as experts, seasoned hobbyists and newcomers readily pass on kernels of wisdom so that they all can share in the delight of making objects in wood.

I experienced the tradition of transmission first hand as the ITE Resident Fellow Scholar (2007). The opportunity to try my hand at the lathe, guided by the world's most talented artists in the field is unforgettable (fig. 1). Their commitment to demonstrate process, teach and guide was ingrained as if returning the favor. To say this experience had a major impact would be putting it mildly. Since that summer, and two major acquisitions later, I am honored to be involved in the Center's strategic planning and usher in a new chapter in its history. The energy emanating from these changes is stimulating, and there is plenty to celebrate: a new mission, new name, and an imminent move to a new location. As this essay goes to press, the trucks will have pulled up on Vine Street, packed up all that used to be the Wood Turning Center and moved it into a new space at 141 N. 3rd Street in Old City Philadelphia. Although the physical move is real, it also is a metaphor for the positioning of The Center for Art in Wood and all that is possible for its promising future.

I really do not need a divining rod; I know a good thing when I see it. ■

THREADS AND HUMAN CHAINS

Albert LeCoff

CO-FOUNDER AND EXECUTIVE DIRECTOR

THE CENTER FOR ART IN WOOD

PHILADELPHIA

Last year, we started planning for the Wood Turning Center's 25th anniversary in 2011, and entering a new era with a new name and a new location. Early on, the Center's publications committee said, "...Albert, this means celebrating your 35th anniversary too..." This made my life-long obsession with wood turning and artists flash before me. Not in the scary way they say when you're dying, but in a huge flip book of people and memories. One thing always leads to another, and life and work thrust us forward. Interviewers always tell me that I have a hard time separating myself from the organization that my twin brother, Alan, and I started in 1986, and I admit that people (and my staff and wife) have to continually ask me, "...now Albert, who is the WE in your last sentence?"

When you only think you can, you never learn you can't...

For this project, editor Judson Randall has pressed me over and over to clarify the Me in all this. Here I try to unravel the very personal influences and people...the phases and the bridges that inspired and motivated me through 35 years of never comprehending, "No, we can't..." When you only think you can, you never learn you can't, and I guess I've became unconsciously contrary, and dogmatic, and obsessed, and determined. My forte is streaming ideas, and driving, and dreaming, and being a pain-in-the-ass. This results in new projects and books, and making unnatural matches between artists, people, places, materials, equipment, museums, publishers, curators, teachers, writers, trustees and collectors.

Each happening over 35 years resulted in life-changing experiences and meeting invaluable people who have become my human chain and my life. In a nut shell, here are my flip book highlights that I'll explore with you:

- organizing early wood turning symposia and first exhibit and publication (1976–81)
- starting the Wood Turning Center and the Challenge series (1986)
- pulling off the first international survey of lathe turned art, ITOS (1987)
- staging the World Turning Conferences (1993, 1997 and 2005)
- starting the summer residency program, ITE (1995)
- moving the Center out of my home office to public space (2000)

- partnering to sponsor the touring exhibit, *Wood Turning in North America Since 1930*, with the team at the Yale University Art Gallery (2001)
- innovative book designs—*Cabinets of Curiosities* and CD (2003); award-winning *Challenge VII: dysFUNctional* (2008), and *Magic Realism: Material Illusions* (2010)
- SAVE John Grass Wood Turning Company preservation project (2005)
- Surviving the United States recession years and moving to new space (2011)

My human chain of acquaintances and friends helps me pull off every project, especially all the artists with whom I've worked. Their work keeps evolving and shaping the wood world, and that always stimulates my ideas on how to present their work. Encouraging the creative process in using wood is the thread that connects all my ideas, from lathe turning in the 1970s to wood and other media now. All my early administrative assistants were martyrs and I thank them all. Some dealt with numbers, logistics and paper pushing which makes me crazy; my brother Alan gets the first crown for this. Still others grew me in business, museum practices and publications: especially Bruce A. Kaiser and Charles Hummel. People have taken risks along with me, such as the financiers of the ITOS book, the builders of public space, and the funders of our summer residency program, the ITE. Designer Dan Saal of Milwaukee, Wisconsin, changed what books can be. Finally, the Save John Grass project led to invaluable links—my wife of 21 years, Tina Van Dyke LeCoff, and the board members who now contribute expertise and friendship too expensive to buy. Without these and my other humans, my story would be much more boring.

I am lucky. I grew up in the 1950s and '60s when schools still taught shop. My chain of influences started in junior high woodshop where I horrified my teacher by painting the wood night table I'd made for my grandmother, the exact color scheme of her white and gold trim bedroom set. In high school, our shop teacher provided a table of books to stimulate project ideas, noting that we always had to change one thing so we weren't copying. Through junior and senior high school, I loved shop and wrestled and competed on the gymnastics team. I was a lousy student.

Gymnastics also wove throughout my college career (fig. 1). When it was time for college in the late 1960s, I wanted to become an industrial arts teacher but my parents squashed that idea, and pointed me toward a math major. With my gymnastics scholarship, I competed through college and finally got my degree. Then I started doing what I wanted to do—learn more woodworking. Briefly,

FIG. 1

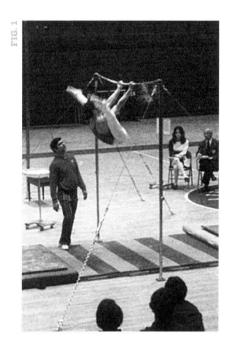

FIG. 1 Albert competes on high bar at Temple University, ca. 1972.

I taught at the Jewish Y, pairing kids and senior citizens, and at a special education school, where I had the older students teach the younger ones—one on one—in organized chaos. I gravitated to making connections between people.

I loved teaching and I miss it, but I wanted to improve my woodworking skills. Through a friend of the family, I met Manny Erez (figs. 2, 3), an experienced Israeli wood turner, paid him $2,000 and apprenticed to him from 1973 to 1975. Manny's English was bad so he resorted to the drawings in Frank Pain's *Practical Woodturner* book to show me the things he couldn't find words to explain. After two years, he retired and left me his complete shop and tools, and I was sitting on top of the world at age 25. I opened Amaranth Gallery and Workshop, took turning orders, designed and made custom furniture, and exhibited the work of my friends in the gallery. This was the late 1970s in Philadelphia. During this time, I met Richard Kagan whose craft gallery I really admired, and I remember seeing work that totally wowed me by Wendell Castle, Jere Osgood, Jon Brooks and others. I also met Lou Bower Sr. who ran the century-old John Grass Wood Turning Company, and took him lots of my turning orders, production turning being too repetitive for me. The first time I saw his family's line shaft and belt-driven shop, it was like a thunderbolt. I told Lou, this has to be preserved!

Because I wanted to learn more than wood turning, I applied to the Rochester Institute of Technology in Rochester, New York, for a graduate assistantship in the wood shop. One of the students, Steve Meder, knew I was a wood turner, and at the students' request, I taught them over a weekend how to use the dusty lathes and how to turn. In another chance meeting, student John Kelsey kiddingly suggested that I organize a real wood-turning weekend.

FIG. 2

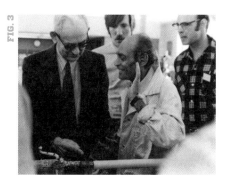

FIG. 3

I gravitated to making connections between people.

This was a life-changing moment, and I left the institute with serious intentions to organize such a weekend. Steve had a contact at the George School, a private Quaker school in Newtown, Pennsylvania; meeting life-long shop teacher Palmer Sharpless changed my life. Palmer liked the adult workshop idea, and soon I roped my brother Alan into handling the business and paper

work while Palmer organized the shop and lathes and materials. I visited each prospective instructor in their home shop, to ensure that each reflected a different approach to wood turning.

From 1976 to 1980, the Palmer/Alan/Albert team organized nine symposia (fig. 4), while holding down our full-time jobs. My business, Amaranth Gallery and Workshop, specialized in lathe-inspired functional sculpture and free form built-in cabinets and shelving that reflected the curvilinear styles of the era.

The George School symposia were structured, with small groups that rotated to all five instructors' demos so they would experience various approaches to wood turning (fig. 5). I still meet people who tell me they attended one or more of those symposia. The group ate and drank together, and at night returned to the shop for open shop and hands-on sessions. The last day of the weekend symposium included a Turn and Tell Session where the participants shared

FIG. 2 Manny and Albert discuss a project, ca. 1974.

FIG. 3 Paul Eshelman, left, and Manny Erez, right, discuss at first symposium, 1976.

FIG. 4 1976 Symposium: Left to right: Janet Eshelman, Albert and Alan LeCoff, Paul Eshelman, and Palmer Sharpless.

FIG. 5 March 1977 Symposium: Group watches Bob Stocksdale, right, at the lathe. Richard Kagan, center with big hair, meets Stocksdale for the first time, after showing his work for years. John Kelsey, standing on right, reports for *Fine Woodworking* Magazine.

FIG. 4

FIG. 5

their ideas, jigs and specialized tools and equipment. The instructors' and participants' objects were collected at the beginning of the weekend and shown in the adjacent clay studio, on work tables covered with tablecloths for an impromptu gallery all weekend.

During the symposia years, my love of bringing people together to make things really gelled. Visits to instructors, and organizing the next symposia energized me. I treasure my vivid memories of the instructors including:

- The late Jake Brubaker (fig. 6) of Lancaster, Pennsylvania. A wood turner of German Pennsylvania Dutch heritage, Jake specialized in traditional lidded containers to hold the spice saffron. Although I appreciated how he had carried the traditional design from his father to his grandson, at some point I couldn't stand it any longer and I challenged him during the second symposium to "loosen up a little." The next time I saw Jake, he brought me his new-fangled, off-center saffron container—complete with a crooked tail in contrast to the traditional container I'd already bought. Those objects are among my favorites to this day (plates 3, 4).

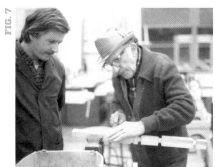

- The late Robert Yorkey (fig. 7) of Olney, Pennsylvania, shaped spindles with a file as the wood rotated in a vise. Seemingly primitive, he got perfect results.

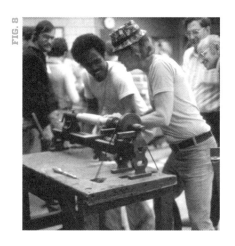

- When Frank Cummings (fig. 8) of California was asked to give a presentation at an ornamental turning symposium at the Smithsonian in Washington, D.C., he called me and asked what he should talk about, since he did not do ornamental turning. I told him his designs and carving were completely ornamental, and that should be his topic.

- The late C.R. "Skip" Johnson (fig. 8) of Wisconsin was a long-time university woodworking teacher, maker, stand up comic, and beer drinker. Since he did not consider himself a wood turner, he told me that he had prepared for the symposium by buying a book on wood turning which he read on the flight down. I laughed and reassured him that he was invited for his clever ideas and beer drinking.

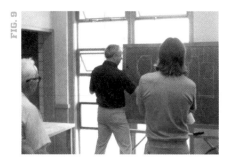

- William Daley (fig. 9), a well-known clay artist maker in Philadelphia, Pennsylvania, was the first guest speaker. Bill mesmerized the audience by explaining why objects made on a potter's wheel and wood turnings are just a series of bumps and holes.

We held the final symposium in 1981 at Bucks County Community College. The large facility allowed us to invite all of the past instructors and over 100 participants. I organized my first professional exhibition, *Turned Objects: The First North American Turned Object Show* and documentation, a small black and white catalogue entitled *A Gallery of Turned Objects*. Vic Wood of Australia answered my call for work, and it killed me when I had to decline him because he was not an American. My frustration over this incident changed my thinking forever; I wanted to include great work from everywhere. My belief in organizing and documenting exhibits came from the symposia years. So did my appreciation and respect for Alan's constant, quiet management of all the boring administrative details.

This era was filled with lots of stimulating influences. My business continued and I traveled to see new work at the early American Craft Council craft shows in Rhinebeck, New York, where I met the likes of Mel and Mark Lindquist, David Ellsworth, Steve Madsen, Giles Gilson, and others. I was impressed at the stir created when the Lindquists introduced revolutionary display innovations and lighting into their booth. About the same time, a 1981 color catalogue documenting a survey of art glass stopped me in my tracks. It was so beautiful and it showed the work so well. I longed to do this for wood.

From 1982 to 1983, a non-work injury really stopped me in my tracks. My business had to close and it took me a year to get on my feet again. Despite this serious incident, I never had any sense that my work (or my life) was over. A bad leg and a cane are the remnants of this era, but many artists came to my rescue as you'll soon learn.

All the while, more events were bringing wood turners together. Dale Nish started wood turning symposia in Utah, and flattered me by saying he was inspired by his participation in the George School symposia.

In 1986, I was pleased to give the keynote address at the Vision & Concept Symposium and exhibit at the Arrowmont School of Arts and Crafts in Gatlinburg, Tennessee. I suggested creating an organization that would promote the wood turning movement as had the other craft disciplines. Dick Gerard had the same idea, and he immediately presented a survey to determine the group's interest in an organization. At this tremendously exciting event, we founded the American Association of Woodturners (AAW). David Ellsworth emerged as the first president, and I was pleased to serve as the

FIG. 10

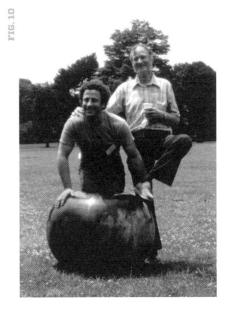

FIG. 6 Paul Eshelman gets a closer look at Jake Brubaker's demonstration, March 1977 Symposium.

FIG. 7 Robert Yorkey clamped spindles in a vice, shaped one quarter, then unclamped and rotated spindle manually to expose and shape the next quarter until complete, ca. 1978.

FIG. 8 C.R. "Skip" Johnson, left, and Frank Cummings demonstrate turning on a treadle lathe, March 1978 Symposium.

FIG. 9 William Daley discusses the fine points of design, June 1977 Symposium.

FIG. 10 Albert inside Ed Moulthrop's huge vessel, June 1979 Symposium.

first vice president, and the head of the education committee which included symposia. Several people received official awards, but I got a special one—an impromptu award, made at the event by Del Stubbs and Alan Stirt and signed by all the attendees, to thank me for my contributions to date. I cherish this gesture and fondly recall its timely presentation.

AAW board meetings started and projects emerged. I proposed an international touring exhibition and color documentation, to be staged at the second AAW symposium in my home town, Philadelphia. Meetings about the details dragged on and on, and friends asked me what I'd like to be doing. I said running a museum full of lathes, a library, classes and exhibitions. When they asked me what was holding me up, I replied, "Money." With that, one of them donated $5,000 as seed money to my dream, with the condition that the gift be matched. We raised the money and in the fall of 1986, my brother and I co-founded the nonprofit Wood Turning Center in Philadelphia. Consequently, 2011 is both the Center's and the AAW's 25th anniversary.

FIG. 11

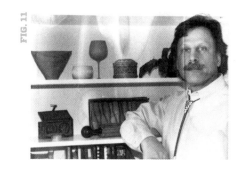

FIG. 12

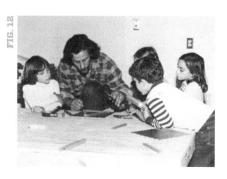

My vision for the Center was to showcase all sorts of lathe-turned art, and to offer artists opportunities to show their work to the public. I ran the Center out of my house (fig. 11) and Alan quietly handled all the business and paperwork. I continued to teach shop at a local private school to pay my mortgage, but people started visiting the "Center" to see my wood collection, and I needed to make calls during business hours. This led to my resigning from teaching so I could devote full time to developing the Center. I loved the adventure of teaching kids and I miss it to this day (fig. 12).

My vision for the Center was to showcase all sorts of lathe-turned art, and to offer artists opportunities to show their work to the public.

When I started the Center, I was asked to leave the AAW board, to avoid any potential or perceived conflicts of interest between the two groups. At first, this separation made me very sad, but the AAW board offered me the international wood exhibition that was stuck in committee and I ran with it. This led to working with jurors, finding museums and organizing the tour, physically making the crates, and publishing a book to document the artists' work.

FIG. 13

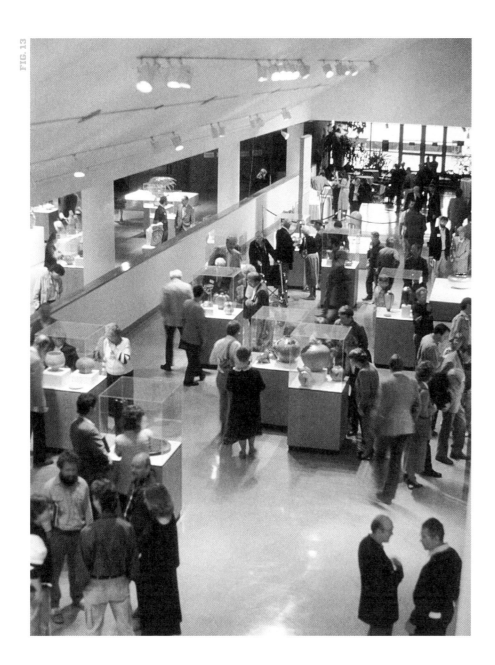

FIG. 14

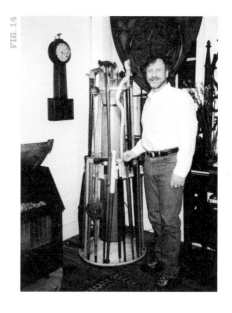

FIG. 11 Albert with collection at West Washington Lane home, 1990.

FIG. 12 Albert and kids in the classroom ca. 1974.

FIG. 13 ITOS opening crowd includes lower left Robyn Horn, David Sengel, John Horn, and Susan and Stoney Lamar, 1988.

FIG. 14 Cane set the ITOS artists made for Albert, at home, 1990.

By 1987, I had organized the first large, invited and juried public exhibition, entitled the *International Turned Objects Show (ITOS)*. I also learned to beg wealthy collectors to bankroll my conviction that the exhibit must be documented in a beautiful color catalogue with photographs and scholarly essays, like the glass survey catalogue I'd seen years ago.

I had to pinch myself to be sure ITOS was real. This large museum exhibit was a first for turned objects and it fulfilled my dream of pulling off an international survey that showcased contemporary turning in the same way that other studio crafts had been presented (fig. 13). As a personal thank you, the community of artists in the exhibit surprised me with a handsome set of walking canes. This double-tier column of large and small canes reflects the wit and design trademark of each maker, and makes it one of my prize possessions (fig. 14). To the amusement of my students, I used a different cane every day I taught at Chestnut Hill Academy. I will always be indebted to the small generous group

FIG. 15

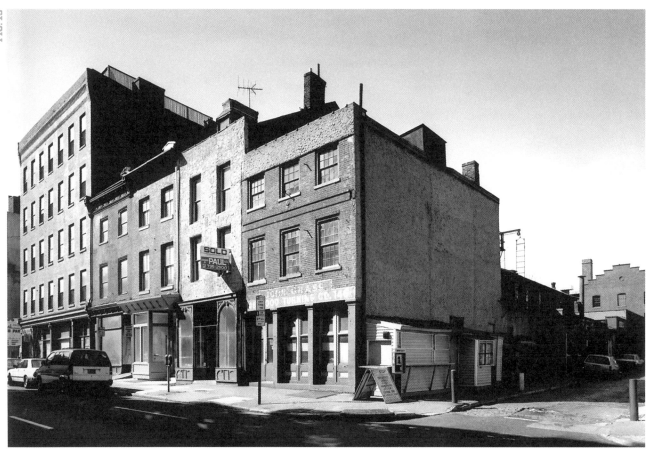

FIG. 16

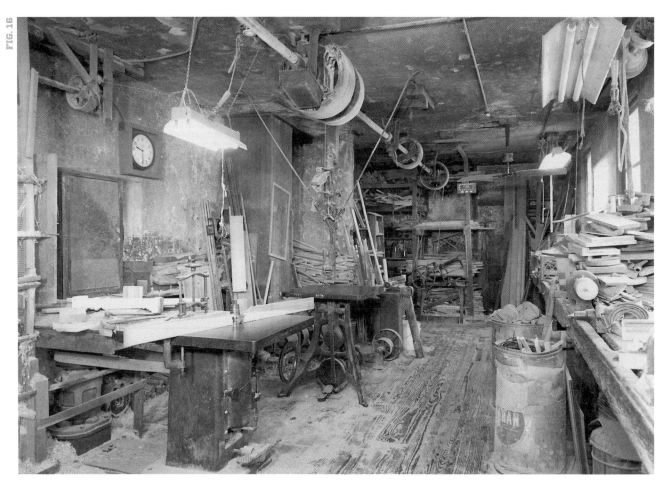

who risked backing the ITOS catalogue, including Ron Abramson, Robyn and John Horn, Arthur and Jane Mason, Sam Rosenfeld, and Ron Wornick. I had slip cases made for their copies of the book to thank them. With Alan, they were early links in my human chain.

Meeting Bruce A. Kaiser was a tremendous gain from ITOS. I dragged Bruce, originally a glass collector, out of the Snyderman Gallery to see a "real wood show," ITOS. He bought Michelle Holzapfel's *Self Portrait* hand and bowl (plate 97) right out of the show. Bruce continued to buy wood art until he amassed a large elegantly special collection. He also served as the president of the board for the first ten years, herding me and coaching me like a Dutch uncle, based on his business career at DuPont. Bruce is an "uncle" I claim to this day.

In the same year the Center was established, I began the Challenge series of exhibitions, first with the Craft Alliance of St. Louis. I insisted on established and emerging artists, various materials, and new work that facilitated the artists' creations without worrying about the market. I loved meeting all the artists over the years and seeing the ideas, humor, and execution of pieces they made to challenge themselves without marketplace concerns. Each show became its own challenge to document, first with thin black and white books, and gradually with slide portfolios then full color publications, essays and artist information. I have to say that publishing books of high quality has become one of my deepest satisfactions. We try to make each one innovative and interesting. Book designers, especially Dan Saal of Milwaukee, stimulate my creative juices and become my favorite professional friends. Books are adrenaline to me.

In 1989, I fell for my new love, the John Grass Wood Turning Company (figs. 15, 16), headed by Lou Bower. When I obtained a small grant to document the machinery and operation to Historic American Engineering Record standards, I met two people who would change my life. Through the grant, I met Charles Hummel of the Winterthur Museum in Wilmington, Delaware. Someone suggested him for the Center's board and he served for years through thick and thin. I benefited from Charles' 40 years of professional experience and collegial coaching. We don't always agree on museum and planning issues, but he always helps me understand why I am wrong.

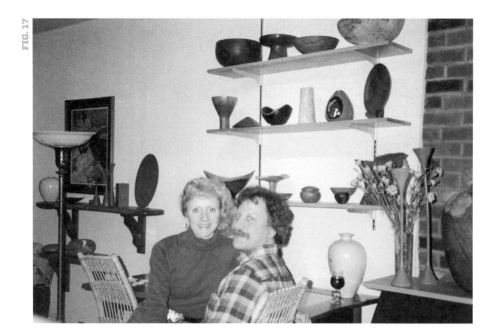

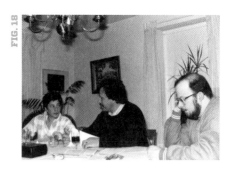

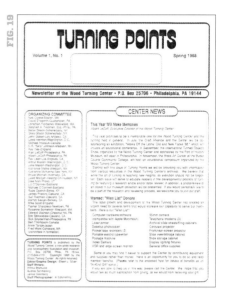

Through the documentation of John Grass, I met Tina Van Dyke, a landscape architect with the National Park Service. We had many overlapping interests and mutual friends in Philadelphia. When we married in 1990, she put all her possessions in storage because my three-story row house (fig. 17) was already full of my collection, the Center, and my home office and library. We lived the first ten years with the Center in our home. Happily, she applied her professional background to learning what artists do with wood, etc., and she got hooked on the field. Having Tina as part of my evolution has doubled my life.

Early on, the Center's newsletter, Turning Points (fig. 19), got the Center and I connected with the wood turning world. Started on my kitchen table with a local writer (fig. 18), the goal was to promote lathe turning as an art, and publicize the Center's programs and exhibits. Turning Points graduated from small black and white, folded mailers to magazines with professional editors. At one point, I did a call for editors and got a letter from a newspaper man in Oregon. This got buried on my desk for a year until an extreme clean-up session. I called the guy, Judson Randall, and we hit it off, and he became the Turning Points editor. Jud changed my life by framing the Center's publications program, and editing Turning Points and all of our books, including this one. His humor, experience, nudging, insults and guidance are a personal and professional godsend.

The first World Turning Conference in 1993 led to establishing a profoundly life-changing program, the International Turning Exchange (ITE). A European participant at the conference asked me, "Why did you bring me all this way here for just one day?" I became consumed with starting a summer residency

FIG. 17 Tina and Albert at West Washington Lane home, 1990.

FIG. 18 Eileen Silver, editor, and Albert and Alan LeCoff work on early Turning Points, ca. 1987.

FIG. 19 First generation Turning Points as printed, black and white folding mailer.

FIG. 20

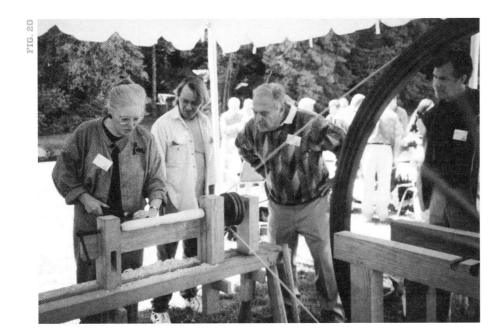

FIG. 21

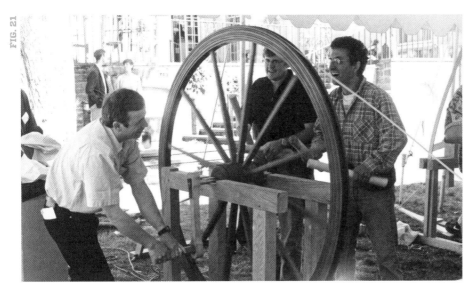

FIG. 22

FIG. 23

FIG. 20 Patricia Kane turns as Arthur Mason looks on at 1997 World Turning Conference, Winterthur Museum, Wilmington, DE.

FIG. 21 French turners, Jean-François Escoulen and Alain Mailland, horse around on great wheel lathe at 1997 World Turning Conference, Winterthur Museum.

FIG. 22 1993 World Turning Conference cancellation drafted by Albert's father, Jesse LeCoff, and designed by Ron Fleming.

FIG. 23 Conference cancellation applied at onsite post office, 1993.

program, and the Windgate Charitable Foundation provided the Center with the early funding that made it happen. Windgate, with Robyn Horn as the Center's quiet advocate, forged links to the ITE and many other Center initiatives. Over 16 years, I've thrived on meeting over 100 artists, photojournalists and scholars from 14 countries. Interacting with the residents and watching them grow personally and professionally explodes my personal and professional outlook for two months every summer.

With key organizational partners, we repeated the 1993 World Turning Conference (figs. 22, 23) in 1997 and in 2005, at Wood Now, co-organized with the Collectors of Wood Art Forum. New links were forged to critical organizational partners, including the University of the Arts, Philadelphia; the Philip and Muriel Berman Museum of Art at Ursinus College, Collegeville, Pennsylvania; and the Hagley and Winterthur Museums in Wilmington, Delaware.

The Center's reach grew and grew, with the hot air I blew into it every day. From 1991 to 1999, I ran the touring exhibitions and publications out of the larger house Tina and I bought to accommodate us plus the Center. With the help of a series of administrators and the board of trustees, I organized traveling exhibitions, partnered with museums, published books and Turning Points, and established the International Turning Exchange.

In 1999, however, the Center lost its home. Board President Fleur Bresler received a letter from Tina, complete with photographs that showed that the Center had taken over our house, exposing the crates that filled the living room and dining room, and the office and library that took up two rooms on the second floor (figs. 24, 25). The "landlord" gave the Center one year to vacate. I entered this transition with fear and excitement over the possibilities.

FIG. 24

FIG. 25

Meeting Fleur Bresler expanded and delighted my life. I watched her enthusiastically develop her wood collection, while she led the trustees in the charge to find the Center a public location in downtown Philadelphia. In 2000, we opened at 501 Vine Street, and again I had to pinch myself. For the first time, we had: a key, a public space, a door open to visitors, and space to present our own exhibitions on our own timing, the Center's collection, and the research library and archives. We doubled our space in 2005, and started a small museum store to help support expanded operations. This turned into a huge financial leap, but what happiness: space, staff, growth.

From our new space, we launched our next huge exhibition. Over several years, Charles Hummel, Fleur and I co-organized *Wood Turning in North America Since 1930* and its documentation with the Yale University Art Gallery. This was our biggest touring exhibition and color publication to date. All during the planning, these new museum collaborators ramped up my learning curve, including gallery director Patricia Kane; Edward "Ned" Cooke, newbie doctoral candidate Glenn Adamson, and registrar extraordinaire, Nancy Yates behind the scenes. The book, the traveling exhibit, and three symposia were huge and it felt great!

From 2004 to 2009, success was offset by a poignant and heart-breaking separation. It was finally time to help save the John Grass Wood Turning Company from extinction, a long-time dream of mine. The Center's board, under president Gregory Rhoa, attempted to raise the money to save the John Grass Wood Turning Company AND keep the Center's programming intact. The

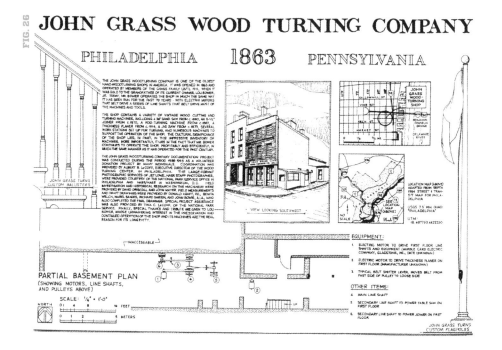

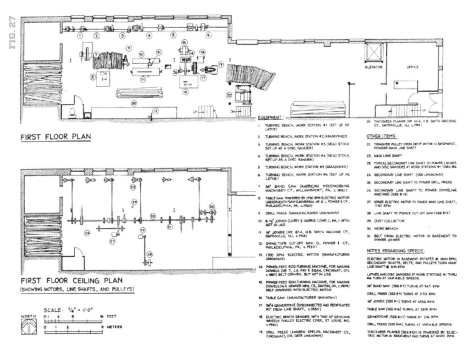

FIG. 24 Collection displayed at Albert and Tina's West Washington Lane home, 1990.

FIG. 25 Center's library in Albert and Tina's West Coulter Street home, ca. 1995.

FIGS. 26 & 27 HAER drawings of John Grass shop, team leader, John Bowie, AIA, 1989.

multi-million dollar preservation project (figs. 26, 27) would save the John Grass building and its belt-driven wood turning equipment, and provide new quarters for the Center. Under one roof, we could show the industrial history of wood turning, compared and contrasted to contemporary wood turned art. Our fundraising coincided with the United States recession and divergent views about the Center's mission and sustainability. John Grass attracted new iron-clad board members, however, and the Center and powerful friends ultimately facilitated the transfer of the John Grass building and contents from Lou and Marcia Bower to the local Carpenters and Joiners union. Happily, the union has stabilized and mothballed John Grass, with all of its future educational potential intact. Thanks to Walter Palmer for all his hard work for the Center, and for helping execute a successful ending. As sad as I was that the

FIG. 28

FIG. 29

FIG. 28 Albert demonstrates turning beads at March 1978 Symposium.

FIG. 29 Center's new home at 141 N. 3rd Street, coinciding with 25th anniversary, Philadelphia, 2011.

Center would not run John Grass, I gained a posse of trustees in Richard "Dick" Goldberg, the current board president, and Alan Keiser. Their leadership led the board and staff though strategic planning and successful fundraising for future programs and a busy new location in Old City at 141 N. 3rd Street, between Arch and Race Streets (fig. 29). Our updated vision and mission provides international artists who work in wood with forums to develop and show their work, and invites the public to learn, understand and come to appreciate all aspects of contemporary art initiated from the raw material of wood.

Today, we embark on the Center's new era, new name and new location. What a relief to see the Center thrive on its 25th anniversary and head toward the future. Our new name, The Center for Art in Wood, reflects decades of my promoting art work that is way beyond lathe turning, our original mission. This new era finds us moved to a strategic new location in a busy, art- and culture-centered, part of Philadelphia. This places us in a foot-traffic district, and close to other art galleries, nonprofits and local businesses. Our large team of designers, suppliers, laborers and financial supporters forged the new links to make the move happen. What a relief and what a bright future for wood! I am ecstatic to have such a colorful carousel of friends and trick ponies going forward. ■

CONTOURS OF A COMMUNITY

Gerard Brown

ASSISTANT PROFESSOR AND DEPARTMENT CHAIR, FOUNDATIONS

TYLER SCHOOL OF ART AT TEMPLE UNIVERSITY

PHILADELPHIA

The Wood Turning Center's roots—in a series of ten symposia organized by Albert LeCoff (the Center's co-founding executive director), his co-founding brother Alan LeCoff, and Palmer Sharpless between 1976 and 1981—are mentioned in each of the Center's publications with a force that borders on incantation. These weekend-long events at the George School in Newtown, Pennsylvania, combined discussions and demonstrations, and provided the first evidence of intelligent life at other lathes.

Before the George School symposia, the public conversation about wood turning as a serious craft or art form was widely diffuse. When it was exhibited, work by James Prestini and, less frequently, Arthur Espenet Carpenter or John "Jake" May, appeared in exhibits of design or shows combining crafts and decorative objects. By the late 1950's, Bob Stocksdale became a fixture on the shortlist of artists whose work found its way to exhibit, and the attention paid to his signature forms and use of exotic woods led to his 1969 one-person exhibit at the American Craft Museum. In 1975, Dale Nish's book *Creative Woodturning* was published, and, in subsequent years, other books (notably Stephen Hogbin's 1980 book, *Wood Turning: The Purpose of the Object*) reflected the formation of a dialog around the practice.

Still, wood turning was a poor cousin of the studio crafts. When *American Craft* published an anniversary issue celebrating fifty years of the American Craft Council, they included more than a hundred photographs in a twenty-page spread designed to give a sense of the breadth and diversity of contemporary crafts. The feature is a powerful visual essay about the relevance of crafts in visual culture, but it includes only three pictures of turned objects: by James Prestini, Ed Moulthrop, and David Ellsworth.

All of these reflected an enormous latent interest in the lathe and what it could make. Wood turning had been a central part of middle-school and high-school education from the early to the mid 20th century, and was thought to be a good way of teaching hand-eye coordination. Lathes, like potters' wheels to which they are often compared, are relatively simple to operate, but unlike ceramics, wood finishing doesn't require a kiln or other elaborate equipment. One can—as many did and still do—have a lathe in the basement or the woodshop for recreational purposes. Elegant, accomplished objects can be made with little training.

FIG. 1
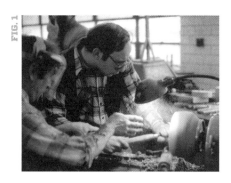

FIG. 2
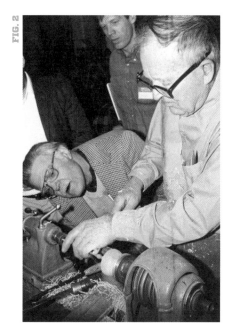

FIG. 3

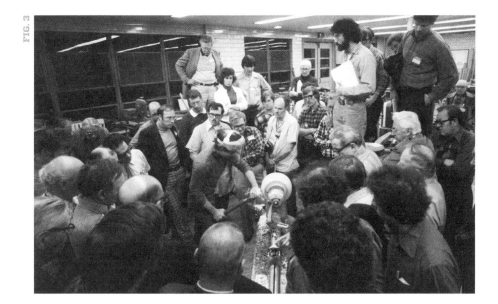

FIG. 4

FIG. 1 Instructor guides Matt Sinberg's right hand in evening symposium session, ca. 1978.

FIG. 2 A participant takes a close look at Jake Brubaker's turning techniques, March 1977 Symposium.

FIG. 3 Russ Zimmerman demonstrate on his Myford lathe imported from the United Kingdom, June 1977 Symposium.

FIG. 4 Instant Gallery showcases symposium participants' work, March 1978.

The first wood turning symposium took place at the George School in March, 1976. Advertised by direct mail, the event cost $25 for three days, including three meals. Six inst ructors, Max Brody, Manny Erez, Paul Eshelman, John Kelsey, Palmer Sharpless and Albert LeCoff, presented to a group of fifty participants who moved in rotation through stations. After the demonstrations (fig. 3), participants could try out techniques they'd learned under the guidance of the instructors. Palmer Sharpless provided the tools and facilities of the George School while Alan LeCoff managed the logistics of the events and Albert LeCoff took care of the creative aspects.

In addition to the information that was disseminated through demonstrations and conversations, the symposium featured "instant exhibits" (figs. 4, 6) where participants could display and discuss work. Each symposium ended with a banquet and a "turn and tell" session where participants shared ideas and technical information (fig. 5). This was an important feature of the events.

The symposium was mentioned in the newly inaugurated magazine *Fine Woodworking*, and requests for notes and information led to the planning of subsequent events on the model of the first. A second event took place in March of 1977 with Stephen Hogbin and Bob Stocksdale among its presenters.

These events were an important venue for established artists to discuss work and for unknowns to make a first appearance. This offered some participants a few surprises. David Ellsworth tells of a participant, the late Robert Yorkey of Olney, Pennsylvania, invited to the conference to offer demonstrations on how he made certain gate leg tables. As it happened, he brought a bag of small sticks that he joined in a vise and shaped with a rasp.

But the symposia also became a magnet for talent that previously had no spotlight in which to appear. One of the most interesting people to emerge was Californian Del Stubbs, who hitchhiked from the west coast and went on to become an influential figure with his techniques for turning exceptionally thin bowls.

Ellsworth recalls that he began attending the symposia in March 1978. "They were wonderful," Ellsworth recalls. "They were happy, they were non-political, they were poorly organized and rough and crude."

In addition to these symposia, other events presaged the formation of a formal organization for wood turners and reflected widespread interest. The Utah Woodturning Symposium started in 1979, and in Saskatoon, Saskatchewan, Michael Hosaluk organized a conference at Emma Lake in 1982 that drew turners from Canada, the United States, and the international community. It was through these disparate events that the contours of a community began to emerge.

By 1981, it was unclear whether the symposia revealed an interest in turning or were creating it themselves.[1] The last symposium took on a retrospective air. Instructors from the previous nine events were invited back to demonstrate and exhibit. This juried and invited show was supported by the publication of a black and white catalogue, *A Gallery of Turned Objects*. The catalogue was the beginning of an important tradition in the pre-history of the Wood Turning Center, one of documenting events so that not only participants, but also later researchers, could understand their place in the emerging field.

FIG. 5

FIG. 6

FIG. 5 Phil Brown demonstrates his cutting jig, during a Turn and Tell Session, June 1979 Symposium.

FIG. 6 Participants study each other's work in the Instant Gallery exhibit, June 1977 Symposium.

Perhaps because of entrenched perceptions that it was a hobby with an industrial (as opposed to creative) past, recognition of turning as a distinct field with artistic merit has been notably elusive from the start, even in the criticism and journalism that record its evolution. John Kelsey, writing about the 1981 *Turned Objects: The First North American Turned Object Show* in *Fine Woodworking*, seems reluctant to accord art-status to a turned bowl by Bruce Mitchell that was named best-of-show by jurors David Ellsworth and Rude Osolnik. Kelsey reported that "several artisans declared Mitchell's silhouette a cliché, tritely modern, as dated as Prestini's shapes," and then he mused on the object's relation to function. "What good is a bowl like this?" Kelsey wrote. "Could you ever serve candy or pickles in it? Where would you keep it, besides on a pedestal? Is it purpose enough for a bowl to be a beautiful expression of nature's wonder, revealed by human skill? Does this make it art, or does art require newer and more profound insights?"

It was through these disparate events that the contours of a community began to emerge.

Kelsey's dilemma suggests that a critical culture was taking shape in turning, and, like any culture, opposing values were evident. One camp valued innovation—be it technical or conceptual—and sought to situate its products and discourses in relation to forms of expression whose value was unquestionably great: art. Others were uncertain of these values, as Kelsey ultimately declared himself to be when he concluded that "the bowl's beauty is its function" and concluded that it is "not the same as art." "It is proud craft, admirably good craft, and that's enough for a bowl to be," Kelsey wrote, suggesting that—for a while longer at least—wood turning should know and remain in its place.

Kelsey was an instructor at the first symposium in 1976 and his role in framing the discussion of the field after an intense five-year period is significant. The first critical comments about wood turning came not from a sculptor or critic, but from a maker. The new field had begun to find itself, but hadn't reached beyond its own borders to start a larger conversation.

■　　■　　■

The decade from 1975 to 1985 saw wood turners coming out of their shops and sheds and meeting one another for demonstrations and discussion. Some had begun to whisper about their craft as an art form, and others in the community had moved past words into deeds.

The critical moment arrived when Sandra Blain, director of the Arrowmont School of Arts and Crafts, with help from David Ellsworth, Mark Lindquist, and Clare Verstegen organized a conference called *Woodturning: Vision & Concept* which included an exhibit titled *Woodturning: A Motion Toward the Future*. Arrowmont had begun offering wood turning classes three years earlier. The weekend-long conference, which took place in October 1985, was the catalyst for forming two of the most influential organizations in the turning field, the American Association of Woodturners and, a few months later, the Wood Turning Center (precursor to The Center for Art in Wood).

...LeCoff became convinced of the need for a global center that would encourage international artists and promote broader interest and scholarship in the field.

According to the American Association of Woodturners' history, more than 250 attendees participated in the conference, at which Albert LeCoff, one of the three planners of the influential George School symposia, was a speaker. Throughout the weekend, Dick Gerard, a woodturning enthusiast, canvassed the crowd looking for others who thought the time had come for some sort of organization to take shape.[2] With financial support from gallerists Ray Leier (of del Mano Gallery in Los Angeles) and Rick Snyderman (of the Works Gallery in Philadelphia) and others (notably Mark Lindquist) and charismatic leadership by David Ellsworth, the AAW quickly evolved from a planning meeting on a dormitory porch to an incorporated non-profit organization in February 1986. The new grassroots organization saw its primary function as providing information about tools, techniques, and suppliers and serving as a conduit for makers with questions who wished to approach "experts" for advice. Audiences, whether critical or curatorial, were not part of the equation.

FIG. 7

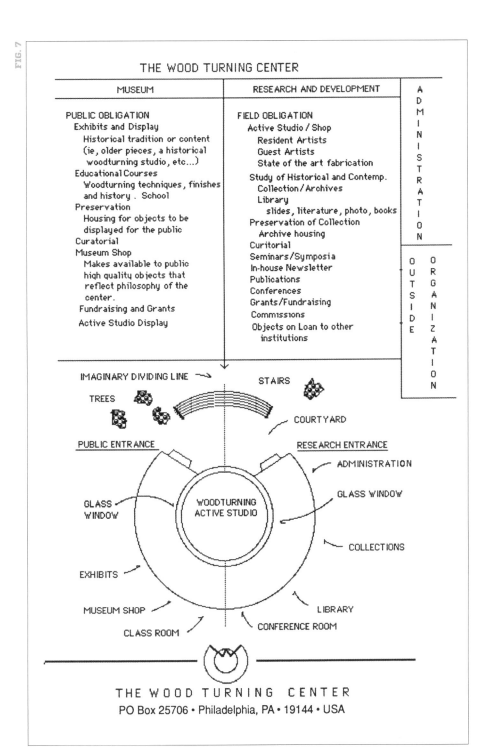

THE WOOD TURNING CENTER

MUSEUM	RESEARCH AND DEVELOPMENT	
PUBLIC OBLIGATION Exhibits and Display Historical tradition or content (ie, older pieces, a historical woodturning studio, etc...) Educational Courses Woodturning techniques, finishes and history . School Preservation Housing for objects to be displayed for the public Curatorial Museum Shop Makes available to public high quality objects that reflect philosophy of the center. Fundraising and Grants Active Studio Display	FIELD OBLIGATION Active Studio / Shop Resident Artists Guest Artists State of the art fabrication Study of Historical and Contemp. Collection / Archives Library slides, literature, photo, books Preservation of Collection Archive housing Curitorial Seminars/Symposia In-house Newsletter Publications Conferences Grants/Fundraising Commissions Objects on Loan to other institutions	A D M I N I S T R A T I O N O U T S I D E O R G A N I Z A T I O N

IMAGINARY DIVIDING LINE →
TREES
STAIRS
COURTYARD
PUBLIC ENTRANCE
RESEARCH ENTRANCE
ADMINISTRATION
GLASS WINDOW
WOODTURNING ACTIVE STUDIO
GLASS WINDOW
COLLECTIONS
EXHIBITS
MUSEUM SHOP
LIBRARY
CLASS ROOM
CONFERENCE ROOM

THE WOOD TURNING CENTER
PO Box 25706 • Philadelphia, PA • 19144 • USA

FIG. 7 Designer Katherine McKenna converted Albert LeCoff's program ideas for a Wood Turning Center into visual concepts, 1986.

Albert LeCoff was involved in the inception of the AAW, serving on its first Board of Directors as its vice president. But as the fledgling organization took shape and its focus on amateurs and its regional chapter structure clarified, LeCoff became convinced of the need for a global center that would encourage international artists and promote broader interest and scholarship in the field. He left the AAW and started the Wood Turning Center with his brother Alan LeCoff in November 1986.

THE WOODTURNING CENTER

Another facet of the origin of these two similar organizations so close in time needs to be explored. In the wake of the 1985 Arrowmont conference, the issue of wood turning's place in relation to contemporary art again came to the foreground. The George School symposia were, by many accounts, relaxed and collegial affairs. But things had changed by the Arrowmont conference. In *Wood Turning in North America Since 1930*, Glenn Adamson describes "a lavish display of work by top turners" that left "many hobbyists [...] disgruntled".[3] In *Fine Woodworking*, David Sloan, apparently put off by the exhibit's "arty aura" complained that "much of the work was outstanding, but something bothered me. The display of these flawless wooden pieces as *objects-d'arte* seemed inappropriate at a turning conference."[4] Sloan was clearly not alone in his feelings toward the exhibit. He gleefully recounts the appearance of a piece collaboratively assembled by Al Stirt, Del Stubbs and Michael O'Donnell that mocked the exhibit's pretense.[5]

The real or imagined division between a rank-and-file and artists was perhaps reflective of an increasingly divided culture in mid-'80s America. This was a time of exploding personal wealth and declining public support for the poor. For many, it was an era of AIDS and governmental indifference. While it was a time of tremendous political transformation, the ground was being laid for the culture wars of the 1990s.

Another aspect of the art world that didn't entirely gel with the profile of wood turning was the pluralism of the mid to late-'80s and the "multicultural moment" it brought about in the art world. Demographics play a role here. It's hard to elude references to the "great old men" of wood turning, and the art world of the '80s was a young person's game. (Little has changed—the YBAs—or Young British Artist—phenomenon has slipped into middle age, but only two years ago, the New Museum's signature triennial exhibit focused on artists born after 1976.) Artists of color, notably Frank Cummings and Michael Chinn, and women, among them Michelle Holzapfel, Merryll Saylan, Robyn Horn, and others have been important contributors to the field from its early days. Nonetheless even twenty six years after the Arrowmont event, there are a lot of pictures of white men in the pages of, for example, *Woodwork*, a magazine that describes itself as "a magazine for *all* woodworkers" (italics mine).

As a small organization unencumbered by membership, the Wood Turning Center was in a position to pursue a singular vision. The new organization immediately began assembling exhibits, with Albert LeCoff serving as a guest curator for the Craft Alliance Gallery's 1987 exhibit, *Works off the Lathe: Old & New Faces*, which was the first of the "challenge" series by the Center. Fifty four artists whose work ranged from traditional wood turning forms (such as bowls or spindles) to furniture forms to sculptural forms were included. The show was also highly inclusive of media, with metal spinning and turning as a part of larger furniture pieces. A slim pamphlet illustrated with black and white photographs was produced, and in it, the guest curator's notes outline the show's objectives, of which the first is "to bring to the public's awareness the high quality and diversity of work" in the field. This is a notable departure from the insular tone of earlier conference literature that emphasized the formation of a community of artists and craftspersons who share technical and material information.

It's also notable that this first exhibit includes brief statements by "participating artists" and thumbnail biographies. The statements are remarkable for their conceptual range. While some hew close to the familiar rhetoric of wood art, ruminating over grain and function, many others discuss an interest in narrative, imagery, and other factors that guide aesthetic decisions. It's a moment when you can sense the conversation shifting from "how" one might make things using these materials and techniques to "why." While a number of artists described themselves as "self-taught" or drew clear connections to industry experience that informed their work, thirteen of the artists in the show held MFA or MA degrees in areas from painting and printmaking to jewelry and metal-smithing. Six participants were women. Clearly, the Center attracted artists from a number of media who were beginning to see potential in turning.

The Center continued creating exhibitions. In September 1988, the Port of History Museum in Philadelphia opened an exhibit titled *International Turned Objects Show (ITOS)* (figs. 9–11), which subsequently toured under the aegis of the International Sculpture Center until 1992. Organized by the Wood Turning Center, the exhibit included over a hundred artists from Europe, Australia, and North America that were juried by Jonathan Fairbanks, independent curator Lloyd Herman and Rude Osolnik. David Ellsworth, Albert LeCoff and Rude Osolnik selected the invited section. Like previous exhibits, the show was documented by a catalogue. As before, the exhibit and catalogue aimed to expose

FIG. 9

FIGS. 9–11 *International Turned Objects Show (ITOS)* installed at the Port of History Museum, Philadelphia, PA November 1988.

FIG. 10

FIG. 11

the breadth of activity in the turning field, and arranged artists alphabetically rather than according to any curatorial vision. But this time, it was an elaborate, full-color production where nearly every object was printed as large as the page would allow.

It's hard to imagine the impact this beautifully executed volume had on the field. Extending far beyond the walls of the gallery, the publication summarized a diversity of approaches to media and processes. There was something for everyone to like in ITOS, from vintage Prestini and Stocksdale pieces to the big names of the moment like Ellsworth, Osolnik, Lindquist, and others. Pieces reflecting the industrial design of the mid- to late-'80s, such as Michael Chinn's *TRI - 1000* (fig. 12), were a few pages away from very personal, sculptural works like Michelle Holzapfel's *Self Portrait* (fig. 13). One could detect nods to turning's industrial past in Gail Redman's rosettes and finials, or peek into its future through Michael Brolly's vaguely alien *Mother-Daughter/ Hunter-Prey*.

Something for everyone to like also means plenty of material to which one might find objection. When John Perreault reviewed ITOS for *American Craft* in 1989, one can sense his patience for diversity wearing thin toward the article's end. After complaining that the use of paint had "compromised" a Stephen Hogbin bowl, Perreault began cataloguing lesser forms in the show, such as "pens, a chandelier, a few musical instruments and honey dippers" before he concluded by asking, "how can the field protect itself from hobbyists without becoming inordinately exclusionary?" This idea of a clear line dividing high and low was already crumbling in the art world (as evinced by MoMA's 1990 exhibit *High and Low: Modern Art and Popular Culture*), but reflected a mainstream belief in the last years of the 1980s that anything with artistic aspirations was, by definition, opposed to mass audiences and the possibility of popularity.

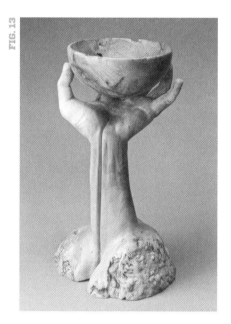

FIG. 12 Michael Chinn, *TRI - 1000*, 1986.

FIG. 13 Michelle Holzapfel, *Self Portrait*, 1987. (plate 97)

But things were already changing. The conversation about wood turning had sought outside input through the inclusion of curator (and Founding Director of the Smithsonian Institution's Renwick Gallery) Lloyd Herman and was getting responses from outside its boundaries from artist/poet/critic John Perreault in a magazine with a broader agenda than talking about wood with wood workers. What had begun as a conversation among makers was spilling over into something one could care about whether or not one stood behind a lathe.

In the AAW's silver anniversary book, Ellsworth notes that "it is important to recognize that unlike [established fields of ceramic, glass, fiber, and metal] woodturning did not have an academic or art(full) base. In effect, woodturning had never graduated beyond high school woodshop class, while other media fields had gone on to graduate school in university art departments." Soon after its establishment, the Wood Turning Center began trying to make up for that lack of critical density through an ambitious combination of strategies, some of which have had a direct impact on the collection that forms the basis for this exhibit.

First, the Center continued to mount exhibitions that challenged artists to move into new territories and challenged viewers to expand their ideas about wood and craft. Over the years, these have become increasingly imaginative and collaborative. The Center has encouraged critical examination of materials, forms and traditions through inventive themes (as with the 2008 exhibit, *Challenge VII: dysFUNctional*). Other notable exhibits involved collaboration with craft-based groups. *Cabinets of Curiosities* was a 2003 project with The Furniture Society that was shown throughout Philadelphia before an extensive tour. *Magic Realism: Material Illusions*, a 2010 exhibit, was inspired by the Philadelphia conference of the National Council on Education in the Ceramic Arts that year.

The second and far-reaching Center tactic fostered scholarly work and critical self-examination through conferences. These expanded beyond the sharing of technical information and into the realm of theorizing about the field. In 1993, The Wood Turning Center and the Hagley Museum and Library presented the first World Turning Conference. Bobby Hansson began his report on the World Turning Conference by observing that, "Unlike many craft conventions that focus on demonstrations, this one was very much centered on talk." He was clearly engaged by presentations made by Bill Daley, Vic Wood and Merryll Saylan, among others, and grateful that the "how small/thin/exotic/rotten a piece of wood can you turn?" part of the event was minimized. "Emphasis on technical virtuosity," Hansson wrote, "wears as thin as some of the bowls themselves in a very short time."[6] Subsequent Center conferences have continued to nourish discussion of the conceptual and contextual facets of the emerging field, bringing together small groups of diverse thinkers and makers to focus the conversation.

The ITE has helped foster a community of collectors who eagerly await each year's residents.

In 1995, another program essential to the Wood Turning Center's expansive and inclusive agenda was launched: the International Turning Exchange (ITE). This continued to nourish the Center by bringing artists from around the globe together to explore and share techniques and grow artistically. Following the Center's tradition of producing documentation for its programs, the ITE has also included scholars and photojournalists since its inception, creating a unique record and interaction with fellow residents as it grew. The program has proven to be a fertile opportunity for collaboration between artists.

Furthermore, the ITE has had a direct impact on the collection. Visiting artists are often unaware of the value of their work and are grateful for the support of American collectors they encounter through the eight-week residency. A number of pieces in the collection were donated by participating artists, many of whom experimented with innovative and collaborative techniques as part of the experience. The ITE has helped foster a community of collectors who eagerly await each year's residents.

Through all of this, the Wood Turning Center continued collecting, and has recently begun acquiring significant works at auction (as when the Center acquired Mark Sfirri and Robert G. Dodge's 1989 *Secretaire* (plate 56) in 2006). By the end of the first ten symposia in 1981, nearly eighty objects had been donated by artists and participants in anticipation of an institution that could care for and display them. When York Graphic Services published a guide to the Center's collection in 1997, it contained "more than 300 objects."[7] In 2000, when the Center moved to 501 Vine Street, its collection included more than 900 art objects, 25,000 books, slides and artists' files. That collection has been the wellspring for the current exhibit.

◼ ◼ ◼

In thinking about the newly inaugurated The Center for Art In Wood, I was not initially compelled by a love of wood, of turning wood, or of any of the usual things that attract people to this institution. I was compelled to understand its identity by examining the objects it had assembled in its collection, and curious to see if these reflected its history in any real way.

One thing I've learned is that the logic of the pedestal that is said to govern the field is not useful when attempting to create a historical narrative. It is due to be replaced with what I might call the logic of the collection, in which the arrangement of objects, their adjacency, proximity, unity, contrast, etc., combine to create meaning as usefully as objects themselves. If a collection is to be useful, it is not in its atomized state as a list of valuable, unique objects made by isolated individuals. A collection's value lies in the possibilities of its configuration and in how it can be *used*, not in what its content means. ◼

ENDNOTES

1 Starr, Richard. *Last was Best.
 Fine Woodworking.* Jan–Feb 1982
 (N. 32). p. 61.

2 *History of AAW.* American
 Association of Woodturners. <www.
 woodturners.org/info/history.htm>.
 30 Apr 2011. p. 57.

3 *Wood Turning in North America
 Since 1930.* Yale University Art
 Gallery, New Haven, and Wood
 Turning Center, Philadelphia, 2001.
 p. 108.

4 Sloan, David. *Arrowmont Turning
 Conference: New Work, New Guild.
 Fine Woodworking.* 56. Jan/Feb
 1986: pp. 64–66.

5 Ibid. p. 66.

6 Hansson, Bobby. *World Turnout.
 American Craft.* Aug/Sept 1993.
 p. 20+.

7 York Graphic Services, Inc., York, PA,
 *Enter the World of Lathe-Turned
 Objects*, 1997. p. 3.

NOTES ON A COLLECTION

Gerard Brown

ASSISTANT PROFESSOR AND DEPARTMENT CHAIR, FOUNDATIONS

TYLER SCHOOL OF ART AT TEMPLE UNIVERSITY

PHILADELPHIA

First, a confession: When I agreed to organize this exhibit, I had learned virtually nothing about wood turning since my seventh-grade shop class. ℮ My ignorance didn't deter Albert LeCoff, then co-founder and executive director of the Wood Turning Center (now The Center for Art in Wood), who asked if I would go through the Center's collection and organize an exhibit marking the 25th anniversary of the Wood Turning Center, which was coincidentally the 35th anniversary of a series of symposia that led to the creation of the Wood Turning Center, which—coincidentally—would be the first exhibit of the newly renamed organization in its new home.

No pressure.

So if it wasn't the kind of obsessive love of wood and lathes I've observed in some of the Center's constituents that led me to do this, what was it? I wanted to test a theory that rests at the core of all museum thinking: that what we *have* in some way reflects who we *are*.

... I would occasionally ask myself, what am I looking at?

As I went through the collection of more than 1,000 objects, visited collectors to look at gifts they had promised, read through some of the thousands of documents, publications, images in the archives, I would occasionally ask myself, what am I looking at? That question was a reflection of a belief that the objects in a collection constitute a history or identity of the collector, and that any difficulty reading that history or discerning that identity was problematic.

In fact, I learned I was not interested in these objects as souvenirs or relics or for their status as things that had come down to us from certain makers. To be interested in them in that way would yield a "greatest hits" parade of the Center, which I've come to respect as an institution but which hardly needs to congratulate itself through such a gesture. I *am* interested in how this collection might propel a conversation forward by creating new conversations between artists and among objects.

The first thing I found was a vigorous conversation among the objects on the shelves. Among the obvious displays of skill and assertively meaningful imagery that mingled with clothes pins and nesting dolls, I began to notice a body of work struggling to push forward and define itself in new terms.

Sometimes these conversations are within a single artist's work. In 1977, Jake Brubaker brought a rosewood saffron container to the second George School wood turning symposium. It was a traditional form he'd learned from his father and grandfather, a Lancaster County, Pennsylvania, object in which a basically cylindrical box rests atop a foot and is covered by a lid with an acorn ornament (plate 3). Praised for the skill with which he executed this traditional form, Brubaker was also challenged by the symposium co-organizer Albert LeCoff to carry the idea further. The next year, he arrived with an asymmetrical box turned from Swedish birch (plate 4). Its lively gesture contrasted sharply against the classically-inspired balance of his earlier work. Pushed to innovate by encountering other artisans, Brubaker's growth is a parable of the importance of the community that has evolved into the Wood Turning Center.

PLATE 3

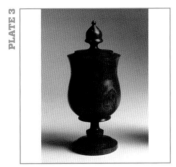

Jake Brubaker, *Saffron Container*, 1977

PLATE 4

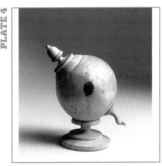

Jake Brubaker, *Saffron Container with Tail*, 1978

... I began to notice a body of work struggling to push forward and define itself in new terms.

Conversations also take place between contemporaries in the field, as when one compares two turned bowls by Bob Stocksdale and Rude Osolnik. Both of them are natural edge bowls. The Stocksdale bird mouth bowl (plate 5) reflects the natural curvature of the outside shape of the log, while Osolnik's eccentric rim follows the curved edges of the salvaged tree cross-sections from a veneer mill (plate 6). One artist finds form in the natural world, while another finds it in the byproducts of others' work.

Occasionally, these conversations take place across continents or generations. The comprehensive history *Wood Turning in North America Since 1930*[1] describes the influence David Pye's technical innovations had on John Diamond-Nigh's sculptural bowl forms. The ability to place these objects side-by-side in the collection set them into a dialog about how form is realized in a way that neither object voiced alone (plates 7, 8).

Encouraged by this conversation, I looked for other topics around which objects in the collection could gather and saw David Ellsworth's 1981 Sonora Desert Ironwood *Vessel* (plate 9) as a call to which many artists formulated responses. *Wood Turning in North America Since 1930* indicates that Dale Nish began his experiments with worm-eaten wood (plate 10) as a sardonic response to pieces by Ellsworth and Mark and Melvin Lindquist in which the possibilities of rotten and spalted wood were being explored. But clearly Nish found in that material something much more meaningful than a joking rejoinder to another maker's material.[2] Michael Brolly takes the idea of an aperture in another direction in his 1981 *Shark Bowl* (plate 11), creating a lively caricature of the menacing creature with Brancusi-like economy. Ten years later, Todd Hoyer incised ominous black crosses in his *X Series* (plate 12), decisively canceling their function as vessels.

Joe Dickey's 1992 *Offering Bowl* (plate 13) is nearly disintegrated, its apertures too large to contain anything. It comes from a decidedly different dialog about the bowl that cannot hold water. Asked by a covetous clergyman to make a collection plate, Dickey sensed that the bowl he'd been commissioned to make wouldn't reflect the values he thought it ought to and made a piece that mocked his acquisitive patron, according to my interview in April 2011 with Neil and Susan Kaye. Sometimes these conversations are not limited to objects, and are not entirely polite.

PLATE 5

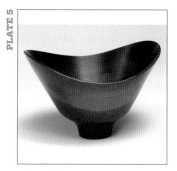

Bob Stocksdale, *Snakewood Bowl*, 1984

PLATE 6

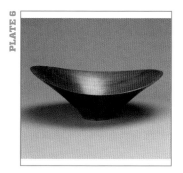

Rude Osolnik, *Untitled*, 1995

PLATE 7

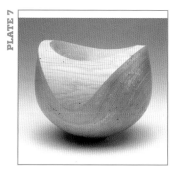

John Diamond-Nigh, *Untitled*, ca. 1985

PLATE 8

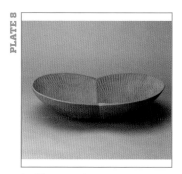

David Pye, *Bowl*, ca. 1980

PLATE 9

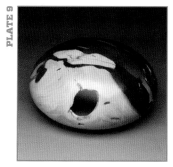

David Ellsworth, *Vessel (Sonora Desert Ironwood)*, 1981

PLATE 10

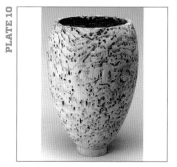

Dale Nish, *Nagare Vessel*, 1990

PLATE 11

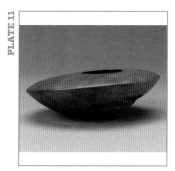

Michael Brolly, *Shark Bowl*, 1981

PLATE 12

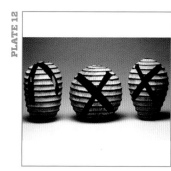

Todd Hoyer, *X Series*, 1991

PLATE 13

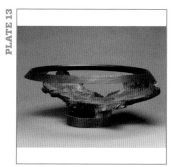

Joe Dickey, *Offering Bowl*, 1992

Another conversation formed around material. In 1977, Rude Osolnik, a productive turner whose work took many vernacular and sculptural forms, produced a large bowl of laminated plywood and walnut veneer (plate 14). It's a remarkable object in the context of the Center's collection for its elegant use of a pedestrian material, which creates a regular rhythm of vertical bands along its surface. Virginia Dotson's 1991 bowl (plate 15) remixes the materials, shifting their axis and concentrating the contrast around a swoosh of walnut that seems almost painted along the surface of the form. Gianfranco Angelino pushes the painterly notion Dotson advanced to an extreme in another plywood bowl form (plate 16). In this case, turning through inlayed layers of wood creates a painterly abstraction on the surface. Remi Verchot takes another tack in a bowl he created in 2003 (plate 17). Forsaking surface variation, he amplifies the possibilities of asymmetrical form in his turned plywood bowl. With its complex geometry of intersecting conical forms and spherical voids, Verchot's bowl creates a rhythm of concentric bands. Same materials, very different results.

The collection reveals connections that linear narrative conceals.

Did these artists know of one another? Do these objects belong to some kind of historical lineage? Possibly, but engaging with the collection offers the possibility that one might get more than explanations of how we got to where we are with a medium or process. As the Wood Turning Center becomes The Center for Art in Wood, it seems like an appropriate moment to look to the future, using the collection not only to talk about the history of wood turning, but also where the conversation about art in wood is headed. The collection reveals connections that linear narrative conceals.

WHAT IS A BOWL?

Given that the bowl is a primary form of turned object, with a 2,600-year history,[3] it's not surprising that its form would be the subject of one of contemporary turning's most lively conversations. How thick, how thin, how figured or plain, how organic or architectural a bowl can be is a microcosm for the diversity of positions and values held by artists and craftspersons.

A simple comparison can get the conversation started: Mark Lindquist's nearly formless 1977 Black Birch bowl (plate 19) harkens back to nature. Its organic form seems to be determined by the section of knotty wood from which it was carved as if all that were unnecessary had been shorn away leaving only an essential natural form revealed by handwork. In another bowl Lindquist maintains the sculptural mass of the 1977 Spalted Maple bowl's shape, but through the addition of five small, carved feet gives the form a lift and a place in relation to ceramics, where such bases are part of the formal vocabulary (plate 20). Lindquist can be imagined carrying out an internal debate on the relative merits of nature and culture through these works, with the emphasis shifting from nature's beauty revealed by the craftsman in one example to the genius of human engineering on the other. Don Kelly's 1979 *Black Walnut Bowl* (plate 21) comes into this conversation squarely on the side of culture. A graceful cone that tapers into a cylindrical base punctured by two small arches, Kelly's bowl looks like a tiny architectural proposal for a stadium or ceremonial structure. It transfers that sense of importance to its identity as a hand-scaled object, implying ritual significance.

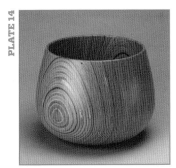

Rude Osolnik, *Bowl*, 1977

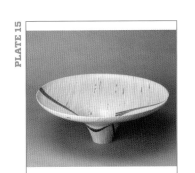

Virginia Dotson, *Calligraphy Bowl*, 1991

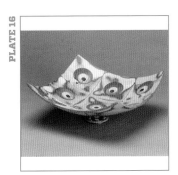

Gianfranco Angelino, *Palo Santo & Maple Swirl*, ca. 1999

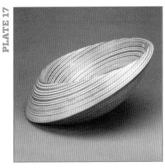

Rèmi Verchot, *Bowl*, 2003

Mark Lindquist, *Black Birch Bowl*, 1977

Mark Lindquist, *Spalted Maple Bowl, carved foot*, 1977

Don Kelly, *Black Walnut Bowl*, 1979

The bowl and other vernacular forms like plates and goblets are not only forums for the discussion of form, but also for the demonstration of skill. Del Stubbs attracted enormous attention from the turning world for his paper-thin bowls in the late 1970s and 1980s (plates 22, 23). Similarly, Robert Street drew praise for his luminous Translucent Goblet in Wood (plate 24).[4]

While Stubbs and Street (and many others) created technical *tours de force* in their thin-walled works, attention should also be paid to artists who imaginatively explored the implicit structure of the basic woodturning forms. Dewey Garrett's skeletal structures (plate 25) hint at a ghostly infrastructure that underlies the ordinary bowl, while Richard Hooper's work suggests a more robust, woven matrix (plate 26). Frenchman Daniel Guilloux, in his untitled 1998 sycamore and paint work suggests a more organic, almost cellular structure to matter (plate 27). Impossibly fragile, Guilloux's piece offers what might be the last word on thinness.

And here again the collection offers an interesting way of reviving history and realizing that it is more like a conversation than a story inexorably moving from one place to another. It would be easy to look over the literature of wood art and conclude a principle narrative of turning is the pursuit of thinness. Technical literature and instructional videos abound, and there is no lack of praise for objects so thin they transmit light in the reviews of wood turning exhibits one can locate. But concurrent with the pursuit of thinness are other conversations about vernacular form, and one sees them in the work of Jim Partridge (plates 28–30) and Robyn Horn (plate 31), whose massive-walled bowls, cups, and platters push against the idea of usefulness with sheer bulk.

If the conversation were to have only two poles, it wouldn't be very interesting. Consider the mutant and hybrid forms suggested by Hugh McKay and Irene Grafert. McKay devised a remarkable system of sliding jigs and adjustable tools to create forms whose borders bleed into one another, merging into multiple-opening jars that propose an alternate vision of the body of a vessel (plate 32). Danish artist Irene Grafert has seamlessly merged a pale green resin lip to her delicate bowls (plate 33). This edge, in the context of so much wood throughout the collection, startles the viewer, but seems like a functionally brilliant adaptation, as if Grafert's forms had developed hybrid properties and evolved beyond other more primitive bowls.

PLATE 22

Del Stubbs, *Bowl*, 1980

PLATE 23

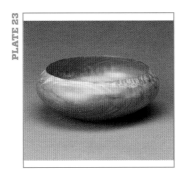

Del Stubbs, *Translucent Bowl*, 1979

PLATE 24

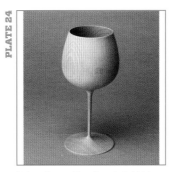

Robert Street, *Translucent Goblet in Wood*, 1986

PLATE 25

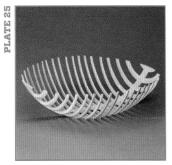

Dewey Garrett, *LIM #3*, 1992

PLATE 26

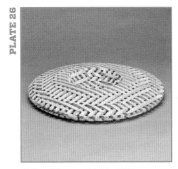

Richard Hooper, *Matrix*, 1993

PLATE 27

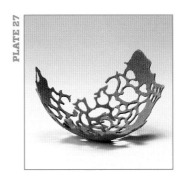

Daniel Guilloux, *Untitled*, 1998

PLATE 28

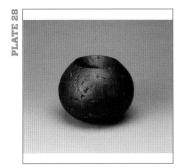

Jim Partridge, *Blood Vessel Series*, 1987

PLATE 29

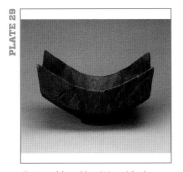

Jim Partridge, *Blood Vessel Series*, 1987

PLATE 30

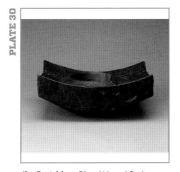

Jim Partridge, *Blood Vessel Series*, 1987

PLATE 31

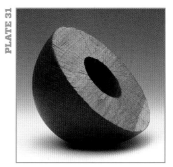

Robyn Horn, *Sheoake Geode*, 1987

PLATE 32

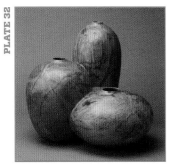

Hugh McKay, *Tripot #5*, 1995

PLATE 33

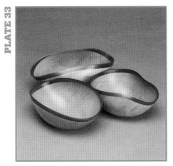

Irene Grafert, *Bowl with green resin lip*, 2008

The ability to find the beauty in wood or the willingness to turn to other materials to achieve an effect is another area of discussion that emerged in my investigation of the collection. It is one that objects themselves declare strongly without artists' statements or other texts. "Truth to materials" has been a central idea of art and design for more than a century, and in the crafts, the willingness to use screws to join two pieces of wood is a political gesture.

In this context, Derek Bencomo's sensitivity to the forms and figuration in wood, which he seems to caress out of the material more than carve out of it, was echoed (to varying degrees) in many artists' work. One imagines them all nodding in agreement with Ed Moulthrop, who said, "I don't design beauty [...] I just uncover it. I reveal the swirls, shadings, and grains that nature has placed within each log"[5] (plates 35, 36). There is a tendency among wood turners to give credit to the wood itself, and many objects in the collection bear labels identifying specific species of tree and the indications of the wood's history, as if to acknowledge time and nature as collaborative partners in the work. Bencomo's *Yesterday, Today and Tomorrow* (plate 37) carries a label indicating it is made of: 275-year-old oak. It's interesting to note that in the catalogue for *Turned Objects: The First North American Turned Object Show*, the first major national juried and invited exhibit of turned wood, there aren't dates on many of the works, but detailed descriptions of the woods accompany each photograph.

PLATE 35

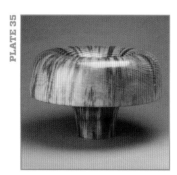

Ed Moulthrop, *Rolled Edge Bowl*, 1988

PLATE 36

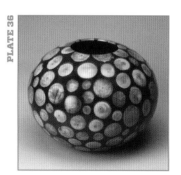

Phillip Moulthrop, *White Pine Mosaic*, 1990

PLATE 37

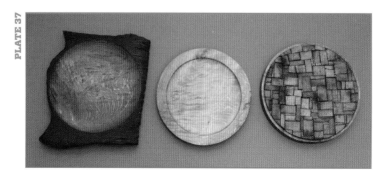

Derek Bencomo, *Yesterday, Today And Tomorrow*, 2009 ITE

But other artists seem to somehow distrust the innate beauty of the material, and have sought other, stranger beauties. Or perhaps they were simply taking a cue from James Prestini, who said, "I have reverence not for wood but for work."[6] Peter Exton's astonishing *Scorpion* (made of blackened cedar shingles) (plate 38) or Hilary Pfeifer and Liam Flynn's *Pegboard Inspired Vessel* (referring to a remarkably base material found on the walls of nearly every shop but seldom seen as a useful—let alone beautiful—wood with which to make anything) (plate 39) and Kevin Burrus *Sanding Disk* (which approaches being a book, as it's made largely from old, discarded Wood Turning Center publications) (plate 40) all suggest that one needn't have beautiful materials to produce beautiful results.

Like Irene Grafert, many artists worked with provocatively mongrel media. In some cases, this practice responds to overlaps between wood turning and other techniques for generating forms. William Moore marries spun metal to wood (plate 41), and Hugh McKay finds a place for brilliant blue glass (plate 42). Robin Wood brings video to the party (plate 43). These artists may not be intentionally (or even consciously) flouting any boundaries in their work, but when one looks at the totality of the collection, exceptions that employ multiple media stand out as useful provocations that beckon creative responses.

PLATE 38

Peter Exton, *Scorpion*, 2008 ITE

PLATE 39

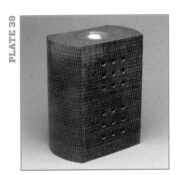

Hilary Pfeifer & **Liam Flynn**, *Pegboard Inspired Vessel*, 2006 ITE

PLATE 40

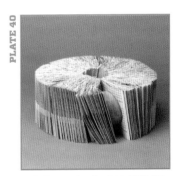

Kevin Burrus, *Sanding Disk*, 2003 ITE

PLATE 41

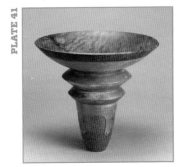

William Moore, *Timna*, 1990

PLATE 42

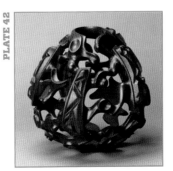

Hugh McKay, *Blue Rose*, 1996 ITE

PLATE 43

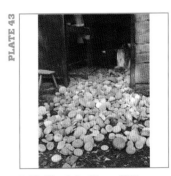

Robin Wood, *Cor Blimey*, 2007

Moreover, orthodoxies have a way of setting in and paralyzing artists with questions about their allegiances and "purity." Frank Cummings, an inventive sculptor for more than five decades, is represented in the collection by a tiny, spectacular piece that incorporates ivory and gold in its turned and carved form (plate 48). One shudders to think that his work would be seen as somehow not part of the conversation of wood art simply because of its inclusion of non-wood materials and carving as opposed to "pure" turning.

In this context, it was especially exciting to find in the collection objects that had little to do with wood at all. Giles Gilson slyly borrows the forms of wood in his Fiberglas vessels. Max Krimmel, who created astonishing platter forms from tiny fragments of oddly shaped wood, turns stone (plate 46). Lynne Hull (plate 49) and Boris Bally (plate 51) work with metal, creating forms that do away with wood, leaving only turning.

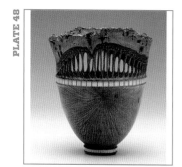

PLATE 48

Frank E. Cummings, III, *Nature in Transition*, 1989

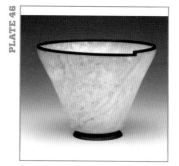

PLATE 46

Max Krimmel, *Alabaster Vessel #79*, 1987

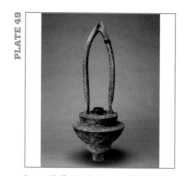

PLATE 49

Lynne Hull, *Vertical Basket #10E*, 1992

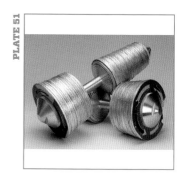

PLATE 51

Boris Bally, *Rep Forms*, 1996

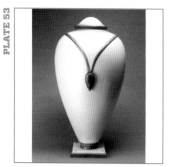

PLATE 53

Giles Gilson, *Vase with Necklace*, 1987

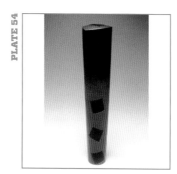

PLATE 54

Wayne & **Belinda Raab**, *Vase - Red with Blue Squares*, 1987

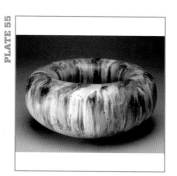

PLATE 55

Hap Sakwa, *Torus*, 1988

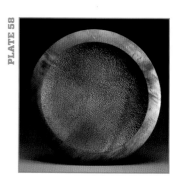

PLATE 58

Merryll Saylan, *North Seas*, 1988

COLOR (A DIGRESSION)

Related to the problem of material orthodoxy is the issue of color. The application of color to an object's surface seems, to some, like a shock or offense.[7] Nothing seems to locate an object in time more unfortunately than color, creating the feeling of "datedness" that contrasts with the "timelessness" of unpainted objects. David Batchelor has convincingly explored the bias against color in detail, and because of the forcefulness of negative reaction to color it seems appropriate to look through the collection for examples of its use that challenge new responses.

Perhaps because its founding coincided with a prominent use of color in fashion and industrial design, the Center has several interesting examples. Giles Gilson's unorthodox use of materials was discussed earlier, (and his use of color has been described as a form of humorous provocation.[8]) Certainly his *Vase with Necklace 87* (plate 53) is an emphatic assertion of the potential of color. Finishing his works with industrially smooth textures and almost imperceptibly subtle shifts in hue and value, Gilson invites viewers to see the sculptural forms of his turned objects with seemingly different weight and presence.

Another emblem of color's possibility is Wayne and Belinda Raab's 1987 *Vase - Red with Blue Squares* (plate 54). Color appears to dissolve form as a series of blue squares ascend from a circular base to a square opening at the top of the vessel. Slender to the point of worrisome, the vessel seems to teeter precariously on its little base, but is surprisingly stable. Color here has the effect of optically lightening the form, creating an illusion of fragility where there is surprising strength. Certainty and uncertainty coexist in the vessel, where clearly nameable shapes and colors gradually slide into one another.

Hap Sakwa's *Torus* (plate 55) suggests no such frailty. Nor geometric control. It's a low donut, like a deflated vessel streaked with painterly color. Where the Raab vase creates ambiguity through geometry, Sakwa uses painterly edges to create an atmospheric volume.

Color has occupied Merryll Saylan for much of her career, and in contrast to Raab and Sakwa, her *North Seas* platter (plate 58) seems positively reserved. It's monochrome, and color is embodied in the form, not applied. Saylan worked with dyes and other finishes to sink color into the wood itself, allowing her to carve out the texture of the platter's center without revealing an underlying wood or gumming up the texture with paint.

Collaborators Robert G. Dodge and Mark Sfirri produced another piece that reflects the enthusiastic pluralism of the time. Their 1989 *Secretaire* (plate 56) is a pastiche of traditional furniture styles and contemporary decorative motifs spun together in an early post-modern blender. Playfully mixing exotic woods and painted, patterned surfaces, the piece's surface treatment almost makes one look past its subtle physical humor (legs that don't quite reach the ground, for instance). It's hard to remember a time when animation was thought to be just for kids, but Sfirri and Dodge's cartoonish desk—from the same year that *The Simpsons* first appeared—might be a refreshing reminder that you're only as old as you think you are.

Like many of the exciting possibilities of early post-modernism, color has been a less powerful force over the last twenty years than when it appeared (at least this is the way the collection plays out). One recent work that suggests that color may still be a vital issue is Robert Lyon's 2009 vessel *Turner's Pallet #2* (plate 59). Lyon has embedded segments of color pencils in the wood before turning it, producing vibrant dots of color over the surface. These are streaked from the revolution of the form on the lathe and, like Saylan's embedded color, become a part of the final object rather than a coat applied to its surface. Lyon's work suggests that color may be a frontier for renewed exploration in the expanded field wood turning now finds itself.

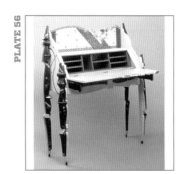

Mark Sfirri & **Robert G. Dodge**, *Secretaire*, 1989

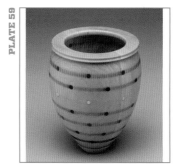

Robert F. Lyon, *The Turner's Pallet #2*, 2009 ITE

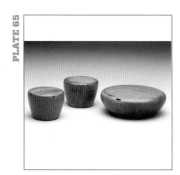

David Ellsworth, *Salt, Pepper & Sugar Containers*, ca. 1978

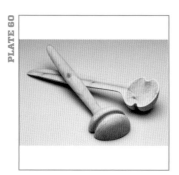

Stephen Hogbin, *Spoons*, ca. 1978

Stuart King, *Spoon*, 1993

Returning to the conversations one listens in on through the Center's collections, none is more enduring or divisive than the question of function. Though craft artists long ago discovered that a cup needn't hold water, the issue of function and how directly it is addressed runs through the collection like a thread.

Hundreds of objects (many of them anonymous) could serve as a starting point in this conversation, but it seems appropriate to begin with David Ellsworth's 1978 *Salt, Pepper, and Sugar Containers* (plate 65). They are ingenious in every way. Made of rosewood and padauk laminated to walnut, they are strikingly elegant objects, with cleanly modern shapes that conform delightfully to the hand. The means by which the sugar bowl is filled is a marvel of craftsmanship. Given that these were production items, they are all the more startling for their attention to detail.

... the issue of function and how directly it is addressed runs through the collection like a thread.

But Ellsworth stopped making them when his hollow vessel forms gained the attention of collectors. As well designed as they are, sugar bowls cannot compete on economic terms with sculpture, which brings the artist not only attention, but a different kind of collector.[9] By the time he made his production line of spoons (plate 60) in the late 1970s, Canadian Stephen Hogbin was already recognized as an innovative wood artist. These remarkable turned and carved forms were not only "good design" but art objects as well, and it's hard to imagine them being used to dole out salads, even in the most design-loving home. Therefore they function not only as what they are—spoons—but as emblems of the collector's sensitivity to quality and his ability to obtain it.

Spoons have an interesting place in material culture. Not all of them are even really meant to be used for eating or stirring coffee. Some function as souvenirs. Stuart King marked the first World Turning Conference by making a spoon of green sycamore taken from the Penn Woods in 1993 (plate 61).

Michelle Holzapfel's arresting *Candelabra* shows signs of use (plate 62). Its ritual value removes it from the day-to-day, and its elaborate craftsmanship demands it be taken care of by those who use it. But what about Merryll Saylan's and David Sengel's visions of the teacup? Saylan's painted box elder cup has a dry texture and slightly disproportionate scale (plate 63). Sengel's menacing black vessel is protected by thorns that run down its handle and encircle the cup and saucer (plate 64). Neither functions as a tea service, but both of them work exceedingly well to make the viewer consider our relations to everyday objects.

In an odd way, they bring to mind Joanne Shima's whimsical *Child's Chair* (plate 57), which is pristine and looks as if it has been spared the indignity of actual play with real children. Indeed, Shima's chair was an icon of late '80s furniture, in part representing that era's fascination of conspicuous consumption. Could a child really *use* this chair? Exactly what would be the economic circumstances in which studio furniture finds its way to the play room?

PLATE 62

Michelle Holzapfel, *Candelabra*, 1995

PLATE 63

Merryll Saylan, *Tea Set*, 1997 ITE

PLATE 64

David Sengel, *Tea Cup*, 1996

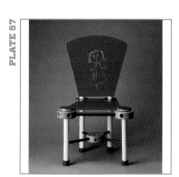
PLATE 57

Joanne Shima, *Child's Chair*, 1987

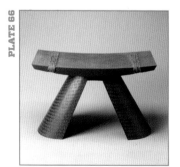
PLATE 66

Doug Finkel, *Bench*, 2000

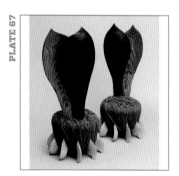
PLATE 67

Jack Larimore, *Natural Desire*, 2003 ITE

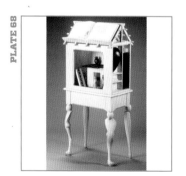
PLATE 68

Mark Sfirri & **Amy Forsyth**, *Figurati*, 2002

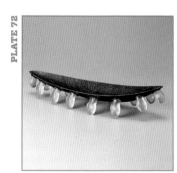
PLATE 72

David Rogers, *Something to Put Small Things In*, 1999 ITE

As Shima's chair suggests, furniture forms are another potent area in which the conversation about use plays out. Doug Finkel and Jack Larimore make ceremonial gestures toward seating in widely divergent ways. Finkel's stool (plate 66) seems like a primitive form, until one notices the patterned nylon cord that binds its seat. Larimore's *Natural Desire* (plate 67) looks like nature's answer to the wing back chair, a nest in which one might comfortably take refuge. Mark Sfirri (collaborating with Amy Forsythe this time) imagines the writing desk as a sort of intimate museum in which enigmatic objects and texts are mingled (plate 68). Are they stored? Will the open book be read?

Does it matter? The role of the object is to provoke questions. Returning to our first case—the bowl—I think of David Rogers' 1999 sculpture *Something to Put Small Things In* (plate 72). The piece is a shallow, boat-like bowl held aloft on cast resin toes. If one looks only at the walnut bowl form, one could imagine putting keys in it, but the toes seem to make such an ordinary use inappropriate. We are left with an empty object that insists (through its title) that it has a job to do.

As I sorted through the Wood Turning Center's collection, a poem by Marge Piercy called *To Be of Use* sprung to mind. All around me in the basement of the building at 501 Vine Street were bowls, clothespins, rolling pins, nesting dolls. On the floor there were bundles of balusters. Piercy writes about how the

> [...] thing worth doing well done
> has a shape that satisfies, clean and evident

I saw that all around, but like the ceramic vessels in her poem, I also felt that many of these objects

> [...] are put in museums
> but you know they were made to be used.
> The pitcher cries for water to carry
> and a person for work that is real

These last lines rang in my head. The tension between form and function is a central aspect of craft discourse, a subject far exceeding the scope of this project and one that artists in the field are a little tired of talking about. But Piercy's not writing about function in some abstract and theoretical way. She's

talking about the value of work—its capacity to make life meaningful. These objects, collected around me, took various stands towards functionality, but together they constituted a mass of labor that made the discussion of wood turning seem more than merely academic. In the words of Matthew Crawford, they spanned the gap from shop class to soulcraft.

A collection has a use, and its function is to push a field forward.

But Piercy also uses the museum as a straw man in her poem, suggesting that those objects withdrawn from everyday use have no function as contemplative or discursive objects. But we can plainly see: A collection has a use, and its function is to push a field forward.

It seems to me that the discussion of use is one that is altogether too narrowly focused. In my home, the salt is kept in what the maker of the container sold to me as a sugar bowl. It's quite happy there. Since the sugar lives in another container next to the coffee maker, no one seems to get confused and put salt in his coffee.

Artist Jasper Johns said something very interesting about intent,

> Basically, artists work out of rather stupid kinds of impulses and then the work is done. After that the work gets used [...] Publicly a work becomes not just intention, but the way it is used. If an artist makes something—or if you make chewing gum and everybody ends up using it as glue, whoever made it is given the responsibility of making glue, even if what he really intends is chewing gum. You can't control that kind of thing.[10]

With the advent of postmodernism, the ground has gradually shifted from conceiving of the work of art as a thing to be seen (by a "viewer") or experienced (by an "audience") or read, (subsequent to its creation by a possibly dead "author"). Now, design critic Ellen Lupton suggests, we've caught up with what Johns said in 1964, and art and design are engaged with the issue that has defined craft for centuries:

> The dominant subject of our age has become neither reader nor writer but user, a figure conceived as a bundle of needs and impairments—cognitive, physical, emotional.[11]

GAME CHANGERS

Possibly the first object to excite me in the collection was Garry Knox Bennett's *Pre-Turned Wood Object* (plate 70). Coming from a background in criticism and painting, this was an object I understood. It seemed not to be so much in conversation with its surroundings as to have crossed its arms and turned its back on them. Bennett had, with Duchampian wit, reduced woodturning to a field of potential. Anything might be made from that truculent block of wood. Anything might yet be made.

Bennett's perverse comment on potential was a game-changing discovery in the collection. More eloquently than the form and figure work that surrounded it, it spoke to the wood, the tools, and the process of making. It invited a conversation about how things get made.

Round things may be useful, and they get tiresome. The lathe is exceptionally good at producing round things, but getting anything else requires innovation and imagination. Stephen Hogbin's 1981 *Walnut Bowl of Walnut* (plate 71) was an early and inventive solution to the lathe's inherent limitations. By turning, then cutting and reassembling a flanged bowl form, Hogbin was able to undermine the basic aesthetic principles of wood turning and to incorporate asymmetry into his work. Despite its scale, this was no small achievement. Hogbin had been thinking about the limits of the lathe and inventing tools to accomplish large scale work since the early 1970s (fig. 1).

PLATE 70

Garry Knox Bennett, *Pre-Turned Wood Object*, 2000

PLATE 71

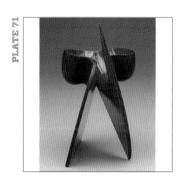

Stephen Hogbin, *Walnut Bowl of Walnut*, 1981

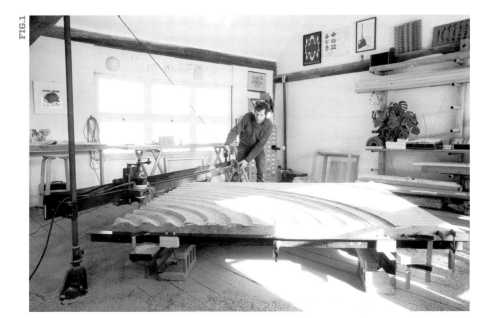

FIG.1

FIG. 1 Stephen Hogbin customized his milling machine to create forms for large architectural installations, 1976.

FIG. 2

FIG.3

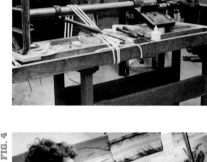

FIG. 4

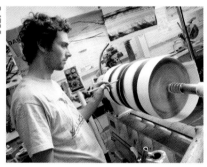

FIG. 2 David Ellsworth rides his lathe to get the perfect angle, 1977.

FIG. 3 Gord Peteran utilizes his bench-mounted drill press to turn forms.

FIG. 4 Jérôme Blanc adapts the lathe to create paintings during his ITE residency, 2009. (obj. 699)

Hogbin was not the only person to make his own lathe and tools. David Ellsworth (fig. 2), Ed Moulthrop and Mark Lindquist each devised new tools and uses for existing tools to propel their work into new territories of form and scale. But few artists have carried out as thorough an investigation of what wood turning might be as Canadian furniture artist Gord Peteran. If the wood spinning against a cutting surface is what defines wood turning, then sharpening a pencil is wood turning (plate 73). Peteran and Swiss artist Jérôme Blanc have each, in individual ways, re-imagined the function of the lathe (figs. 3, 4), re-casting it as a drawing tool (plates 74–83).

PLATE 73

Gord Peteran, *Two Bracelets*, 2002 ITF

PLATE 74

Gord Peteran, *Five Sounds*, 2002 ITE

PLATE 75

Gord Peteran, *Five Sounds*, 2002 ITE

PLATE 76

Gord Peteran, *Five Sounds*, 2002 ITE

PLATE 77

Gord Peteran, *Five Sounds*, 2002 ITE

PLATE 78

Gord Peteran, *Five Sounds*, 2002 ITE

PLATE 79

Jérôme Blanc, *Dance Final*, 2009 ITE

PLATE 80

Jérôme Blanc, *Untitled, #4*, 2009 ITE

PLATE 81

Jérôme Blanc, *Premiere Dance, #1*, 2009 ITE

PLATE 82

Jérôme Blanc, *Untitled, #5*, 2009 ITE

PLATE 83

Jérôme Blanc, *Dance Souterraine*, 2009 ITE

In the early 1980s, C.R. "Skip" Johnson, with a technician's fascination for tools, made up a model kit for a wandering wood turner with a cask of beer thoughtfully included among the (carved wooden) gouges and calipers (plate 84). Johnson's gesture was sweet and playful, but when Gord Peteran's *Untitled So Far* (plate 85) appeared on the cover of the Wood Turning Center's 1997 exhibit *Curators' Focus*, people took offense. *Untitled So Far* is the last object reproduced in the catalogue of *Wood Turning in North America Since 1930*, a show that some regarded as not so much a history of the emerging field as an obituary for it. But is there really that much difference between these two works? Both reveal a fascination with the products and processes of making, though one looks at the maker and the other begins with the made object. As the Wood Turning Center turns into The Center for Art in Wood, it is perhaps time that we listen with special attention to the conversations that have been taking place on the boundaries of wood turning, as they are now part of a larger, shifting terrain.

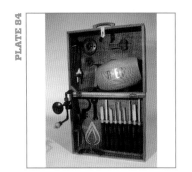

PLATE 84

C.R. (Skip) Johnson, *The Itinerant Turner's Toolbox*, 1981

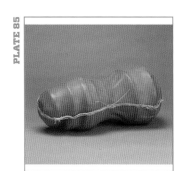

PLATE 85

Gord Peteran, *Untitled So Far*, 1996

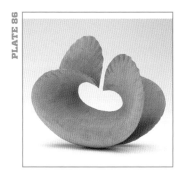

PLATE 86

David Pye, *Study in Flower Form*, ca. 1980

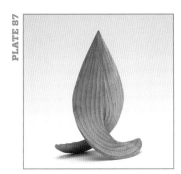

PLATE 87

David Pye, *Study in Flower Form*, ca. 1980

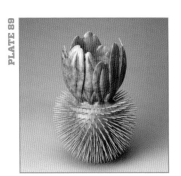

PLATE 89

Ron Fleming, *Echinacea*, 1999

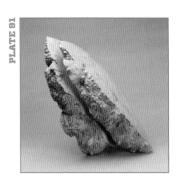

PLATE 91

Stoney Lamar, *Monarch*, 1995

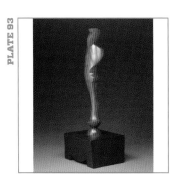

PLATE 93

Mark Sfirri, *Glancing Figure*, 2000

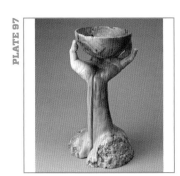

PLATE 97

Michelle Holzapfel, *Self Portrait*, 1987

One of the conversations that is now implicitly within the boundaries of "art in wood" is sculpture. Contemporary sculpture is a well-articulated field of diverse practices in innumerable media, one that has been operating in what Rosalind Krauss has called "the expanded field" for nearly a half century. The situation of wood art in that arena reveals how heavily the craft legacy weighs on artists who work in wood. For now, it's impossible to consider the range of diversity of sculptural practices in terms of wood art, but possibly productive to look at the inspirations of some wood artists in terms of sculpture.

One of the conversations that is now implicitly within the boundaries of "art in wood" is sculpture.

One of the principal inspirations for sculptors in wood is the natural world itself. In varying degrees of abstraction, nature has been a sculptural topic in wood art for more than 30 years. The collection contains two remarkable studies of floral forms by David Pye (plates 86, 87). The sensitively carved works betray not only a thoughtful consideration of the flower form itself, but also a masterful knowledge of their woods' properties. Pye's studies have many conversational partners in the collection, but Ron Fleming's *Echinacea* (plate 89) makes compelling use of both literal and abstract nature forms. Stoney Lamar also participates in this conversation. His *Monarch* (plate 91) is an almost wholly abstract form tethered to the image of a butterfly by the slender thread of its title.

The figure is another of sculpture's oldest subjects that has also attracted artists in the collection. Mark Sfirri's elegant *Glancing Figure* (plate 93) recalls the abstractions of Constantin Brancusi. Michelle Holzapfel's powerful *Self Portrait* (plate 97) speaks to the creative power of its maker and the potential of her medium.

Some of the most interesting discussions take place at the borders of bodies and cultures. The two figures in California artist Wendy Maruyama's *Kokeshi Series: Midori and Michiko* (plate 96) are derived from a traditional Japanese craft form (plate 94), but have been substantially updated and, um, enhanced. Their transformation speaks to the complex identities of women in the globalized 21st century world.

The dialectic between literal representation and abstraction is not always managed with grace. Perhaps because of its industrial arts legacy, wood turning can stray into awkwardness when it attempts to embrace formalism, revealing more than it perhaps intends. Such, one imagines, is the case with a curious candlestick by an unknown artist in the collection (plate 95), which, when placed in dialog with Maruyama's sexualized dolls, hints that there are realms of gender identity yet to be explored in the wood art universe.

Happily, not all gestures toward abstraction are so inelegant. Consider Mark Lindquist's *Drum Song* (plate 98), which builds on the legacy of Brancusi in its articulation of segments in relation to the whole. Or Connie Mississippi's *Phythagorus* (plate 99), whose monumental scale implies an enormous human presence overseeing us all, like a wooden descendant of some primitive monolith. On a smaller scale, Gael Montgomerie's *Tribute* (plate 100) also functions like a stele or marker recording human presence, now long gone.

Evolutionary anthropologists will tell you that it was early humans' ability to think symbolically that set us on the road to the present. Where nearly all the examples I've cited so far depict or describe in some more or less literal way natural or human imagery or inspiration, David Sengel's *Two Hemispheres, Still one Brain, Still Leaning Right* (plate 101) seems uniquely symbolic rather than iconic. In it, the two sides of the mind are represented by flanges of wood that seem to swirl and spin as if wandering. Material here suggests meaning, opening a little room for a new idea about the mind, about how it works, and how it sees itself.

WHAT DOES IT ALL MEAN?

David Sengel's work (among others) begins to hint at the possibility that a work in the collection of the Wood Turning Center or The Center for Art in Wood might be about something more than wood. We've seen content in other pieces, but the last conversation in the collection that I wanted to eavesdrop on is between works that attempt to be specific, not merely evocative.

Politics are a slippery issue for art. Somehow using "political" as a qualifier diminishes the aesthetic value of a work, as if it could do only one thing: look good or say something. Mike Darlow isn't taking on the world in his 1987 *Graffiti Bowl* (plate 106), but he's taking on the world of wood. His bulky awkward bowl taunts the icons of the field, like Prestini and Ellsworth, while proudly pointing to its own flaws. This may seem like an inside joke, but it's a form of engagement one can appreciate in a field that's suffered from more celebration than genuine criticism.

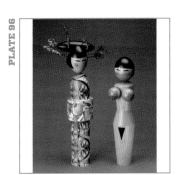

PLATE 96

Wendy Maruyama, Turning assisted by **Jason Schneider**, *Kokeshi Series: Midori and Michiko*, 2003

PLATE 94

Setu Hayasaka, *Squeaky Head Doll*, ca. 20th Century

PLATE 95

Unknown Artist, *Cylindrical Candlesticks with Spherical Bases*, ca. 20th Century

PLATE 98

Mark Lindquist, *Drum Song #1*, 1987

PLATE 99

Connie Mississippi, *Pythagorus*, 1995

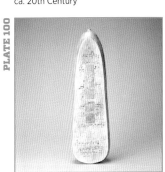

PLATE 100

Gael Montgomerie, *Tribute*, 1998 ITE

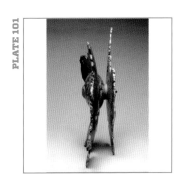

PLATE 101

David Sengel, *Two Hemispheres, Still One Brain, Still Leaning Right*, 1999

Dewey Garrett, Ted Hunter, and Alan Stirt also take specific content as places to begin work. Garrett's *Finding Resolve* (plate 103) attempts to come to terms with the 9/11 attacks, adapting his skeletal vocabulary of form to eerily echo the ruins of the World Trade Center Towers. Ted Hunter mocks Gulf War era militarism in *Our Children Watch* (plate 104), blurring the lines between weapons and toys. But Alan Stirt wrestles most with the idea of making art in wartime. His 1990 *War Bowl* (plate 105) is a distressed object, burned and seemingly shot through. At this point in his career, Stirt had been making bowls for over two decades with an acute interest in formal beauty and technical finesse. "This is the first bowl I have made where I do not want to express beauty of some kind," he wrote in a statement about the work.

At this point in the conversation, I am reminded of Jake Brubaker, compelled to do something he'd never done before.

■ ■ ■

Can a bowl really help understand a war or an act of terrorism? I don't know. Can a painting? Or a sculpture? Is it too much to ask of any object that it be more than it is? Art historian Ernst Gombrich pointed out that art doesn't really exist, there are only artists. In other words, the art is the byproduct of making things. One doesn't set out to make art, one sets out to make a painting, or a sculpture, or a bowl. And if one sets out to make more than a good pile of shavings, one might be doing all that one needs. ■

ENDNOTES

[1] *Wood Turning in North America Since 1930*. Yale University Art Gallery, New Haven, and Wood Turning Center, Philadelphia, 2001; p. 128.

[2] Ibid. p. 71.

[3] Kelsey, John. *The Turned Bowl: The end of infancy for a craft reborn. Fine Woodworking.* Jan–Feb 1982 (N. 32). pp. 54–61.

[4] Ibid. p. 60.

[5] Hoffman, Marilyn. *Art for Use. Christian Science Monitor.* 15 Apr 1980.

[6] Kelsey, John; p. 56.

[7] Perreault, John. "Turning Point." *American Craft.* Feb–Mar, 1989. pp. 24–31.

[8] *Wood Turning in North America Since 1930*. Yale University Art Gallery, New Haven, and Wood Turning Center, Philadelphia, 2001; p. 98.

[9] Ellsworth, David. Personal Interview. 18 Feb 2011.

[10] Selz, Peter and Stiles, Kristine. *Theories and Documents of Contemporary Art: A Sourcebook of Artists' Writings.* Berkeley: University of California, 1996. p. 324.

[11] Lupton, Ellen. *Thinking with Type: A Critical Guide for Designers, Writers, Editors, and Students.* New York: Princeton Architectural Press, 2010. p. 97.

Is it too much to ask of any
object that it be more than it is?

PLATE 106
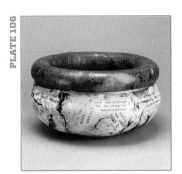

Mike Darlow, *Graffiti Bowl*, 1987

PLATE 103
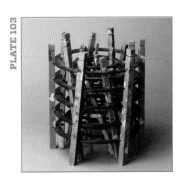

Dewey Garrett, *Finding Resolve*, 2001

PLATE 104
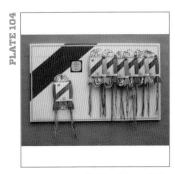

Ted Hunter, *Our Children Watch*, 1990

PLATE 105
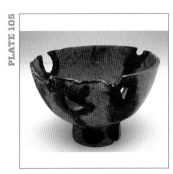

Alan Stirt, *War Bowl*, 1990

PLATES

A collection is not an historical narrative; it is more like a large pile of nouns. How one organizes a collection—in this case the more than 1,000 objects that compose The Center for Art in Wood's collection—tells a story that may in fact reveal more about the story teller than about the subject.

For that reason, we have tried to replicate the experience of viewing the collection through the following series of plates. Although the plates documenting this exhibit have been arranged roughly in page-number order, the viewer of this publication can rearrange the plates to imagine new relationships between objects and hear conversations that go beyond the present exhibit.

As resident scholar and curator of the exhibit, I have been privileged to make selections that I feel help situate The Center for Art in Wood in the larger conversations about sculpture and craft. Because this exhibit draws from the collection of the Center and promised gifts, it cannot be seen as a comprehensive reflection of the field's growth and evolution, and should rather be understood as an array of vibrant moments in a lively and polyphonic conversation. The Center invites viewers to visit its website—centerforartinwood.org—where objects from the collection not included in the exhibit can be explored and assembled into private online galleries entitled "MyCenter." ■

Each object in this plate section is identified with the name of its maker or makers, the title, and the year of creation. The wood (and other materials) appears next. Dimensions follow, in inches, with height followed by width followed by depth or diameter. Next is donor information unless the work was purchased by the Center, followed by the object's acquisition number, which may be used to locate items online.

GERARD BROWN

EXHIBITION CURATOR, RESIDENT SCHOLAR

THE CENTER FOR ART IN WOOD

PHILADELPHIA

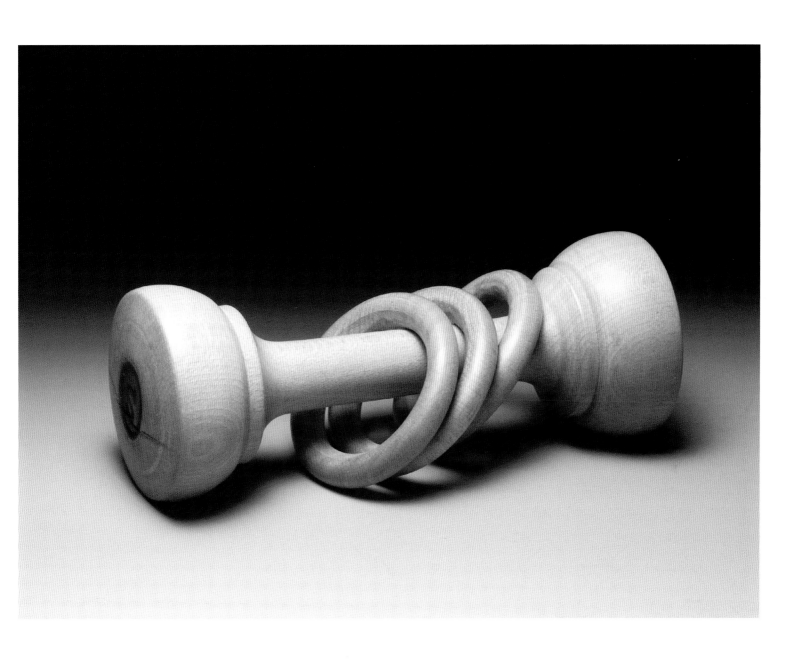

PLATE 1 | **Palmer Sharpless**, United States | *Circus*, 1988 | Dogwood | 2 x 2 x 4″ | Donated by the Artist | 1995.01.01.219.01G | (obj. 63)

PLATE 2 | **Jason Russell**, Canada | *The Balance*, 2001 ITE | Mahogany, sterling silver, paper, dye | 20 x 17 ¾ x 3″ | Donated by the Artist | 2005.04.25.004G | (obj. 421)

PLATE 3 | **Jake Brubaker**, United States | *Saffron Container*, 1977 | Rosewood | 6 x Dia. 2 ½" | Promised Gift of Albert & Tina LeCoff

PLATE 4 | **Jake Brubaker**, United States | *Saffron Container with Tail*, 1978 | Swedish birch | 4 ½ x Dia. 3" | Promised Gift of Albert & Tina LeCoff

PLATE 5 | **Bob Stocksdale**, United States | *Snakewood Bowl*, 1984 | Snakewood from Suriname | 5 x Dia. 7 ½" | Promised Gift of Neil & Susan Kaye

PLATE 6 | **Rude Osolnik**, United States | *Untitled*, 1995 | Walnut | 3 ½ x 9 x 7" | Promised Gift of Neil & Susan Kaye

PLATE 7 | **John Diamond-Nigh**, United States | *Untitled*, ca. 1985 | Birch | 7 x 8 x 8 ½″ | 1995.01.01.040P | (obj. 109)

96 TURNING TO ART IN WOOD: A CREATIVE JOURNEY

PLATE 8 | **David Pye**, United Kingdom | *Bowl*, ca. 1980 | Walnut | 2 ½ x 15 x 8 ¾" | 1995.01.01.193P | (obj. 155)

PLATE 9 | **David Ellsworth**, United States | *Vessel (Sonora Desert Ironwood)*, 1981 | Desert ironwood | 5 ½ x Dia. 9 ½" |
Donated by Bruce Kaiser | 2008.05.07.001.10G | (obj. 605)

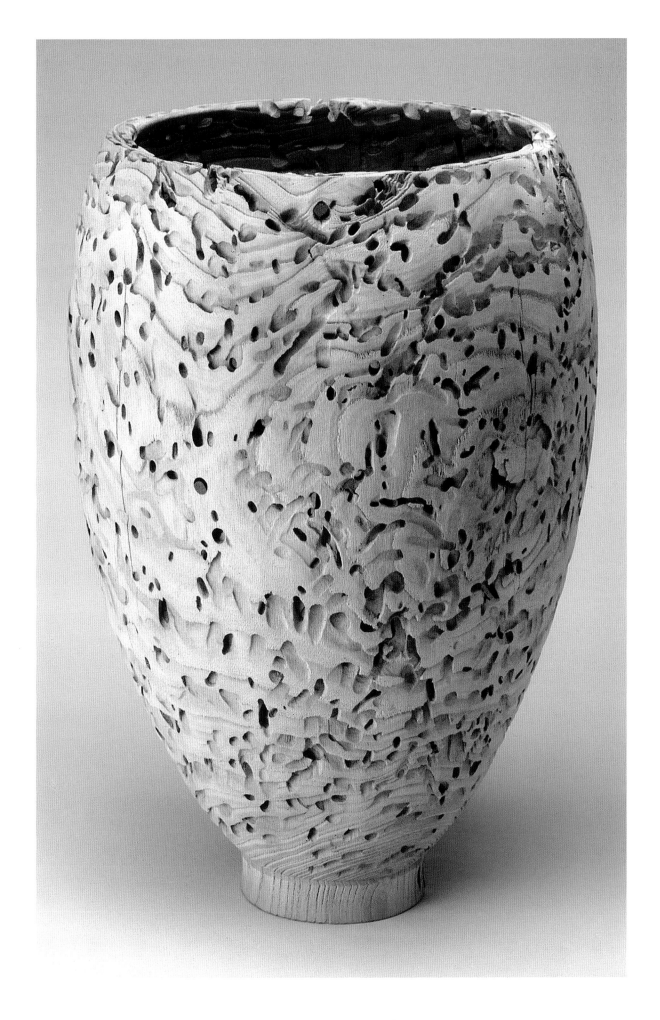

PLATE 10 | **Dale Nish**, United States | *Nagare Vessel*, 1990 | Wormy ash | 16 x Dia. 11″ | Promised Gift of Neil & Susan Kaye

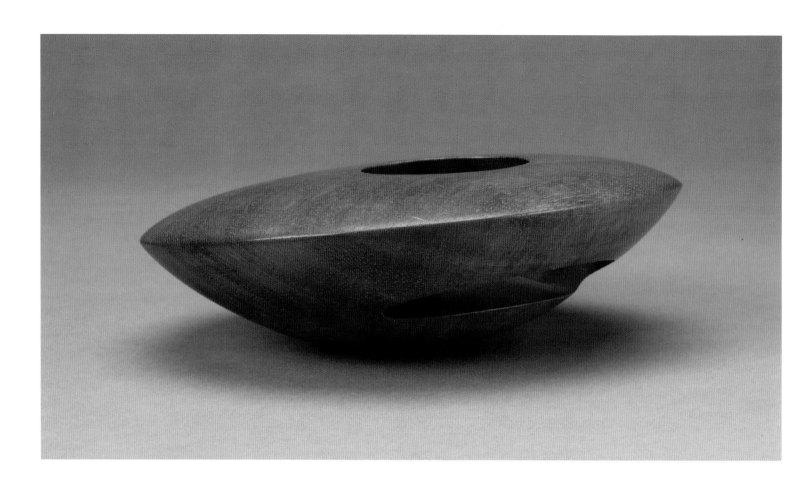

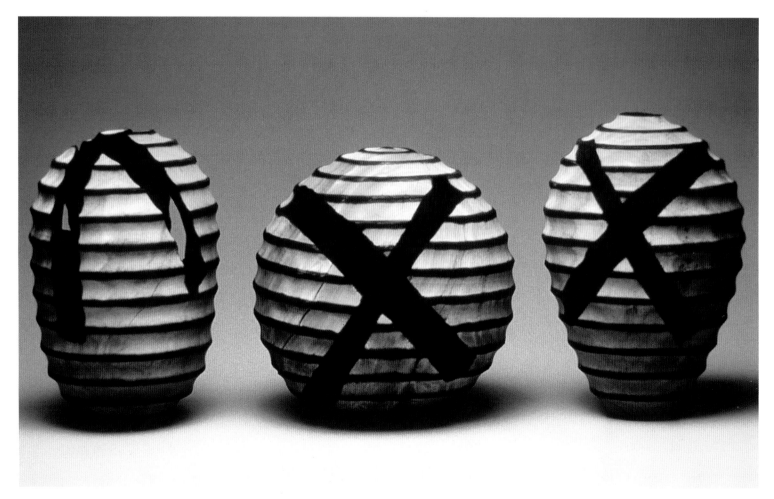

PLATE 11 | **Michael Brolly**, United States | *Shark Bowl*, 1981 | Koa wood | 1 ¾ x Dia. 5 ¼" | Donated by the Artist | 1995.01.01.008G | (obj. 37)

PLATE 12 | **Todd Hoyer**, United States | *X Series*, 1991 | Cottonwood | 13–14 x Dia. 9–14" | Donated by Fleur Bresler, Robyn & John Horn, Albert & Tina LeCoff, Arthur & Jane Mason, & Connie Mississippi | 1998.04.23.001a–c.G | (obj. 366)

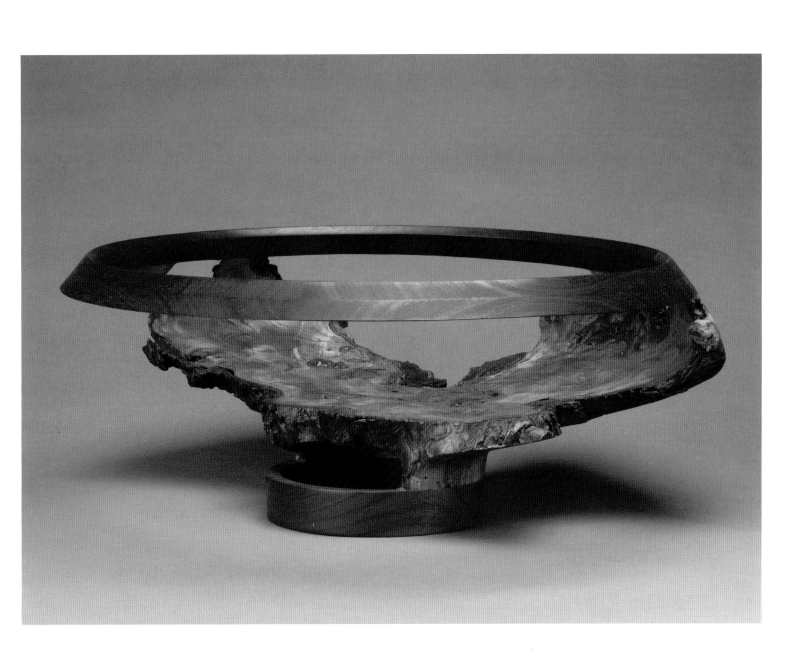

PLATE 13 | **Joe Dickey**, United States | *Offering Bowl*, 1992 | Weeping willow | 6 x Dia. 14 ¼" | Promised Gift of Neil & Susan Kaye

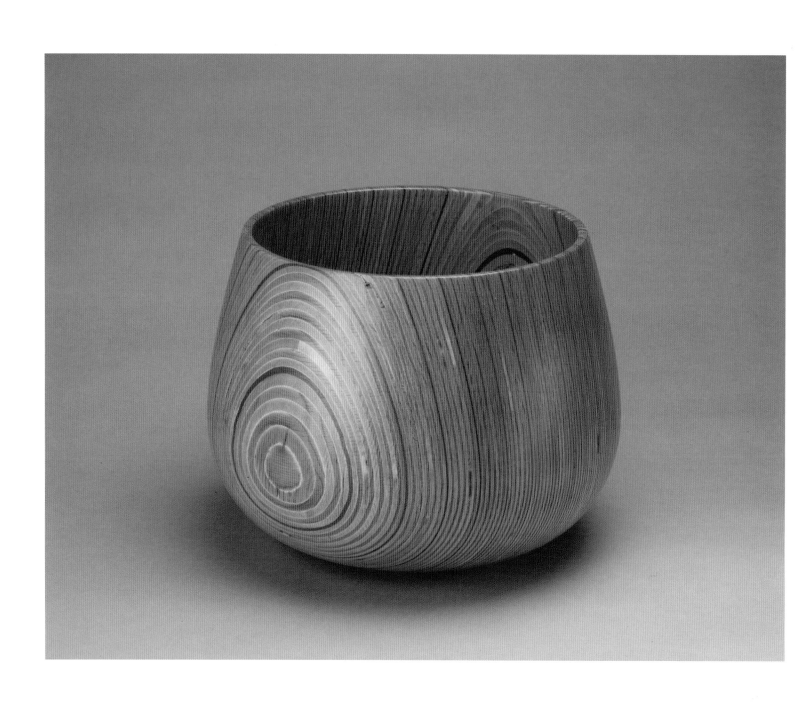

PLATE 14 | **Rude Osolnik**, United States | *Bowl*, 1977 | Birch plywood, walnut veneer | 11 x Dia. 8 ½" | Promised Gift of Albert & Tina LeCoff

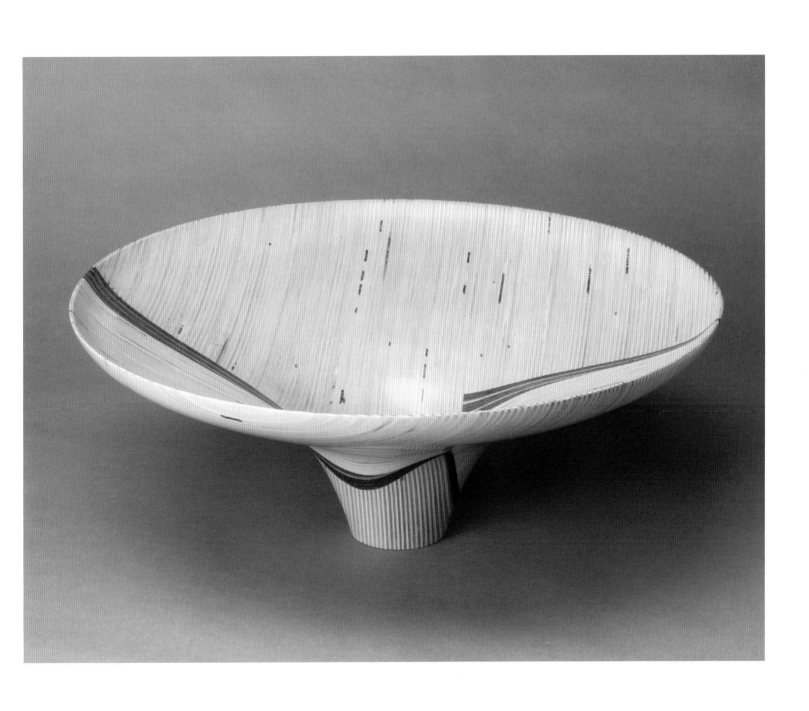

PLATE 15 | **Virginia Dotson**, United States | *Calligraphy Bowl*, 1991 | Baltic birch, wenge, walnut | 5 ¾ x Dia. 14 ¾" | 1995.01.01.043P | (obj. 82)

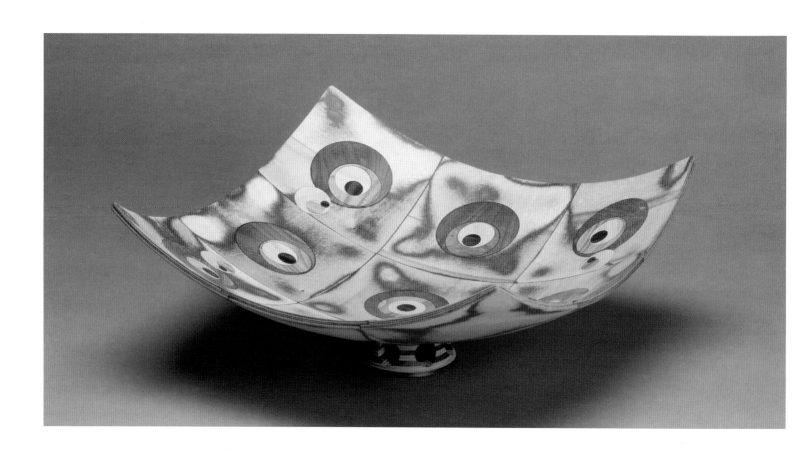

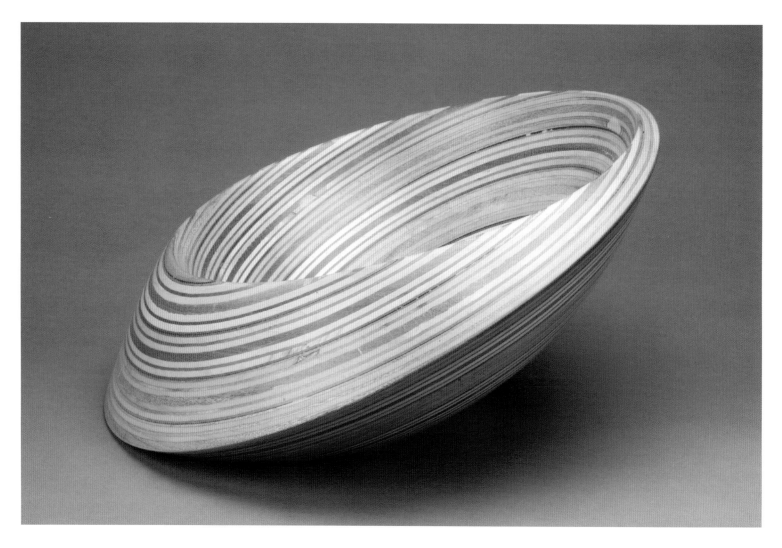

PLATE 16 | **Gianfranco Angelino**, Italy | *Palo Santo & Maple Swirl*, ca. 1999 | Palo Santo, maple | 4 ¼ x 11 x 11" | Promised Gift of Neil & Susan Kaye

PLATE 17 | **Rèmi Verchot**, Australia | *Bowl*, 2003 | Laminated plywood | 7 ½ x 15 x 16" | Promised Gift of Albert & Tina LeCoff

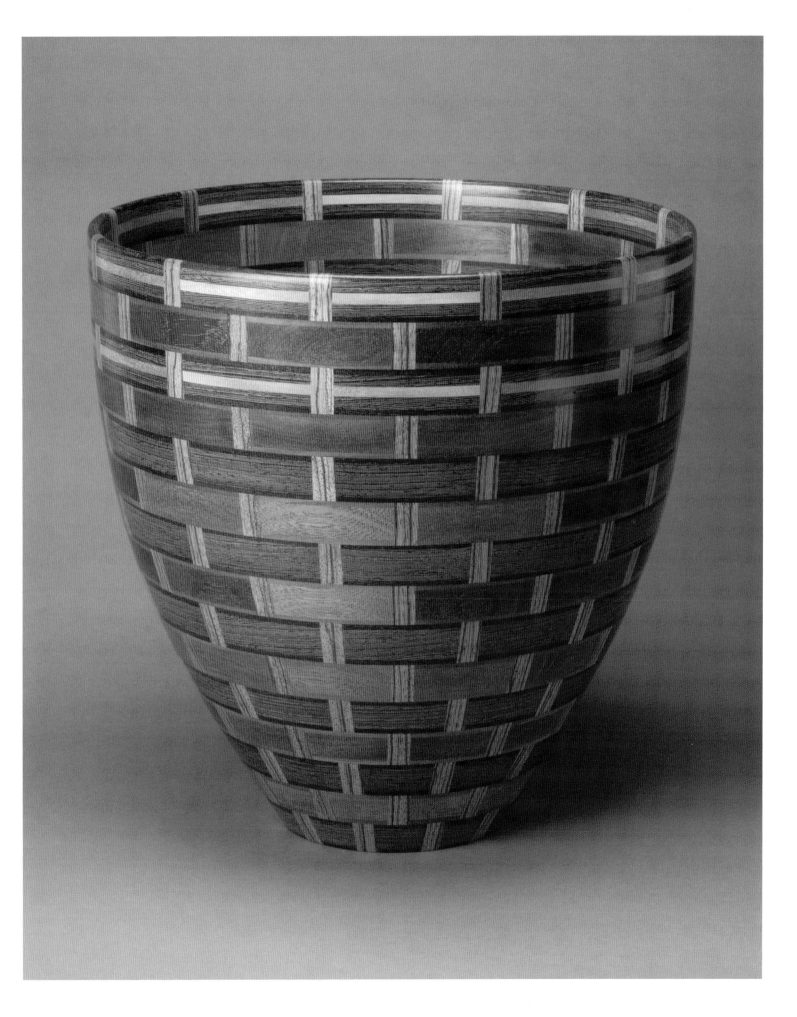

PLATE 18 | **Lincoln Seitzman**, United States | *Petrified Basket*, 1987 | Various hardwoods | 14 x Dia. 14″ | Donated by the Artist | 1995.01.01.216G | (obj. 168)

105 PLATES

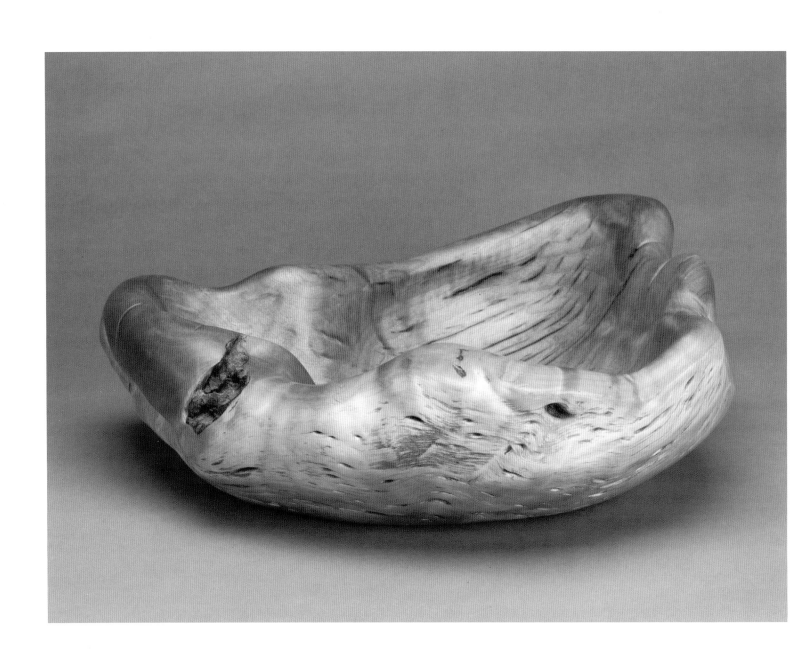

PLATE 19 | **Mark Lindquist**, United States | *Black Birch Bowl*, 1977 | Black birch burl | 4 x 13 x 14″ | Promised Gift of Neil & Susan Kaye

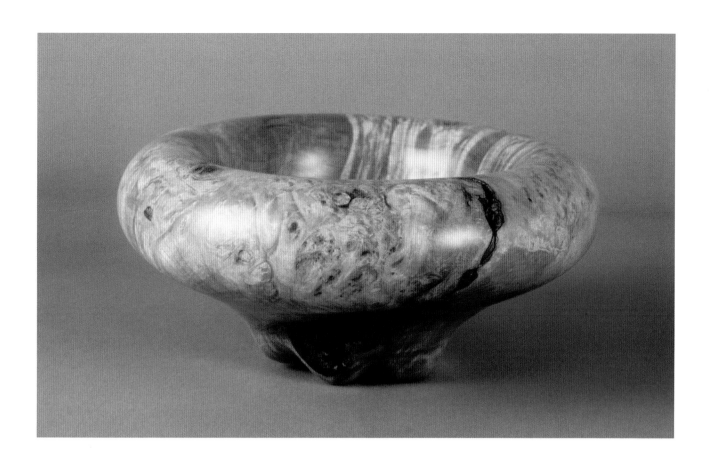

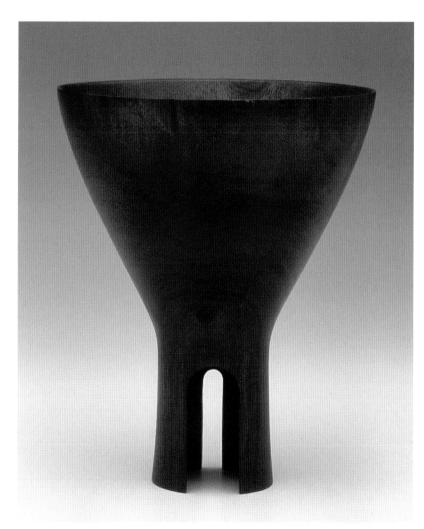

PLATE 20 | **Mark Lindquist**, United States | *Spalted Maple Bowl, carved foot*, 1977 | Spalted maple burl | 4 ½ x Dia. 10″ | Donated by Arthur & Jane Mason | 1995.01.01.136G | (obj. 136)

PLATE 21 | **Don Kelly**, United States | *Black Walnut Bowl*, 1979 | Black walnut | 7 ½ x Dia. 6 ¼″ | Promised Gift of Albert & Tina LeCoff

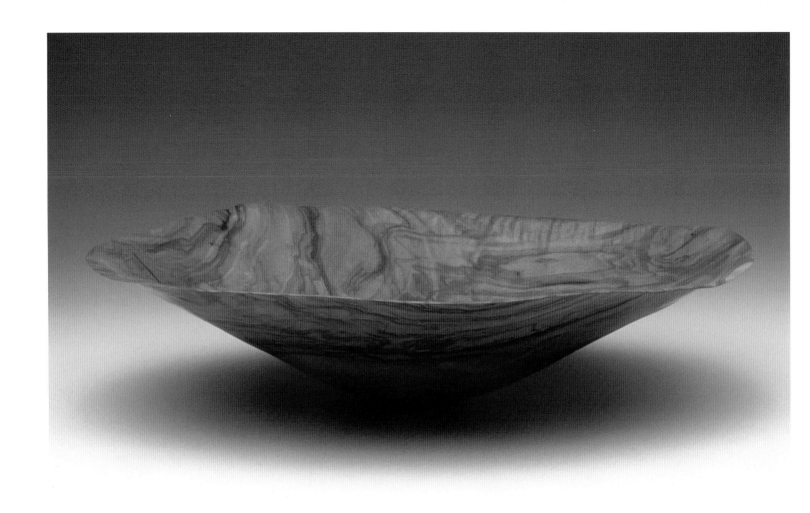

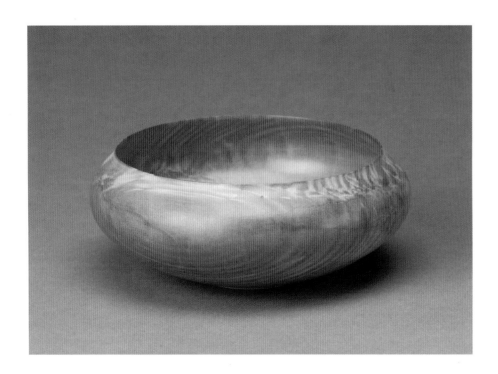

PLATE 22 | **Del Stubbs**, United States | *Bowl*, 1980 | Olive | 2 ¾ x Dia. 11 ¼" | Donated by the Artist | 1995.01.01.243G | (obj. 17)

PLATE 23 | **Del Stubbs**, United States | *Translucent Bowl*, 1979 | Curly maple | 1 ⅞ x Dia. 4 ½" | Donated by the Artist | 1995.01.01.245G | (obj. 16)

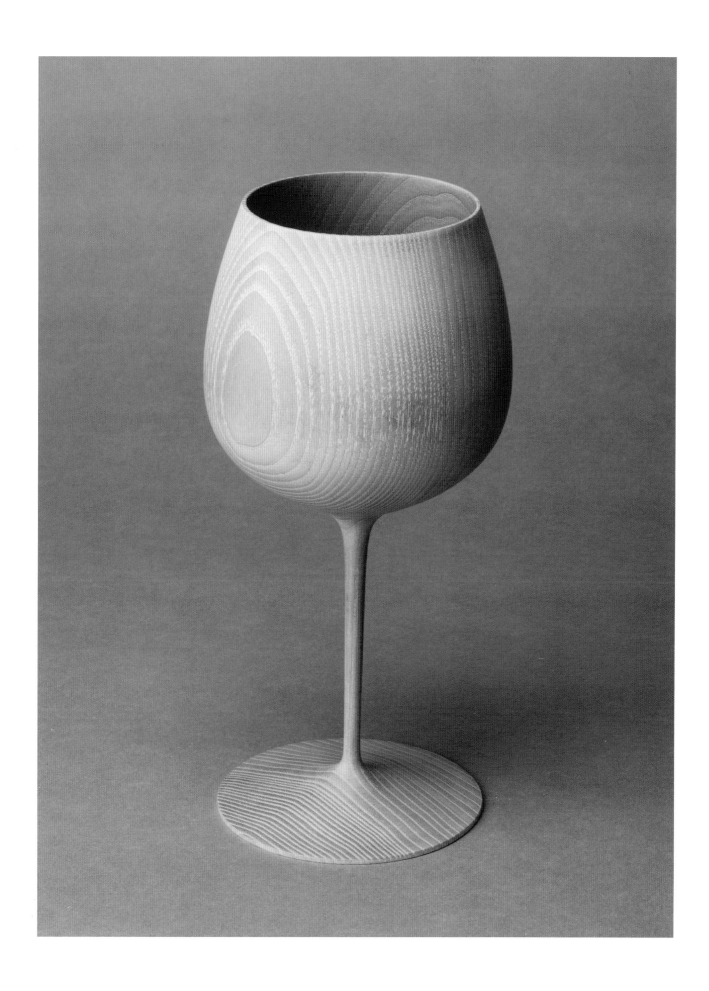

PLATE 24 | **Robert Street**, United States | *Translucent Goblet in Wood*, 1986 | Oregon ash | 7 ¼ x Dia. 3 ¼" |
Donated by the Artist | 1995.01.01.242G | (obj. 30)

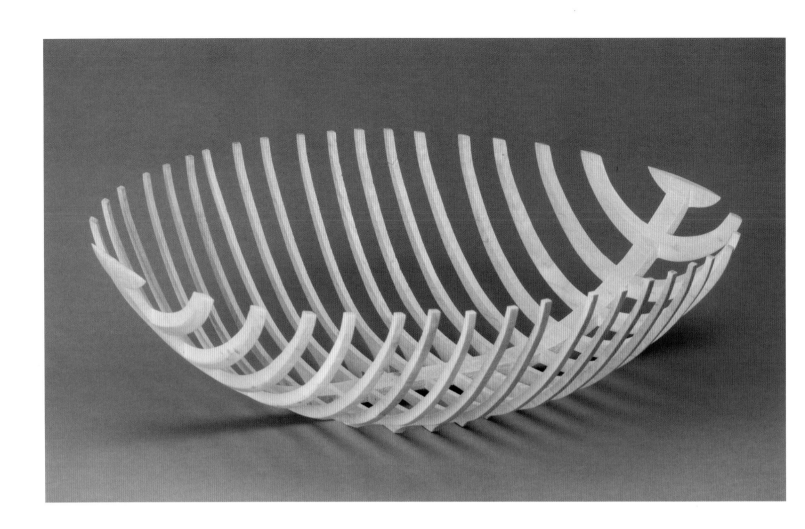

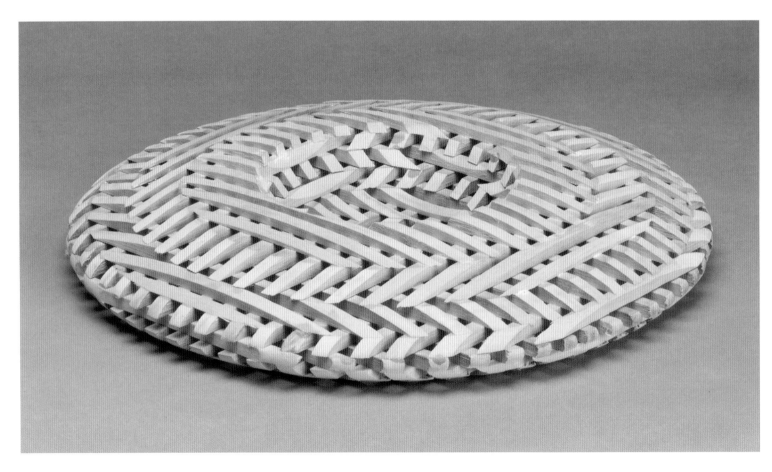

PLATE 25 | **Dewey Garrett**, United States | *LIM #3*, 1992 | Maple (bleached) | 4 x Dia. 12″ | Donated by the Artist | 1995.05.09.001G | (obj. 278)

PLATE 26 | **Richard Hooper**, United Kingdom | *Matrix*, 1993 | Ramin | 1 ½ x Dia. 12″ | Promised Gift of Neil & Susan Kaye

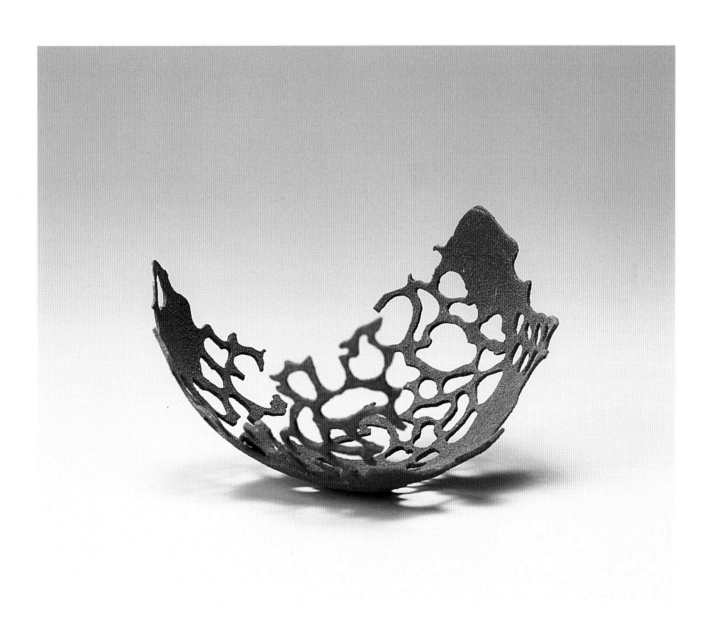

PLATE 27 | **Daniel Guilloux**, France | *Untitled*, 1998 ITE | Sycamore, paint | 3 x Dia. 4 ½″ | Donated by the Artist | 1998.08.31.002G | (obj. 368)

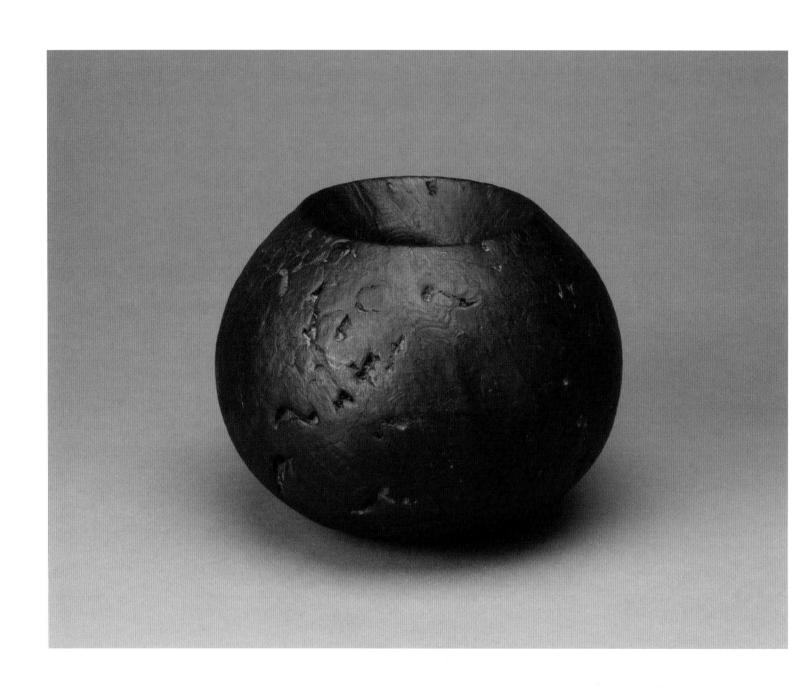

PLATE 28 | **Jim Partridge**, United Kingdom | *Blood Vessel Series*, 1987 | Scorched burr oak | 5 ½ x Dia. 7″ | 1995.01.01.172P | (obj. 53)

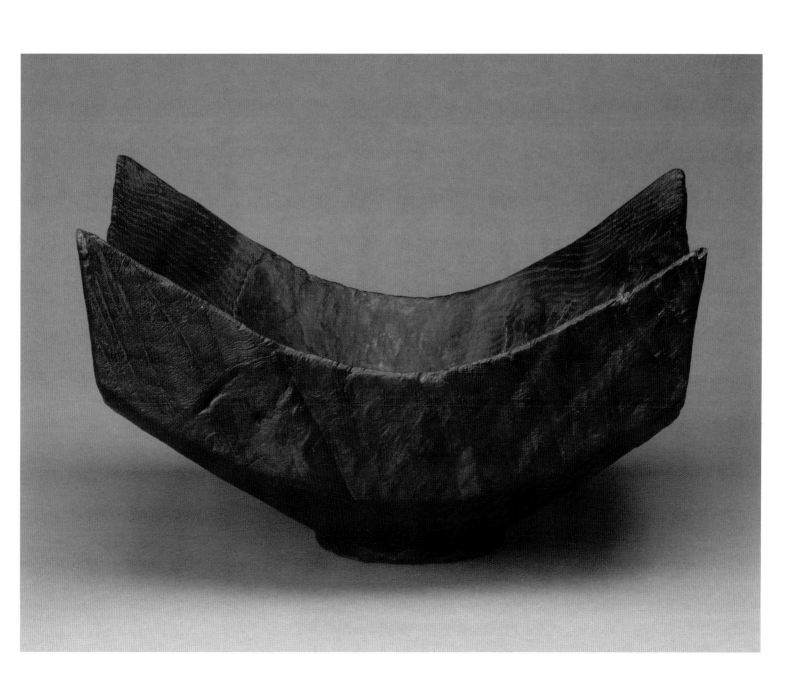

PLATE 29 | **Jim Partridge**, United Kingdom | *Blood Vessel Series*, 1987 | Scorched burr oak | 6 ¼ x 10 ¼ x 7 ¼" | 1995.01.01.174P | (obj. 55)

PLATE 30 | **Jim Partridge**, United Kingdom | *Blood Vessel Series*, 1987 | Scorched burr oak | 5 x 11 ¾ x 8 ¾" | 1995.01.01.173P | (obj. 54)

114 TURNING TO ART IN WOOD: A CREATIVE JOURNEY

PLATE 31 | **Robyn Horn**, United States | *Sheoake Geode*, 1987 | Sheoake | 7 x 8 ¼ x 6 ¾" | Donated by the Artist | 1995.01.01.087G | (obj. 44)

PLATE 32 | **Hugh McKay**, United States | *Tripot #5*, 1995 | Spalted maple | 12 x 14 x 12" | Promised Gift of Neil & Susan Kaye

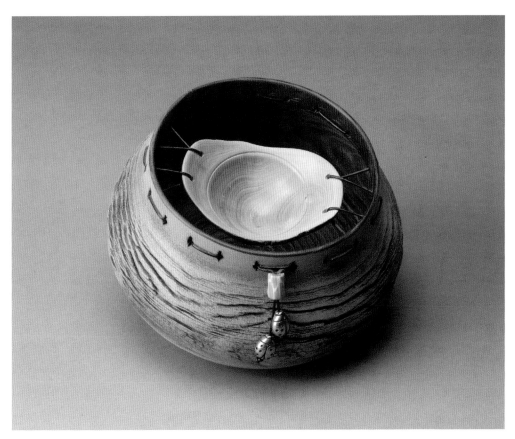

PLATE 33 | **Irene Grafert**, Denmark | *Bowl with green resin lip*, 2008 | Wood, acrylic | 2 x 4 ½ x 3 ½" | 2 ¼ x 5 x 3 ½" | 2 ½ x 5 x 3 ½" | Promised Gift of Albert & Tina LeCoff

PLATE 34 | **Stuart King**, United Kingdom | *Lady Token Pot*, 2001 ITE | Mulberry, brass, glass, boxwood, leather | 3 ¾ x Dia. 5 ½" | Promised Gift of Bruce & Marina Kaiser

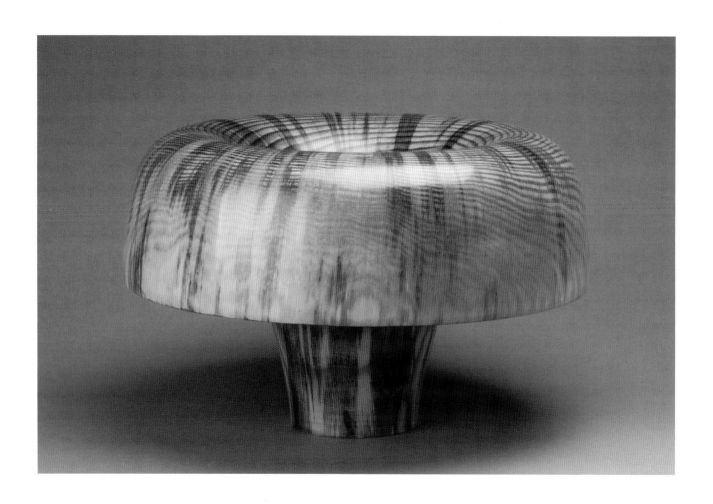

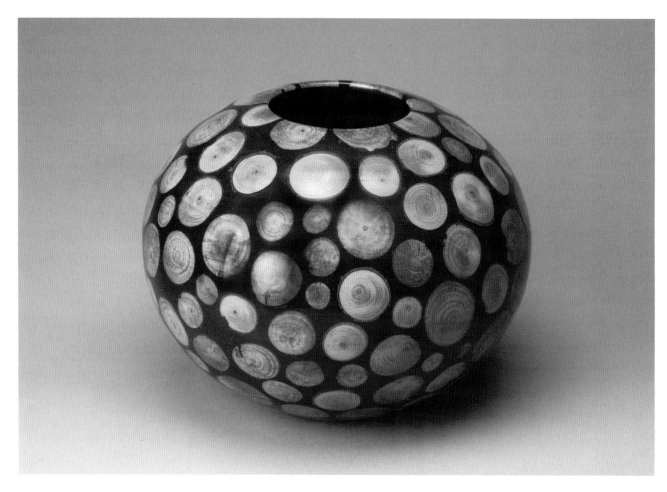

PLATE 35 | **Ed Moulthrop**, United States | *Rolled Edge Bowl*, 1988 | Georgia pine | 9 x Dia. 14" | Donated by Fleur Bresler | 2011.06.04.009.02G | (obj. 968)

PLATE 36 | **Phillip Moulthrop**, United States | *White Pine Mosaic*, 1990 | White pine | 8 x Dia. 10" | Promised Gift of Bruce & Marina Kaiser

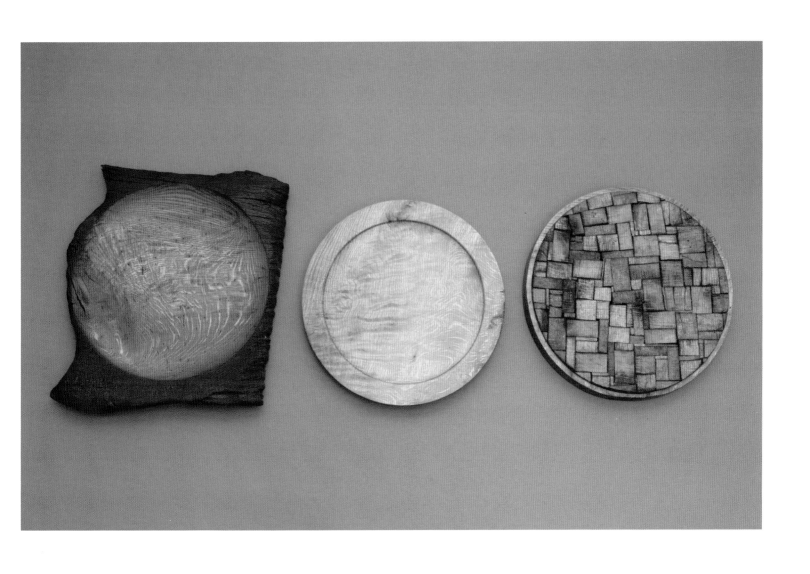

PLATE 37 | **Derek Bencomo**, United States | *Yesterday, Today And Tomorrow*, 2009 ITE | 275-year-old oak | 21 ¾ x 58 x 1 ¾" |
Donated by the Artist | 2009.08.07.002G | (obj. 690)

PLATE 38 | **Peter Exton**, United States | *Scorpion*, 2008 ITE | Cedar shingles, dye, screws | 6 x 18 x 33″ |
Donated by the Artist | 2008.08.01.003G | (obj. 664)

PLATE 39 | **Hilary Pfeifer**, United States & **Liam Flynn**, Ireland | *Pegboard Inspired Vessel*, 2006 ITE | Masonite, paint | 7 x 6 x 4″ |
Donated by the Artists | 2006.08.04.005G | (obj. 525)

PLATE 40 | **Kevin Burrus**, United States | *Sanding Disk*, 2003 ITE | Ash, Wood Turning Center brochures | 4 x Dia. 9 ¾″ | Donated by the Artist | 2003.08.26.004G | (obj. 440)

PLATE 41 | **William Moore**, United States | *Timna*, 1990 | Madrome burl, copper | 10 ¼ x Dia. 11 ⅜″ | 1995.01.01.158P | (obj. 143)

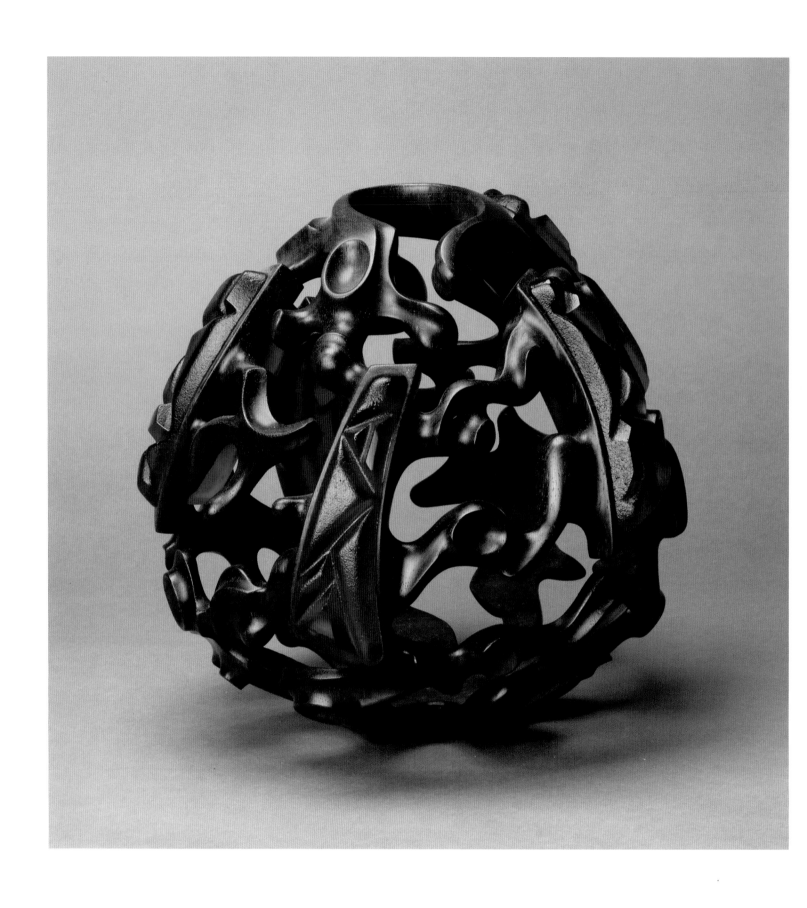

PLATE 42 | **Hugh McKay**, United States | *Blue Rose*, 1996 ITE | Rosewood, glass | 9 x Dia. 10" | Donated by the Artist | 1996.11.16.004G | (obj. 298)

PLATE 43 | **Robin Wood**, United Kingdom | *Cor Blimey*, 2007 | Wood, video | Donated by the Artist | 2009.03.07.002G | (obj. 688)

125 PLATES

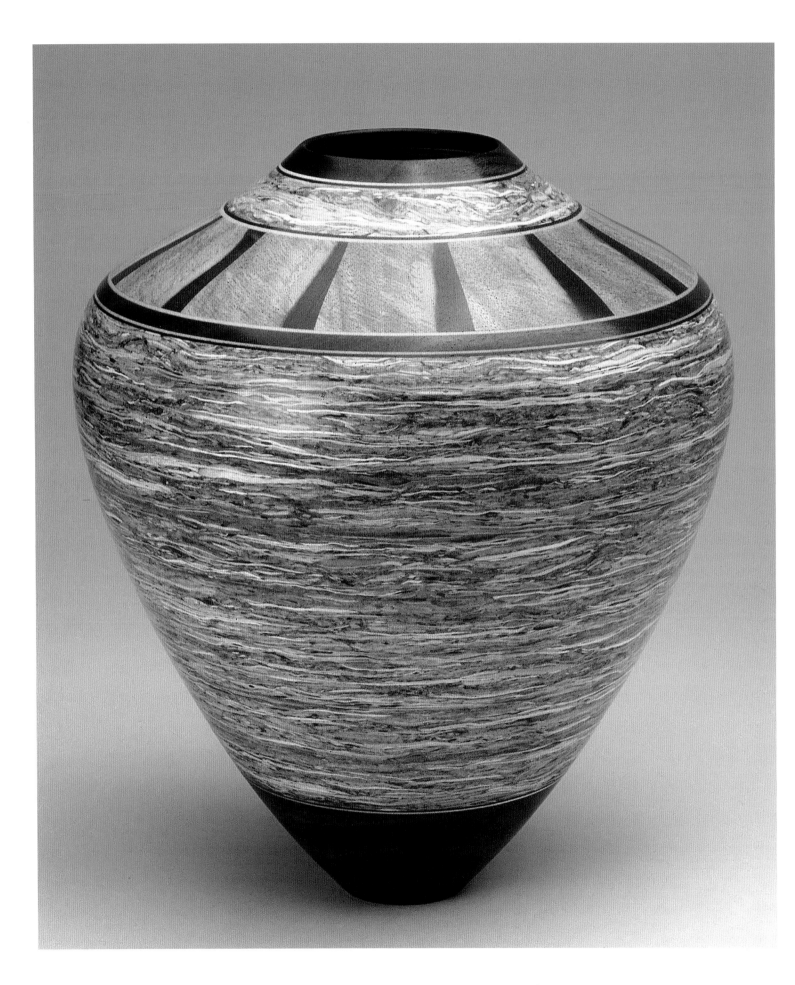

PLATE 44 | **Galen Carpenter**, United States | *Untitled*, 1995 | Chipboard, Belize rosewood, zircote | 8 x Dia. 9" | Donated by Neil & Susan Kaye | 2010.08.06.006.03G | (obj. 719)

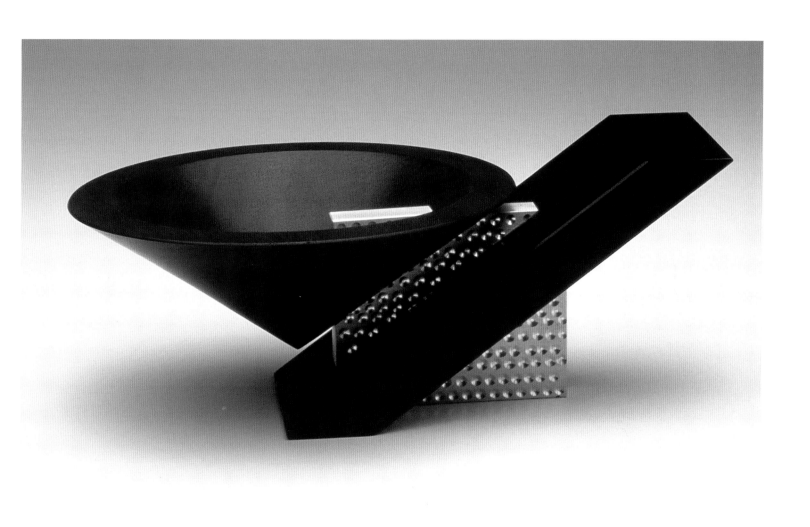

PLATE 45 | **Michael Chinn**, United States | *TRI - 10,000*, 1988 | Purpleheart, Indian ebony, aluminum | 3 ⅝ x 9 x 6 ⅛" | 1995.01.01.029P | (obj. 38)

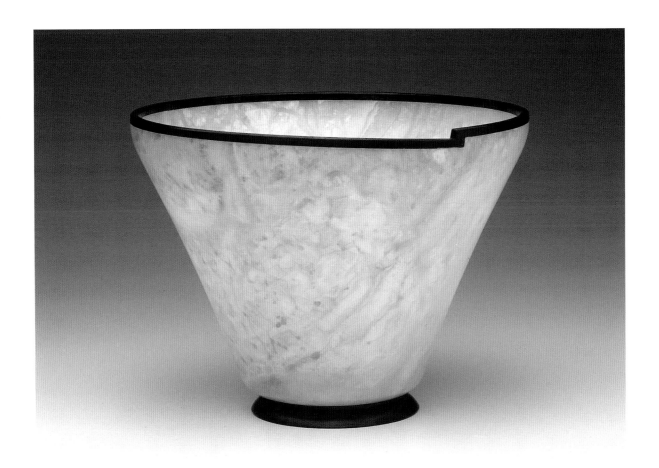

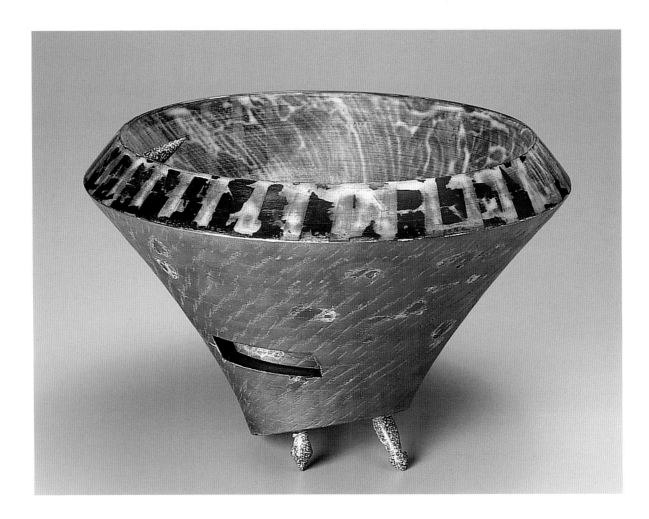

PLATE 46 | **Max Krimmel**, United States | *Alabaster Vessel #79*, 1987 | Colorado alabaster, ebony, satine | 6 x Dia. 8″ |
Donated by the Artist | 1995.01.01.124G | (obj. 49)

PLATE 47 | **Bo Schmitt**, Australia | *From 'The Dark Heart,' Book 4, Chapter 7*, 1995 ITE | MDF, Corian, enamel, acrylic, heat-tempered bronze | 9 ¼ x Dia. 12 ¾″ |
Donated by the Artist | 1995.09.01.003G | (obj. 282)

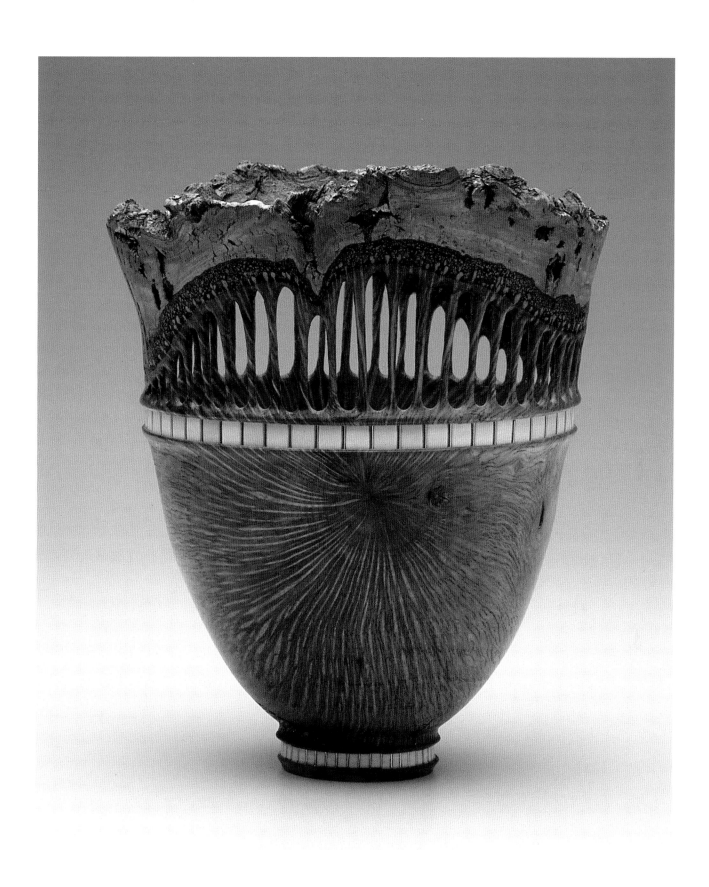

PLATE 48 | **Frank E. Cummings, III**, United States | *Nature in Transition*, 1989 | Cork oak, 18K gold, exotic material | 6 ¼ x Dia. 5 ¾" |
Donated by Dr. Irv Lipton | 1995.01.01.033G | (obj. 79)

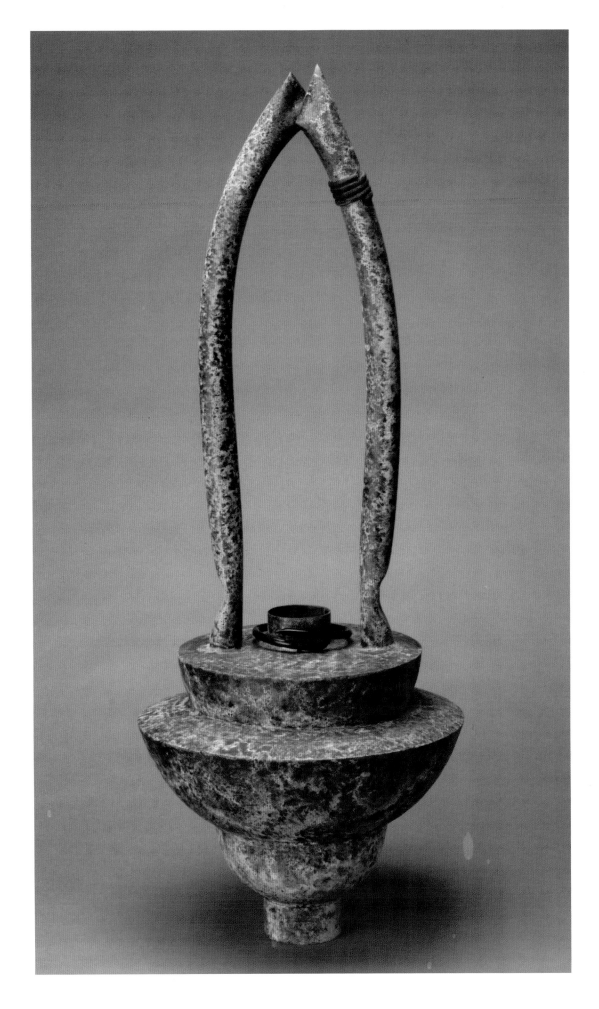

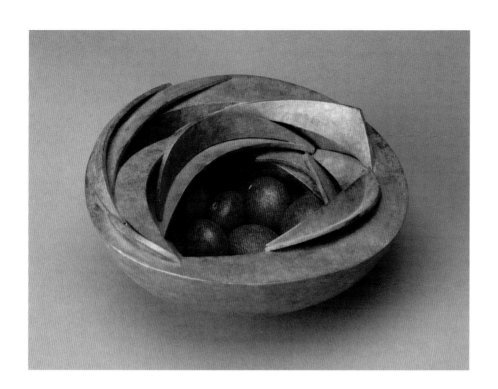

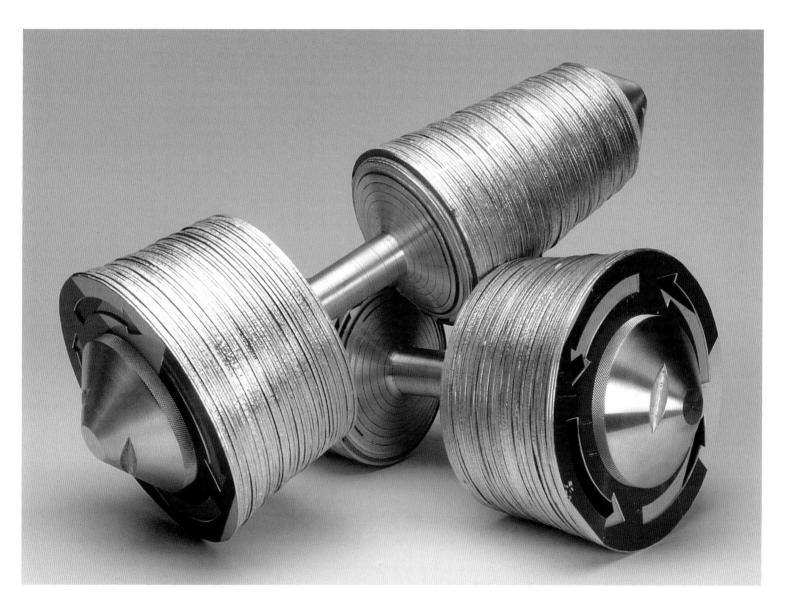

PLATE 50 | **Darlys Ewoldt**, United States | *Untitled*, 1998 | Bronze | 2 x 4 x 3 ½" | Promised Gift of Bruce & Marina Kaiser

PLATE 51 | **Boris Bally**, United States | *Rep Forms*, 1996 | Reused traffic signs, aluminum | 22 x 9 x 9" in. each |
Donated by the Artist | 1999.12.01.001a–bG | (obj. 390)

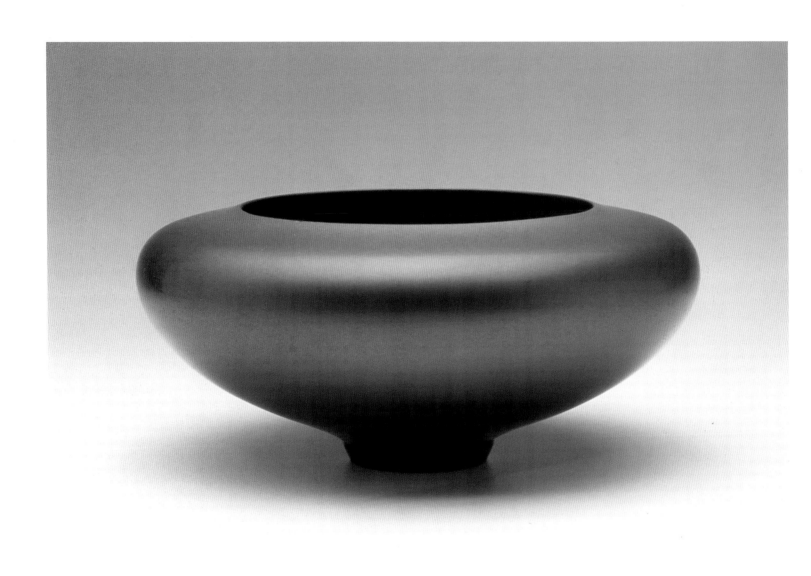

PLATE 52 | **Giles Gilson**, United States | *Gum Metal Black Bowl Form*, 1885 | Mahogany. lacquer, flocking | 5 x Dia. 11" |
Donated by Dr. Irving Lipton | 1995.01.01.064G | (obj. 116)

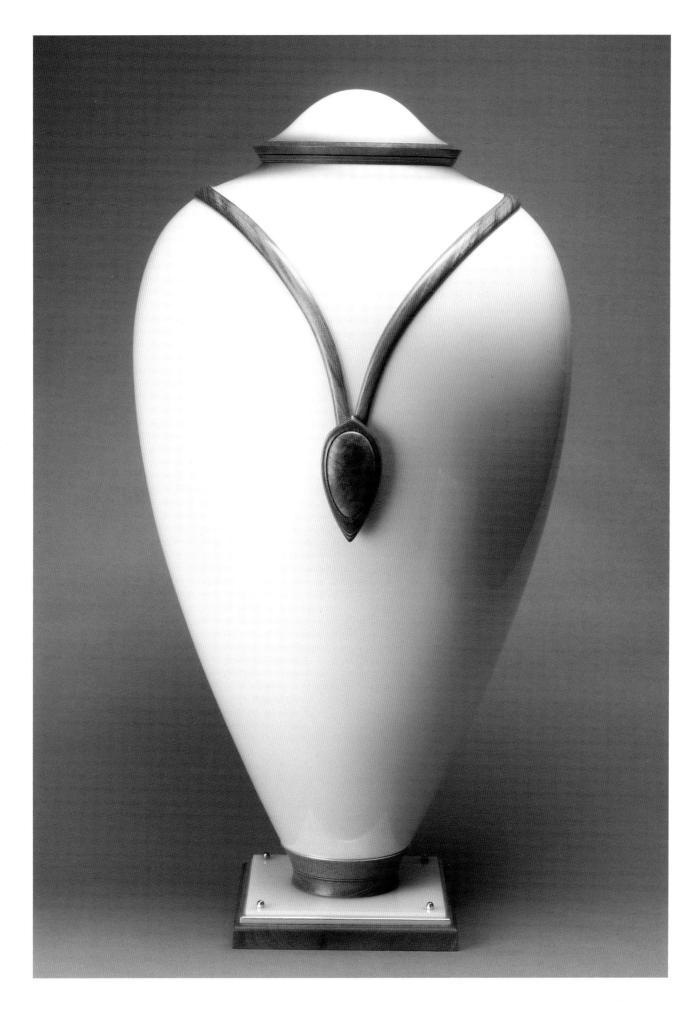

PLATE 53 | **Giles Gilson**, United States | *Vase with Necklace*, 1987 | Lacquered wood, exotic wood, stainless steel | 32 x Dia. 16" | Promised Gift of Fleur Bresler

PLATE 54 | **Wayne** & **Belinda Raab**, United States | *Vase- Red with Blue Square*, 1987 | Walnut, curly maple, acrylic lacquer | 24 x 6 ½ x 5″ | 1995.01.01.195P | (obj. 57)

PLATE 55 | **Hap Sakwa**, United States | *Torus*, 1988 | Poplar, maple, lacquer | 6 ½ x Dia. 13 ¾" | Promised Gift of Garry & Sylvia Bennet

PLATE 56 | **Mark Sfirri** & **Robert G. Dodge**, United States | *Secretaire*, 1989 | Lacewood, purpleheart, plywood, acrylic paint, gold leaf | 62 x 51 x 20″ |
2004.12.01.001P | (obj. 478)

PLATE 57 | **Joanne Shima**, United States | *Child's Chair*, 1987 | Wood, paint | 26 x 10 x 12" | 1995.01.01.221P | (obj. 65)

PLATE 58 | **Merryll Saylan**, United States | *North Seas*, 1988 | Maple, fiber-reactive dye, tung oil finish | 2 ¼ x Dia. 20 ½″ | 1995.01.01.212P | (obj. 167)

PLATE 60 | **Stephen Hogbin**, Canada | *Spoons*, ca. 1978 | Birch | 11 ½ x 3 x 1 ½" each | Donated by Alan LeCoff | 1995.01.01.083a–bG | (obj. 15)

PLATE 61 | **Stuart King**, United Kindgom | *Spoon*, 1993 | Wood | 12 ⅜ x 2 ⅞ x ½" | Donated by Bruce Kaiser | 2008.05.07.001.28G | (obj. 623)

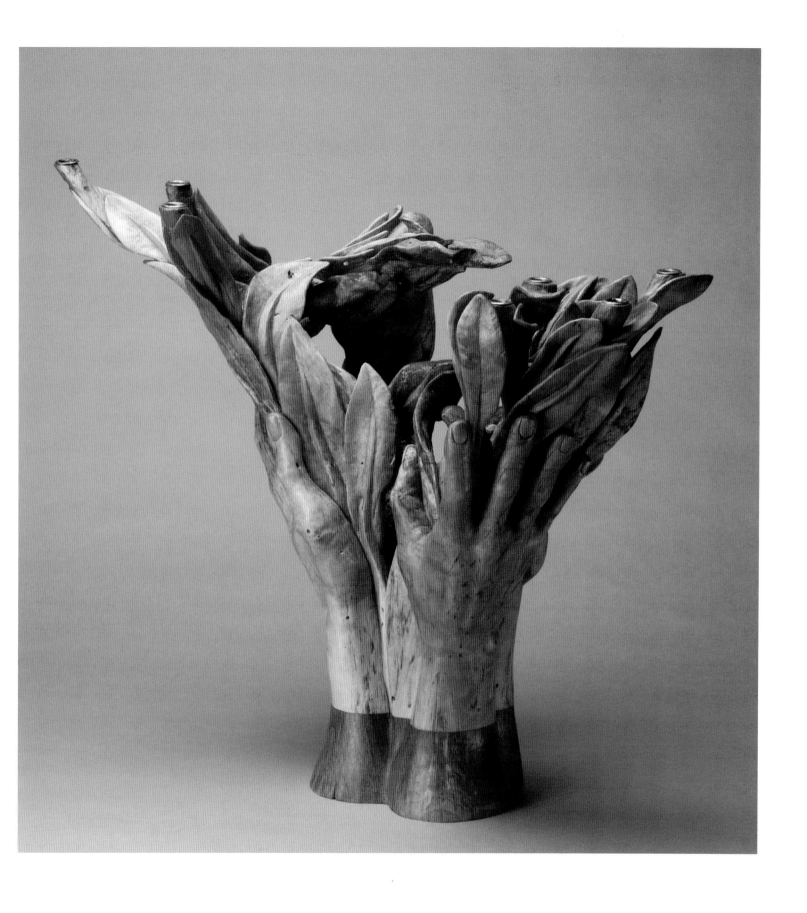

PLATE 62 | **Michelle Holzapfel**, United States | *Candelabra*, 1995 | White birch, walnut, brass | 17 x 20 x 11" | Promised Gift of Neil & Susan Kaye

PLATE 63 | **Merryll Saylan**, United States | *Tea Set*, 1997 ITE | Box elder | 6 x Dia. 6″ | Donated by the Artist | 1997.12.01.005G | (obj. 314)

PLATE 64 | **David Sengel**, United States | *Tea Cup*, 1996 | Pearwood, black paint, thorns | 3 ¼ x Dia. 5 ¼″ |
Donated by the Artist | 2000.12.30.001G | (obj. 397)

PLATE 66 | **Doug Finkel**, United States | *Bench*, 2000 | Walnut, maple, poplar, paint, fabric | 17 ½ x 26 ⅞ x 12" | Promised Gift of Bruce & Marina Kaiser

PLATE 67 | **Jack Larimore**, United States | *Natural Desire*, 2003 ITE | Paulownia, ash, felt, bronze | 66 x Dia. 24″ each | Promised Gift of Greg & Regina Rhoa

PLATE 68 | **Mark Sfirri** & **Amy Forsyth**, United States | *Figurati*, 2002 | Assorted wood, milk paint, paper, leather, ink, colored pencil | 54 x 24 x 17" |
On loan from the Artists

PLATE 69 | **Arthur Espenet Carpenter**, United States | *Snake Music Stand*, 1982 | Wood and paint | 50 x 21 ½ x 6 ½" | Promised Gift of Bruce & Marina Kaiser

PLATE 70 | **Garry Knox Bennett**, United States | *Pre Turned Wood Object*, 2000 | Wood | 11 x 14 x 9 ½" |
Donated by Glenn Adamson | 2005.12.31.002G | (obj. 515)

PLATE 71 | **Stephen Hogbin**, Canada | *Walnut Bowl of Walnut*, 1981 | Walnut, paint | 10 ¼ x 5 ¼ x 7 ¼" | Promised Gift of Albert & Tina LeCoff

PLATE 72 | **David Rogers**, United States | *Something to Put Small Things In*, 1999 ITE | Polyurethane rigid foam, walnut | 3 x 5 x 14″ |
Donated by the Artist | 2005.04.25.009G | (obj. 504)

PLATE 73 | **Gord Peteran**, Canada | *Two Bracelets*, 2002 ITE | Pencil shavings | Dia. 5″ | Promised Gift of Albert & Tina LeCoff

PLATE 74 | **Gord Peteran**, Canada | *Five Sounds*, 2002 ITE | Graphite on paper | 36 x 27" | Donated by the Artist | 2002.12.31.001aG | (obj. 425)

PLATE 75 | **Gord Peteran**, Canada | *Five Sounds*, 2002 ITE | Graphite on paper | 36 x 27" | Donated by the Artist | 2002.12.31.001bG | (obj. 426)

PETERAN 2002

PLATE 76 | **Gord Peteran**, Canada | *Five Sounds*, 2002 ITE | Graphite on paper | 36 x 27" | Donated by the Artist | 2002.12.31.001cG | (obj. 427)

PLATE 77 | **Gord Peteran**, Canada | *Five Sounds*, 2002 ITE | Graphite on paper | 36 x 27" | Donated by the Artist | 2002.12.31.001dG | (obj. 428)

PLATE 78 | **Gord Peteran**, Canada | *Five Sounds*, 2002 ITE | Graphite on paper | 36 x 27" | Donated by the Artist | 2002.12.31.00eG | (obj. 429)

PLATE 79 | **Jérôme Blanc**, Switzerland | *Dance Final*, 2009 ITE | Red & black ink, watercolor paper | 22 ⅛ x 30″ | 2011.06.25.001.04P | (obj. 973)

PLATE 80 | **Jérôme Blanc**, Switzerland | *Untitled, #4*, 2009 ITE | Red & black ink, watercolor paper | 22 ⅛ x 30″ |
Donated by the Artist | 2009.08.07.004.03G | (obj. 694)

PLATE 81 | **Jérôme Blanc**, Switzerland | *Premiere danse, #1*, 2009 ITE | Red & black ink, watercolor paper | 22 ⅛ x 30″ | 2011.06.25.001.01P | (obj. 970)

PLATE 82 | **Jérôme Blanc**, Switzerland | *Untitled, #5*, 2009 ITE | Red & black ink, watercolor paper | 22 ⅛ x 30″ | 2011.06.25.001.02P | (obj. 971)

PLATE 83 | **Jérôme Blanc**, Switzerland | *Dance Souterraine*, 2009 ITE | Red & black ink, watercolor paper | 22 ⅛ x 30" | 2011.06.25.001.03P | (obj. 972)

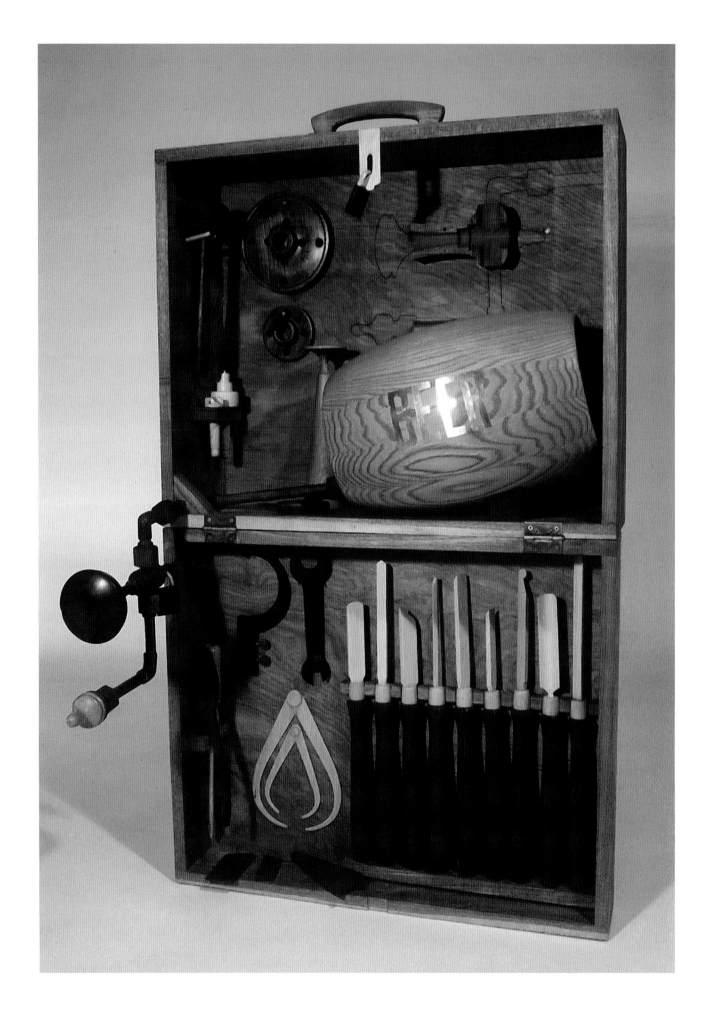

PLATE 84 | **C.R. (Skip) Johnson**, United States | *The Itinerant Turner's Toolbox*, 1981 | Mahogany, basswood, walnut, padauk, honey locust | 42 ⅜ x 26 x 7 ¾" | Donated by the Artist | 1995.01.01.103G | (obj. 124)

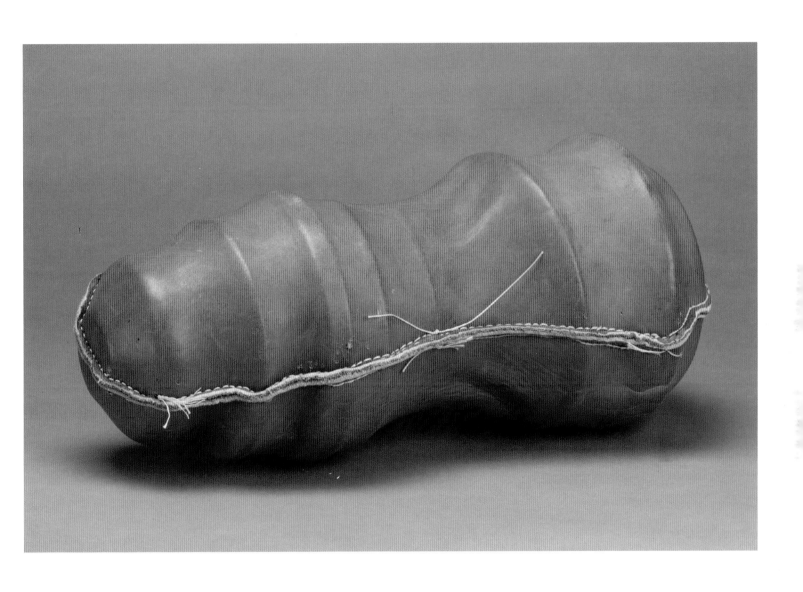

PLATE 85 | **Gord Peteran**, Canada | *Untitled So Far*, 1996 | Leather, wood, linen thread | 14 x 6 ½ x 7″ |
Donated by Albert & Tina LeCoff | 1996.11.20.001G | (obj. 304)

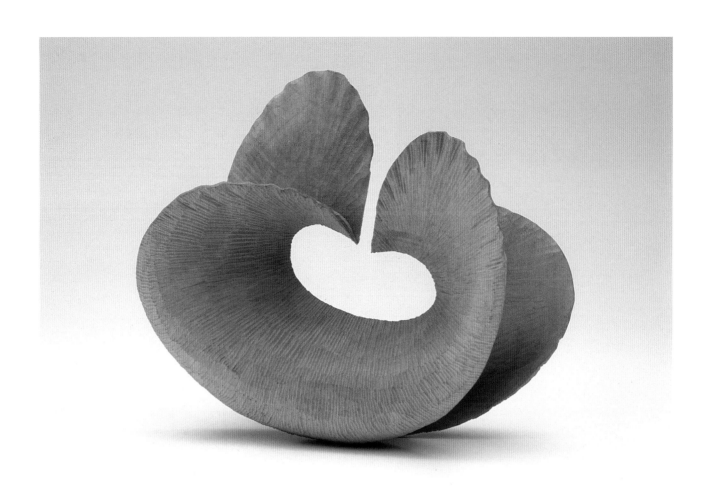

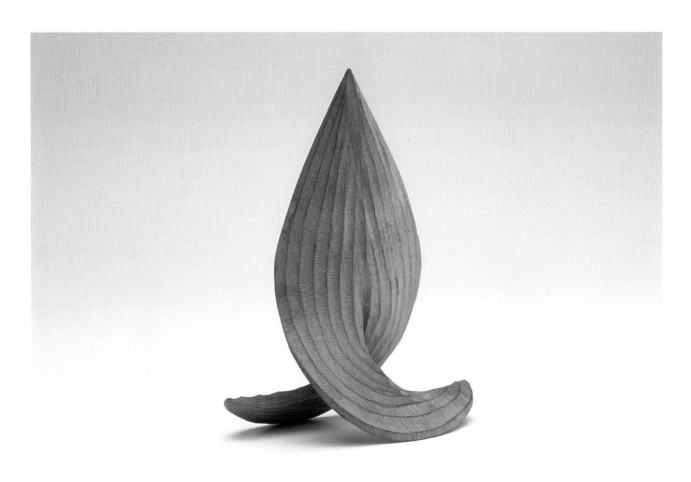

PLATE 86 | **David Pye**, United Kingdom | *Study in Flower Form*, ca. 1980 | Wood | 6 ⅜ x 7 x 3″ | 1995.01.01.185.01P | (obj. 148)

PLATE 87 | **David Pye**, United Kingdom | *Study in Flower Form*, ca. 1980 | Wood | 5 ½ x 4 x 2 ½″ | 1995.01.01.185.02P | (obj. 149)

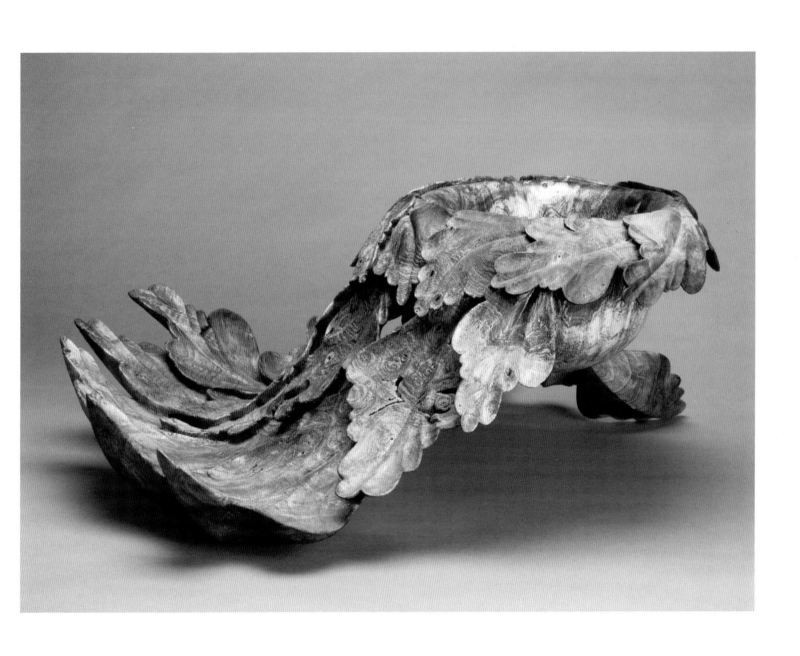

PLATE 88 | **Ron Fleming**, United States | *Earth Offering*, 1992 | Buckeye burl | 9 x 23 x 20" | Promised Gift of Neil & Susan Kaye

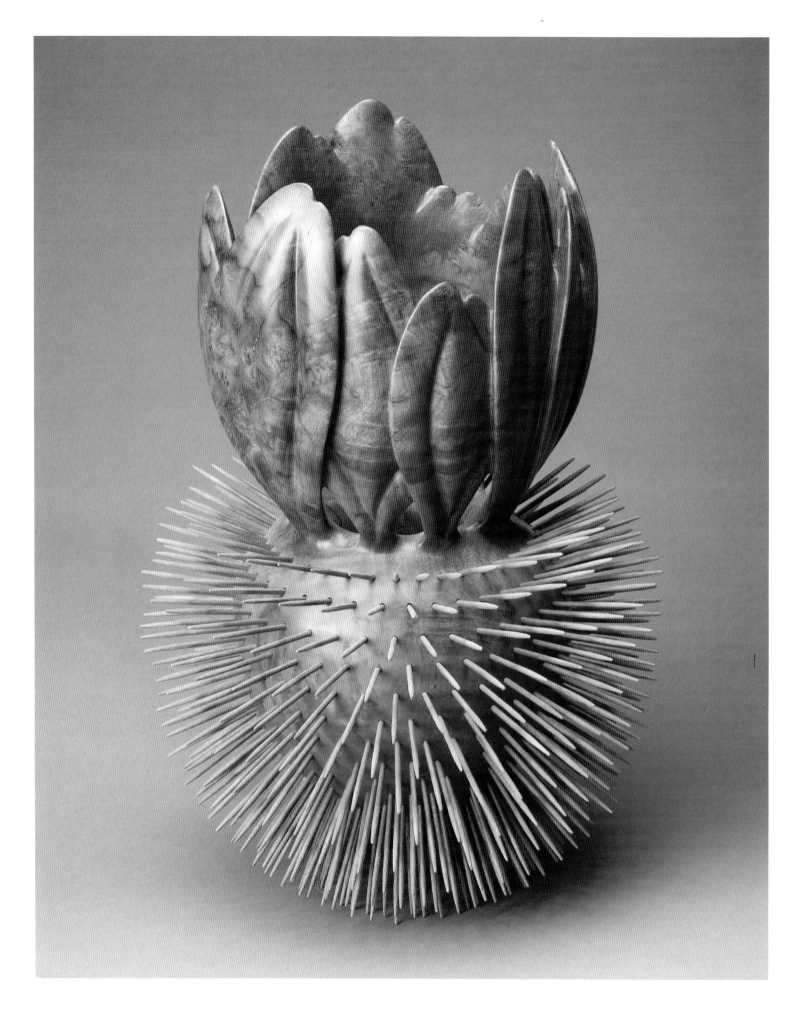

PLATE 89 | **Ron Fleming**, United States | *Echinacea*, 1999 | Dogwood burl, maple | 11 x Dia. 9″ | Promised Gift of Bruce & Marina Kaiser

166 TURNING TO ART IN WOOD: A CREATIVE JOURNEY

PLATE 90 | **Ron Fleming**, United States | *Drawing*, 1992 | Tissue paper, pencil, colored pencil | 10 x 8" | Promised Gift of Bruce & Marina Kaiser

PLATE 93 | **Mark Sfirri**, United States | *Glancing Figure*, 2000 | Bubinga | 11 x 1 ¾ x 2 ½″ | Donated by Bruce Kaiser | 2008.05.07.001.61G | (obj. 656)

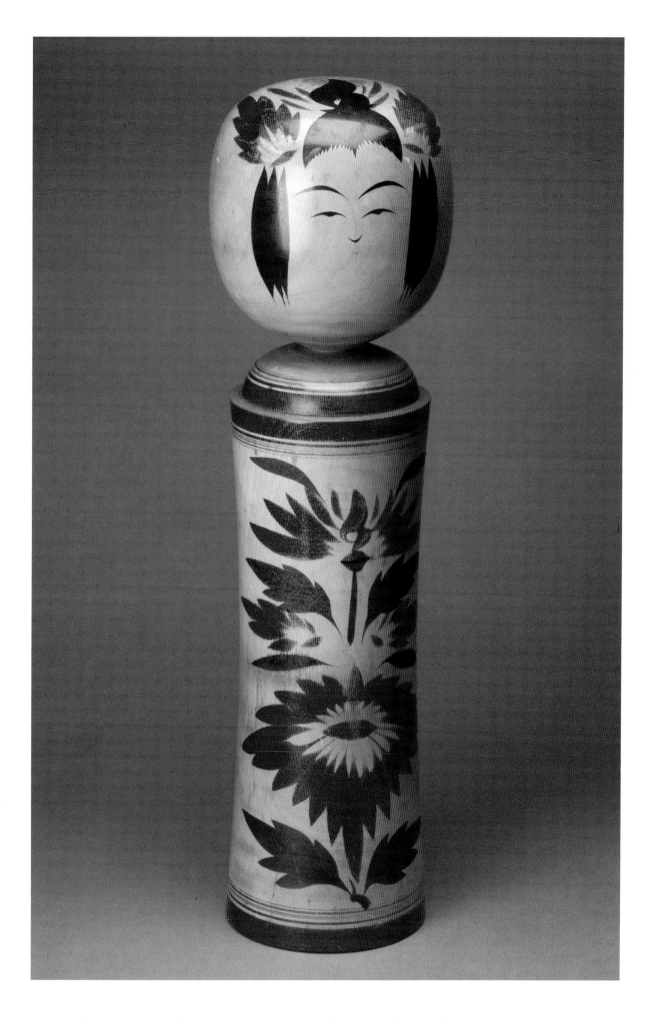

PLATE 94 | **Setu Hayasaka**, Japan | *Squeaky Head Doll*, ca. 20th Century | Wood, paint | 18 x Dia. 5" | Promised Gift of Albert & Tina LeCoff

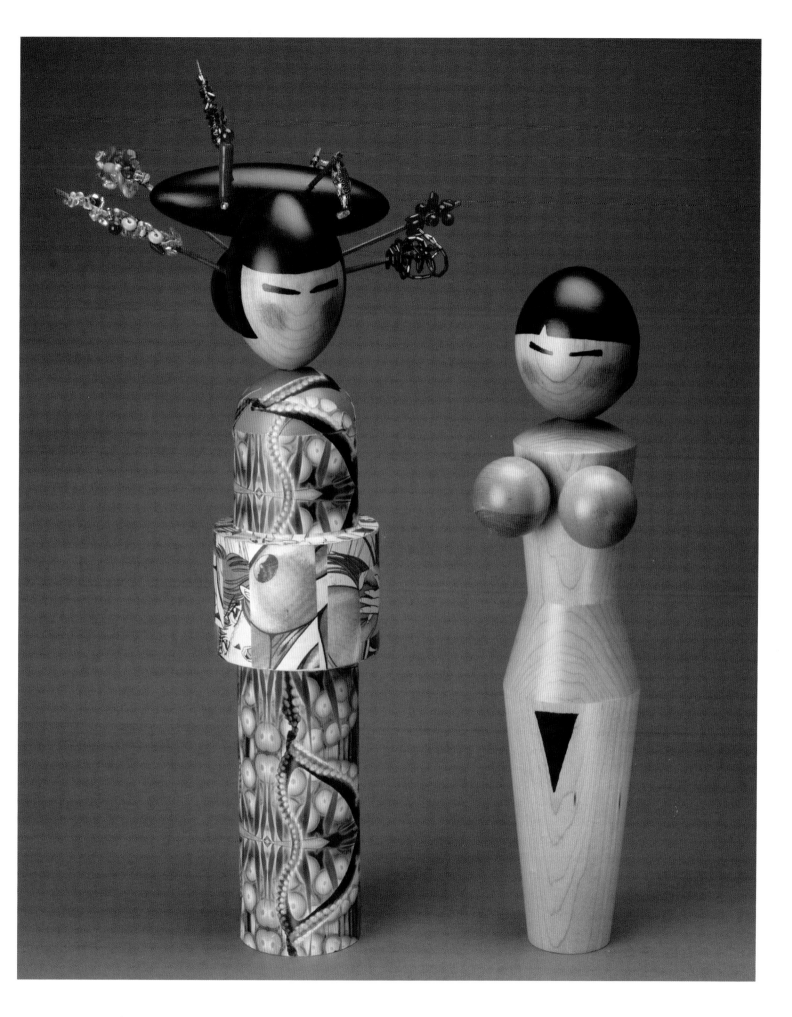

PLATE 96 | **Wendy Maruyama**, United States, Turning assisted by **Jason Schneider**, United States | *Kokeshi Series: Midori and Michiko*, 2003 |
Maple, digital media, collage, paint, mixed media | 15 ½ x 3 ¾ x 5″ | 17 ½ x 5 ¾ x 5″ | Donated by the Artist | 2003.12.31.004.01–.02G | (objs. 449, 450)

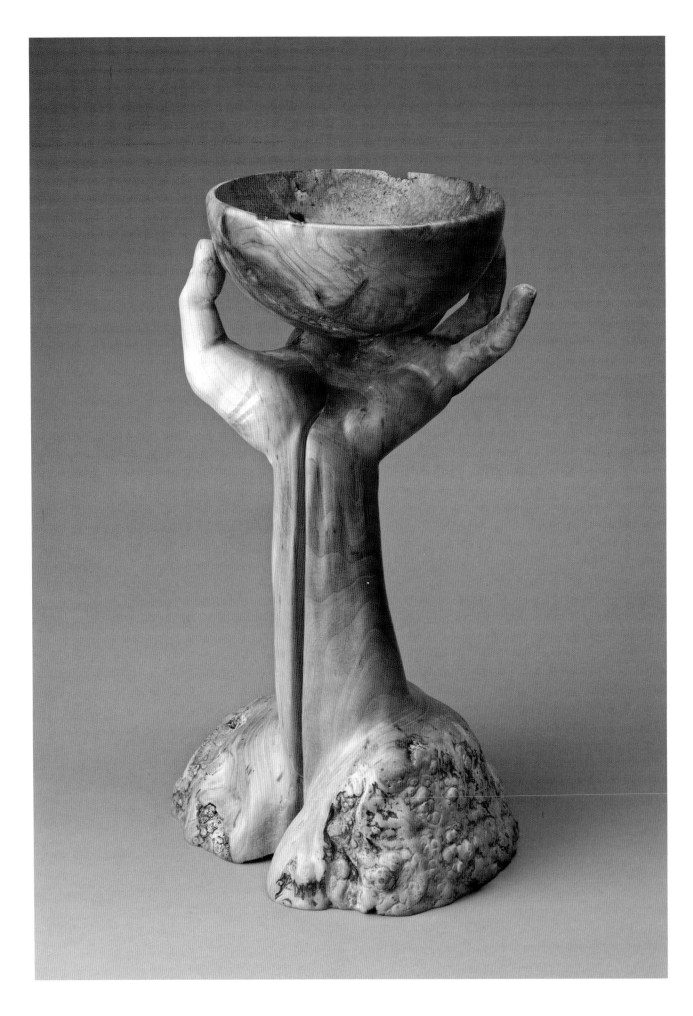

PLATE 97 | **Michelle Holzapfel**, United States | *Self Portrait*, 1987 | Cherry burl | 15 x 9 x 8" | Promised Gift of Bruce & Marina Kaiser

PLATE 98 | **Mark Lindquist**, United States | *Drum Song #1*, 1987 | Walnut | 22 ¾ x Dia. 16″ | Promised Gift of Albert & Tina LeCoff

PLATE 99 | **Connie Mississippi**, United States | *Pythagorus*, 1995 | Ash | 92 x Dia. 16" | Promised Gift of Bruce & Marina Kaiser

PLATE 100 | **Gael Montgomerie**, New Zealand | *Tribute*, 1998 ITE | Elm, acrylic paint, metal leaf, patina, ink | 26 ½ x 8 x 7″ |
Donated by the Artist | 1998.08.31.005G | (obj. 372)

PLATE 101 | **David Sengel**, United States | *Two Hemispheres, still one brain, still leaning right*, 1999 | Buckeye burl, brass, bronze | 20 x 20 x 6″ | Promised Gift of Neil & Susan Kaye

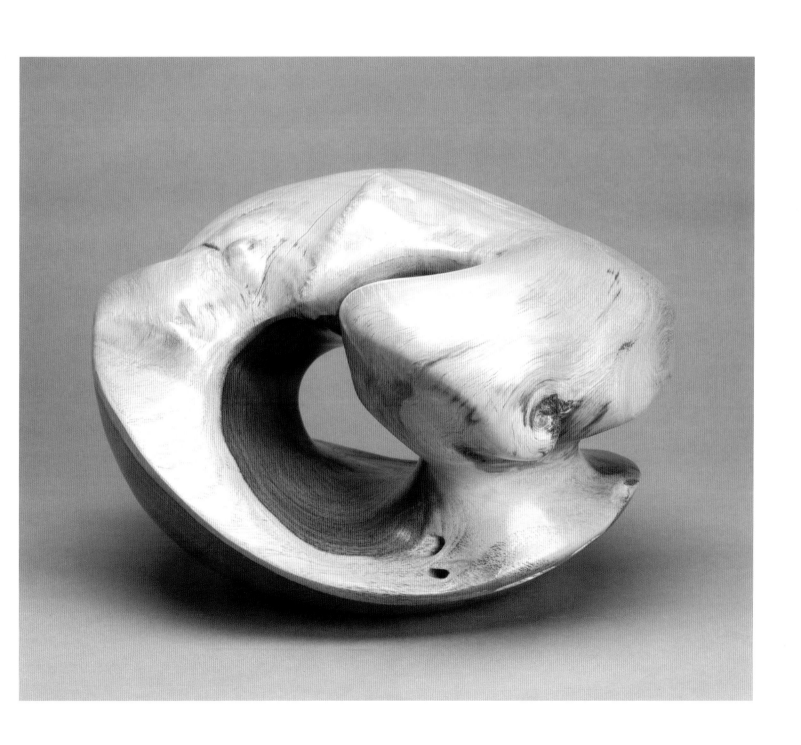

PLATE 102 | **Ed Bosley**, United States | *Wind Cave*, 1990 | Mesquite | 8 x 11 x 9" | Promised Gift of Neil & Susan Kaye

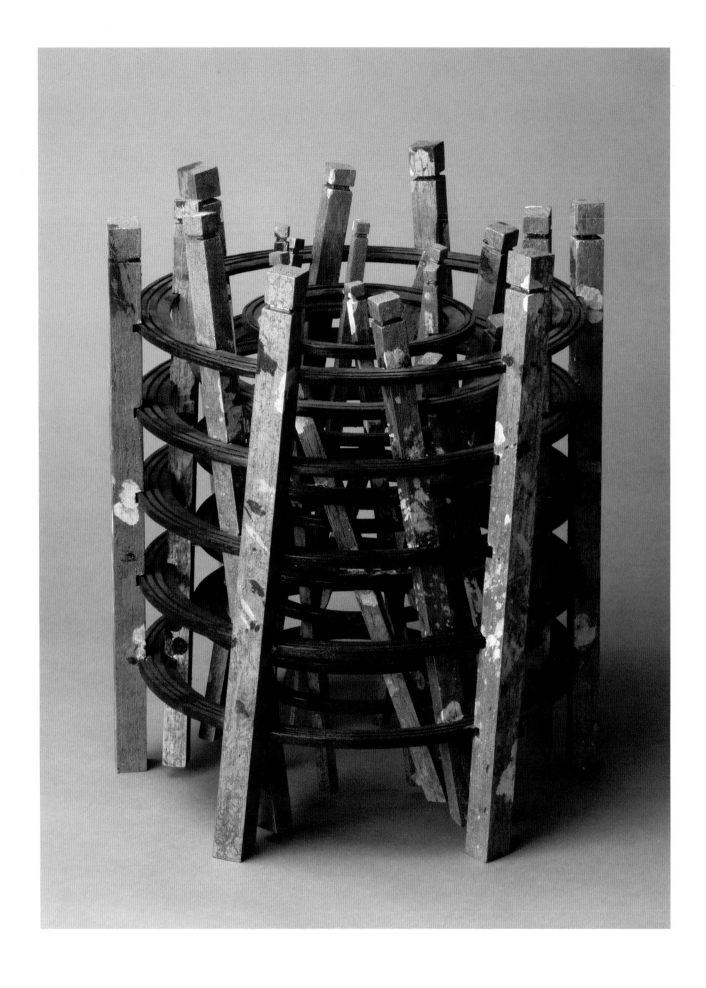

PLATE 103 | **Dewey Garrett**, United States | *Finding Resolve*, 2001 | Oak, metalized acrylics, chemical patinas | 12 x Dia. 10" |
Donated by the Artist | 2001.12.01.003G | (obj. 413)

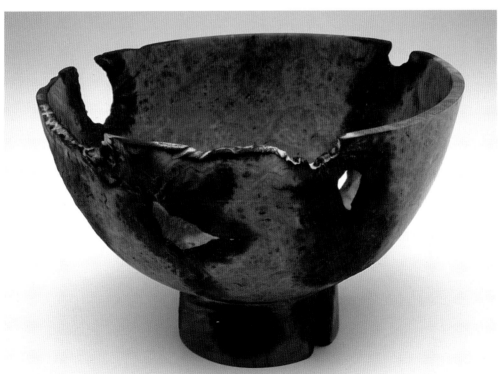

PLATE 104 | **Ted Hunter**, Canada | *Our Children Watch*, 1990 | Mixed media | 17 ¼ x 30 x 4 ½" | Donated by the Artist | 1995.01.01.100G | (obj. 84)

PLATE 105 | **Alan Stirt**, United States | *War Bowl*, 1990 | Ceanothus burl | 5 ¾ x Dia. 9" | 1995.01.01.230P | (obj. 85)

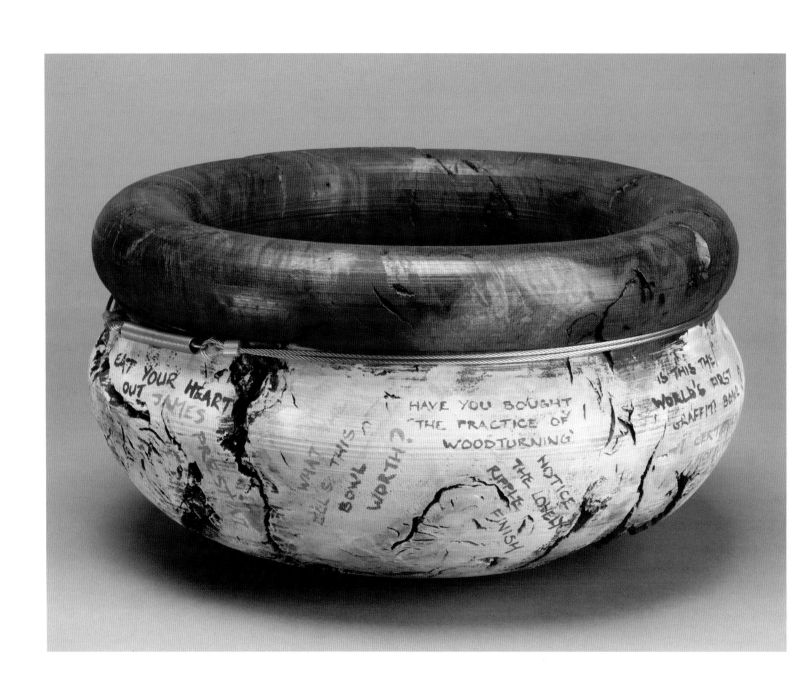

PLATE 106 | **Mike Darlow**, Australia | *Graffiti Bowl*, 1987 | Wood, stainless steel, paint | 8 x Dia. 13″ |
Donated by Arthur & Jane Mason | 1995.01.01.034G | (obj. 40)

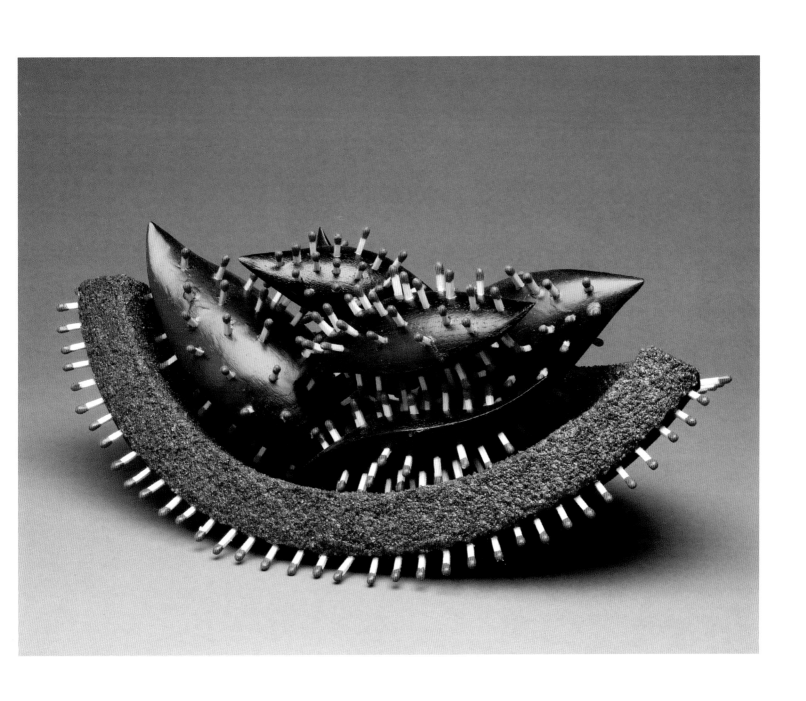

PLATE 107 | **Hilary Pfeifer**, **Dennis Carr**, United States & **Neil Scobie**, Australia | *Art Object to be Destroyed*, 2006 ITE | Mixed media | 6 x 13 x 7" | Donated by the Artists | 2006.08.04.006G | (obj. 526)

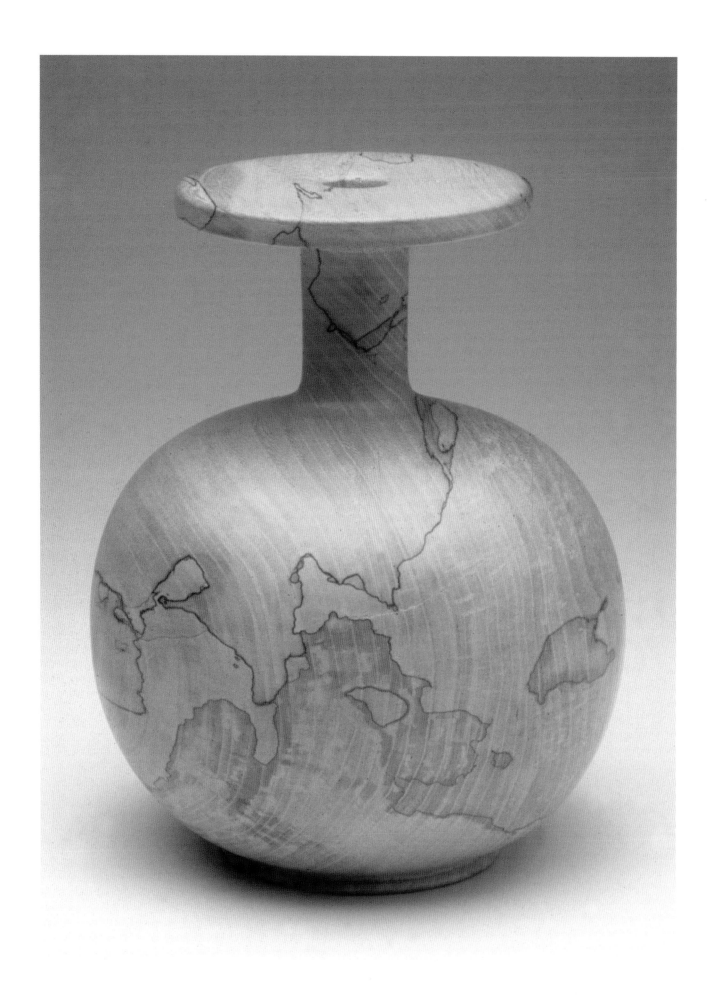

PLATE 108 | **Melvin Lindquist** | *Spalted Elm Vase, Hollow*, 1980 | Spalted elm | 8 x Dia. 6 ½″ | Donated by the Artist | 1995.01.01.134G | (obj. 19)

184 TURNING TO ART IN WOOD: A CREATIVE JOURNEY

ACQUISITION AND EVOLVING TRADITION

Robin Rice

AUTHOR

MEMBER OF THE BOARD OF TRUSTEES

THE CENTER FOR ART IN WOOD

PHILADELPHIA

ADJUNCT ASSOCIATE PROFESSOR

UNIVERSITY OF THE ARTS

PHILADELPHIA

The permanent collection of The Center for Art in Wood—more than 1,000 objects—has evolved from one man's passionate connoisseurship to today's encyclopedic array that represents not just the acquisition of individual seminal works but the reflection of an art field's growth. It is a tangible record of the Center's consistent efforts to refine and articulate the field through symposia, exhibitions, and publications.

In 1995 the Collection's Advisory Committee, which has been active since 1988, formalized its policies and procedures. Although the earliest work in the collection is now from the 1960s, the range of dates to be potentially collected begins with 1930. The collection is to be used as an educational tool accessible to people of all ages and backgrounds and to foster research in the field. The best examples of representative types, work that contributes to a full narrative of the field will be sought, as will work of the very highest caliber. Scholarship or interpretation of the collection in whole or in part is an on-going objective.

FIG. 1

The collection is to be used as an educational tool accessible to people of all ages and backgrounds and to foster research in the field.

When most people think of lathe turning, they think of functional things like chair legs. Although such useful elements do not dominate the Center's collection, they are represented. Acquired in 1977, a policeman's billy club and a few similar items illustrate the range of commercial turnings produced by the John Grass Wood Turning Company located in Old City Philadelphia (fig. 2). Founded in 1863, it was operated by six generations of owners. Albert had discovered the company in the 1970s when he was looking for a turning shop to help complete orders for his own work. In 2005, after John Grass had shut down, Albert purchased an abandoned pile of turned balusters (fig. 3). The order had never been picked up. Now in the collection, the order is still intact, wrapped with string and tied with an example of the rotten balusters it was intended to replace. Considered as a found object, this piece makes an almost nostalgic comment on the way time and dislocation alter narratives and perceptions.

FIG. 2

FIG. 4

FIG. 3

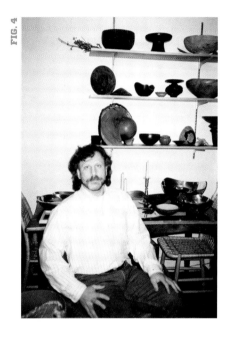

FIG. 1 Collection housed in the basement of 501 Vine Street with work from *Challenge VI—Roots: Insights & Inspirations in Contemporary Turned Objects* organized on the central table, 2004.

FIG. 2 John Grass Wood Turning Company: early 20th century photograph of worker and various turned wood products. Includes meat tenderizer (9), police billy club (31), offering plate (49), and mallet (50), all in Center's collection.

FIG. 3 Lou Bower, Jr, in the John Grass Wood Turning Company office ca. 1997. Sample turnings on back wall (left). Baluster original and duplicates now in Center's collection. (obj. 980)

FIG. 4 Albert amidst his collection in West Washington Lane home, 1989. Several pieces are now in the permanent collection.

The mid- to late-twentieth century Studio Crafts Movement grew out of revived interest in traditional craft techniques, techniques that people did not learn because mass production had made them seemingly irrelevant. Artists in many disciplines caught the fever. Some of the most brilliant of these were wood workers and turners. Stephen Hogbin put a Modernist spin on production turning to make a pair of spoons (acquired by the collection in 1979 (fig. 5)). Hogbin ingeniously turned a spindle form, slicing it in half lengthwise and hollowing out the bowls. A groove encircling the bowls facilitates tying the pair together for storage. As a studio artist, Hogbin made a number of similar spoons to evaluate the properties of different types of wood. In his intentionally short-term goal, he is distinct from a John Grass crafts turner who worked as fast as he could to make as many identical, predictable products as he could.

Charles Hummel, Curator Emeritus of Winterthur Museum and a member of the Collections Advisory Committee for many years, considers that the Center's collection of pieces by Bob Stocksdale comprise in themselves a first-class representation of mid-twentieth-century Modernism. One elegant ebony bowl (fig. 6) from the 1981 exhibit *Turned Objects: First North American Turned Object Show*, was anonymously donated to Albert. Very thin-walled, simple and clean-lined, the subtle individualized curve in the rim of Stocksdale's piece sets it apart from the turning cliché of "round and brown."

...the Center's collection of pieces by Bob Stocksdale comprise in themselves a first-class representation of mid-twentieth-century Modernism.

True, non-functional sculpture has been part of the collection almost from the beginning. Even decades after it was made, C.R. "Skip" Johnson's *Floor Walker* table (1987, acquired 1989 (fig. 7)) that appears to march across the room with profound but mindless deliberation remains an apt commentary on robotic machinery.

The twentieth-century Pattern and Decoration movement was inspired by handwork, by beautiful things, like quilts and embroideries, made in traditional ways. There are many examples of painted, flocked, inlaid, and otherwise

ornamented wood in the collection. A particular standout is a *Secretaire* (plate 56) made by Mark Sfirri and painted by Robert G. Dodge (1989). The legs, the product of Sfirri's characteristic multiple-axis turning, have been enhanced by Dodge's fine black and white checkerboard painting on flat surfaces, contrasting with trompe l'oeil blue marble on the broader curved ones and occasional swathes of gold leaf. Decoration on the rest of the piece is equally lavish except for the intentionally plain writing surface. The desk perfectly fulfills the Center's interest in unconventional techniques that are used before and after turning. Partly on the advice of Charles Hummel, this is the only piece the Collection has purchased at auction.

Art became more topical toward the end of the twentieth century and art in wood commented directly on world events. Important expressions of topical themes in the collection include *War Bowl* (plate 105), made in 1990 by Alan Stirt in response to the Gulf War. After turning the bowl, Stirt flamed it with a blowtorch, burning completely through the walls in some places. The environment is a topic of practical interest to artists who require wood. With the black-painted *Wait a Minute Dad* (fig. 8), two skewed halves of a steel saw "cutting" through a cylinder of mahogany, Glenn Elvig makes a plea to halt the destruction of the rainforest.

The complex work of Michelle Holzapfel is, as Charles Hummel says, "not only beautiful to behold; it is technically superior and her ideas are important." Michelle uses the lathe as a tool for sculpture. Her *Fishes Vase* (fig. 9) is an environmental commentary in which a pair of fish carved from a single turning bracket a traditional water flask. The fish are literally out of the water. The canteen-like flask through its conventional design suggests the importance of preserving water.

Frank Cummings's *Nature in Transition* (plate 48), one of the richest works in the collection (made 1989, donated by Dr. Irving Lipton, 1990) pays homage to wood in a special way. It was turned across a section of cork oak, extending from bark at the rim to bark at the foot. The walls display a growth ring pattern and Cummings painstakingly carved lacy fretwork through the cambium level around the top. Cummings was a pioneer of combining non-wood materials with turned wood. In a virtuoso performance here he encircles the vessel with inset bands of ivory and gold.

FIG. 7

FIG. 8

FIG. 9
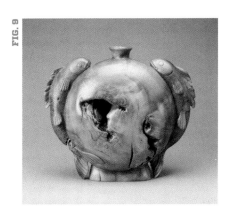

FIG. 5 Stephen Hogbin, *Spoons*, ca. 1978. (plate 60)

FIG. 6 Bob Stocksdale, *Ebony Wood Bowl*, 1981. (obj. 22)

FIG. 7 C.R. (Skip) Johnson, *Floor Walker*, 1988. (obj. 125)

FIG. 8 Glenn Elvig, *Wait a Minute Dad*, 1989. (obj. 83)

FIG. 9 Michelle Holzapfel, *Fishes Bottle Vase*, 1987. (obj. 120)

FIG. 10

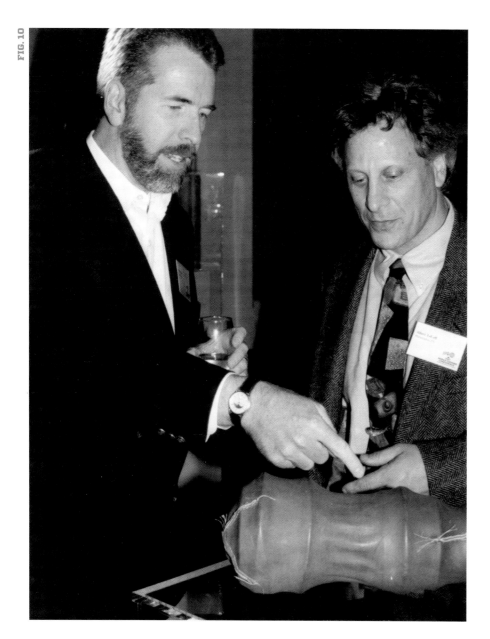

FIG. 11

FIG. 10 Mark Leach, one of three curators of *Curators' Focus* exhibit, discusses Gord Peteran's *Untitled So Far* with Albert LeCoff at the opening at the Philip & Muriel Berman Museum of Art, Ursinus College, 1997.

FIG. 11 Robin Wood, *Cor Blimey*, 2007. (plate 43)

FIG. 12 Picking work from the 1999 ITE for the collection. Left to right: Remi Verchot (France), Henri Gröll (France), Charles Hummel, Collection Advisory Committee, Albert, and Dina L. Intorrella-Walker (US) in the George School shop. The work on the table is by Henri Gröll.

Perhaps the most cryptic and controversial piece in the entire collection, *Untitled So Far* (plate 85), is an anonymous discarded turning covered in red leather by furniture maker Gord Peteran. It was made at the annual Emma Lake collaborative (Saskatoon, Canada) in which turners and other artists gather, make art, and auction it all off to finance the next year's gathering. The not-remotely functional turning is sewn tightly into its covering, never to be seen, always to be experienced as a sensual but mysteriously potential revelation. At the 1996 Emma Lake, Peteran gave this work to Albert. Saying he had planned to sneak it home in his suitcase but wanted Albert to have it "because you 'get' it." If *Untitled So Far* were not in the collection, it might have disappeared completely; but now, because it has been exhibited, studied, and documented, it has become a milestone in the wood field (fig. 10).

Peteran's 2002 drawings, *Five Sounds* (plates 74–78) represent the turning process in an original way and were the first two-dimensional works on paper in the collection.

FIG. 12

Robin Wood's *Cor blimey* (an exclamation of amazement) produced for the 2008 *Challenge VII: dysFUNctional* show was the first video installation in the collection (fig. 11). It integrates a film of the English artist turning traditional bowl forms, using a pole lathe. In the film, Wood turns a bowl and tosses the core down where it joins a heap of 1,000 real solid-waste cores on the gallery floor. This installation unites contemporary technology (video) with the most traditional craft approach. With this installation, Wood in a sense recycles what would be wasted into something useful—even instructive.

> ## "The more innovative work that we consistently and immediately get into the Center collection is what our ITE residents do."
>
> — *Fleur Bresler*

The International Turning Exchange (ITE) residency program, inaugurated in 1995, has been a source of new ideas and work. As Fleur Bresler, former board president and part of the Collections Advisory Committee since the beginning, notes, "The more innovative work that we consistently and immediately get into the Center collection is what our ITE residents do." The original plan was that a work would be chosen from all the objects made by each fellow during the residency (fig. 12); however, an unanticipated dilemma arose in the very first ITE. Todd Hoyer and Hayley Smith made a collaborative piece (*Untitled #1* (fig. 13)). Each saw it as a step forward in thinking.

The committee wanted work like this that showed artists getting out of their comfort zone. Would the resident fellows be asked to donate collaborative work *in addition* to their individual donations? The answer was "Yes." When a person is part of the ITE, chances are that at least one pre-ITE work will also be acquired for the collection. The Center likes to document growth.

The headline says clearly what the Center wanted to do with its collection: "New Acquisition Breaks Tradition."

In fact, growth is at the center of the collection and has been from the beginning. The first expression of the Center's collecting philosophy was recorded in its first newsletter, Spring 1988. Initiating a projected series on important objects in the collection, Albert wrote about Mark Lindquist's *Spalted Maple Bowl, Carved Foot* (fig. 14), which was adopted by Jane and Arthur Mason and later donated to the Center: "For me it was the earliest example of a wood bowl I had seen made from the lathe, that went beyond the traditional high-crafted, designed bowl. This bowl had sculpted features—the individually carved feet... it had a sensuous quality, yet the heftiness would not let me forget it was made of wood." The headline says clearly what the Center wanted to do with its collection, a goal that is as valid today as it was 23 years ago: "New Acquisition Breaks Tradition." ■

FIG. 13 Todd Hoyer & Hayley Smith, *Untitled #1*, 1995 ITE. (obj. 284)

FIG. 14 Mark Lindquist, *Spalted Maple Bowl, carved foot*, 1977. (plate 20)

FIG. 13

FIG. 14

THE COMPLETE COLLECTION

1977–2011

W hat follows here is The Center for Art in Wood's vast and varied collection of works produced over many decades and gathered since 1977 by Albert LeCoff, the co-founder and executive director, and the Center's trustees and its Collections Advisory Committee. The order of these images reflects the estimated years that the Center acquired the art works, even though the Center's first inventory in 1995 is represented in the acquisition numbers.

The Center invites viewers to visit its website—centerforartinwood.org—where objects from the collection can be explored and assembled into private online galleries entitled "MyCenter." ■

Each object in this plate section is identified with the name of its maker or makers, the title, and the year of creation. The wood (and other materials) appears next. Dimensions follow, in inches, with height followed by width followed by depth or diameter. Next is donor information unless the work was purchased by the Center, followed by the object's acquisition number, which may be used to locate items online.

All objects are also labeled in the upper left corner with object numbers which opproximates the order in which the objects were acquired into the collection.

1977
»

OBJ-1

John Grass Wood Turning Company, United States. *Billy Club*, ca. 1970. Oak. 14 x 1 ⅝ x 1 ⅝". Donated by the John Grass Wood Turning Company. 1995.01.01.069G

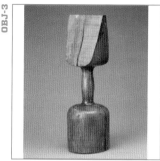

OBJ-2

John Grass Wood Turning Company, United States. *Finial*, ca. 1970. Redwood. 10 x 5 x 5". Donated by the John Grass Wood Turning Company. 1995.01.01.071G

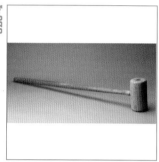

OBJ-3

John Grass Wood Turning Company, United States. *Tool*, ca. 1970. Wood. 13 x Dia. 4 ¼". Donated by the John Grass Wood Turning Company. 1995.01.01.072G

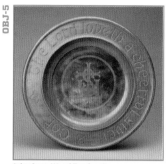

OBJ-4

John Grass Wood Turning Company, United States. *Large Mallet*, ca. 1970. Ash. 35 ½ x 6 ¼ x 3 ½". Donated by the John Grass Wood Turning Company. 1995.01.01.073G

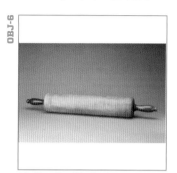

OBJ-5

John Grass Wood Turning Company, United States. *Offering Plate*, ca. 1970. Walnut. 1 ⅝ x Dia. 12". Donated by the John Grass Wood Turning Company. 1995.01.01.074G

OBJ-6

John Grass Wood Turning Company, United States. *Rolling Pin*, ca. 1970. Cherry. 27 ½ x Dia. 4". Donated by the John Grass Wood Turning Company. 1995.01.01.076G

OBJ-7

John Grass Wood Turning Company, United States. *Mallet*, ca. 1970. Lignum vitae. 10 ½ x Dia. 3 ⅞". Donated by the John Grass Wood Turning Company. 1995.01.01.077G

OBJ-8

Paul Eshelman, United States. *Platter*, ca. 1975. Wood. ¾ x Dia. 7 ¼". Donated by Albert & Tina LeCoff. 1995.01.01.141G

OBJ-9

Paul Eshelman, United States. *Platter*, ca. 1975. Wood. ¾ x Dia. 4". Donated by the Artist. 1995.01.01.142G

OBJ-10

Jake Brubaker, United States. *Saffron Container*, 1977. Wood. 6 x Dia. 2 ⅛". Donated by the Artist. 1995.01.01.310.06G

1978
»

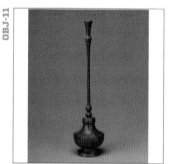

OBJ-11

Jake Brubaker, United States. *Bud Vase*, 1978. Rosewood. 8 ¾ x Dia. 2". Donated by the Artist. 1995.01.01.310.01G

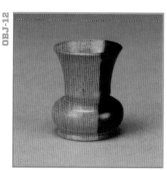

OBJ-12

Jake Brubaker, United States. *Miniature Vase*, 1971. Wood. 1 x Dia. ¾". Donated by the Artist. 1995.01.01.310.03G

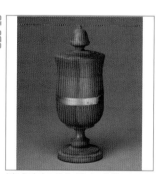

OBJ-13

Jake Brubaker, United States. *Saffron Container*, 1970. Wood, pewter. 5 ½ x Dia. 1 ⅞". Donated by the Artist. 1995.01.01.310.04G

OBJ-14

Jake Brubaker, United States. *Saffron Container*, 1973. Wood. 6 x Dia. 2 ⅛". Donated by the Artist. 1995.01.01.310.05G

1979
»

OBJ-15

Stephen Hogbin, Canada. *Spoons*, ca. 1978. Birch. 11 ½ x 3 x 1 ½" each. Donated by Alan LeCoff. 1995.01.01.083a-bG. (plate 60)

OBJ-16

Del Stubbs, United States. *Translucent Bowl*, 1979. Curly maple. 1 ⅞ x Dia. 4 ½". Donated by the Artist. 1995.01.01.245G. (plate 23)

1980
»

OBJ-17

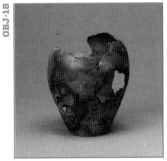

Del Stubbs, United States. *Bowl*, 1980. Olive.
2 ¾ x Dia. 11 ¼". Donated by the Artist.
1995.01.01.243G. (plate 22)

OBJ-18

Don Kelly, Kay Ingalls, & **Bill Stewart**,
United States. *Vessel*, 1980. Cherry burl.
4 ½ x Dia. 3 ½". Donated by Don Kelly.
1995.01.01.304.02G

1981 »

OBJ-19

Melvin Lindquist, United States. *Spalted Elm
Vase, hollow*, 1980. Spalted elm. 8 x Dia. 6 ½".
Donated by the Artist. 1995.01.01.134G.
(plate 108)

OBJ-20

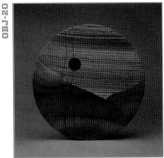

William Patrick, United States. *Plate*, 1981.
Zebra wood, mahogany, walnut, ebony,
amaranth. ¾ x Dia. 11". Donated by the Artist.
1995.01.01.175G

OBJ-21

Henry Schaefer, United States.
Honey Dippers, 1981. Assorted Woods.
8 x Dia. 1" each. 1995.01.01.213a–eP

OBJ-22

Bob Stocksdale, United States. *Ebony Wood
Bowl*, 1981. Ebony from the Philippines.
4 x Dia. 7 ¼". Donated by Albert & Tina
LeCoff. 1995.01.01.238G

OBJ-23

Del Stubbs, United States. *Container*, 1981.
Clara walnut. 3 ½ x Dia. 5 ½". Donated by
Albert & Tina LeCoff. 1995.01.01.244G

OBJ-24

William Schmidt, United States. *Executive
Pacifier*, ca. 1980. Maple. 6 ½ x Dia. 1 ½".
1995.01.01.282P

OBJ-25

Dale Nish, United States. *Ash Bowl*, 1980.
Ash. 3 ¼ x Dia. 12 ¼". Donated by the Artist.
1995.01.01.283G

OBJ-26

Jake Brubaker, United States. *Bud Vase*, 1981.
Wood. 11 ½ x Dia. 2 ½". Donated by the Artist.
1995.01.01.310.02G

1983 »

OBJ-27

Del Stubbs, United States. *Translucent Bowl*,
1983. Almond. 2 ½ x Dia. 4 ¾". Donated by
Charles Aberle. 1995.01.01.246G

1985 »

OBJ-28

Del Stubbs, United States. *Top*, 1985. Maple.
2 x Dia. 1 ½". Donated by the Artist.
1995.01.01.253G

1986 »

OBJ-29

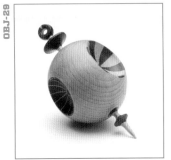

Dave Hardy, United States. *Ornament*, 1986.
Maple, rosewood. 5 ¾ x Dia. 2 ½".
1995.01.01.079P

OBJ-30

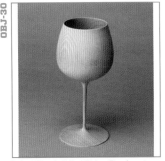

Robert Street, United States. *Translucent
Goblet in Wood*, 1986. Oregon ash.
7 ¼ x Dia. 3 ¼". Donated by the Artist.
1995.01.01.242G. (plate 24)

1987 »

OBJ-31

Karl Decker, Germany. *Door Handles*, 1987.
Palisander, ebony, rosewood, bone, brass.
5 x 2 ¾ x Dia. 1 ⅜", 5 ¾ x 2 ¾ x 1 ⅜".
1995.01.01.036a–bP. (see p. 198)

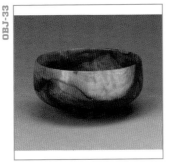

Michael Mode, United States. *Lidded Vessel with natural top*, 1987. Spalted elm burl, walnut. 5 x Dia. 4 ½". 1995.01.01.151P

Bob Stocksdale, United States. *Olive Wood Bowl*, 1987. Olive. 2 ½ x Dia. 4 ½". Donated by Albert & Tina LeCoff. 1995.01.01.280G

1988
»

Gottfried Bockelmann, Germany. *Cross-turned globe box*, 1987. False acacia. Dia. 3 ½". Donated by the Artist. 1995.01.01.004G

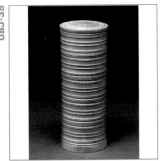

Gottfried Bockelmann, Germany. *Ribbed Jar*, 1987. Boxwood. 5 ⅞ x Dia. 2 ⅞". Donated by the Artist. 1995.01.01.005G

Gottfried Bockelmann, Germany. *Jar*, 1988. Moor oak, amaranth. 5 ½ x 3 ⅝ x 1 ¾". 1995.01.01.006P

Michael Brolly, United States. *Shark Bowl*, 1981. Koa wood. 1 ¾ x Dia. 5 ¼". Donated by the Artist. 1995.01.01.008G. (plate 11)

Michael Chinn, United States. *TRI - 10,000*, 1988. Purpleheart, Indian ebony, aluminum. 3 ⅝ x 9 x 6 ⅛". 1995.01.01.029P. (plate 45)

Clead Christiansen, United States. *Nuts*, 1988. Tagua nut. 1 ⅝–2 x Dia. 1 ½–2". 1995.01.01.030a–cP

Mike Darlow, Australia. *Graffiti Bowl*, 1987. Wood, stainless steel and paint. 8 x Dia. 13". Donated by Arthur & Jane Mason. 1995.01.01.034G. (plate 106)

J. Paul Fennell, United States. *Miniature Goblets #1*, 1987. Tulipwood. ⅛–1 ¼". Donated by the Artist. 1995.01.01.056G

J. Paul Fennell, United States. *Miniature Goblets #2*, 1987. Boxwood. ¾–4 ⅝". Donated by the Artist. 1995.01.01.057G

J. Paul Fennell, United States. *Miniature Goblets #3*, 1987. Rosewood, ebony. ⁷⁄₁₆–1 ½". Donated by the Artist. 1995.01.01.058G

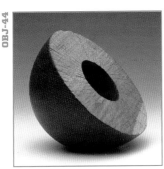

Robyn Horn, United States. *Sheoake Geode*, 1987. Sheoake. 7 x 8 ¼ x 6 ¾". Donated by the Artist. 1995.01.01.087G. (plate 31)

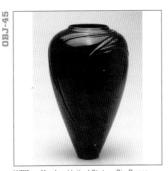

William Hunter, United States. *Rio Dunes*, 1988. Cocobolo rosewood. 17 x Dia. 11". Donated by Dr. Irving Lipton. 1995.01.01.101G

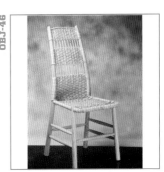

Tom Kealy, United Kingdom. *Somerset Sidechair*, 1987. Ash, willow. 39 x 18 x 19". 1995.01.01.108P

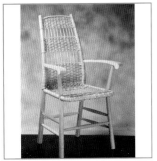

Tom Kealy, United Kingdom. *Arm Somerset Sidechair*, 1987. Ash, willow. 39 x 18 x 19". 1995.01.01.109P

Richard Kell, United Kingdom. *Three Tray Hinged, No. 649*, 1987. African blackwood, boxwood, nickel silver hinge. 4 x Dia. 2". 1995.01.01.110P

Max Krimmel, United States. *Alabaster Vessel #79*, 1987. Colorado alabaster, ebony, satine. 6 x Dia. 8 ⅛". Donated by the Artist. 1995.01.01.124G. (plate 46)

Max Krimmel, United States. *Alabaster Bowl #196*, ca. 1987. Alabaster, ebony, blackwood. 4 ½ x Dia. 17". Donated by the Artist. 1995.01.01.125G

OBJ-31 | **Karl Decker**, Germany | *Door Handles*, 1987 | Palisander, ebony, rosewood, bone, brass | 5 x 2 ¾ x Dia. 1 ⅜″ | 5 ¾ x 2 ¾ x 1 ⅜″ | 1995.01.01.036a–bP

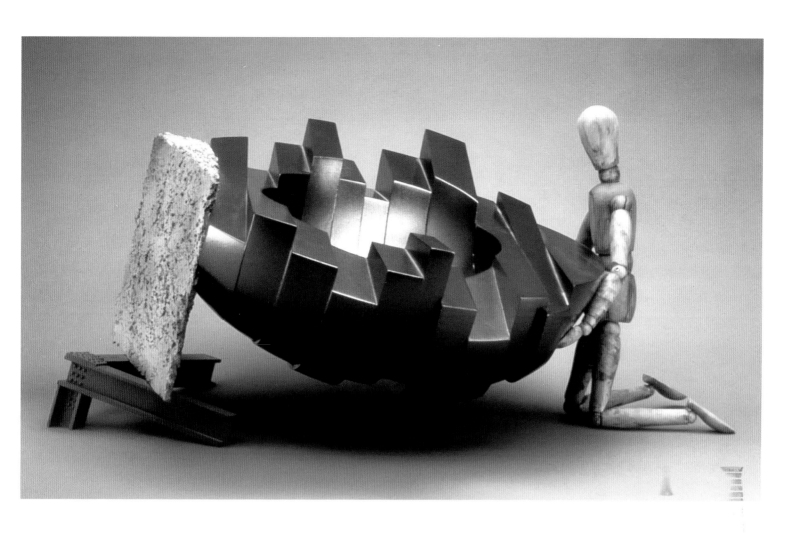

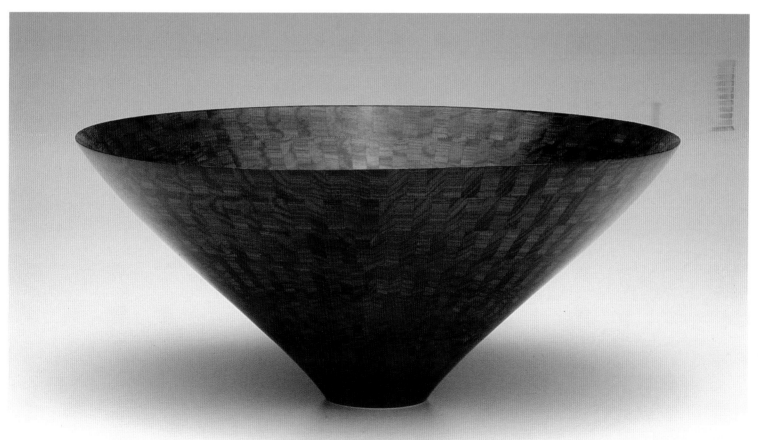

OBJ-60 | **Hap Sakwa**, United States | *Perfect Reflection*, 1987 | Poplar, polyester resin, acrylic lacquer, Artist mannequin | 9 ½ x 19 x 16″ | 1995.01.01.201P

OBJ-67 | **Michae! Shuler**, United States | *Cocobolo Bowl #367*, 1987 | Cocobolo | 5 ³⁄₁₆ x Dia. 11 ¹⁵⁄₁₆″ | Donated by the Artist | 1995.01.01.223G

Bud Latven, United States. *Wenge Bowl*, 1987. Wenge, holly. 3 ¾ x Dia. 4 ¼". 1995.01.01.128P

Robert Leung, United States. *Jewelry Box*, 1988. Birds Eye Maple, andaman, Brazilian rosewood, paduak. 7 x 16 x 6". Donated by the Artist. 1995.01.01.132G

Jim Partridge, United Kingdom. *Blood Vessel Series*, 1987. Scorched burr oak. 5 ½ x Dia. 7". 1995.01.01.172P. (plate 28)

Jim Partridge, United Kingdom. *Blood Vessel Series*, 1987. Scorched burr oak. 5 x 11 ¾ x 8 ¾". 1995.01.01.173P. (plate 30)

Jim Partridge, United Kingdom. *Blood Vessel Series*, 1987. Scorched burr oak. 6 ¼ x 10 ¼ x 7 ¼". 1995.01.01.174P. (plate 29)

Stephen Paulsen, United States. *A Collection of Goblets and Chalices from the Seventeen Peoples of the Eight Inner Worlds*, 1987. Various woods. 9 x 12 x 3 ½". Donated by Dr. Irving Lipton. 1995.01.01.178G

Wayne & **Belinda Raab**, United States. *Vase- Red with Blue Square*, 1987. Walnut, curly maple, acrylic lacquer. 24 x 6 ½ x 5". 1995.01.01.195P. (plate 54)

Gail Redman, United States. *Railing with Newel Post*, 1983. Redwood. 44 ½ x 5 ½ x 39 ¼". Donated by the Artist. 1995.01.01.196G

Gail Redman, United States. *Rosettes and Finials*, 1983. Redwood. 21 ½ x 31 ½ x 3". Donated by the Artist. 1995.01.01.197G

Hap Sakwa, United States. *Perfect Reflection*, 1987. Poplar, polyester resin, acrylic lacquer, Artist mannequin. 9 ½ x 19 x 16". 1995.01.01.201P. (see p. 199)

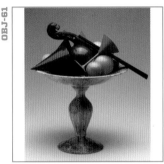

Hap Sakwa, United States. *Against That Which All Else is Measured*, 1985. Poplar, maple, lacquer, a violin neck circa 1780. 17 ½ x 17 x 12 ½". 1995.01.01.202P

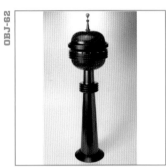

Hap Sakwa, United States. *Space Burger*, 1988. Poplar, acrylic paint, BB's. 57 x Dia. 15". Donated by the Artist. 1995.01.01.203G

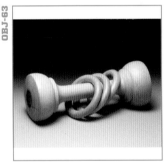

Palmer Sharpless, United States. *Circus*, 1988. Dogwood. 2 x 2 x 4". Donated by the Artist. 1995.01.01.219.01G. (plate 1)

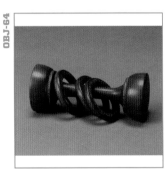

Palmer Sharpless, United States. *Circus*, 1988. Walnut. 2 x 2 x 4". Donated by the Artist. 1995.01.01.219.02G

Joanne Shima, United States. *Child's Chair*, 1987. Maple, birch, medium-density fiberboard, lacquer. 26 x 10 x 12". 1995.01.01.221P. (plate 57)

Joanne Shima, United States. *Child's Chair*, 1987. Maple, birch, medium-density fiberboard, lacquer. 21 x 14 x 12". 1995.01.01.222P

Michael Shuler, United States. *Cocobolo Bowl #367*, 1987. Cocobolo. 5 ³⁄₁₆ x Dia. 11 ¹⁵⁄₁₆". Donated by the Artist. 1995.01.01.223G. (see p. 199)

Alan Stirt, United States. *Textured Bowl*, 1987. Cocobolo. 4 ⅛ x Dia. 10". 1995.01.01.227P

Maria van Kesteren, Netherlands. *Volume*, 1987. Elm, gray paint. 3 ⅛ x Dia. 10 ⅛". 1995.01.01.257P

Maria van Kesteren, Netherlands. *Box*, 1987. Elm, gray paint. 2 x Dia. 5 ⅛". 1995.01.01.258P

OBJ-71

Maria van Kesteren, Netherlands. *Landscape*, 1987. Elm, indigo paint. 3 ½ x Dia. 12 ⅛". 1995.01.01.259P

OBJ-72

Christopher Weiland, United States. *Wall Mirror*, 1987. Maple, paint, brass. Dia. 15 x 3". 1995.01.01.264P

OBJ-73

Vic Wood, Australia. *Huon Pine Box*, 1987. Huon pine. 2 ½ x 5 x 4". 1995.01.01.276P

OBJ-74

Vic Wood, Australia. *Huon Pine Box*, 1987. Huon pine. 3 x 8 x 6". 1995.01.01.277P

OBJ-75

Broder Burow, Germany. *Spindle Box*, ca. 1987. Ebony, amaranth. 11 x Dia. 2 ¼". Donated by the Artist. 1995.01.01.346G

1989
»

OBJ-76

Boris Bally, United States. *Kalimba, Bottlecork Sculpture*, 1989. Silver, ebony, aluminum, goldplate. 8 x 3 x 1". Donated by the Artist. 1995.01.01.002G

OBJ-77

Paul Clare, United Kingdom. *Bowl*, 1989. Burl oak. 6 x Dia. 6 ¾". Anonymous Donor. 1995.01.01.031G

OBJ-78

Arthur Cummings, United Kingdom. *Box*, 1989. Rosewood. 2 ¾ x Dia. 3". Donated by the Artist. 1995.01.01.032G

1990
»

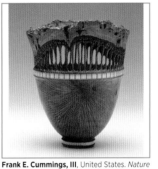

OBJ-79

Frank E. Cummings, III, United States. *Nature in Transition*, 1989. Cork oak, 18K gold, exotic material. 6 ¼ x Dia. 5 ¾". Donated by Dr. Irving Lipton. 1995.01.01.033G. (plate 48)

OBJ-80

Neil Donovan, United States. *Walking Stool*, 1990. Mahogany, oak, maple, suede, leather lace, antique shoemaker lasts. 28 x Dia. 12". 1995.01.01.042P

1991
»

OBJ-81

Walter Balliet, United States. *Container*, 1991. Apricot base, dogwood lid, African blackwood finial. 7 ¼ x Dia. 3 ½". Donated by the Artist. 1995.01.01.001G

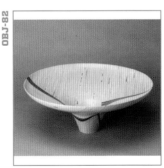

OBJ-82

Virginia Dotson, United States. *Calligraphy Bowl*, 1991. Baltic birch, wenge, walnut. 5 ¾ x Dia. 14 ¾". 1995.01.01.043P. (plate 15)

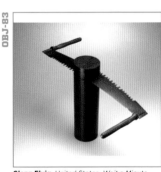

OBJ-83

Glenn Elvig, United States. *Wait a Minute Dad*, 1989. Lacquered mahogany, steel saw. 36 x 20 x 56". Donated by the Artist. 1995.01.01.054G. (see p. 204)

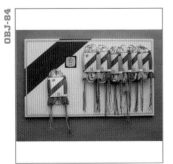

OBJ-84

Ted Hunter, Canada. *Our Children Watch*, 1990. Mixed media. 17 ¼ x 30 x 4 ½". Donated by the Artist. 1995.01.01.100G. (plate 104)

OBJ-85

Alan Stirt, United States. *War Bowl*, 1990. Ceanothus burl. 5 ¾ x Dia. 9". 1995.01.01.230P. (plate 105)

OBJ-86

Dewey Garrett, United States. *Serene Moiré*, ca. 1991. Maple, padauk. 4 x Dia. 9". Donated by the Artist. 1995.01.01.347.01G

OBJ-87

Dewey Garrett, United States. *Walnut Petal Vessel*, ca. 1991. Walnut. 3 x Dia. 9". Donated by the Artist. 1995.01.01.347.02G

1992 »

Lynne Hull, United States. *Vertical Basket #10E*, 1992. Copper, patinaed. 28 x Dia. 11". 1995.01.01.092P. (plate 49)

Lynne Hull, United States. *Strapped Bowl Form #2*, 1992. Aluminum, paint. 3 ¾ x 11 ¾ x 9". 1995.01.01.096P

Hans Joachim Weissflog, Germany. *Napoleon Box*, 1992. Purple Heart. 2 x 2 ¾ x 1 ½". 1995.01.01.265P

Hans Joachim Weissflog, Germany. *Box with floating rings*, 1992. Blackwood. 1 ¼ x Dia. 1 ¾". Donated by Dr. Irving Lipton. 1995.01.01.266G

Hans Joachim Weissflog, Germany. *Drunken Box*, 1992. Zapatero boxwood, ebony. Dia. 2". 1995.01.01.268P

Hans Joachim Weissflog, Germany. *Saturn Box*, 1992. Boxwood. 2 x 4 ¾ x 4 ¾". Donated by Dr. Irving Lipton. 1995.01.01.269G

Hans Joachim Weissflog, Germany. *Ball-Box, Turned Broken Through*, 1992. Basswood, ebony. Dia. 2". Donated by Dr. Irving Lipton. 1995.01.01.270G

Hans Joachim Weissflog, Germany. *Walnut Box*, 1992. Nut, walnut. 1 ¾ x Dia. 1 ½". 1995.01.01.271P

Hans Joachim Weissflog, Germany. *Walnut Box*, 1992. Nut, walnut. 1 ¾ x Dia. 1 ½". 1995.01.01.272P

1994 »

Bud Latven, United States. *Irv's Grief*, 1994. Various woods, formica. 27 ½ x 28 x 7 ¼". Donated by Dr. Irving Lipton & Artist. 1995.06.01.001G

1995 »

M. Dale Chase, United States. *Lidded Container*, 1989–90. African blackwood. 2 ¾ x Dia. 3". 1995.01.01.015P

M. Dale Chase, United States. *Lidded Container*, 1985. African blackwood. 1 ½ x Dia. 1 ¾". 1995.01.01.018P

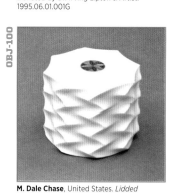

M. Dale Chase, United States. *Lidded Container*, 1986. Ivory, blackwood, gold. 1 ½ x Dia. 1 ¾". 1995.01.01.022P

M. Dale Chase, United States. *Lidded Container*, 1989–90. African blackwood. 1 ¼ x Dia. 2 ¾". Donated by the Artist. 1995.01.01.023G

M. Dale Chase, United States. *Lidded Container*, ca. 1988. African blackwood 1 ¼ x Dia. 3 ¾". Donated by the Artist. 1995.01.01.027G

Peter Chatwin & Pamela Martin, United Kingdom. *Stud Earrings*, 1987. Laminated sycamore veneer. Dia. 1 ⅞" each. 1995.01.01.028.01P

Peter Chatwin & Pamela Martin, United. Kingdom. *Stud Earrings*, 1987. Laminated sycamore veneer. Dia. 1 ⅝" each. 1995.01.01.028.02P

Peter Chatwin & **Pamela Martin**, United. Kingdom. *Stud Earrings*, 1987. Laminated sycamore veneer. Dia. ⅞" each. 1995.01.01.028.03P

Peter Chatwin & **Pamela Martin**, United Kingdom. *Stud Earrings*, 1987. Laminated sycamore veneer. Dia. ⅞" each. 1995.01.01.028.04P

Karl Decker, Germany. *Box*, ca. 1988. Blackwood, thuya burl inlay. 1 ⅞ x Dia. 3 ⅞". Donated by the Artist. 1995.01.01.035G

John Diamond-Nigh, United States. *Wing Form*, ca. 1985. Birch. 3 ¼ x 23 ½ x 4 ¾". 1995.01.01.039P

John Diamond-Nigh, United States. *Untitled*, ca. 1985. Birch. 7 x 8 x 8 ½". 1995.01.01.040P. (plate 7)

John Diamond-Nigh, United States. *Wing Form*, 1987. Birch. 3 x 34 x 3 ½". 1995.01.01.041P

Leo Doyle, United States. *Matched Candlesticks with Matched Drawers*, 1987. Bird's eye maple. 14 x Dia. 4" each. Donated by the Artist. 1995.01.01.044a–bG

Addie Draper, United States. *From the Wolf Series #1*, 1987. Black and white airbrushed mahogany. 9 x 6 x 4". 1995.01.01.045P

Quelle Est Belle Co., France. *Bird Whistles*, ca. 1990. Wood. L 3–4 ½". Donated by Hans Joachim Weissflog. 1995.01.01.060a–IG. (see p. 205)

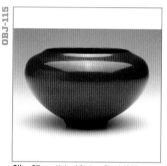

Werkstatt Leichsenring, Germany. *Flower Turnings*, 1989. Wood. 3 ½ x 9 x 6". 1995.01.01.061.01–.09P. (see p. 205)

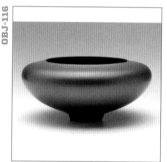

Giles Gilson, United States. *Bowl*, 1985. Mahogany, pearlescent lacquer. 4 ¼ x Dia. 7". 1995.01.01.062P

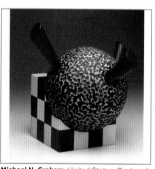

Giles Gilson, United States. *Gum Metal Black Bowl Form*, 1985. Mahogany. lacquer, flocking 5 x Dia. 11". Donated by Dr. Irving Lipton. 1995.01.01.064G. (plate 52)

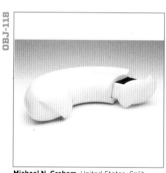

Michael N. Graham, United States. *Captured Sphere*, 1991. Wood, lacquer. 14 x 11 x 14". 1995.01.01.066P

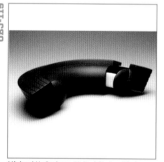

Michael N. Graham, United States. *Split Ellipse, #22/35*, 1987. Basswood, paint. 3 ¾ x 15 x 6 ¾". 1995.01.01.067P

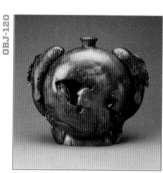

Michael N. Graham, United States. Circle *Square, #15/35*, 1987. Basswood, paint. 4 ⅛ x 9 x 18". 1995.01.01.068P

Michelle Holzapfel, United States. *Fishes Bottle Vase*, 1987. Cherry burl. 12 x 14 x 4 ½". 1995.01.01.086P

Michael Hosaluk, Canada. *Spectrum #3*, 1986. Colorcore, anodized aluminum, glass, lacquered maple. 24 x Dia. 18 ½". Donated by the Artist. 1995.01.01.088G

Michael Hosaluk, Canada. *Mach IV*, 1986. Colorcore, anodized aluminum, glass, lacquered maple. 24 x Dia. 18 ½". 1995.01.01.089P. (see p. 208)

Michael Hosaluk, Canada. *Tri-Cone*, 1985. Lacquered maple. 5 ½ x 11 x 11". Donated by the Artist. 1995.01.01.090G

C.R. (Skip) Johnson, United States. *The Itinerant Turner's Toolbox*, 1981. Mahogany, basswood, walnut, padauk, honey locust. 42 ⅜ x 26 x 7 ¾". Donated by the Artist. 1995.01.01.103G. (plate 84)

OBJ-83 | **Glenn Elvig**, United States | *Wait a Minute Dad*, 1989 | Lacquered mahogany, steel saw | 36 x 20 x 56" | Donated by the Artist | 1995.01.01.054G

OBJ-113 | **Quelle Est Belle Co.**, France | *Bird Whistles*, ca. 1990 | Wood. L 3–4 ½" | Donated by Hans Joachim Weissflog | 1995.01.01.060a–IG

OBJ-114 | **Werkstatt Leichsenring**, Germany | *Flower Turnings*, 1989 | Wood | 3 ½ x 9 x 6" | 1995.01.01.061.01–.09P

OBJ-125

C.R. (Skip) Johnson, United States. *Floor Walker*, 1988. Cherry. 29 x Dia. 21 ¾". 1995.01.01.104P

OBJ-126

C.R. (Skip) Johnson, United States. *Spud, the Potato Peeler's Stool*, 1987. Walnut, leather. 27 ½ x 15 ½ x 15 ½". 1995.01.01.105P. (see p. 209)

OBJ-127

Don Kelly, United States. *Horizon Bowl*, 1988. Maple, aluminum base. 13 x 48 x 3 ¼". 1995.01.01.112P

OBJ-128

Frank Knox, United States. *Candlesticks*, 1987. Lignum vitae, blackwood, ivory. 11 ¼ x Dia. 5" each. 1995.01.01.118a–bP

OBJ-129

Michael Korhun, United States. *Plate*, 1992. Paduak, silver. 1 x Dia. 17". Donated by Dr.Irving Lipton & Artist. 1995.01.01.120G

OBJ-130

R.W. Bob Krauss, United States. *Lidded Vessel*, 1988. Spalted Tiger-striped myrtle. 6 ½ x Dia. 6 ½". Donated by the Artist. 1995.01.01.121G

OBJ-131

R.W. Bob Krauss, United States. *Lidded Vessel*, 1988. Spalted Tiger-striped myrtle. 7 x Dia. 6 ¼". Donated by Charles Aberle. 1995.01.01.122G

OBJ-132

Max Krimmel, United States. *Magahomapleny, Bowl #46*, ca. 1987. Mahogany, maple, imbuya. 2 ½ x Dia. 24". Donated by the Artist. 1995.01.01.123G

OBJ-133

Stoney Lamar, United States. *Reflections at Dusk*, 1989. Box elder. 12 ½ x 14 ½ x 11". Donated by Robyn & John Horn. 1995.01.01.127G

OBJ-134

Melvin Lindquist, United States. *Vessel*, 1980. Maple. 4 ¹¹⁄₁₆ x Dia. 3". Donated by Rick & Ruth Snyderman. 1995.01.01.133G

OBJ-135

Melvin Lindquist, United States. *Hopi Cherry Burl Bowl*, 1985. Cherry burl. 12 ¾ x Dia. 8 ¼". Donated by Ron Wornick. 1995.01.01.135G

OBJ-136

Mark Lindquist, United States. *Spalted Maple Bowl, carved foot*, 1977. Spalted maple burl 4 ½ x Dia. 10". Donated by Arthur & Jane Mason. 1995.01.01.136G. (plate 20)

OBJ-137

Jack Mankiewicz, Germany. *Fountain Pens*, 1987. Snakewood, ebony burr, oak. 5 ½" each. 1995.01.01.139.01–04P

OBJ-138

Jack Mankiewicz, Germany. *Fountain Pen*, 1987. Snakewood, ebony. 5 ½ x Dia. ½". 1995.01.01.140P

OBJ-139

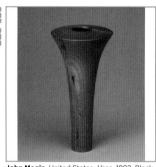

John Megin, United States. *Vase*, 1982. Black walnut. 6 ¾ x Dia. 3 ⅜". Donated by Arthur & Mary Megin. 1995.01.01.143G

OBJ-140

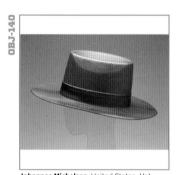

Johannes Michelsen, United States. *Hat*, 1990. Cherry. 5 x Dia. 15". Donated by the Artist. 1995.01.01.148G

OBJ-141

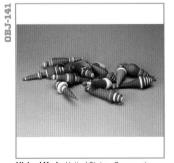

Michael Mode, United States. *Ornaments*, ca. 1988. Poplar, paint. 5 ½ x Dia. 1 ½" each. Donated by the Artist. 1995.01.01.153.01–.13G

OBJ-142

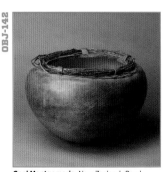

Gael Montgomerie, New Zealand. *Bowl*, 1990. Maple, paint. 7 ½ x Dia. 11 ½". 1995.01.01.157P

OBJ-143

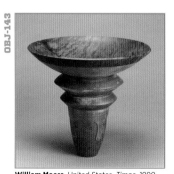

William Moore, United States. *Timna*, 1990. Madrome burl, copper. 10 x Dia. 11". 1995.01.01.158P. (plate 41)

OBJ-144

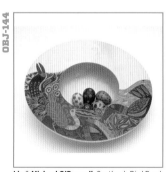

Liz & **Michael O'Donnell**, Scotland. *Bird Bowl*, 1989. European beech, oil paints. 2 ½ x Dia. 9 ½". Donated by the Artists. 1995.01.01.160G

OBJ-145

David Pye, United Kingdom. *Dish*, ca. 1980. Ash. 2 x Dia. 15 ½". 1995.01.01.181P

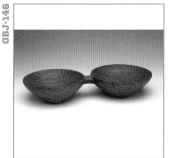

OBJ-146

David Pye, United Kingdom. *Bowl*, ca. 1980. Walnut. 3 x 16 ½ x 7 ¾". 1995.01.01.182P

OBJ-147

David Pye, United Kingdom. *Lidded Container*, ca. 1980. Rosewood. 3 ¾ x Dia. 2 ¼". 1995.01.01.184P

OBJ-148

David Pye, United Kingdom. *Study in Flower Form*, ca. 1980. Wood. 6 ⅜ x 7 x 3". 1995.01.01.185.01P. (plate 86)

OBJ-149

David Pye, United Kingdom. *Study in Flower Form*, ca. 1980. Wood. 5 ½ x 4 x 2 ½". 1995.01.01.185.02P. (plate 87)

OBJ-150

David Pye, United Kingdom. *Lidded Container*, ca. 1980. Wood. 2 ½ x Dia. 2 ⅜". 1995.01.01.186P

OBJ-151

David Pye, United Kingdom. *Threaded Lidded Container*, ca. 1980. Blackwood, unidentified wood. 7 ½ x Dia. ⅞". 1995.01.01.187P

OBJ-152

David Pye, United Kingdom. *Lidded Container*, ca. 1980. Rosewood. 4 ⅞ x Dia. 3 ⅛". 1995.01.01.189P

OBJ-153

David Pye, United Kingdom. *Threaded Lidded Needle Container*, ca. 1980. Rosewood. 5 x Dia. 1 ¼". 1995.01.01.190P

OBJ-154

David Pye, United Kingdom. *Threaded Lidded Container*, ca. 1980. Rosewood. 3 x Dia. 1 ¼". 1995.01.01.191P

OBJ-155

David Pye, United Kingdom. *Bowl*, ca. 1980. Walnut. 2 ½ x 15 x 8 ¾". 1995.01.01.193P. (plate 8)

OBJ-156

David Pye, United Kingdom. *Bowl*, ca. 1980. Walnut. 2 ½ x 15 x 8 ¾". 1995.01.01.194P

OBJ-157

Allen Ritzman, United States. *Walnut Vase*, 1987. Walnut. 15 x 6 ¼". Donated by the Artist. 1995.01.01.198G

OBJ-158

Hap Sakwa, United States. *Malibu*, 2/50, 1986. Poplar, acrylics, acrylic lacquer. 4 ½ x Dia. 15". 1995.01.01.200P

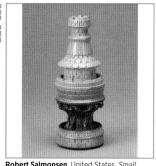

OBJ-159

Robert Salmonsen, United States. *Small Castle*, ca. 1988. Apple. 5 x 2 x 2". Donated by the Artist. 1995.01.01.204G

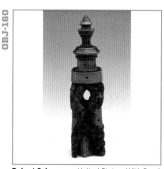

OBJ-160

Robert Salmonsen, United States. *With Pearl Tower*, 1987. Poplar, paint. 9 x 2 ½ x 2 ½". 1995.01.01.208P

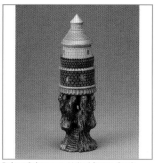

OBJ-161

Robert Salmonsen, United States. *Castle*, 1989. Carved, painted apple. 6 ½ x 2 x 2". Donated by the Artist. 1995.01.01.206G

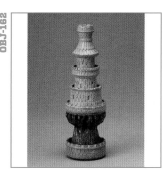

OBJ-162

Robert Salmonsen, United States. *Castle*, 1989. Carved, painted apple. 6 ½ x 2 x 2". Donated by the Artist. 1995.01.01.207G

OBJ-163

Robert Salmonsen, United States. *Red Star Hold*, 1988. Apple. 11 x 2 ¾ x 2 ¾". 1995.01.01.205P

OBJ-164

Robert Salmonsen, United States. *Castle*, ca. 1988. Wood. 9 ½ x Dia. 2". Donated by the Artist. 1995.01.01.209G

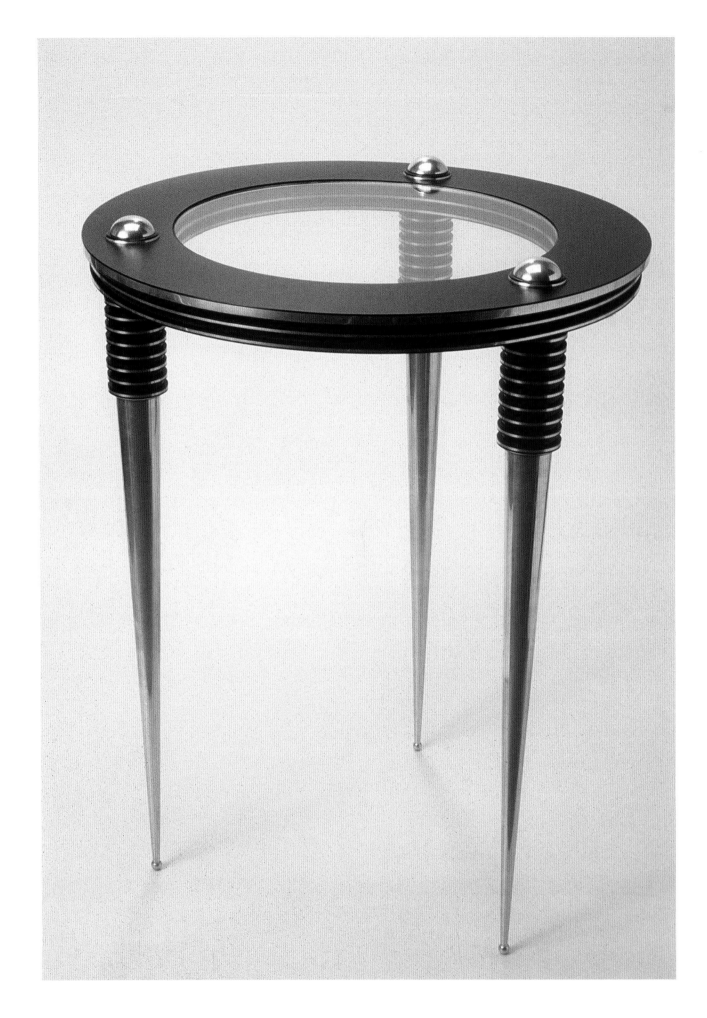

OBJ-122 | **Michael Hosaluk**, Canada | *Mach IV*, 1986 | Colorcore, anodized aluminum, glass, lacquered maple | 24 x Dia. 18 ½″ | 1995.01.01.089P

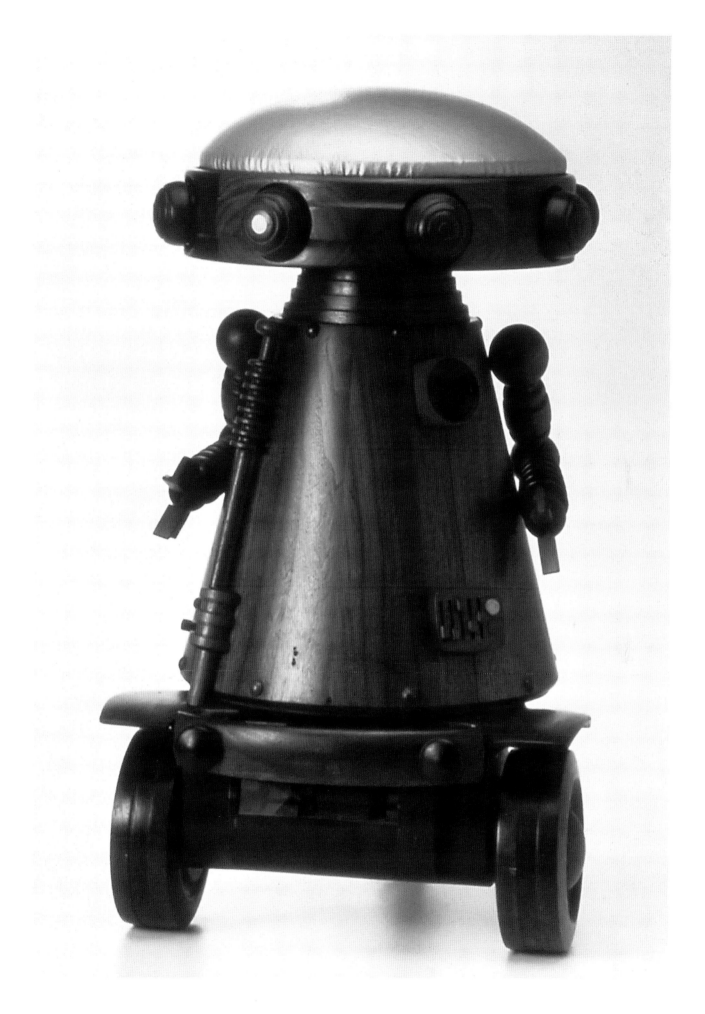

OBJ-126 | **C.R. (Skip) Johnson**, United States | *Spud, the Potato Peeler's Stool*, 1987 | Walnut, leather | 27 ½ x 15 ½ x 15 ½" | 1995.01.01.105P

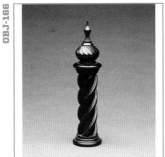

Jon Sauer, United States. *Box*, 1990. Blackwood, bisselon. 6 ½ x 1 ⅜". Donated by the Artist. 1995.01.01.210G

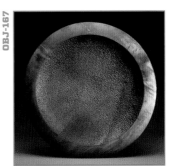

Jon Sauer, United States. *Blackwood Container*, 1993. Blackwood. 5 ¼ x Dia. 1 ½". Donated by the Artist. 1995.01.01.211G

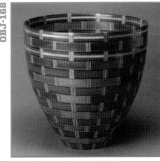

Merryll Saylan, United States. *North Seas*, 1988. Maple, fiber-reactive dye, tung oil finish. 2 ¼ x Dia. 20 ½". 1995.01.01.212P. (plate 58)

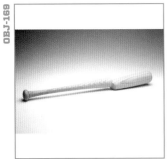

Lincoln Seitzman, United States. *Petrified Basket*, 1987. Various hardwoods. 14 x Dia. 14". Donated by the Artist. 1995.01.01.216G. (plate 18)

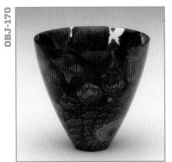

Mark Sfirri, United States. *Bat*, 1994. Ash. 28 ½ x 3". Donated by the Artist. 1995.01.01.218G

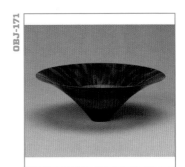

Michael Shuler, United States. *Pine Cone Bowl*, 1989. Pine cone. 2 ½ x Dia. 2 ⅜". 1995.01.01.224P

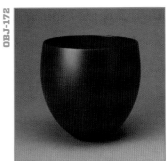

Michael Shuler, United States. *Bowl*, 1989. Brazilian rosewood. 1 ⅝ x Dia. 4 ¾". Donated by the Artist. 1995.01.01.225G

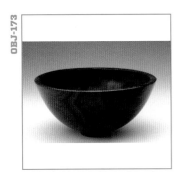

Bob Stocksdale, United States. *Snakewood Bowl*, 1988. Snakewood. 5 ½ x Dia. 6". Donated by Charles Aberle. 1995.01.01.231G

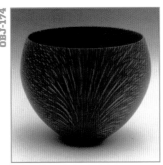

Bob Stocksdale, United States. *Putumuju Wood Bowl*, 1985. Putumuju wood. 3 ¾ x Dia. 8". 1995.01.01.232P

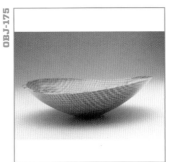

Bob Stocksdale, United States. *Macadamia Wood Bowl*, 1986. Macadamia wood. 3 ¼ x Dia. 4 ⅜". 1995.01.01.236P

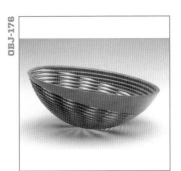

Bob Stocksdale, United States. *Ash Wood Bowl*, 1987. Curly ash. 3 x 11 x 9 ⅝". 1995.01.01.237P

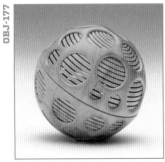

Hans Joachim Weissflog, Germany. *Bowl Turned Broken Through Spider Bowl*, 1994. Yew wood. Dia. 8". Donated by the Artist. 1995.01.01.273G

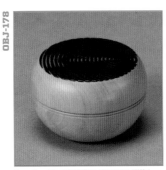

Hans Joachim Weissflog, Germany. *Ball-Box, Turned Broken Through With Windows*, 1992. Basswood. Dia. 2". Donated by Dr. Irving Lipton. 1995.01.01.274G

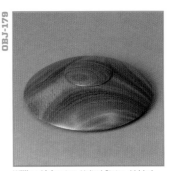

Hans Joachim Weissflog, Germany. *Eiffel Tower Box*, 1992. Basswood, ebony. 1 ½ x Dia. 2". Donated by Dr. Irving Lipton. 1995.01.01.275G

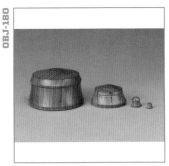

William Livingston, United States. *Lidded Vessel*, 1990. Vera. Dia. 5 ½". Donated by the Artist. 1995.01.01.278G

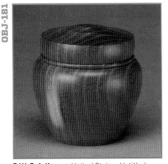

Del Stubbs, United States. *Containers Within Containers*, ca. 1980. Wood. Dia. ¼–2 ½". Donated by the Artist. 1995.01.01.281.a–dG

R.W. Bob Krauss, United States. *Untitled*, 1984. Osage orange. 3 x Dia. 3". Donated by the Artist. 1995.01.01.284G

Ray Key, United Kingdom. *Box*, ca. 1990. Blackwood. 2 x Dia. 1 ½". Donated by the Artist. 1995.01.01.285G

Del Stubbs, United States. *Box*, 1982. Mistletoe, walnut, spalted sycamore. 2 ½ x Dia. 3 ¾". Donated by the Artist. 1995.01.01.286G

Thomas Nicosia, United States. *Vase*, ca. 1970. Various woods. 21 x 8 ¼ x Dia. 10". Donated by Neil & Susan Kaye. 1995.01.01.287.01G. (see p. 218)

OBJ-185

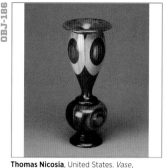

Thomas Nicosia, United States. *Vase*, ca. 1970. Various woods. 8 ¼ x 7 ½ x 6 ¼". Donated by Neil & Susan Kaye. 1995.01.01.287.02G

OBJ-186

Thomas Nicosia, United States. *Vase*, ca. 1970. Various woods. 8 ¾ x Dia. 3 ½". Donated by Neil & Susan Kaye. 1995.01.01.287.03G

OBJ-187

Thomas Nicosia, United States. *Miniature Vase*, ca. 1970. Various woods. 1 ⅛ x Dia. 1". Donated by the Artist. 1995.01.01.287.04G

OBJ-188

Rude Osolnik, United States. *Untitled*, ca. 1980. Buckeye. 1 ¾ x Dia. 2 ½". Donated by the Artist. 1995.01.01.288G

OBJ-189

Ed Moulthrop, United States. *Untitled*, 1978. Wood. 3 ½ x Dia. 7 ¼". Donated by the Artist. 1995.01.01.289G

OBJ-190

John Diamond-Nigh, United States. *Untitled*, ca. 1985. Birch. 5 ¼ x 8 ⅞ x 7". 1995.01.01.290P

OBJ-191

Ray Huskey, United States. *Fruit (Pear)*, ca. 1980. Wood. 3 ¼ x Dia. 2". Donated by the Artist. 1995.01.01.291.01G

OBJ-192

Ray Huskey, United States. *Fruit (Apple)*, ca. 1980. Wood. 3 x Dia. 2". Donated by the Artist. 1995.01.01.291.02G

OBJ-193

Unknown Artist, United States. *Cylindrical Candlesticks with Spherical Bases*, ca. 20th Century. Wood. 6 ⅞ x 4 ½ x 4". 1995.01.01.292a-bP. (plate 95)

OBJ-194

Unknown Artist, United States. *Cylindrical Candlesticks with Spherical Bases*, ca. 20th Century. Wood. 6 ⅞ x 4 ½ x 4". 1995.01.01.293a-bP

OBJ-195

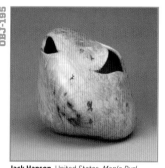

Jack Hanson, United States. *Maple Burl Vessel*, 1990. Maple burl. 7 x 9 x 7". Donated by the Artist. 1995.01.01.294G

OBJ-196

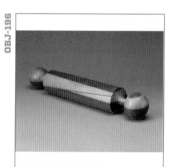

Rude Osolnik, United States. *Rolling Pin*, ca. 1970's. Wood. 16 x Dia. 2 1/2". Donated by the Artist. 1995.01.01.295.01G

OBJ-197

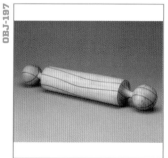

Rude Osolnik, United States. *Rolling Pin*, ca. 1970's. Maple, walnut. 15 ½ x Dia. 2 ½". Donated by the Artist. 1995.01.01.295.02G

OBJ-198

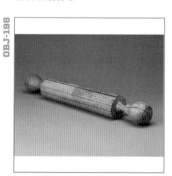

Rude Osolnik, United States. *Rolling Pin*, ca. 1970's. Plywood, cherry, walnut. 18 ¼ x Dia. 2 ½". Donated by the Artist. 1995.01.01.295.03G

OBJ-199

Unknown Artist, United States. *Rolling Pin, Relief Patterened (spiral) Roller*, ca. 20th Century. Wood. 18 ½ x Dia. 2 ½". 1995.01.01.296P

OBJ-200

Unknown Artist, United States. *Rolling Pin*, ca. 20th Century. Wood, paint. 17 ½ x Dia. 2 ½". 1995.01.01.297P

OBJ-201

Unknown Artist, United States. *Cookie Cutter Rolling Pin*, ca. 20th Century. Wood. 15 ¾ x Dia. 2 ⅛". 1995.01.01.298P

OBJ-202

K.S. *Shaker Style Rolling Pin with Handle*, ca. 20th Century. Wood. 6 x 12 ½". 1995.01.01.299a-bP

OBJ-203

Frank Knox, United States. *Lidded Vessel*, 1987. DuPont Corian. 5 ½ x Dia. 3 ¾". Donated by the Artist. 1995.01.01.300G

OBJ-204

Unknown Artist, Egypt. *Egyptian Figure*, ca. 1980. Wood, paint. 9 ⅝ x Dia. 1 ¼". 1995.01.01.301a-bP

OBJ-205

Unknown Artist, Russia. *Russian Birch Box*, ca. 1987. Birch. 3 ¾ x Dia. 4 ½". Donated by Del Stubbs. 1995.01.01.302G

OBJ-206

Unknown Artist, Romania. *Bird Sculpture*, ca. 1995. Wood. 3 ½ x 6 x 5". 1995.01.01.303

OBJ-207

Don Kelly, United States. *Vessel*, 1980. Cherry burl. 5 x Dia. 3 ¾". Donated by Don Kelly. 1995.01.01.304.01G

OBJ-208

Paul Eshelman, United States. *Salad Spoons*, ca. 1975. Cherry. 15 x 2 ¼" each. Donated by the artist. 1995.01.01.305a–bG

OBJ-209

Palmer Sharpless, United States. *Ornament*, ca. 1990. Wood. 4 x Dia. 2 ¾". Donated by the Artist. 1995.01.01.307G

OBJ-210

Unknown Artist, Australia. *Lidded Container*, ca. 1940. Mulga. 5 x Dia. 2 ⅞". Donated by Terry Martin. 1995.01.01.308G

OBJ-211

Michael Korhun, United States. *Lidded Container*, 1993. Wood. 2 ¼ x Dia. 6 ½". Donated by the Artist. 1995.01.01.309G

OBJ-212

Jack Hanson & **Herbert Harbor**, United States. *Thimble*, ca. 1984. Ivory. 1 x Dia. ¾". 1995.01.01.311.01P

OBJ-213

Unknown Artist, United States. *Thimble*, ca. 20th Century. Wood. 1 ⅛ x Dia. ⅝". 1995.01.01.311.02P

OBJ-214

Unknown Artist, United States. *Thimble*, ca. 20th Century. Wood. 1 x Dia. ¾". 1995.01.01.311.03P

OBJ-215

Unknown Artist, United States. *Container*, ca. 1980. Plastic. 1 ⅛ x Dia. ½". 1995.01.01.311.04P

OBJ-216

Unknown Artist, United States. *Miniature Gavel*, ca. 20th Century. Wood. 2 ⅛ x ¾". 1995.01.01.311.05P

OBJ-217

Jay Weber, United States. *Wing Nut with Screw*, 1987. Cherry. 4 ½ x 4 ¼ x 2". Donated by the Artist. 1995.01.01.312.01G

OBJ-218

Jay Weber, United States. *Bolt with Nut*, 1987. Wood. 3 ¾ x Dia. 1". Donated by the Artist. 1995.01.01.312.02G

OBJ-219

Jay Weber, United States. *Bolt with Nut*, ca. 1990. Cherry. 3 ½ x Dia. 1 ½". Donated by the Artist. 1995.01.01.312.03G

OBJ-220

Jay Weber, United States. *Bolt with Nut*, ca. 1990. Maple. 3 ⅞ x Dia. 1". Donated by the Artist. 1995.01.01.312.04G

OBJ-221

Jay Weber, United States. *Bell Ornament*, ca. 1990. Cherry. 2 ½ x Dia. 2". Donated by the Artist. 1995.01.01.312.05G

OBJ-222

Jay Weber, United States. *Spinning Top*, ca. 1990. Maple. 5 ½ x 6 ¾ x 2 ¾". Donated by the Artist. 1995.01.01.312.06G

OBJ-223

Kay Bojesen, Denmark. *Toy Elephant*, ca. 1980. Oak. 5 ½ x 6 ½ x 3". 1995.01.01.313.01P

OBJ-224

Kay Bojesen, Denmark. *Toy Monkey*, ca. 1980. Teak, limba. 7 x 6 ¼ x 2". 1995.01.01.313.02–.03P

OBJ-225

Kay Bojesen, Denmark. *Toy Bear*, ca. 1980. Oak, maple. 5 x 3 x 1 ½". 1995.01.01.313.04P

OBJ-226

Dave Hardy, **Mark Krick**, **Ken Wurtzel**, United States. *Paper Weight*, ca. 1993. Plexiglas. ⅞ x Dia. 1 ¾". Donated by the Artists. 1995.01.01.314G

OBJ-227

Ray Key, United Kingdom. *Lidded Container*, ca. 1990. Indian ebony. 1 ⅝ x Dia. 1 ¼". Donated by the Artist. 1995.01.01.315.01G

OBJ-228

Ray Key, United Kingdom. *Lidded Container*, ca. 1990. Wood. 2 ½ x Dia. ⅞". Donated by the Artist. 1995.01.01.315.02G

OBJ-229

Unknown East German Artist. *Nesting Dolls*, ca. 20th Century. Wood, paint. ¾–4 ¾ x Dia. ½–1 ¾". 1995.01.01.316a–dP

OBJ-230

Unknown Artist, United States. *Toy Gymnasts*, ca. 1970. Wood, paint. 6 x 8 x 1 ½". 1995.01.01.317P

OBJ-231

Unknown Artist, China. *Toy Figure*, ca. 1980. Wood, paint. 5 ¼ x Dia. 1 ¼". 1995.01.01.318.01P

OBJ-232

Unknown Artist, China. *Toy Figure*, ca. 1980. Wood, paint. 5 x Dia. 1 ¼". 1995.01.01.318.02P

OBJ-233

Unknown Artist, China. *Toy Figure*, ca. 1980. Wood, paint. 4 ¾ x Dia. 1 ¼". 1995.01.01.318.03P

OBJ-234

Unknown Artist, China. *Toy Figure*, ca. 1980. Wood, paint. 5 ¼ x Dia. 1 ¼". 1995.01.01.318.04P

OBJ-235

Unknown Artist, China. *Toy Thermometer*, ca. 1980. Wood, paint. 4 ¼ x 4 ½ x 2". 1995.01.01.319P

OBJ-236

Unknown Artist, Russia. *Nesting Dolls*, ca. 20th Century. Wood, paint. ¾–4 ¼ x Dia. ¼–1 ¾". 1995.01.01.320a–fP

OBJ-237

Unknown Artist, China. *Nesting Doll*, ca. 20th Century. Wood, paint. 1 ¾–7 x Dia. ¾–2 ¼". 1995.01.01.321a–dP

OBJ-238

Unknown Artist, Germany. *Tree*, ca. 1990. Wood. 5 x Dia. 1 ¾". 1995.01.01.322P

OBJ-239

Unknown Artist, Germany. *Flower Turning Process*, ca. 1990. Wood. Dia. ½–2". 1995.01.01.323.01–.09P

OBJ-240

Unknown Artist, Germany. *Figures*, 1990. Wood, paint. 3 ½–4". 1995.01.01.324.01–.02P

OBJ-241

Jay Weber, United States. *Candles*, ca. 1990. Cherry, walnut. 11 ¼ x Dia. ¾" each. Donated by the Artist. 1995.01.01.325.01–.02G

OBJ-242

Jay Weber, United States. *Bud Vase*, 1994. Cherry. 8 x Dia. 2" each. Donated by the Artist. 1995.01.01.325.03G

OBJ-243

Jay Weber, United States. *Love Cup*, 1995. Cherry. 5 x Dia. 2 ¾". Donated by the Artist. 1995.01.01.325.04G

OBJ-244

Jay Weber, United States. *Lidded Container*, 1993. Cherry. 5 ¼ x Dia. 3 ⅜". Donated by the Artist. 1995.01.01.325.05G

Jay Weber, United States. *Football Pencil Holder*, 1995. Cherry. 3 ½ x Dia. 4". Donated by the Artist. 1995.01.01.325.06G

Jay Weber, United States. *Baseball Pencil Holder*, 1995. Cherry. 4 x Dia. 3". Donated by the Artist. 1995.01.01.325.07G

Jay Weber, United States. *Toothpick Holder*, 1995. Cherry. 4 ¾ x Dia. 2 ½". Donated by the Artist. 1995.01.01.325.08G

Jay Weber, United States. *Vase*, 1981. Bubinga. 4 ¾ x Dia. 2 ¼". Donated by Albert LeCoff. 1995.01.01.325.09G

Jay Weber, United States. *Vase*, 1995. Cherry. 3 ⅞ x Dia. 3 ⅛". Donated by the Artist. 1995.01.01.325.10G

Jay Weber, United States. *Miniature Wooden Bell*, ca. 1990. Cherry. 1 ¼ x Dia. ⅝". Donated by the Artist. 1995.01.01.325.11G

Jay Weber, United States. *Miniature Goblets*, 1981. Walnut. 1 ¼ x Dia. ⅜" each. Donated by the Artist. 1995.01.01.325.12a–bG

Jay Weber, United States. *Thimbles*, ca. 1990. Walnut, maple, cherry. 1 x Dia. ⅞" each. Donated by the Artist. 1995.01.01.325.13–.16G

Jay Weber, United States. *Nutcracker Serving Dish*, 1996. Cherry, metal. 6 x Dia. 9". Donated by the Artist. 1995.01.01.325.17G

Melvin Lindquist, United States. *Study in Off-Set Turning*, 1981. Poplar, paint. 1 ¼ x Dia. 9 ¼". Donated by Albert LeCoff. 1995.01.01.326G

Don Kelly, United States. *Bowl*, 1981. Poplar. 1 ½ x Dia. 9 ¼". Donated by Albert LeCoff. 1995.01.01.327G

Del Stubbs, United States. *Plate*, 1981. Poplar, paint. 1 ½ x Dia. 9". Donated by Albert LeCoff. 1995.01.01.328G

John Aebi, United States. *Plate*, 1981. Poplar, paint. 1 ½ x Dia. 9 ½". Donated by Albert LeCoff. 1995.01.01.329G

Jim Aebi, United States. *Sculpture*, 1981. Poplar. 10 x 6 ⅝ x 2". Donated by Albert LeCoff. 1995.01.01.330G

C.R. (Skip) Johnson, United States. *Straw Spit Trophy*, 1981. Poplar, paint. 15 x 4 x 3". Donated by Albert LeCoff. 1995.01.01.331G

Garth Graves, United States. *Cup*, 1981. Poplar, paint. 6 x Dia. 6 ½". Donated by Albert LeCoff. 1995.01.01.332G

"Blue" Hawkins, United States. *Plate*, 1981. Poplar, paint. 1 ¾ x Dia. 8 ¼". Donated by Albert LeCoff. 1995.01.01.333G

Jay Weber, United States. *Plate*, 1981. Poplar, paint. 1 ¾ x Dia. 9 ½". Donated by Albert LeCoff. 1995.01.01.334G

Robert Trout, United States. *Sculpture*, 1981 Poplar, paint. 1 ½ x 9 ½ x 9 ½". Donated by Albert LeCoff. 1995.01.01.335G

Unknown Artist, United States. *Sculpture*, 1981. Poplar, paint. 7 x Dia. 2". Donated by Albert LeCoff. 1995.01.01.336G

Giles Gilson, United States. *Untitled*, 1981. Burnt poplar, burnt bubinga, plastic containers. 5 ½ x Dia. 4 ¾" each. Donated by the Artist. 1995.01.01.348.01–.02G

Bob Trout, United States. *Vase*, 1981. Bubinga. 8 ¼ x Dia. 3". Donated by Albert LeCoff. 1995.01.01.337G

"Blue" Hawkins, United States. *Mortar and Pestle*, 1981. Bubinga. 6 ¾ x Dia. 2 ¾". Donated by Albert LeCoff. 1995.01.01.338G

Melvin Lindquist, United States. *Vase*, 1981. Bubinga. 5 x Dia. 3". Donated by the Artist. 1995.01.01.137G

Jack Hanson, United States. *Vessel*, 1981. Bubinga. 5 x Dia. 3". Donated by the Artist. 1995.01.01.279G

Jim Aebi, United States. *Goblet*, 1981. Bubinga. 7 x Dia. 2 ⅜". Donated by Albert LeCoff. 1995.01.01.339G

Garth Graves, United States. *Lidded Container*, 1981. Bubinga. 5 ¾ x Dia. 2 ¾". Donated by Albert LeCoff. 1995.01.01.340G

John Aebi, United States. *Vase*, 1981. Bubinga. 6 ½ x Dia. 3 ¼". Donated by Albert LeCoff. 1995.01.01.341G

Don Kelly, United States. *Vase*, 1981. Bubinga. 4 ¾ x Dia. 2 ⅞". Donated by Albert LeCoff. 1995.01.01.342G

Virginia Dotson, United States. *Vessel*, 1993. Purpleheart, holly, ebony. 3 ¾ x Dia. 3 ⅜". Donated by the Artist. 1995.01.01.344.01G

Pete Arenskov, United States. *Orbicular*, 1987. Ash, padauk, purple heart, walnut, poplar, birdseye maple, cedar, red oak. 4 x Dia. 16". Donated by the Artist. 1995.03.13.001G

Jim Hume, United States. *Tumble Pot*, 1994. Curly maple, cherry, ebony, aluminum. 7 ½ x Dia. 7 ¾". Donated by the Artist. 1995.03.01.001G

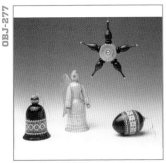

Michael Korhun, United States. *Christmas Tree Ornaments*, 1995. Box elder, beads. 4–6 ½". Donated by the Artist. 1995.03.01.006a–dG

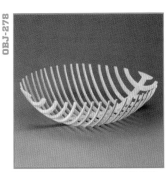

Dewey Garrett, United States. *LIM #3*, 1992. Maple (bleached). 4 x Dia. 12". Donated by the Artist. 1995.05.09.001G. (plate 25)

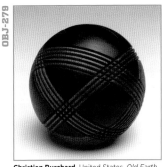

Christian Burchard, United States. *Old Earth Series: Black Walnut with black fields*, 1995. Black walnut, ink. 5 ½ x Dia. 5 ½". Donated by Dr. Irving Lipton. 1995.08.24.001G

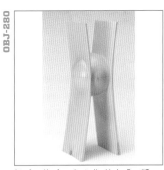

Stephen Hughes, Australia. *Vader Box #3*, 1995. Huon Pine. 15 ¼ x 5 ½ x 5". Donated by Dr. Irving Lipton. 1995.08.24.002G

Todd Hoyer, United States & **Bo Schmitt**, Australia. *Shapes of Things to Come*, 1995 ITE. Ash, paint. 16 x Dia. 16". Donated by the Artists. 1995.09.01.001G

Bo Schmitt, Australia. *From 'The Dark Heart,' Book 4, Chapter 7*, 1995 ITE. MDF, Corian, enamel, acrylic, heat-tempered bronze. 9 ¼ x Dia. 12 ¾". Donated by the Artist. 1995.09.01.003G. (plate 47)

Timothy Stokes, United Kingdom. *Double Cone/Sphere*, 1995 ITE. Black walnut. 14 ½ x Dia. 4 ½". Donated by the Artist. 1995.09.01.004G

Todd Hoyer & **Hayley Smith**, United States. *Untitled #1*, 1995 ITE. Ash. Dia. 16". Donated by the Artists. 1995.09.01.005G

OBJ-285

Al Francendese, United States. *Acer Quattro Aves- Container*, 1994. Various materials. 3 ⅞ x Dia. 2 ½". Donated by the Artist. 1995.09.01.007G

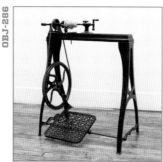

OBJ-286

Unknown Maker, United States. *Antique Childs Treadle Lathe*, ca. 20th Century. Metal. 32 x 27 ½ x 15". Donated by Margaret Stineman. 1995.09.01.008G

OBJ-287

Peter Kovacsy, Australia. *Emotions Series- Wood You Like Me To Seduce You"*, 1993. Shedak, fiber board, brass foil, lacquer. 3 x 12 ½ x 12 ½". Donated by the Artist. 1999.12.01.003G

1996
»

OBJ-288

Ron David, United States. *What to do with Albert's toothpicks if one has false teeth*, 1993. Maytree, turned Japanese toothpicks. 4 ½ x Dia. 9". Donated by the Artist. 1996.02.22.001G

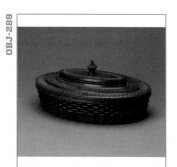

OBJ-289

Foster Giesmann, United States. *Oval Box*, 1994. Black walnut. 5 x 7 ⅝ x 4 ¾". Donated by the Artist. 1996.04.08.001.02G

OBJ-290

Foster Giesmann, United States. *Oval Box*, 1994. Black walnut. 4 x 9 ¼ x 6 ¼". Donated by the Artist. 1996.04.08.001.01G

OBJ-291

Vic Wood, Australia. *Bowl*, 1987. Red gum. 6 x 22 ½ x 14". Donated by the Artist. 1996.04.09.002G

OBJ-292

Unknown Artist, Russia. *Toy Tower*, ca. 1977. Wood, paint. 17 ¼ x Dia. 3". Donated by Albert & Tina LeCoff. 1996.04.09.003G

OBJ-293

Unknown Artist, Germany. *Nutcracker*, ca. 1977. Wood, paint. 14 ½ x 4 ¾ x 3 ½". Donated by Albert & Tina LeCoff. 1996.04.09.004G

OBJ-294

Norm Sartorius, United States. *Spoon*, 1995. Quilted honduras mahogany, rose of the mountain, ebony. 16 x 3 ½". Donated by Fleur Bresler. 1996.10.23.001G. (see p. 219)

OBJ-295

Jay Weber, United States. *Wing Nut With Screw*, 1993. Maple. 4 ⅝ x 4 ⅜". 1996.10.23.002P

OBJ-296

Michael Brolly, United States. *Dancing Tryclopes*, 1996 ITE. Curly maple, dyed veneer. 22 x 19 ½ x 18". Donated by the Artist. 1996.11.16.001G

OBJ-297

Terry Martin, Australia. *Vessel*, 1996 ITE. Maple burl. 9 x 14 ½". Donated by the Artist. 1996.11.16.003G

OBJ-298

Hugh McKay, United States. *Blue Rose*, 1996 ITE. Rosewood, glass. 9 x Dia. 10". Donated by the Artist. 1996.11.16.004G. (plate 42)

OBJ-299

Doug Finkel, United States. *Mallet*, 1996 ITE. Various woods. 9 x 5 ½ x 2 ¼". Donated by the Artist. 1996.11.16.005G

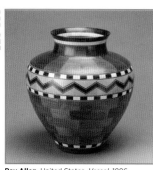

OBJ-300

Ray Allen, United States. *Vessel*, 1996. Walnut, wenge, citrus, bloodwood, dogwood, maple veneer, dyed veneer. 8 ¾ x Dia. 8". Donated by Dr. Irving Lipton. 1996.11.16.007G

OBJ-301

Jean-François Escoulen, France. *La Metamorphose*, 1996 ITE. Oak burl, chekanakot, ebony. 11 ½ x 6 x 19". Donated by the Artist. 1996.11.16.008.01G

OBJ-302

Jean-François Escoulen, France & **Mark Sfirri**, United States. *Hurdy-Gurdy*, 1996. Wood, paint. 17 x 4 ½ x 4 ½". Donated by the Artists. 1996.11.16.008.02G

OBJ-303

Giles Gilson, United States. *Holiday in Spring*, 1993. Wood, lacquer, paint, Corian. 13 x Dia. 5 ¼". Donated by Dr. Irving Lipton. 1996.11.16.009G

OBJ-304

Gord Peteran, Canada. *Untitled So Far*, 1996. Leather, wood, linen thread. 14 x 6 ½ x 7". Donated by Albert & Tina LeCoff. 1996.11.20.001G. (plate 85)

OBJ-305

Stoney Lamar, United States. *Torso Reclining*, 1987. Walnut. 26 x 19 x 4 ¾". Donated by Fleur Bresler. 1996.11.25.001G

1997

»

OBJ-306

Alan Neilson, New Zealand. *Sunburst*, 1993. Matai, dyed pine needles, silver. 3 x Dia. 23". Donated by the Artist. 1997.08.14.001G

OBJ-307

Dennis Mueller, United States. *Woman & Child, Man & Wife*, 1991. Claro walnut, quilted maple, sand, Corian. 21 ½ x 17 x 19 ¼". Donated by the Artist. 1997.08.14.002G

OBJ-308

Stephen Hogbin, Canada. *Buttoning Wood*, 1993. Chacahuante, fir, medium-density fiberboard, paint. 5 x 23 x 19". Donated by the artist & Fleur Bresler. 1997.08.14.003G

OBJ-309

John Jordan, United States. *Vessel*, 1996. Red maple. 13 ¾ x Dia. 7". Donated by Fleur Bresler. 1997.08.14.004G

OBJ-310

Christophe Nancey, France. *After my first and last concert*, 1997 ITE. Wood, wire, guitar. 19 ½ x 19 ½ x 15". Donated by the Artist. 1997.12.01.001G

OBJ-311

Christophe Nancey, France. *Changing of Universe*, 1997 ITE. Yew, manzanita, box tree, wire, red maple burl. 18 x 5 ¾". Donated by the Artist. 1997.12.01.002G

OBJ-312

Christophe Nancey, France. *Star's Eggs*, 1997 ITE. Textured Ash, black paint, gold, copper leaf. 9 ½ x 14 ½". Donated by the Artist. 1997.12.01.003G

OBJ-313

Andrew Gittoes, Australia. *Rocking Bowl*, 1997 ITE. Bleached oak, peruba. 7 x 16 x 10". Donated by the Artist. 1997.12.01.004G

OBJ-314

Merryll Saylan, United States. *Tea Set*, 1997 ITE. Box elder. 6 x Dia. 6". Donated by the Artist. 1997.12.01.005G. (plate 63)

OBJ-315

Mark Bishop, Australia. *Split Sphere II*, 1997 ITE. Wood, bleach, dye. 6 x 8". Donated by the Artist. 1997.12.01.006G

OBJ-316

Tony Boase, United Kingdom & **Christophe Nancey**, France. *Vessel*, 1997 ITE. Maple burl, pewter. 5 x 7". Donated by the Artists. 1997.12.01.007G

OBJ-317

Tony Boase, United Kingdom. *Bowl*, 1997 ITE. Ash, metal clamp. 4 x 15". Donated by the Artist. 1997.12.01.008G

OBJ-318

Zina Manesa-Burloiu, Romania. *Flask*, 1997 Pear. 6 ½ x 4 x 2 ¼". Donated by the Artist. 1997.12.15.001.01G

OBJ-319

Zina Manesa-Burloiu & **Nicolae Purcarco**, Romani. *Spoons*, 1997. Willow. ¾ x 11 ½ x 1 ¼" each. Donated by the Artists. 1997.12.15.001.02a–gG. (see p. 219)

OBJ-320

Nicolae Purcarco, Romania. *Bowl*, 1997. Basswood. 2 ½ x Dia. 3 ⅝". Donated by the Artist. 1997.12.15.001.03G

OBJ-321

Zina Manesa-Burloiu, Romania. *Nutcracker*, 1997. Pear. 11 x 1 ⅝ x 1". Donated by the Artist. 1997.12.15.001.04G

OBJ-322

Zina Manesa-Burloiu, Romania. *Cup*, 1997. Maple. 2 ¼ x 4 ¾ x 2 ⅛". Donated by the Artist. 1997.12.15.001.05aG

OBJ-184 | **Thomas Nicosia**, United States | *Vase*, ca. 1970 | Various woods | 21 x 8 ¼ x Dia. 10″ | Donated by Neil & Susan Kaye | 1995.01.01.287.01G

OBJ-294 | **Norm Sartorius**, United States | *Spoon*, 1995 | Quilted honduras mahogany, rose of the mountain, ebony | 16 x 3 ½" | Donated by Fleur Bresler | 1996.10.23.001G

OBJ-319 | **Zina Manesa-Burloiu** & **Nicolae Purcarco**, Romani | *Spoons*, 1997 | Willow | ¾ x 11 ½ x 1 ¼" each | Donated by the Artists | 1997.12.15.001.02a–gG

OBJ-323

Zina Manesa-Burloiu, Romania. *Cup*, 1997. Pear. 2 x 4 ¼ x 1 ¾". Donated by the Artist. 1997.12.15.001.05bG

OBJ-324

Zina Manesa-Burloiu, Romania. *Spoon Rack*, 1997. Maple. 11 x 10 x 2 ¾". Donated by the Artist. 1997.12.15.001.06aG

OBJ-325

Zina Manesa-Burloiu, Romania. *Spoon Rack*, 1997. Maple. 11 x 10 x 2 ¾". Donated by the Artist. 1997.12.15.001.06bG

OBJ-326

Zina Manesa-Burloiu & **Nicolae Purcarco**, Romania. *Crosses*, 1997. Maple. 12 x 2 ⅛ x 2 ⅛", 11 ¾ x 2 ¼ x 2 ⅛". Donated by the Artists. 1997.12.15.001.07a–bG

OBJ-327

Zina Manesa-Burloiu, Romania. *Secret Box*, 1997. Maple. 1 ¾ x 7 ¾ x 2". Donated by the Artist. 1997.12.15.001.08G

OBJ-328

Zina Manesa-Burloiu, Romania. *Salt and Pepper Holder* 1997. Maple. 4 ½ x 5 x 2 ⅛". Donated by the Artist. 1997.12.15.001.09G

OBJ-329

Zina Manesa-Burloiu & **Nicolae Purcarco**, Romania. *Sculptured Stand with Egg*, 1997. Pear, beads, wax. 5 x 4 ¾ x 3 ½". Donated by the Artists. 1997.12.15.001.10G

OBJ-330

Vic Wood, Australia. *Bowl*, 1987. Coastal banksia. 6 x 18 ½ x 18 ½". Donated by Dr. Irving Lipton. 1997.12.31.001G

OBJ-331

Pete Arenskov, United States. *Segmented and Lathe Turned Bowl Form*, 1992. Maple, macassar ebony. 6 x Dia. 12". Donated by Dr. Irving Lipton. 1997.12.31.004G

OBJ-332

Hap Sakwa, United States. *Aero Bolero*, 1985. Poplar, paint. 14 x Dia. 15". Donated by Dr. Irving Lipton. 1997.12.31.006G

OBJ-333

Michael N. Graham, United States. *Sculptural Coat Rack*, 1986. Wood, acrylic paints, metal. 9 ¼ x 7 ¼ x 9 ½". Donated by Dr. Irving Lipton. 1997.12.31.007G

OBJ-334

Michael Peterson, United States. *Bowl*, 1999. Camphor. 8 ¼ x 18 x 12 ½". Donated by Dr. Irving Lipton. 1997.12.31.008G

OBJ-335

Dennis Stewart, United States. *Wall Piece*, 1983. Punumbuco. Dia. 19 ½". Donated by Dr. Irving Lipton. 1997.12.31.009G

OBJ-336

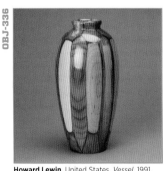

Howard Lewin, United States. *Vessel*, 1991. Dyed maple. 8 x Dia. 4". Donated by Dr. Irving Lipton. 1997.12.31.010G

OBJ-337

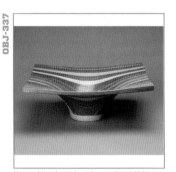

Howard Lewin, United States. *Bowl*, 1991. Dyed maple. 4 ¼ x 11 ½". Donated by Dr. Irving Lipton. 1997.12.31.019G

OBJ-338

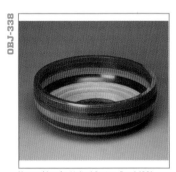

Howard Lewin, United States. *Bowl*, 1991. Dyed maple. 3 ¾ x Dia. 10 ¾". Donated by Dr. Irving Lipton. 1997.12.31.031G

OBJ-339

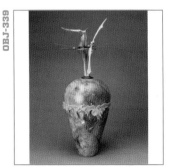

Dennis Stewart, United States. *Sculpture*, 1986. Myrtle burl, ebony, oak burl, mixed media. 20 x Dia. 7". Donated by Dr. Irving Lipton. 1997.12.31.012G

OBJ-340

Euclid Moore, United States. *Bowl*, 1990. Walnut, oak, maple, padauk, wenge. 9 ¼ x Dia. 14". Donated by Dr. Irving Lipton. 1997.12.31.014G.

OBJ-341

Euclid Moore, United States. *Bowl*, 1991. Oak, padauk, walnut. 9 ¼ x Dia. 14". Donated by Dr. Irving Lipton. 1997.12.31.015G

OBJ-342

William Hunter, United States. *Bowl*, 1983. Buckeye burl. 10 x Dia. 9 ½". Donated by Dr. Irving Lipton. 1997.12.31.016G

William Hunter, United States. *Smokey Silk*, 1986. Pink ivory wood. 5 ¼ x Dia. 8 ½". Donated by Dr. Irving Lipton. 1997.12.31.027G

William Patrick, United States. *Bowl*, C 1996. Zebra wood, paint. 5 ⅜ x Dia. 9 ½". Donated by Dr. Irving Lipton. 1997.12.31.017G

William Patrick, United States. *Bowl*, ca. 1996. Koa, acrylic paint. 3 ¾ x Dia. 10". Donated by Dr. Irving Lipton. 1997.12.31.018G

OBJ-343 / OBJ-344 / OBJ-345 / OBJ-346

Dennis Stewart, United States. *Vessel*, 1982. Rosewood, koa, maple, laminated birch. 11 ½ x Dia. 7 ¼". Donated by Dr. Irving Lipton. 1997.12.31.020G

Brenda Behrens, United States. *Bowl 15210*, 1997. Apricot. 4 ¼ x Dia. 7 ½". Donated by Dr. Irving Lipton. 1997.12.31.021G

Brenda Behrens, United States. *Bowl 15217*, ca. 1996. Carob. 6 ½ x Dia. 6 ¾". Donated by Dr. Irving Lipton. 1997.12.31.022G

Christian Burchard, United States. *Vessel*, 1992. Box elder. 8 ¼ x Dia. 5 ½". Donated by Dr. Irving Lipton. 1997.12.31.023G

Christian Burchard, United States. *Vessel*, 1991. Box elder. 10 ½ x Dia. 4". Donated by Dr. Irving Lipton. 1997.12.31.024G

Christian Burchard, United States. *Vessel*, 1991. Box elder. 7 ¾ x Dia. 6 ½". Donated by Dr. Irving Lipton. 1997.12.31.025G

Christian Burchard, United States. *Vessel*, 1992. Box elder. 6 ¼ x Dia. 6 ½". Donated by Dr. Irving Lipton. 1997.12.31.026G

Michael Mode, United States. *Candlestick*, 1988. Rosewood, maple. 9 x Dia. 4 ½". Donated by Dr. Irving Lipton. 1997.12.31.028G

Michael Mode, United States. *Container*, 1987. Spalted elm burl. 5 x Dia. 4 ¾". Donated by Dr. Irving Lipton. 1997.12.31.029G

Michael Mode, United States. *Container*, 1987. Spalted elm burl. 3 ⅜ x Dia. 4 ¼". Donated by Dr. Irving Lipton. 1997.12.31.030G

Frank E. Cummings, III, United States. *Vessel*, 1989. Chittum burl. 6 x 5 x Dia. 2 ¾". Donated by Dr. Irving Lipton. 1997.12.31.033G

Brenda Behrens, United States. *Platter*, ca. 1990. Myrtle burl, brass, turquoise. 1 ½ x Dia. 11 ⅜". Donated by Dr. Irving Lipton. 1997.12.31.036G

Albert Clarke, United States. *Platter*, ca. 1995. Fir, gold leaf. 2 ¼ x Dia. 17 ¼". Donated by Dr. Irving Lipton. 1997.12.31.037G

1998

»

Mark Bishop, Australia. *Split Sphere I*, 1997 ITE. Wood, bleach, dye. 6 x 8". Donated by the Artist. 1998.04.01.001G

Marissa Lopez, United States. *Mini Goblet*, 1997. Wood. 3 ½ x Dia. 2 ¼". Donated by the Artist. 1998.04.22.001G

Judith Valles, United States. *Mortar and Pestle*, 1997. Wood. 6 ¼ x Dia. 2 ½". Donated by the Artist. 1998.04.22.002G

Marilyn Rodriguez-Behrle, United States. *Jewelry Box*, 1997. Wood, paint. 5 ¾ x Dia. 3". Donated by the Artist. 1998.04.22.003.01G

Marilyn Rodriguez-Behrle, United States. *Spinning Top*, 1997. Wood, paint. 1 x Dia. 1 ½". Donated by the Artist. 1998.04.22.003.02G

Jamie Sapp, United States. *Lidded Container*, 1997. Wood. 3 ¼ x Dia. 2". Donated by the Artist. 1998.04.22.005G

Edwin Rodriguez, United States. *Bee-Box*, 1997. Wood. Dia. 2 ¾". Donated by the Artist. 1998.04.22.008G

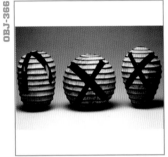

Todd Hoyer, United States. *X Series*, 1991. Cottonwood. 13–14 x Dia. 9–14". Donated by Fleur Bresler, Robyn & John Horn, Albert & Tina LeCoff, Arthur & Jane Mason, & Connie Mississippi. 1998.04.23.001a–cG. (plate 12)

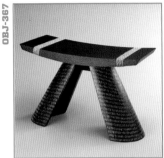

Doug Finkel, United States. *Source Bench*, 1998 ITE. Poplar, paint, rope. 17 ½ x 26 ¾ x 12". Donated by the Artist. 1998.08.31.001G

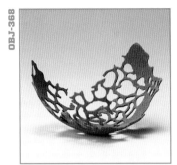

Daniel Guilloux, France. *Untitled*, 1998 ITE. Sycamore, paint. 3 x Dia. 4 ½". Donated by the Artist. 1998.08.31.002G. (plate 27)

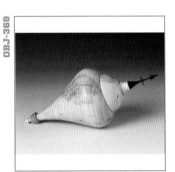

Fabrice Micha, France. *Oblique Box*, 1998 ITE Maple, ebony. 11 ½ x Dia. 4 ½". Donated by the Artist. 1998.08.31.003.01G

Fabrice Micha, France. *Sculpture*, ca. 1995. Ebony, maple. 9 ¾ x 6 ¼ x 3". Donated by the Artist. 1998.08.31.003.02G

Jack Slentz, United States. *Puzzle*, 1998 ITE Ash. 3 ¾ x Dia. 19 ½". Donated by the Artist. 1998.08.31.004G

Gael Montgomerie, New Zealand. *Tribute*, 1998 ITE. Elm, acrylic paint, metal leaf, patina, ink. 26 ½ x 8 x 7". Donated by the Artist. 1998.08.31.005G. (plate 100)

Alain Mailland & **Fabrice Micha**, France. *The Offering's Goddess*, 1998 ITE. Cherry, boxwood, cocobolo, blackwood, other exotic woods. 12 ½ x Dia. 11". Donated by the Artists. 1998.08.31.006G

Daniel Guilloux, France. *The Trilobyte Metamorphosis*, 1997. Sofora, boxwood, acacia, calabash, lime. 9 ¾ x 12 x 5 ½". Donated by the Artist. 1998.08.31.007G

Mark Bressler, United States. *Havdalah Box*, 1998. Cherry burl, ebony. 9 ½ x Dia. 5 ½". Donated by the Artist. 1998.09.01.001G

Daniel Guilloux, France. *Untitled*, 1998 ITE. Wood, paint, ink. 3 ½ x Dia. 4". Donated by the Artist. 1998.10.01.006G

Charles & **Tami Kegley**, United States. *Fire-eating Juggler*, 1998. Wood, paint. 23 x 12 x 4". Donated by the Artists. 1998.12.01.001G

Craig Nutt, David Holzapfel, Michelle Holzapfel, Mark Sfirri, Tom Ray, Tom Loeser, William Leete & **Bobby Hansson**, United States & **Jean-François Escoulen**, France. *Back in a Minute...Wait Here*, 1998. Wood, antler, clock, springs, leather. 62 x 24 x Dia. 12". Donated by Fleur Bresler. 1997.07.07.001G

«

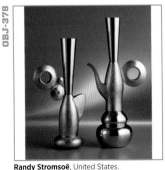

Randy Stromsoë, United States. *Pot à Créme et Cafetière*, 1996. Pewter. 13 ½–16 ½ x 6–8 x 4 ½". Donated by the Aritst. 1998.12.01.002a–bG. (see p. 224)

Norris White, United States. *Child's Lathe*, 1997. Wood. 34 x 37 ¼ x 11 ½". Donated by the Artist. 1998.12.01.003G

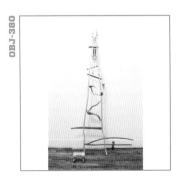
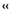

1999 »

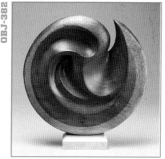

OBJ-381

Mark Sfirri, United States. *Glancing Figure (K)- Elvis*, 1997. English walnut. 33 x 8 x 8". Donated by the Artist. 1999.09.31.001G

OBJ-382

Betty J. Scarpino, United States. *Bittersweet*, 1999 ITE. Walnut. 16 x 2 ¾". Donated by the Artist. 1999.10.01.001G

OBJ-383

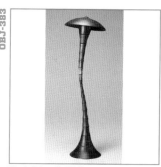

Dina L. Intorrella-Walker, United States. *Which Way To Grow*, 1999 ITE. Walnut, metal. 24 x 8". Donated by the Artist. 1999.10.01.002G

OBJ-384

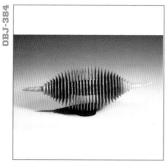

Henri Gröll, France. *Mille Feuille*, 1999 ITE. Maple. 21 ½ x 7". Donated by the Artist. 1999.10.01.003.01G

OBJ-385

Henri Gröll, France. *Quatre Fleures*, 1999 ITE. Black walnut. 13 ¾ x 4". Donated by the Artist. 1999.10.01.003.02G

OBJ-386

Rèmi Verchot, Australia. *Mobius*, 1999 ITE. Bleached walnut. 13 x 11 x 3". Donated by the Artist. 1999.10.01.004G

OBJ-387

Betty J. Scarpino, United States & **Rèmi Verchot**, Australia. *Sculpted Box*, 1999 ITE. Cherry. 2 x 3 ½ x 2 ½". Donated by the Artists. 1999.10.01.005G

OBJ-388

Terry Martin, Australia. *Redgum Cyclops*, 1999 ITE. Redgum. 8 x 3 ½". Donated by the Artist. 1999.10.01.006G

OBJ-389

Robert Ellsworth, United States. *Gavel—Loudspeaker series*, 1999. Maple. 9 ½ x 5 ¼". Donated by the Artist. 1999.10.01.007G

OBJ-390

Boris Bally, United States. *Rep Forms*, 1996. Reused traffic signs, aluminum. 22 x 9 x 9" each. Donated by the Artist. 1999.12.01.001G. (plate 51)

OBJ-391

William Leete, United States. *Pepper & Salt Mills*, 1996. Walnut, dye, maple, bleach, wax. 10 ½ x 4 ½ x 2 ½". Donated by the Artist. 1999.12.01.004G. (see p. 225)

OBJ-392

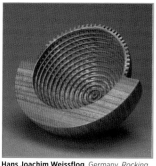

Hans Joachim Weissflog, Germany. *Rocking Bowl*, 1995. Pear. 3 ½ x 6 ¾ x 6". Donated by the Artist. 1999.12.01.005G

OBJ-393

Stephen Paulsen, United States. *Desert Winter on Marquard IV, and Twelve Sacred Objects Exposed by the Storm*, 1999. Various Materials. 15 ⅜ x 12 ⅜ x 2 ¼". Donated by Dr. Irving Lipton. 1999.12.02.002G

2000 »

OBJ-394

Richard Tuttle, United States. *Junk Can*, 1999. Oak, iron oxide, patinas. 5 x Dia. 2". Donated by Albert & Tina LeCoff. 2000.03.15.001G

OBJ-395

David Ellsworth, United States. *Salt, Pepper & Sugar Containers*, ca. 1978. Brazilian rosewood, padauk, walnut. 2 ¼ x Dia. 2 ¾", 2 ½ x Dia. 2 ¾", 1 ¾ x Dia. 5". Donated by Jesse LeCoff. 2000.08.23.001a–cG. (plate 65)

OBJ-396

Jason Marlow, Australia. *Desborough Helm*, 2000. Alder burl, copper, maple. 18 x 8 x 8". Donated by the Artist. 2000.12.01.001G

OBJ-397

David Sengel, United States. *Tea Cup*, 1996. Pearwood, black paint, thorns. 3 ¼ x Dia. 5 ¼". Donated by the Artist. 2000.12.30.001G. (plate 64)

OBJ-398

Mark Bishop, Australia. *Zig Zag Bowl 1 & 11 Black And White*, 1997 ITE. Sandblasted wood, bleach, dye, steel. 13 x 9 ½" each. Donated by the Artist. 2000.12.31.001G

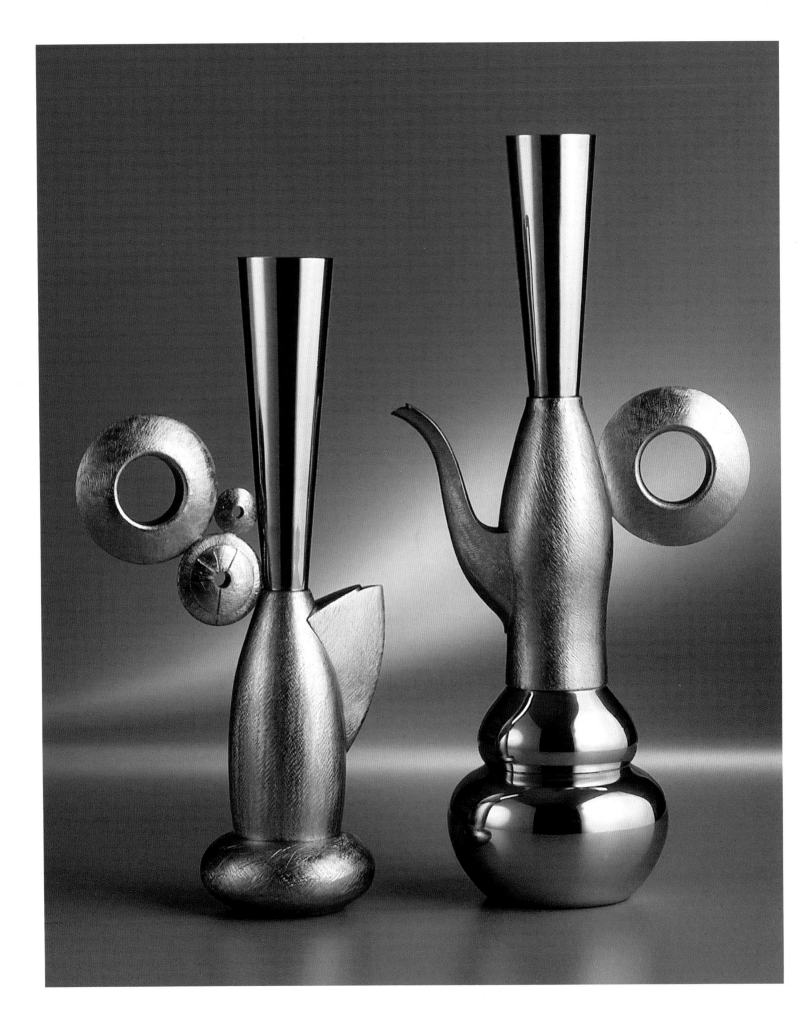

OBJ-378 | **Randy Stromsoë**, United States | *Pot à Créme et Cafetière*, 1996 | Pewter | 13 ½–16 ½ x 6–8 x 4 ½" | Donated by the Aritst | 1998.12.01.002a–bG

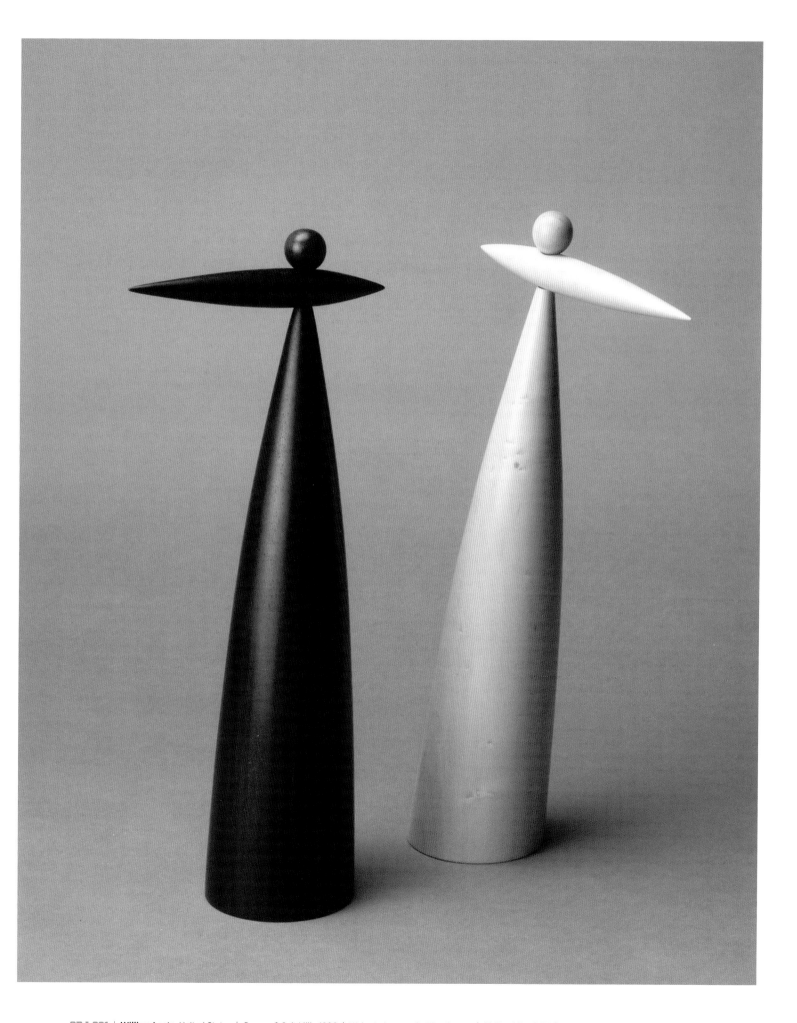

OBJ-391 | **William Leete**, United States | *Pepper & Salt Mills*, 1996 | Walnut, dye, maple, bleach, wax | 10 ½ x 4 ½ x 2 ½" | Donated by the Artist | 1999.12.01.004G

Graeme Priddle, New Zealand. *Missing Home*, 2000 ITE. Ebonized Ash. 14 ½ x 4 ½ x 5". Donated by the Artist. 2000.12.31.002G. (see p. 228)

Mike Scott, United States. *Ceremonial Vessel*, 2000 ITE. Walnut, elm, brass. 22 x Dia. 18". Donated by the Artist. 2000.12.31.003G

Mark Bishop, Australia. *Multi Layer Sphere I & II*, 1997 ITE. Wood, bleach, dye. Dia. 7" each. Donated by the Artist. 2000.12.31.004.01~.02G

Rolly Munro, New Zealand. *Oceanic Angel*, 2000 ITE. Walnut, pigments. 8 x 14". Donated by the Artist. 2000.12.31.005G

Rolly Munro, New Zealand. *Puhapuha*, 1999. Kauri wood, dye. 8 x Dia. 12". Donated by the Artist. 2000.12.31.006G

George Peterson, Canada. *Doorway, Doorway*, 2000 ITE. Charred maple. 34 x 34 x 6". Donated by the Artist. 2000.12.31.007G. (see p. 229)

Jack Larimore, United States. *Tree Turns Table*, 2000 ITE. Red oak, mixed exotic hardwoods, ash. 49 x 20 x 10". Donated by the Artist. 2001.05.01.001G

2001
»

Ted Hunter, Canada. *Once Upon a Sandbank*, 1985. Cherry. 30 x 40 x 64". Donated by the Artist. 2000.12.31.008G. (see p. 230)

Unknown Artist, United States. *Strainer*, ca. 20th Century. Metal. 9 ½ x Dia. 7 ½". Donated by Albert & Tina LeCoff. 2001.06.24.003G

Unknown Artist, United States. *Screw Drive*, ca. 20th Century. Wood, metal. 9 x Dia. 1". Donated by Albert & Tina LeCoff. 2001.06.24.005G

Unknown Artist, United States. *Potato Masher*, ca. 20th Century. Wood, metal. 10 ½ x 3 ¼ x 3 ¼". Donated by Albert & Tina LeCoff. 2001.06.24.006G

Unknown Artist, United States. *Clothes Pins*, ca. 20th Century. Wood. 4 x Dia. ¾" each. Donated by Albert & Tina LeCoff. 2001.06.24.007G

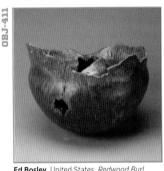

Ed Bosley, United States. *Redwood Burl Bowl*, 1989. Redwood burl. 11 x Dia. 13 ½". Donated by the Artist. 2001.12.01.001G

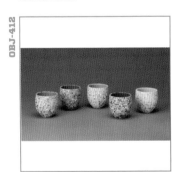

Ulrike Meyer, Germany. *Untitled*, 2001. Maple, milkpaint, acrylics. 2 ¾ x Dia. 2 ⅞" each. Donated by the Artist. 2001.12.01.002a–eG. (see p. 228)

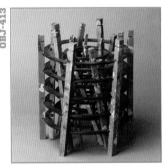

Dewey Garrett, United States. *Finding Resolve*, 2001. Oak, metalized acrylics, chemical patinas. 12 x Dia. 10". Donated by the Artist. 2001.12.01.003G. (plate 103)

Karl Decker, Germany. *Bowl*, 2001. Red and black palmira. ¾ x 11 x 11". Donated by the Artist. 2001.12.01.004G

David Fobes, United States. *Jugnete*, 2001. Wood, paint, brass, rope. 30 ½ x 11 ½". Donated by the Artist. 2001.12.01.005G

Mark Gardner, United States. *Shield*, 2001 ITE. Walnut, paint. 24 ½ x 16 x 4". Donated by the Artist. 2005.05.25.001G

Mark Gardner, United States & **Marc Ricourt**, France. *Shield*, 2001 ITE. Walnut, mahogany, ebony, bone, antler, linen, paint. 22 x 17 x 9". Donated by the Artists. 2005.04.25.003G

Louise Hibbert, Wales. *Spiral Box*, 2001 ITE. Sycamore, resin, ink, texture paste. 8 ½ x Dia. 2 ¾". Donated by the Artist. 2005.04.25.011G

Stuart King, United Kingdom. *Bee Token Pot*, 2001 ITE. Maple, sawdust, paint, ribbon, beads, pewter. 4 ½ x Dia. 5 ½". Donated by the Artist. 2002.07.13.004G

Marc Ricourt, France. *Vessel #12*, 2001 ITE. Ash, dye. 9 x Dia. 9". Donated by the Artist. 2002.07.13.006G

Jason Russell, Canada. *The Balance*, 2001 ITE. Mahogany, sterling silver, paper, dye. 20 x 17 ¾ x 3". Donated by the Artist. 2005.04.25.004G. (plate 2)

2002
»

Marc Ricourt, France. *Vessel #9*, 2001 ITE. Walnut, dye. 13 x Dia. 5 ¼". Donated by the Artist. 2002.07.13.005G

Bruce Mitchell, United States. *Bay Laurel Burl*, 1981. Bay Laurel Burl. 8 ¼ x 19 x 14". Donated by Albert & Tina LeCoff. 2002.07.14.001G

Mark Salwasser, United States. *Wood Bullets*, 1996. Multiple woods. 3 ½ x Dia. 13 ½". Donated by the Artist. 2002.09.10.002G

Gord Peteran, Canada. *Five Sounds*, 2002 ITE. Graphite on Paper. 36 x 27". Donated by the Artist. 2002.12.31.001aG. (plate 74)

Gord Peteran, Canada. *Five Sounds*, 2002 ITE. Graphite on Paper. 36 x 27". Donated by the Artist. 2002.12.31.001bG. (plate 75)

Gord Peteran, Canada. *Five Sounds*, 2002 ITE. Graphite on Paper. 36 x 27". Donated by the Artist. 2002.12.31.001cG. (plate 76)

Gord Peteran, Canada. *Five Sounds*, 2002 ITE. Graphite on Paper. 36 x 27". Donated by the Artist. 2002.12.31.001dG. (plate 77)

Gord Peteran, Canada. *Five Sounds*, 2002 ITE. Graphite on Paper. 36 x 27". Donated by the Artist. 2002.12.31.001eG. (plate 78)

Gord Peteran, Canada. *White Form*, 2002 ITE. Wood. 20 x Dia. 20". Donated by the Artist. 2002.12.31.006G

Gordon Ward, Australia. *Cornicopia*, 2002 ITE. Holly turned green. 4 ½ x 11 x 5". Donated by the Artist. 2002.12.31.007G

Laurent Guillot, France. *Origin*, 2002 ITE. Pear, gesso, milkpaint. 11 x 10 x 5". Donated by the Artist. 2002.12.31.008G

Rudiger Marquarding, Germany. *Display*, 2002 ITE. Ebony. 1 ¾ x 19 ¾ x 4". Donated by the Artist. 2002.12.31.009

Friedrich Kuhn, Germany. *Endangered Species #1*, 2002 ITE. Auracaria Root. 6 x Dia. 9 ½". Donated by the Artist. 2002.12.31.010

Robin Rice, United States; **Friedrich Kuhn**, Germany; **Gordon Ward**, Australia; with ebony dust courtesy of **Rudiger Marquarding**, Germany; & criticism by **Laurent Guillot**, France. *Nail Fetish for the ITE*, 2002 ITE. Ebony sawdust, acrylic/oil paints, nails, epoxy resin, varnish. 7 x 8 x 10". Donated by the Artists. 2005.04.28.001G

«

OBJ-399 | **Graeme Priddle**, New Zealand | *Missing Home*, 2000 ITE | Ebonized Ash | 14 ½ x 4 ½ x 5″ | Donated by the Artist | 2000.12.31.002G

OBJ-412 | **Ulrike Meyer**, Germany | *Untitled*, 2001 | Maple, milkpaint, acrylics | 2 ¾ x Dia. 2 ⅞″ each | Donated by the Artist | 2001.12.01.002a–eG

OBJ-404 | **George Peterson**, Canada | *Doorway, Doorway*, 2000 ITE | Charred maple. 34 x 34 x 6″ | Donated by the Artist | 2000.12.31.007G

OBJ-406 | **Ted Hunter**, Canada | *Once Upon a Sandbank*, 1985 | Cherry | 30 x 40 x 64″ | Donated by the Artist | 2000.12.31.008G

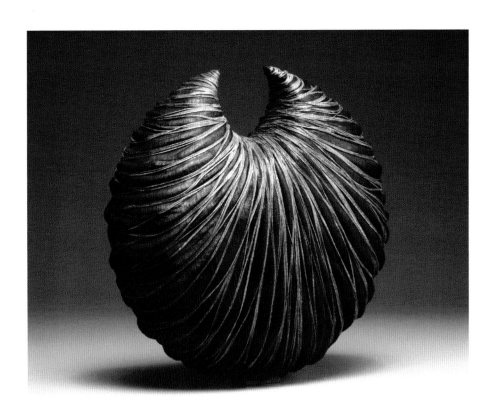

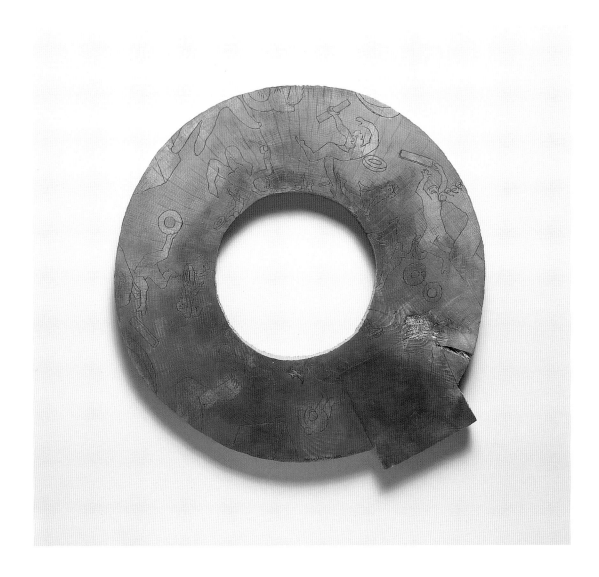

OBJ-442 | **Thierry Martenon**, France | *All Wrapped Up and No Place to Go*, 2003 ITE | Walnut, wax linen | 14 x 14 x 6" | Donated by the Artist | 2003.08.26.006G

OBJ-469 | **Marcus Tatton**, Australia | *Q*, 2004 ITE | Beech, oil pigments | 2 x Dia. 23" | Donated by the Artist | 2004.08.25.004G

2003

Eli Avisera, Israel. *Trembleur Box (with segment inlay)*, 2003. Wenge, maple, Corian base. 36 x Dia. 3". Donated by the Artist. 2003.08.26.001.01G

Eli Avisera, Israel. *Trembleur Box (with segment inlay)*, 2003. Purple heart, maple, Corian. 40 x Dia. 3". Donated by the Artist. 2003.08.26.001.02G

Eli Avisera, Israel. *Goblet Box (with segment inlay)*, 2002. Wenge, purple heart, maple, Corian base. 20 x Dia. 2 ½". Donated by the Artist. 2003.08.26.001.03G

Eli Avisera, Israel. *Nest*, 2003 ITE. Box Elder 11 x 18 x 16". Donated by the Artist. 2003.08.26.002G

Kevin Burrus, United States. *Sanding Disk*, 2003 ITE. Ash, Wood Turning Center brochures. 4 x Dia. 9 ¾". Donated by the Artist. 2003.08.26.004G. (plate 40)

Mark Hancock, United Kingdom. *Untitled*, 2003 ITE. Pear. 2 ⅜ x 3 ¼ x 6 ½". Donated by the Artist. 2003.08.26.005G

Thierry Martenon, France. *All Wrapped Up and No Place to Go*, 2003 ITE. Walnut, wax linen. 14 x 14 x 6". Donated by the Artist. 2003.08.26.006G. (see p. 231)

Jamie Russell, Canada. *Boat Bowl*, 2003 ITE. Walnut. 4 x 20 ½ x 4". Donated by the Artist. 2003.08.26.007G

Melvin Lindquist, United States. *Maple Bud Vase (L3-79)*, 1979. Maple. 3 ¼ x Dia. 2 ¼". Donated by Joe Seltzer. 2003.11.07.001G

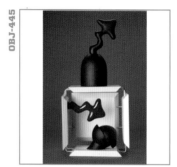

Connie Mississippi, United States. *"This moment is the perfect grape you crush to make your life-wine interesting" Rumi #201*, 2000. Wood, aluminum, paint. 18 x 9 x 9". Donated by the Artist. 2003.11.15.001G. (see p. 236)

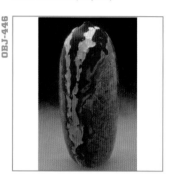

Robert Chatelain, United States. *Wrapt*, 1999. Big leaf burl, epoxy resin, powdered pigments, mica, gold leaf. 14 x 5". Donated by the Artist. 2003.11.15.002G

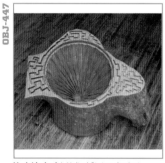

Mark Lindquist, United States. *Ancient Archaeological Captive*, 1992. Pecan, polychrome/verdigris. 27 x 43 ½ x 34". Donated by Gary & Suzette Rogers. 2003.11.15.003G

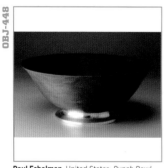

Paul Eshelman, United States. *Punch Bowl*, ca. 1955. Walunt, silver. 5 ½ x Dia. 14 ½". Donated by Victor & Helen Lenox. 2003.12.31.001G

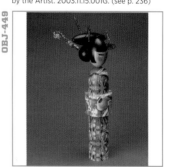

Wendy Maruyama, United States & turning assisted by **Jason Schneider**. *Kokeshi Series: Michiko*, 2003. Maple, digital media, collage, mixed media. 17 ½ x Dia. 4 ½". Donated by the Artist. 2003.12.31.004.01G. (plate 96)

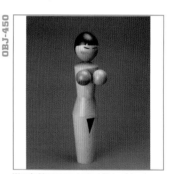

Wendy Maruyama, United States & turning assisted by **Jason Schneider**. *Kokeshi Series: Midori*, 2003. Maple, paint. 15 ½ x Dia. 4". Donated by the Artist. 2003.12.31.004.02G. (plate 96)

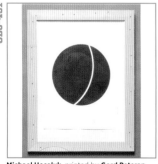

Michael Hosaluk, printed by **Gord Peteran**, Canada. *Centrifugal Landscapes: One*, 2002. Ink, paper. Printed on a Oneway lathe. 14 ½ x 11 ¼". 2003.12.31.005aP

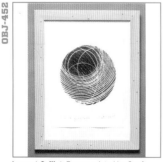

Laurent Guillot, France, printed by **Gord Peteran**, Canada. *Centrifugal Landscapes*, 2002. Ink, paper. Printed on a Oneway lathe. 14 ½ x 11 ¼". 2003.12.31.005bP

Christian Burchard, United States, printed by **Gord Peteran**, Canada. *Centrifugal Landscapes*, 2002. Ink, paper. Printed on a Oneway lathe. 14 ½ x 11 ¼". 2003.12.31.005cP

Robert G. Dodge & **Ed Ryan**, United States. *When You Are the Whole Orchestra, You Have to Bend Over Backwards*, 2002–03. Poplar, cedar. 8 ½ x 14 x 4". Donated by the Artist. 2003.12.31.006G

Ted Hodgetts, Canada. *Armed Vase Series*, 1992. Jamaica dogwood. 26 x 10 ½". Donated by the Artist, in memory of Heward Stikeman. 2004.02.02.001G

Lincoln Seitzman, United States. *Rays (Cutting Board LS39)*, 1985. Various hardwoods. 1 x 10 ¾ x 8". Donated by the Artist. 2004.08.24.002G

Lincoln Seitzman, United States. *Tunnelusion #257*, 2003. Shedua, birch ply, bloodwood, lacewood, rosewood, holly, mahognay, red oak, zerbrawood, wenge. 1 x 13 ½ x 8 ¼". Donated by the Artist. 2004.08.24.003G

Lincoln Seitzman, United States. *Indi-Urn (LS40)*, 1985. Various hardwoods. 8 ½ x Dia. 8". Donated by the Artist. 2004.08.24.004G

Lincoln Seitzman, United States. *Indi-Urn II (LS61)*, 1986. Various hardwoods. 8 x Dia. 8". Donated by the Artist. 2004.08.24.005G

Lincoln Seitzman, United States. *Staved Fruit Bowl*, 1986. Various hardwoods. 5 x Dia. 9". Donated by the Artist. 2004.08.24.006G

Alan Stirt, United States. *Bowl*, 1996. Birdseye maple. 3 ¾ x Dia. 8 ¾". Donated by Lincoln Seitzman. 2004.08.24.009G

Lincoln Seitzman, United States. *Pima Mini- Basket Illusion*, 1995. Maple, paint, ink. 6 x Dia. 6". Donated by the Artist. 2004.08.24.011G

Lincoln Seitzman, United States. *Apache Treasure Basket Illusion*, 1999. Maple, paint, ink. 9 x Dia. 12". Donated by the Artist. 2004.08.24.012G

Lincoln Seitzman, United States. *Mescalero Basket Illusion*, 1992. Maple, paint, ink. 7 x Dia. 7". Donated by the Artist. 2004.08.24.013G

Lincoln Seitzman, United States. *Pima Basket Illusion*, 1992. Maple, paint, ink. 9 x Dia. 8". Donated by the Artist. 2004.08.24.014G

Mathew Harding, Australia. *The Origin*, 2004 ITE. Fijian mahogany. 27 x 8 ½ x 8 ½". Donated by the Artist. 2004.08.25.001G

Michael Mocho, United States. *Sentinal*, 2004 ITE. Spalted box elder, ebony. 16 x 8 x 4". Donated by the Artist. 2004.08.25.002G

Andrew Potocnik, Australia. *Interactive*, 2004 ITE. Douglas fir, pine, paint. 1 ¾ x 11". Donated by the Artist. 2004.08.25.003G

Marcus Tatton, Australia. *Q*, 2004 ITE. Beech, oil pigments. 2 x Dia. 23". Donated by the Artist. 2004.08.25.004G. (see p. 231)

Marcus Tatton, Australia. *Q print*, 2004 ITE. Printers ink, paper. 20 x 16". Donated by Albert & Tina LeCoff. 2004.08.25.010G

Joel Urruty, United States. *Nude*, 2004 ITE. Maple. 9 x 26 x 9". Donated by the Artist. 2004.08.25.005G

Ron Fleming, United States. *Cereus*, 2000. Spalted hackberry, pine. 9 ½ x 6". Donated by the Artist. 2004.08.25.006G

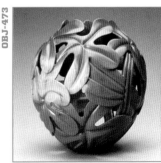

Ron Fleming, United States. *Orpheus*, 2000. Brazilian mahogany. 12 x Dia. 10". Donated by the Artist. 2004.08.25.007G

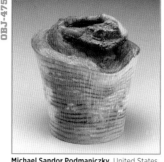

Ernie Newman, Australia. *Carpenter's Dilemma*, 2000. Silky oak, eucalyptus. 14 x 10 x 4". Donated by the Artist. 2004.08.25.008G

OBJ-474

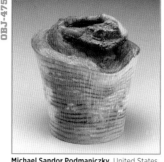

Michael Sandor Podmaniczky, United States. *Knot a Vessel*, 2004 ITE. Red oak. 4 x Dia. 4". Donated by the Artist. 2004.08.25.009G

OBJ-475

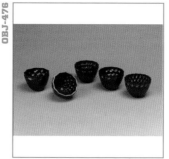

Joshua Salesin, United States. *Starburst - Mandala Cup Set #10*, 2004. African blackwood. 2 ¼–2 ¾ x Dia. 2" each. Donated by the Artist. 2004.08.26.001a–eG

OBJ-476

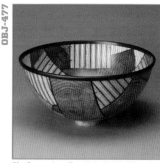

Gianfranco Angelino, Italy. *Untitled Vessel*, ca. 2004. Pine, oak, laminated Pine. 5 x 9 ½". Donated by the Artist. 2004.09.24.001G

OBJ-477

Mark Sfirri & **Robert G. Dodge**, United States. *Secretaire*, 1989. Lacewood, purpleheart, plywood, acrylic paint, gold leaf. 62 x 51 x 20". 2004.12.01.001P. (plate 56)

OBJ-478

Po Shun Leong & **Bob Stocksdale**, United States. *Time Standing Still*, 2002. Various woods and metal. 79 x 42 x 13". Donated by the Artists. 2004.12.01.002G. (see p. 237)

OBJ-479

Kelly Dunn, United States. *Norfolk Pine Bowl*, 2003. Norfolk pine. 3 ½ x 5 ¼ x 5 ¼". Donated by Joe Seltzer. 2004.12.20.001.01G

OBJ-480

Todd Hoyer, United States. *Untitled*, 1987. Mexican blue oak. 6 ½ x 4 ½ x 4 ½". Donated by Joe Seltzer. 2004.12.20.001.02G

OBJ-481

Dave Hardy & **Michael Kehs**, United States. *Untitled*, 1999. Various material. 3 x 5 ½ x 3 ¼". Donated by Joe Seltzer. 2004.12.20.001.03G

OBJ-482

Peter Petrochko, United States. *Untitled*, 2002. Various woods. 1 ¾ x 4 x 3 ¾". Donated by Joe Seltzer. 2004.12.20.001.04G

OBJ-483

Doug Crawford, United States. *Untitled*, 1999. Wood. 2 x 2 ¾ x 2 ¾". Donated by Joe Seltzer. 2004.12.20.001.05G

OBJ-484

Giles Gilson & **David Ellsworth**, United States. *Untitled*, 1994. Wood, paint. 2 ¾ x 8 x 7 ½". Donated by Joe Seltzer. 2004.12.20.001.06G

OBJ-485

Richard Tuttle, United States. *Untitled*, 1999. Maple burl. 1 ¼ x 3 x 3". Donated by Joe Seltzer. 2004.12.20.001.07G

OBJ-486

Maurice Mullins, United Kingdom. *Untitled*, 1988. Yew. 3 ¾ x 5 ½ x 5 ¼". Donated by Joe Seltzer. 2004.12.20.001.08G

OBJ-487

Zina Manesa-Burloiu, Romania. *Cup*, 2000. Maple. 2 ¼ x 4 ½ x 2". Donated by Joe Seltzer. 2004.12.20.001.09G

OBJ-488

Richard Raffan, Australia. *Untitled*, 2003. Claret Ash. 3 ½ x 6 x 6". Donated by Joe Seltzer. 2004.12.20.001.10G

OBJ-489

2005

»

Ed Bosley, United States. *Untitled*, 1987. Lilac burl. 1 ½ x 15 x 15 ¼". Donated by Joe Seltzer. 2005.01.07.001.01G

OBJ-490

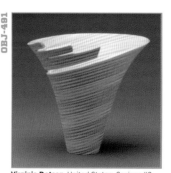

Virginia Dotson, United States. *Savings #8*, 1997. Pau marfim, plywood. 4 ¼ x 4 ¾ x 4 ¾". Donated by Joe Seltzer. 2005.01.07.001.02G

OBJ-491

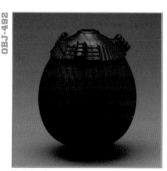

Mark Gardner, United States. *Black Vessel*, 2000. Blackened ash. 3 ½ x 2 ¾ x 2 ¾". Donated by Joe Seltzer. 2005.01.07.001.03G

OBJ-492

OBJ-493

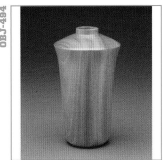

Mark Gardner, United States. *Bowl with Handles*, 2001. Maple burl. 2 ½ x 4 ½ x 3 ¼". Donated by Joe Seltzer. 2005.01.07.001.04G

OBJ-494

Dan Kvitka, United States. *Untitled*, 1990. Satinwood. 5 ½ x 3 ½ x 3 ½". Donated by Joe Seltzer. 2005.01.07.001.05G

OBJ-495

Michael Peterson, United States. *Untitled*, 1987. Maple burl. 4 ¼ x 5 x 5". Donated by Joe Seltzer. 2005.01.07.001.06G

OBJ-496

Joe Seltzer, United States. *Untitled*, 2000. Mesquite burl with natural edge, sapwood burl. 2 ½ x 2 ½ x 2 ½". Donated by the artist. 2005.01.07.001.07G

OBJ-497

Rèmi Verchot, Australia. *Untitled*, 1997. Walnut. 2 x 2 ½ x 2 ½". Donated by Joe Seltzer. 2005.01.07.001.08G

OBJ-498

Norris White, United States. *Untitled*, 2000. Sassafras. 1 ¼ x 1 ¼ x 1 ¼". Donated by Joe Seltzer. 2005.01.07.001.09G

OBJ-499

David Souza, United States. *Lidded Hollow Turning*, 2000. Blacked cherry, satinwood (finial). 9 x 6 ¾ x 6 ¾". Donated by Joe Seltzer. 2005.01.07.001.10G

OBJ-500

Ed Ryan, United States. *Untitled*, 1999. Sassafras. 6 x 5 x 5". Donated by Joe Seltzer. 2005.01.07.001.11G

OBJ-501

Michael Lee, United States. *Untitled*, 2001. Eucalyptus burl. 2 ¾ x 6 x 6". Donated by Joe Seltzer. 2005.01.07.001.12G

OBJ-502

Ray Allen, United States. *Untitled*, 1994. Plum, ebony. 1 ¾ x Dia. 2 ½". Donated by Joe Seltzer. 2005.01.07.001.13G

OBJ-503

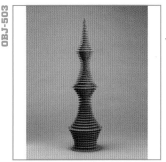

Henri Gröll, France. *Untitled*, 1999 ITE. Dogwood. 16 ¾ x Dia. 4 ¾". Donated by the Artist. 2005.04.25.008G

OBJ-504

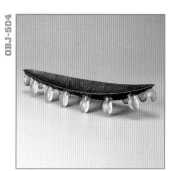

David Rogers, United States. *Something to Put Small Things In*, 1999 ITE. Polyurethane rigid foam, walnut. 3 x 14 x 5". Donated by the Artist. 2005.04.25.009G. (plate 72)

OBJ-505

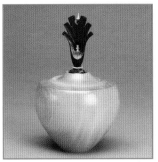

Michael Mocho, United States. *Satinwood Hollow Form*, 2002. Satinwood, ebony. 4 ¼ x Dia. 3". Donated by the Artist. 2005.04.25.010G

OBJ-506

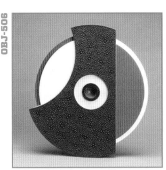

Hayley Smith, United States. *Flamenco*, 2002. English sycamore. 1 ½ x Dia. 12 ½". Donated by Albert & Tina LeCoff & Greg & Regina Rhoa. 2005.05.01.001G. (see p. 236)

OBJ-507

Marc Ricourt, France. *Vessel #6*, 2001 ITE. Oak, vinegar. 11 x Dia. 5 ¾". Donated by the Artist. 2005.05.25.002G

OBJ-508

Gary Stevens, United States. *Vortex #8*, 2003. Fiddleback California maple. 9 x 22 x 14 ½". Donated Mark & Kathy Lindquist in memory of Melvin Lindquist. 2005.11.05.001G

OBJ-509

John Jordan, United States. *Black/White Pair*, 2000. Ash. 7 x Dia. 9 ½" each. Donated by the Artist. 2005.11.05.002a–bG. (see p. 242)

OBJ-510

John Jordan. *Candlesticks*, 1967. Metal, stone. 6 ¾ x 3 x 3" each. Donated by the Artist. 2005.11.05.004a–bG

OBJ-511

Rudiger Marquarding & **Birgit Nass**, Germany. *ITE...the First Ten Years*, 2005. Pearwood (stained), Metal (tin) Inlay. 12 x Dia. 11". Donated by the Artists. 2005.11.05.006G

OBJ-512

Tony Boase, United Kingdom. *Dish, 'O' Ring Bowl*, 2001. Sycamore. 3 x Dia. 8". Donated by Tony & Jacky Boase. 2005.12.30.001G

OBJ-506 | **Hayley Smith**, United States | *Flamenco*, 2002 | English sycamore | 1 ½ x Dia. 12 ½" |
Donated by Albert & Tina LeCoff & Greg & Regina Rhoa | 2005.05.01.001G

OBJ-445 | **Connie Mississippi**, United States | *"This moment is the perfect grape you crush to make your life-wine interesting" Rumi #201*, 2000 |
Wood, aluminum, paint | 18 x 9 x 9" | Donated by the Artist | 2003.11.15.001G

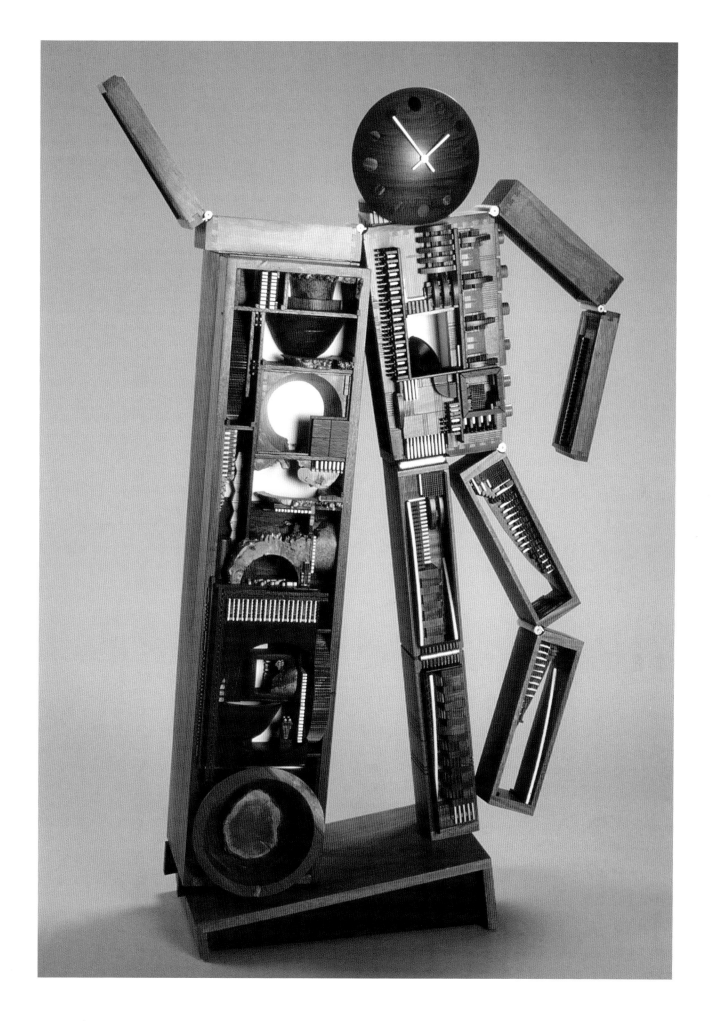

OBJ-479 | **Po Shun Leong** & **Bob Stocksdale**, United States | *Time Standing Still*, 2002 | Various woods and metal | 79 x 42 x 13" |
Donated by the Artists | 2004.12.01.002G

Butch Smuts, Africa. *Out of Africa*, 2004. African blackwood, red ivory, kiaat. 5 ½ x Dia. 10". Donated by the Artist. 2005.12.30.002G

David Ellsworth, United States. *Vessel*, 1978. Cocobolo rosewood. 3 x Dia. 4 ¾". Donated by Kay Sekimachi. 2005.12.31.001G

Garry Knox Bennett, United States. *Pre Turned Wood Object*, 2000. Wood. 11 x 14 x 9 ½". Donated by Glenn Adamson. 2005.12.31.002G. (plate 70)

2006
»

Christophe Nancey, France; **Merryll Saylan**, United States; **Mark Bishop**, Australia; **Tony Boase**, United Kingdom; & **Andrew Gittoes**, Australia. *Scrap Sphere*, 1997 ITE. Various materials. 20 x Dia. 17". Donated by the Artists. 2005.04.25.006G

«

Bill Luce, United States. *Untitled*, 2005. Monkey puzzle wood. 6 ½ x Dia. 9 ¼". Donated by the Artist. 2006.03.04.001G

Rod Cronkite, United States. *Untitled*, 1989. Box elder burl. 6 x Dia. 6". Donated by Robyn Horn. 2006.03.04.002G

David Lory, United States. *Untitled*, 1986. Black cherry burl. Dia. 9 ½". Donated by Robyn Horn. 2006.03.04.003G

Unknown Artist, United States. *Tops*, ca. 20th Century. Wood, paint. 2 x Dia. 2 ¾" each. Donated by Robyn Horn. 2006.03.04.004a–eG

Unknown Artist, United States. *Small Tools*, ca. 20th Century. Wood, metal. 4 ½–10 ⅛ x ¾–2". Donated by Robyn Horn. 2006.03.04.005a–fG

Alan Stirt, United States. *Untitled Platter*, 1987. Brazilian rosewood, carved in rings. ¾ x Dia. 12 ⅝". Donated by Robyn Horn. 2006.03.04.006G

Merryll Saylan, United States. *Turning Sixty, 1:18 (work in progress)*, 1996. Maple. Dia. 5 ¼–9 ¾". Donated by the Artist. 2006.05.01.002a–rG

Siegfried Schreiber, Germany. *Meditative Vessel #58*, 2008. Ash. 5 x Dia. 16". Donated by the Artist. 2006.08.04.001G

Hilary Pfeifer, United States & **Liam Flynn**, Ireland. *Pegboard Inspired Vessel*, 2006 ITE. Masonite, paint. 7 x 6 x 4". Donated by the Artists. 2006.08.04.005G. (plate 39)

Hilary Pfeifer, Dennis Carr, United States & **Neil Scobie**, Australia. *Art Object to be Destroyed*, 2006. Mixed media. 6 x 13 x 7". Donated by the Artists. 2006.08.04.006G. (plate 107)

Liam Flynn, Ireland. *Still Life with Holly*, 2006 ITE. Holly, cherry. 5 ½ x 13 x 6". Donated by the Artist. 2006.08.04.007G. (see p. 242)

(see p. 242)

Marilyn Campbell, Canada & **Neil Scobie**, Australia. *Riding the Waves*, 2006 ITE. Walnut, resin, brass, paint. 5 ¼ x 6 x 3". Donated by the Artists. 2006.08.04.008G

Neil Scobie, Australia. *Erosion Forms (Bleached)*, 2006 ITE. White oak bleached. 13 x 4 ¾ x 1 ½, 11 ½ x 4 ¼ x 1 ½, 10 x 4 x 1 ½". Donated by the Artist. 2006.08.04.009G

Neil Scobie, Australia & **Jo Stone**, United States. *Entrance Table with Green Detail*, 2006 ITE. Mahogany, milk paint. 35 x 22 x 11 ½". Donated by the Artist. 2006.08.04.010G

OBJ-531
Vincent Romaniello, United States & **Neil Scobie**, Australia. *Carpio, Medium*, 2006 ITE. Mixed mediums on turned ash. 1 ¼ x 5 ½ x 2″. Donated by the Artists. 2006.08.04.011G

OBJ-532
Liam Flynn, Ireland. *Fumed Oak Vessel #31*, 2006. Oak. 9 ½ x Dia. 6″. Donated by the Artist. 2006.08.04.012G

OBJ-533
Ray Faunce, **Eli Searce**, & **Beth Gordon**, United States. *Untitled*, 2004. Wood, metal 15 ½ x 8 x 2″. Donated by Joe Seltzer. 2006.08.18.001.01G

OBJ-534
Norris White & **Betty J. Scarpino**, United States. *Untitled*, 2001. Wood, paint. 4 x 3 ½ x 3 ½″. Donated by Joe Seltzer. 2006.08.18.001.02G

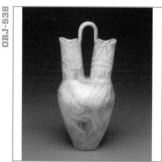

OBJ-535
Phil Brown, United States. *#21*, 1997. Spalted maple. 1 ¾ x Dia. 7″. Donated by Joe Seltzer. 2006.08.18.001.03G

OBJ-536
Buzz Coren, United States. *Untitled*, 1999. Redwood lace. 1 ¼ x Dia. 6 ¼″. Donated by Joe Seltzer. 2006.08.18.001.04G

OBJ-537
Judy Ditmer, United States. *Untitled*, 2001. Dogwood. 2 x 5 ½ x 6″. Donated by Joe Seltzer. 2006.08.18.001.05G

OBJ-538
Linton Frank, United States. *Untitled*, 1993 Maple burl. 7 x 3 ½ x 3 ¼″. Donated by Joe Seltzer. 2006.08.18.001.06G

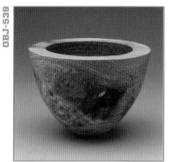

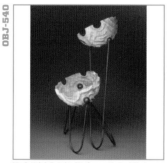

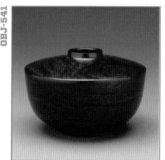

OBJ-539
Tony Boase, United Kingdom & **Graeme Priddle**, New Zealand. *Untitled*, 2003. Elm burl. 3 ¾ x Dia. 5″. Donated by Joe Seltzer. 2006.08.18.001.07G

OBJ-540
Mark Krick & **John Mathews**, United States. *Untitled*, 2003. Wood, metal. 16 x 8 x 7″. Donated by Joe Seltzer. 2006.08.18.001.08G

OBJ-541
Dan Kvitka, United States. *Untitled*, 1989. Cocobolo. 3 x Dia. 4 ½″. Donated by Joe Seltzer. 2006.08.18.001.09G

OBJ-542
Dan Kvitka, United States. *Untitled*, 1993. Amboyna burl. 1 ¾ x Dia. 3″. Donated by Joe Seltzer. 2006.08.18.001.10G

OBJ-543
Dan Kvitka, United States. *Untitled*, 2003. Thuya burl. 1 ¾ x Dia. 4″. Donated by Joe Seltzer. 2006.08.18.001.11G

OBJ-544
Nikolai Ossipov, United States. *Untitled*, 2001. Jetulong. 7 x Dia. 3 ½″. Donated by Joe Seltzer. 2006.08.18.001.12G

OBJ-545
Graeme Priddle, New Zealand. *Untitled*, 2002. Kauri. 2 ½ x Dia. 4 ¼″. Donated by Joe Seltzer. 2006.08.18.001.13G

OBJ-546
William Smith & **Robert G. Dodge**, United States. *Pyramid of Box*, 2000. Box elder, paint. 3 x 3 ¼ x 3 ¼″. Donated by Joe Seltzer. 2006.08.18.001.14G

OBJ-547
Jack Shelly, United States. *Untitled*, 2003. Locust branch. 5 ¼ x Dia. 2 ½″. Donated by Joe Seltzer. 2006.08.18.001.15G

OBJ-548
Dennis Stewart, United States. *Untitled*, 1985. Oak burl, sycamore. 5 x Dia. 2 ¼″. Donated by Joe Seltzer. 2006.08.18.001.16G

OBJ-549
John Williams, United States. *Untitled*, 2002. Cherry, paint. 4 x Dia. 5″. Donated by Joe Seltzer. 2006.08.18.001.17G

OBJ-550
Phil Wall, United States. *Untitled*, 2001. Spalted maple. 5 x Dia. 3″. Donated by Joe Seltzer. 2006.08.18.001.18G

OBJ-551

Unknown Artist, Japan. *Untitled*, ca. 20th Century. Wood. 1 ¾ x Dia. 3 ½". Donated by Joe Seltzer. 2006.08.18.001.19G

OBJ-552

Jean-François & **Monique Escoulen**, France. *Untitled*, 2001. Pear. 14 ¾ x 6 ½ x 5". Donated by Joe Seltzer. 2006.08.18.001.20G

2007
»

OBJ-553

Dewey Garrett, United States. *Vase Palm*, 2000. Palm, dye. 7 ½ x Dia. 4". Donated by Joe Seltzer. 2007.03.02.001.01G

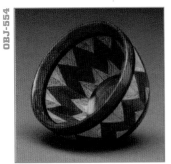

OBJ-554

Joel Gulker, United States. *Minature Bowl*, 2001. Paduak, yellowheart, lenga, ebony. ¾ x Dia. 1 ¼". Donated by Joe Seltzer. 2007.03.02.001.02G

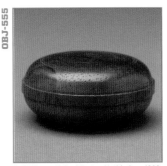

OBJ-555

Todd Hoyer, United States. *Untitled*, ca. 1982. Koa. 5 x Dia. 1 ¼". Donated by Joe Seltzer. 2007.03.02.001.03G

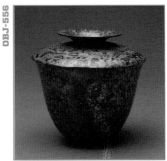

OBJ-556

Lynne Hull, United States. *Untitled*, 1992. Copper, patinaed. 3 ¼ x Dia. 3 ½". Donated by Joe Seltzer. 2007.03.02.001.04G

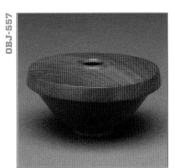

OBJ-557

Dan Kvitka, United States. *Untitled*, 1992. Pink ivory. 1 x Dia. 1 ¾". Donated by Joe Seltzer. 2007.03.02.001.05G

OBJ-558

David Lory, United States. *Untitled*, 1985. Sumac. 1 ¾ x Dia. 5". Donated by Joe Seltzer. 2007.03.02.001.06G

OBJ-559

David Lory, United States. *Untitled*, 1985. Red oak burl. 2 x 6 x 5 ¾". Donated by Joe Seltzer. 2007.03.02.001.07G

OBJ-560

Michael Mode, United States. *Untitled*, 1986. Maple burl, walnut. 3 ½ x Dia. 3". Donated by Joe Seltzer. 2007.03.02.001.08G

OBJ-561

Philip Moulthrop, United States. *Untitled*, 1995. Madrone. 1 ½ x Dia. 3 ½". Donated by Joe Seltzer. 2007.03.02.001.09G

OBJ-562

Philip Moulthrop, United States. *Untitled*, 1994. Spalted maple. 3 x Dia. 3". Donated by Joe Seltzer. 2007.03.02.001.10G

OBJ-563

Mark Sfirri & **Robert G. Dodge**, United States. *Untitled*, 2001. Maple, paint, copper wire. 3 x 4 ½ x 7 ¾". Donated by Joe Seltzer. 2007.03.02.001.11G

OBJ-564

Unknown Artist. *Untitled*, ca. 20th Century. Wood. 1–2 x Dia. 2 ¼–6 ⅝". Donated by Joe Seltzer. 2007.03.02.001.12G

OBJ-565

Warman Castle, United States. *Untitled*, 1996. Walnut crotch. 3 ¾ x 7 x 4 ½". Donated by Joe Seltzer. 2007.03.02.001.13G

OBJ-566

Jean-François Escoulen, France. *Untitled, demo piece*, 2001. Ash. 4 ½ x 3 x 3". Donated by Joe Seltzer. 2007.03.02.001.14G

OBJ-567

Ken Goodrich, United States. *Apple*, 1994. Apple. 4 ½ x Dia. 5". Donated by Joe Seltzer. 2007.03.02.001.15G

OBJ-568

Bill Smith, United States. *Untitled*, 1998. Padauk, mahogany, pau amarello with bank of segmented pieces. 6 x Dia. 4". Donated by Joe Seltzer. 2007.03.02.001.16G

OBJ-569

Hans Joachim Weissflog, Germany. *Drunken Box*, 2005. Cocobolo. 3 x Dia. 3". Donated by Larry Gabriel. 2007.08.04.001G

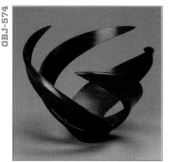

Michael Mode, United States. *Chess Set*, 1993. Purpleheart, holly, ebony, tagua, persimmon, rosewood, walnut. 12 x Dia. 6 ½". Donated by Neil & Susan Kaye. 2007.08.04.002.01G

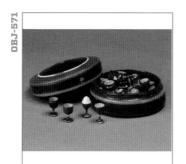

Unknown Artist, India. *Turned Box from India and Miniature Vessels*, ca.1895. Wood, paint. 1 ½ x Dia. 3". Donated by Michael Mode. 2007.08.04.003G

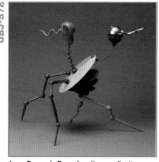

Jean-François Escoulen, France. *Darling... You Are Getting Better Looking Every Day*, 1996 ITE. Wood. 14 x 14 x 15". Donated by Neil & Susan Kaye. 2007.08.04.002.02G

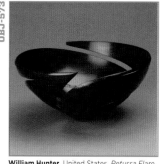

William Hunter, United States. *Retussa Flare*, 1994. Cocobolo. 3 ¾ x Dia. 7 ¾". Donated by Neil & Susan Kaye. 2007.08.04.002.03G

William Hunter, United States. *Savannah Dancers*, 1995. Cocobolo. 5 x Dia. 6". Donated by Neil & Susan Kaye. 2007.08.04.002.04G

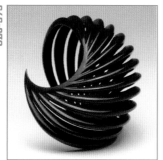

William Hunter, United States. *Vallarta Shell*, 1995. Cocobolo. 5 ¼ x 6". Donated by Neil & Susan Kaye. 2007.08.04.002.06G. (see p. 243)

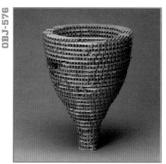

Richard Hooper, United Kingdom. *Natural Force*, 1995 ITE. Cherry. 10 x Dia. 8". Donated by Neil & Susan Kaye. 2007.08.04.002.05G

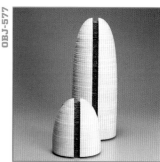

Thierry Martenon, France. *Duolythe*, 2003 ITE. Maple, slate. 22 x Dia. 8 ½", 9 ¼ x Dia. 8 ½". Donated by the Artist. 2007.08.04.004.01G

Thierry Martenon, France & **Eli Avisera**, Israel. *Paper Bowl*, 2003 ITE. Box elder, acrylic, paper. 11 ½ x Dia. 8". Donated by the Artists. 2007.08.04.004.02G

Eli Avisera, Israel. *Hollow Form Vase (unfinished work)*, 2003 ITE. Maple, gesso. 8 ½ x Dia. 7". Donated by Albert & Tina LeCoff. 2007.08.04.005.01G. (see p. 243)

Merryll Saylan, United States & **Tony Boase**, United Kingdom. *Sycamore Platter*, 2003. Sycamore, paint. 3 x Dia. 11". Donated by Albert & Tina LeCoff. 2007.08.04.005.02G

Friedrich Kuhn, Germany. *American Maple Experience #1*, 2002 ITE. Maple. 6 x Dia. 18 ½". Donated by the Artist. 2007.08.04.006G

Malcolm Martin & **Gayner Dowling**, United Kingdom. *Wave II*, 2003. Oak. 66 x 7 ½ x 3". Base- Dia. 11". Donated by the Artists. 2007.08.04.007G

Jean-François Delorme, France. *Vessel*, 2007 ITE. Maple burl. 5 ½ x Dia. 6 ¼". Donated by the Artist. 2007.08.04.008G

Peter Harrison, United States. *Cable Study 1*, 2007 ITE. Honey locust, cable, Plasti Dip. 12 x 2 ½ x 6". Donated by the Artist. 2007.08.04.009.01G

Peter Harrison, United States. *Cable Study 3*, 2007 ITE. Honey locust, cable, Plasti Dip. 6 ½ x 2 ½ x 13". Donated by the Artist. 2007.08.04.009.02G

Sean Ohrenich, United States. *Homage*, 2007 ITE. Mahogany, micaceous iron oxide. 6 ½ x 4 ½ x 1 ½". Donated by the Artist. 2007.08.04.010.01G

Sean Ohrenich, United States. *The Tower of Babble*, 2007 ITE. Ebony, mahogany, maple, oak. 12 x 6 ¾ x 5". Donated by the Artist. 2007.08.04.010.02G

Siegfried Schreiber, Germany. *Runaway*, 2007 ITE. Mulberry. 4 ½ x Dia. 5 ¾". Donated by the Artist. 2007.08.04.011G

Lynne Yamaguchi, United States. *Learning to Cope: Pear Incognito under a Mantle of Cherry*, 2007 ITE. Pear, cherry bark, waxed string. 5 ¾ x Dia. 6". Donated by the Artist. 2007.08.04.012G

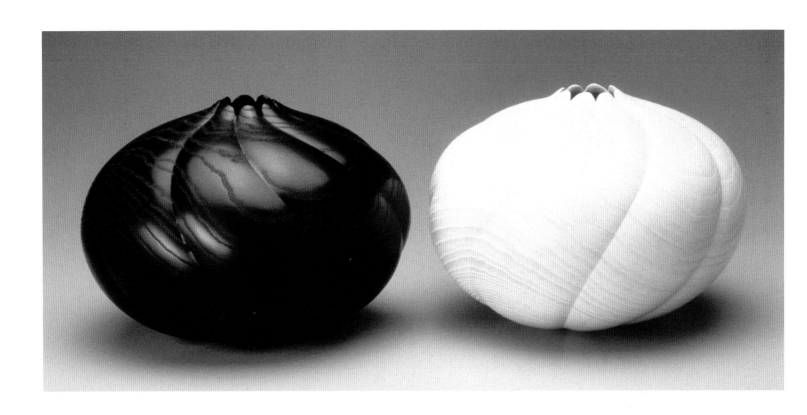

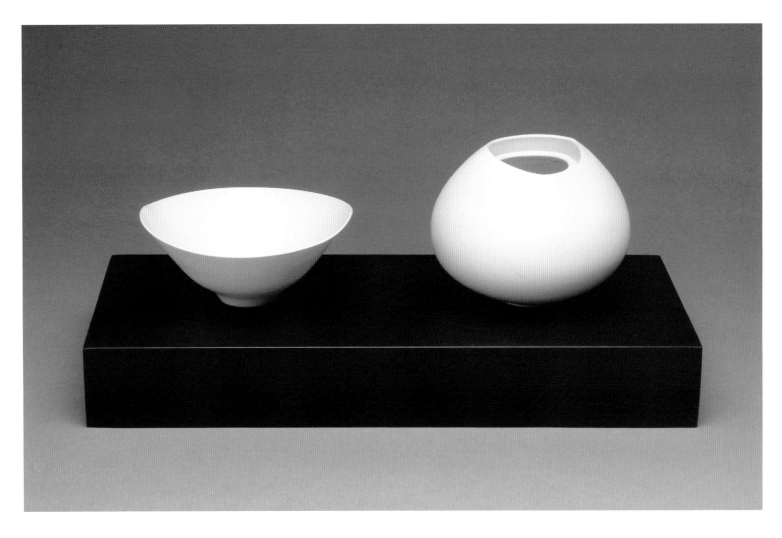

OBJ-509 | **John Jordan**, United States | *Black/White Pair*, 2000 | Ash | 7 x Dia. 9 ½" each | Donated by the Artist | 2005.11.05.002a–bG

OBJ-527 | **Liam Flynn**, Ireland | *Still Life with Holly*, 2006 ITE | Holly, cherry | 5 ½ x 6 x 13" | Donated by the Artist | 2006.08.04.007G

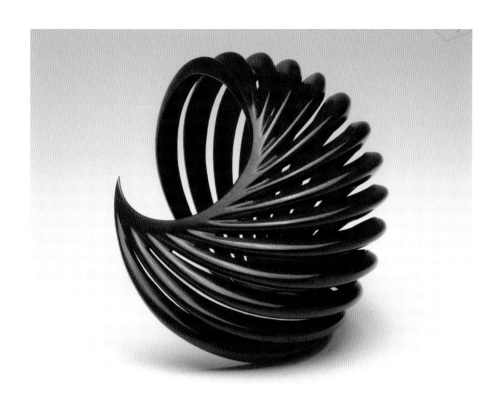

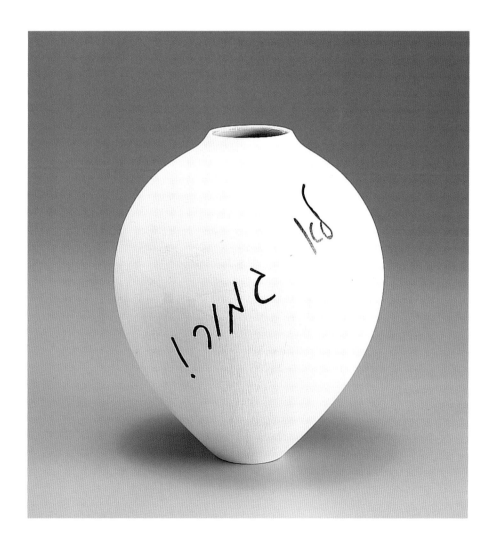

OBJ-575 | **William Hunter**, United States | *Vallarta Shell*, 1995 | Cocobolo | 5 ¼ x 6″ | Donated by Neil & Susan Kaye | 2007.08.04.002.06G

OBJ-579 | **Eli Avisera**, Israel | *Hollow Form Vase (unfinished work)*, 2003 ITE | Maple, gesso | 8 ½ x Dia. 7″ | Donated by Albert & Tina LeCoff | 2007.08.04.005.01G

OBJ-590

Hap Sakwa, United States. *Lilac Burl Bowl*, 1980. Liliac burl. 5 x Dia. 11". Donated by Robert & Mary Lou Sutter. 2007.08.04.013.01G

OBJ-591

Marc Ricourt, France. *Vessel*, 2002. Wood. 6 x Dia. 12". Donated by Robert & Mary Lou Sutter. 2007.08.04.013.02G

OBJ-592

Jean-François Delorme, France. *Broken*, 2007 ITE. Ash, elm, crutches. 68 ½ x 17 x 12". Donated by the Artist. 2007.08.04.014G

OBJ-593

Siegfried Schreiber, Germany. *The Lovers*, 2005. Maple, pear. 9 ½ x Dia. 19 ¼". Donated by the Artist. 2007.08.04.015G

OBJ-594

Jerry Glaser, United States. *Woodturning Tools*, 2007. Wood, metal. 12 ¾" each. Donated by the Artist. 2007.12.01.001a–cG

2008

»

OBJ-595

John Edwards, United Kingdom. *Trinket Box - Fireworks*, 2007. African blackwood. 3 x 3 x 3". Donated by Tim & Sheryl Kochman, Albert & Tina LeCoff, & Greg & Regina Rhoa. 2008.03.15.001G. (see p. 246)

OBJ-596

Dewey Garrett, United States. *Holtz Box*, 2007. Faux ivory. 1 ¾ x Dia. 2 ¾". Donated by Tim & Sheryl Kochman, Albert & Tina LeCoff, & Greg & Regina Rhoa. 2008.03.15.002G

OBJ-597

Ray Allen, United States. *Untitled*, 2000. Maple, cherry. 1 ⅝ x Dia. 2 ⅝". Donated by Bruce Kaiser. 2008.05.07.001.01G

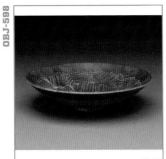

OBJ-598

Gianfranco Angelino, Italy. *Untitled*, 1994. Pine, walnut, waxed (finishing). 1 ⅝ x Dia. 6 ⅛". Donated by Bruce Kaiser. 2008.05.07.001.02G

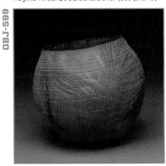

OBJ-599

Christian Burchard, United States. *Basket*, 2000. Madrone burl. 4 ⅞ x Dia. 5 ⅛". Donated by Bruce Kaiser. 2008.05.07.001.03G

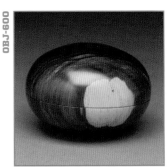

OBJ-600

M. Dale Chase, United States. *Box (Cream Puff)*, 1990. Lignum vitae. 2 ⅛ x Dia. 2 ⅞". Donated by Bruce Kaiser. 2008.05.07.001.04G

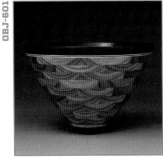

OBJ-601

Addie Draper, United States. *Kingwood Vase*, 1989. Kingwood. 3 ½ x Dia. 5 ⅜". Donated by Bruce Kaiser. 2008.05.07.001.05G

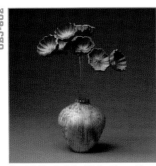

OBJ-602

Gorst duPlessis, United States. *Vase with Flowers*, 2000. Maple, metal. 9 ½ x Dia. 3 ¾". Donated by Bruce Kaiser. 2008.05.07.001.06G

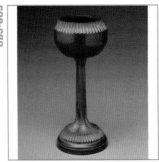

OBJ-603

Gorst duPlessis, United States. *Three Stemmed Vase*, 1999. African blackwood 5 x Dia. 2". Donated by Bruce Kaiser. 2008.05.07.001.07G

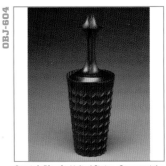

OBJ-604

Gorst duPlessis, United States. *Ornamental Turned Box*, 1998. Dymondwood, African blackwood. 5 ½ x Dia. 1 ¹⁵⁄₁₆". Donated by Bruce Kaiser. 2008.05.07.001.08G

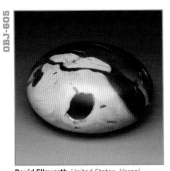

OBJ-605

David Ellsworth, United States. *Vessel (Sonora Desert Ironwood)*, 1981. Desert ironwood. 5 ½ x Dia. 9 ½". Donated by Bruce Kaiser. 2008.05.07.001.10G. (plate 9)

OBJ-606

Jean-François Escoulen, France. *Untitled*, 1995. India rosewood, mahia rosewood. 12 x 3 x 8". Donated by Bruce Kaiser. 2008.05.07.001.11G. (see p. 247)

OBJ-607

Jean-François Escoulen, France. *Untitled*, 1996. Chaet ekoke. 8 ½ x 11 x 4". Donated by Bruce Kaiser. 2008.05.07.001.12G

OBJ-608

Melinda Fawver, United States. *A Taste of Freedom*, 1991. Spalted maple. 4 ⅜ x Dia. 11 ¼". Donated by Bruce Kaiser. 2008.05.07.001.13G

OBJ-609

Ron & **Patti Fleming**, United States. *Geronimo*, 1994. Wood, paint. 13 ½ x Dia. 4". Donated by Bruce Kaiser. 2008.05.07.001.14G

OBJ-610

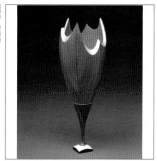

Mark Gardner, United States. *Spoon*, 2001. Wood. 1 x 10 ¹⁵⁄₁₆ x Dia. 1 ¾". Donated by Bruce Kaiser. 2008.05.07.001.15G

OBJ-611

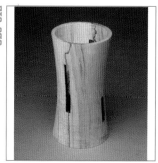

Giles Gilson, United States. *Vessel*, 1994. Wood, paint. 6 ¼ x Dia. 2 ¼". Donated by Bruce Kaiser. 2008.05.07.001.16G

OBJ-612

Andrew Gittoes, Australia. *Castle with Ball*, 1997 ITE. Spalted maple. 6 ⅞ x Dia. 3 ¾". Donated by Bruce Kaiser. 2008.05.07.001.17G

OBJ-613

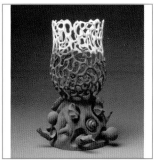

Daniel Guilloux, France. *Petrol*, 1998 ITE. Ash, boxwood, rust paint. 10 ¾ x Dia. 7 ½". Donated by Bruce Kaiser. 2008.05.07.001.18G

OBJ-614

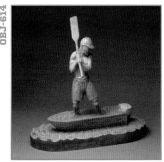

Susan Hagen, United States. *Charon, The Boatman*, 1996. Limewood, oil. 15 ⅛ x 7 ½ x 15 ⅞". Donated by Bruce Kaiser. 2008.05.07.001.19G

OBJ-615

Stephen Hogbin, Canada. *Walking Bowl #1154*, 1998. Chacauante wood, paint. 6 ¹¹⁄₁₆ x 3 ¹³⁄₁₆ x 7". Donated by Bruce Kaiser. 2008.05.07.001.20G

OBJ-616

Richard Hooper, United Kingdom. *Biconic Form*, 1996. Laminated birch. 14 ¼ x 7 x 9 ½". Donated by Bruce Kaiser. 2008.05.07.001.21G

OBJ-617

Todd Hoyer, United States. *Bowl from 'Ringed Series'*, 1996. Ash. 1 ⅝ x Dia. 3 ⅞". Donated by Bruce Kaiser. 2008.05.07.001.22G

OBJ-618

William Hunter, United States. *Volute*, 1991. Cocobolo. 4 x Dia. 5". Donated by Bruce Kaiser. 2008.05.07.001.23G

OBJ-619

C.R. 'Skip' Johnson, United States. *Clarinet-A-Kazoo*, 1994. Walnut, maple. 23 ¾ x 6 x 7 ⅞". Donated by Bruce Kaiser. 2008.05.07.001.24G

OBJ-620

Michael Kehs, United States. *Myotis Exodus*, 1993. Apple burl, rosewood. 7 ⅜ x Dia. 9". Donated by Bruce Kaiser. 2008.05.07.001.25G

OBJ-621

Ron Kent, United States. *Vessel*, 1993. Norfolk island pine. 7 ½ x Dia. 9 ½". Donated by Bruce Kaiser. 2008.05.07.001.26

OBJ-622

Stuart King, United Kingdom. *Knife & Fork*, 1993. Wood. 9 ⅞ x 1", 8 ⅛ x ¾". Donated by Bruce Kaiser. 2008.05.07.001.27a–bG

OBJ-623

Stuart King, United Kingdom. *Spoon*, 1993. Wood. 12 ⅜ x 2 ⅞ x ½". Donated by Bruce Kaiser. 2008.05.07.001.28G. (plate 61)

OBJ-624

Bonnie Klein, United States. *Top*, 1990. Wood, paint. 1 ⅞ x Dia. 1 ¾". Donated by Bruce Kaiser. 2008.05.07.001.29G

OBJ-625

Dan Kvitka, United States. *Banded Vase*, 1996. Vera. 6 ½ x Dia. 4 ¼". Donated by Bruce Kaiser. 2008.05.07.001.30G

OBJ-626

Dan Kvitka, United States. *Vessel*, 1996. Tulipwood. 3 x Dia. 5 ¾". Donated by Bruce Kaiser. 2008.05.07.001.31G

OBJ-627

Peter Lamb, United States. *Bowl*, 1985. White oak. 2 ¼ x Dia. 5 ⁷⁄₁₆". Donated by Bruce Kaiser. 2008.05.07.001.32G

OBJ-628

Dean Malcolm, United Kingdom. *Container*, 1996. Wood. 2 ⅞ x Dia. 3 ⅛". Donated by Bruce Kaiser. 2008.05.07.001.33G

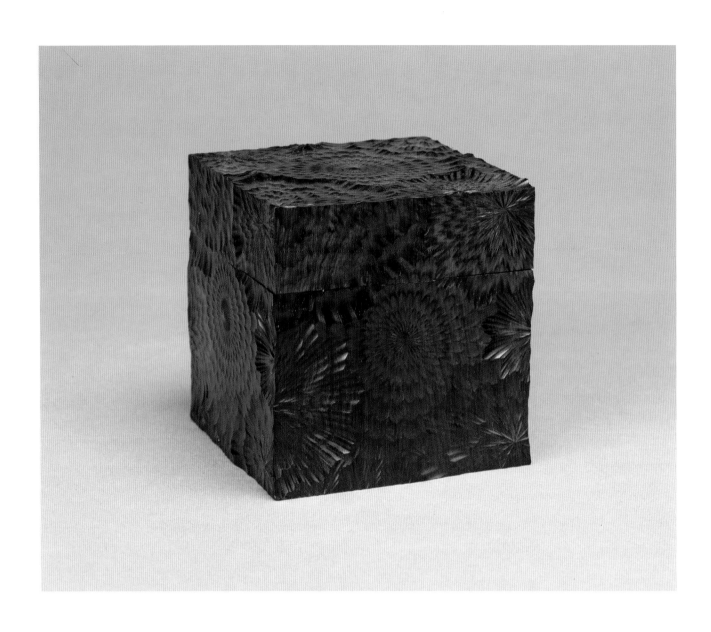

OBJ-595 | **John Edwards**, United Kingdom | *Trinket Box - Fireworks*, 2007 | African blackwood | 3 x 3 x 3" |
Donated by Tim & Sheryl Kochman, Albert & Tina LeCoff, & Greg & Regina Rhoa | 2008.03.15.001G

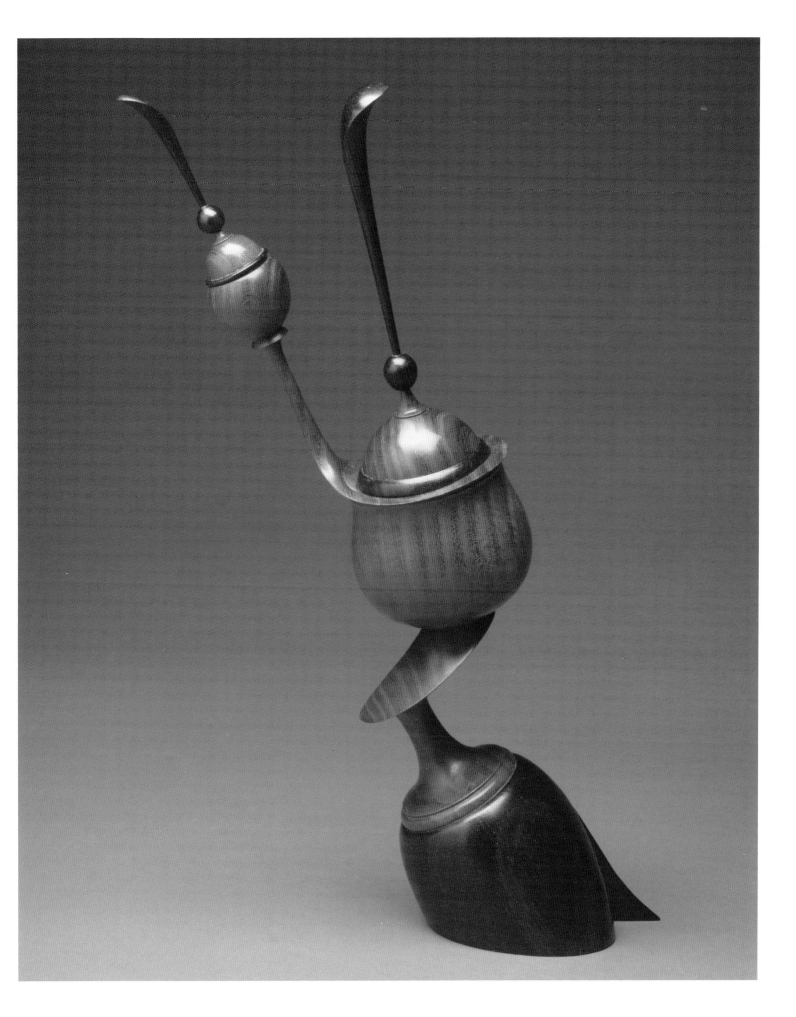

OBJ-606 | **Jean-François Escoulen**, France | *Untitled*, 1995 | India rosewood, mahia rosewood | 12 x 3 x 8" | Donated by Bruce Kaiser | 2008.05.07.001.11G

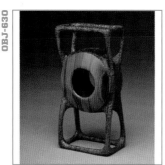

Terry Martin, Australia. *Leafy Cyclops*, 1998. Pink ivory. 4 ½ x 2 x 6 ¾". Donated by Bruce Kaiser. 2008.05.07.001.34G

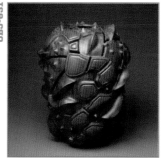

Terry Martin, Australia. *Eye of the Beholder*, 1997. Cocobolo. 5 ¾ x 1 ¾ x 2 ¹³⁄₁₆". Donated by Bruce Kaiser. 2008.05.07.001.35G

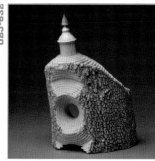

Hugh McKay, United States. *Shard*, 1997. Black madrone burl, soapstone. 12 ⅜ x Dia. 9 ½". Donated by Bruce Kaiser. 2008.05.07.001.36G

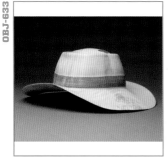

Fabrice Micha, France. *Castle*, 1998. Boxwood. 10 ¾ x 4 ½ x 5". Donated by Bruce Kaiser. 2008.05.07.001.37G

Johannes Michelsen, United States. *Trail Boss (Hat #100)*, 1992. Spalted maple. 5 ½ x 14 x 15 ¼". Donated by Bruce Kaiser. 2008.05.07.001.38G

Johannes Michelsen, United States. *Lotus Vase IV*, 1991. Spalted maple, cherry 23 x Dia. 14 ½". Donated by Bruce Kaiser. 2008.05.07.001.39G

Michael Mocho, United States. *Box*, 2004. Maple. 6 x 1 ¼ x 1 ⅝". Donated by Bruce Kaiser. 2008.05.07.001.40G

Michael Mode, United States. *Akbar's Delight*, 1994. Pink ivory, madagascar rosewood, ebony, purpleheart, holly, tagua nut. 5 ¾ x Dia. 3". Donated by Bruce Kaiser. 2008.05.07.001.41G

Christophe Nancey, France. *Homage a Catherine*, 1997. Manzanita. 5 ½ x ½ x ¾". Donated by Bruce Kaiser. 2008.05.07.001.42G

George Peterson, United States. *Cube*, 2001. Wood. 8 ½ x 7 ⅞ x 8 ½". Donated by Bruce Kaiser. 2008.05.07.001.43G

Michael Peterson, United States. *Clam Shell*, 1994. Madrone burl. 3 ½ x 5 ½ x 6". Donated by Bruce Kaiser. 2008.05.07.001.44G. (see p. 252)

Peter Petrochko, United States. *Oval Vessel*, 1984. African zebrawood. 4 ½ x 10 ⅞ x 8 ⅞". Donated by Bruce Kaiser. 2008.05.07.001.45G

Peter Petrochko, United States. *Oval 'Tent' Series Vessel*, 1996. Purpleheart, wenge, koa, shedua. 10 x 11 ⅝ x 9 ¼". Donated by Bruce Kaiser. 2008.05.07.001.46G

Graeme Priddle, New Zealand. *Shell Form' Series*, 2000. Laburnum. 2 ¾ x 3 ½ x 4 ½". Donated by Bruce Kaiser. 2008.05.07.001.47G

Jason Russell, Canada. *Floral Series*, 2001. Cocobolo, rosewood. 3 ⅜ x 3 ⅜ x 3 ⅜". Donated by Bruce Kaiser. 2008.05.07.001.48G

Jason Russell, Canada. *The Cradle Will Rock*, 2002. Cocobolo, rosewood, mahogany. 4 ½ x 16 x 2 ½". Donated by Bruce Kaiser. 2008.05.07.001.49G

Norm Sartorius, United States. *Spoon (Amboyna Burl)*, 1995. Amboyna burl. 3 x 5 ¼ x 12 ¼". Donated by Bruce Kaiser. 2008.05.07.001.50G

Jon Sauer, United States. *Red Square X Four*, 1990. Blackwood. 6 x Dia. 1 ½". Donated by Bruce Kaiser. 2008.05.07.001.51G

Betty J. Scarpino, United States. *Bowl with 3 Eggs*, 1999. Persimmon. 1 ½ x Dia. 3 ¾". Donated by Bruce Kaiser. 2008.05.07.001.52G

Betty J. Scarpino, United States. *The Missing Piece: Negotiator*, 1997. Dogwood. 3 ½ x 1 ¼ x 3 ½". Donated by Bruce Kaiser. 2008.05.07.001.53G

OBJ-649

Betty J. Scarpino, United States & **Rèmi Verchot**, Australia. *Lined Donut*, 1999 ITE. Ash. 2 ¾ x Dia. 9 ⅜". Donated by Bruce Kaiser. 2008.05.07.001.54G

OBJ-650

Bo Schmitt, Australia. *The Survivor's Suite, 2nd Movement*, 1995 ITE. Rosewood, laminated Corian, she oak, India ink, silver, bronze, gold leaf gilding. 12 ½ x Dia. 7 ⅞". Donated by Bruce Kaiser. 2008.05.07.001.55G

OBJ-651

Neil Scobie, Australia. *Erosion Series Bowl*, 1996. Australian red cedar. 4 x Dia. 16 ½". Donated by Bruce Kaiser. 2008.05.07.001.56G

OBJ-652

Lincoln Seitzman, United States. *Petrified Cherokee Basket (no.4)*, 1996. Guatambu, ipe, bloodwood, ink. 12 x Dia. 9 ⅜". Donated by Bruce Kaiser. 2008.05.07.001.57G

OBJ-653

David Sengel, United States. *Thorned Vessel*, 1993. Wood, rose & locust thorns, paint. 4 ¼ x 4 ½ x 7 ½". Donated by Bruce Kaiser. 2008.05.07.001.58G

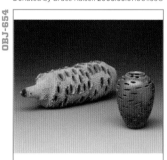

OBJ-654

David Sengel, United States. *Vase (With Banksia Pod)*, 1998. Banksia pod. 3 ¾ x Dia. 2 ½". Donated by Bruce Kaiser. 2008.05.07.001.59G

OBJ-655

David Sengel, United States. *Goblet*, 1995. Wood, paint. 10 ⅛ x Dia. 2 ⅞". Donated by Bruce Kaiser. 2008.05.07.001.60G

OBJ-656

Mark Sfirri, United States. *Glancing Figure*, 2000. Bubinga. 11 x 1 ¾ x 2 ½". Donated by Bruce Kaiser. 2008.05.07.001.61G. (plate 93)

OBJ-657

Heinrich-Andreas Schilling, Germany. *I Busche 201203*, 2001. Amboyna, ebony. 3 ¾ x Dia. 2 ¾". Donated by Bruce Kaiser. 2008.05.07.001.62G

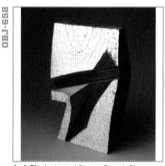

OBJ-658

Jack Slentz, United States. *Bruce's Piece*, 1998. Cherry. 14 x 9 x 4". Donated by Bruce Kaiser. 2008.05.07.001.63G

OBJ-659

Jack Slentz, United States. *Hermana*, 1999. Locust. 14 ½ x Dia. 4 ¼". Donated by Bruce Kaiser. 2008.05.07.001.64G

OBJ-660

Hayley Smith, United States. *Hemispherical Bowl Form #7*, 1995 ITE. English sycamore. 3 x Dia. 6 ¼". Donated by Bruce Kaiser. 2008.05.07.001.65G

OBJ-661

Maria van Kesteren, Netherlands. *Lidded Vessel*, 1997. Elm. 2 ¼ x Dia. 8 ³⁄₁₆". Donated by Bruce Kaiser. 2008.05.07.001.66G. (see p. 253)

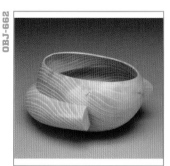

OBJ-662

Hunt Clark, United States. *ON7/08*, 2008 ITE. Osage orange. 5 x 9 ¼ x 11". Donated by the Artist. 2008.08.01.001G. (see p. 252)

OBJ-663

Martina Plag, United States. *...fissured...*, 2008 ITE. Poplar, pressure-treated pine, bamboo, paint. 18 x 5 ½ x 5 ½". Donated by the Artist. 2008.08.01.002G

OBJ-664

Peter Exton, United States. *Scorpion*, 2008 ITE. Cedar shingles, dye, screws. 6 x 18 x 33". Donated by the Artist. 2008.08.01.003G. (plate 38)

OBJ-665

Satoshi Fujinuma, Japan. *Sea Form*, 2008 ITE. Maple, boxelder. 17 x 12 x 7". Donated by the Artist. 2008.08.01.004.01G

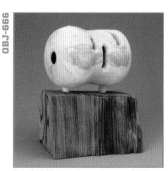

OBJ-666

Satoshi Fujinuma, Japan. *Journey of Will*, 2000. Cherry. lignitized cedar. 6 ¾ x 4 ⅞ x 3 ½". Donated by the Artist. 2008.08.01.004.02G. (see p. 253)

OBJ-667

Stephan Goetschius, United States. *Untitled*, 2008 ITE. Cherry, cedar, elm, paint. 18 x 26 x 18". Donated by the Artist. 2008.08.01.005G

OBJ-668

Stephan Goetschius, United States & **Peter Oliver**, New Zealand. *Relic*, 2008 ITE. Tawa, poplar, paint. 22 x 16". Donated by the Artists. 2008.08.01.006G

OBJ-669

Alain Mailland, France. *Babel II*, 1999. Pistachio root. 5 ⅜ x Dia. 4 ¾". Donated by Pat McCauley. 2008.08.01.007G

OBJ-670

Alain Mailland, France. *Gospel*, 2003. African blackwood burl. 7 ⅜ x 8 ½ x 9 ¼". Donated by the Artist. 2008.08.01.008G

OBJ-671

Malcolm Zander, Canada. *True Love 7*, 2006. Pink ivory. 3 ⅝ x Dia. 3". Donated by the Artist. 2008.08.01.009G

OBJ-672

Tony Boase, United Kingdom & **David Ellsworth**, United States. *Untitled*, 2003. English burl oak. 3 x Dia. 3 ½". Donated by Joe Seltzer. 2008.11.15.001.01G

OBJ-673

Addie Draper, United States. *Untitled*, 1985. Walnut, padauk, maple. 2 x Dia. 3 ¼". Donated by Joe Seltzer. 2008.11.15.001.02G

OBJ-674

Robyn Horn, United States. *Natural Edge Geode*, 1990. Chittam. 6 ¼ x 9 x 6 ¼". Donated by Joe Seltzer. 2008.11.15.001.03G

OBJ-675

John Jordan, United States. *Graphite Vessel*, 1994. Maple. 3 ½ x Dia. 6 ½". Donated by Joe Seltzer. 2008.11.15.001.04G

OBJ-676

Bud Latven, United States. *Untitled*, 1991. Honduras mohagany, dye. 4 ½ x Dia. 3 ½". Donated by Joe Seltzer. 2008.11.15.001.05G

OBJ-677

Liam O'Neill, Ireland. *Untitled*, 1988. Bog oak 1 x 5 ¾ x 4 ½". Donated by Joe Seltzer. 2008.11.15.001.06G

OBJ-678

Michael Peterson, United States. *Untitled*, 1987. Maple burl. 3 ¼ x 5 x 4 ½". Donated by Joe Seltzer. 2008.11.15.001.07G

OBJ-679

Joe Seltzer, United States. *Untitled, grouping of 14 miniatures*, 2000–04. Various woods. Dia. ½–2". Donated by the artist. 2008.11.15.001.08G

OBJ-680

Bob Stocksdale, United States. *Untitled*, 1993. Douglas fir. 1 x Dia. 5". Donated by Joe Seltzer. 2008.11.15.001.09G

OBJ-681

William Smith & **Joe Seltzer**, United States. *Clock*, 2006. Maple Burl, venner, clock mechanism. 10 ½ x 11 ½" x 1". Donated by Joe Seltzer. 2008.11.15.001.10G

OBJ-682

Janice Smith, **Anne Walsh**, & **Joe Seltzer**, United States. *Drunk Descending Staircase*, 2007. Ash. 10 x 19 x 13". Donated by Joe Seltzer. 2008.11.15.001.11G

OBJ-683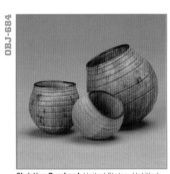

John Jordan, United States. *Untitled*, 1990. English walnut. 2 ¾ x Dia. 3 ¾". Donated by Joe Seltzer. 2008.11.15.001.12G

OBJ-684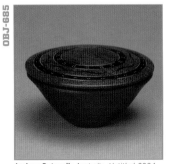

Christian Burchard, United States. *Untitled*, 2004. Madrone. ¾–1 ½ x Dia. ¾–1 ½". Donated by Joe Seltzer. 2008.11.15.001.13G

OBJ-685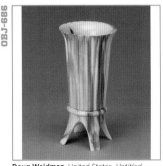

Andrew Potocnik, Australia. *Untitled*, 2004. Red gum. 1 ¾ x Dia. 3 ¾". Donated by Joe Seltzer. 2008.11.15.001.14G

OBJ-686

Doug Weidman, United States. *Untitled*, 2003. Wood. 4 ¾ x Dia. 2 ½". Donated by Joe Seltzer. 2008.11.15.001.15G

2009
»

OBJ-687

Robert Sutter, United States. *Folding Bowl*, 2007. Cherry, mahogany. 5 x 10 x 4 ½". Donated by the Artist. 2009.03.07.001G

Robin Wood, United Kingdom. *Cor Blimey*, 2007. Wood, video. Donated by the Artist. 2009.03.07.002G. (plate 43)

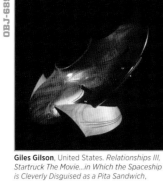

Giles Gilson, United States. *Relationships III, Startruck The Movie...in Which the Spaceship is Cleverly Disguised as a Pita Sandwich*, 1990. Various materials. 16 x 35 x 19". Donated by Robyn Horn. 2009.08.07.001G

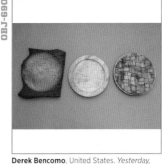

Derek Bencomo, United States. *Yesterday, Today And Tomorrow*, 2009 ITE. 275-year-old oak. 21 ¾ x 58 x 1 ¾". Donated by the Artist. 2009.08.07.002G. (plate 37)

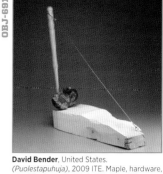

David Bender, United States. *(Puolestapuhuja)*, 2009 ITE. Maple, hardware, wire, black granite, birch. 32 x 10 x 28". Donated by the Artist. 2009.08.07.003G

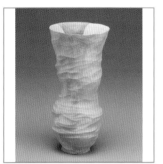

Jérôme Blanc, Switzerland. *Wood Tango I*, 2009 ITE. Maple. 10 x Dia. 5". Donated by the Artist. 2009.08.07.004.01G

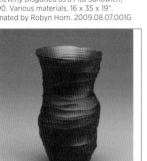

Jérôme Blanc, Switzerland. *Wood Tango II*, 2009 ITE. Pear. 9 ½ x Dia. 5 ½". Donated by the Artist. 2009.08.07.004.02G

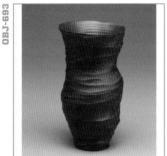

Jérôme Blanc, Switzerland. *Untitled, #4*, 2009 ITE. Red & black ink, watercolor paper. 22 ⅓ x 30". Donated by the Artist. 2009.08.07.004.03G. (plate 80)

Robert F. Lyon, United States. *The Turner's Pallet #2*, 2009 ITE. Basswood, woodless colour pencils, archival varnish. 8 ½ x Dia. 6 ¾". Donated by the Artist. 2009.08.07.005G. (plate 59)

Leah Woods, United States. *Evolution*, 2009 ITE. Maple, cherry. 32 x 10 x 10". Donated by the Artist. 2009.08.07.006G

Karl Seifert, United States. *Derek Bencomo*, 2009 ITE. Pigment print on Hahnemühle paper. 10 x 13". Donated by the Artist. 2009.08.07.007.01G

Karl Seifert, United States. *David M. Bender*, 2009 ITE. Pigment print on Hahnemühle paper. 10 x 13". Donated by the Artist. 2009.08.07.007.02G

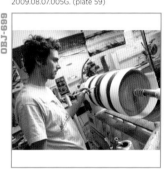

Karl Seifert, United States. *Jerome Blanc*, 2009 ITE. Pigment print on Hahnemühle paper. 10 x 13". Donated by the Artist. 2009.08.07.007.03G

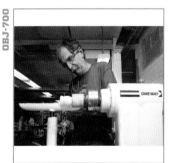

Karl Seifert, United States. *Robert Lyon*, 2009 ITE. Pigment print on Hahnemühle paper. 10 x 13". Donated by the Artist. 2009.08.07.007.04G

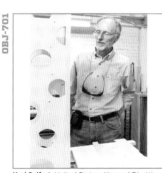

Karl Seifert, United States. *Howard Risatti*, 2009 ITE. Pigment print on Hahnemühle paper. 10 x 13". Donated by the Artist. 2009.08.07.007.05G

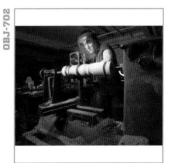

Karl Seifert, United States. *Leah Woods*, 2009 ITE. Pigment print on Hahnemühle paper. 10 x 13". Donated by the Artist. 2009.08.07.007.06G

Levco Company, Japan. *Plastic "Wood Grain" Bowl*, ca. 2000. Plastic. 2 x Dia. 6". Donated by Gord Peteran. 2009.12.01.01G

2010
»

Richard Tuttle, United States. *Pop-A-Top: From the Junk Series*, 2000. Oak, iron oxides, MDF, acrylics. 6 ½ x 18 ¾ x 4 ½". Donated by the Tuttle Family, In Memory of Richard Tuttle. 2010.04.02.001a-gG

Luc De Roo, Belgium. *Nid De Fourmi*, 2010 ITE. Honey locust. 13 x Dia. 9". Donated by the Artist. 2010.08.06.001G

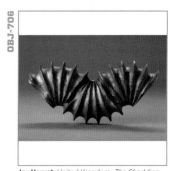

Jay Heryet, United Kingdom. *The Shedding Skin of Evelyn Mind*, 2010 ITE. Maple, gesso. 3 ½ x Dia. 11 ½". Donated by the Artist. 2010.08.06.002G

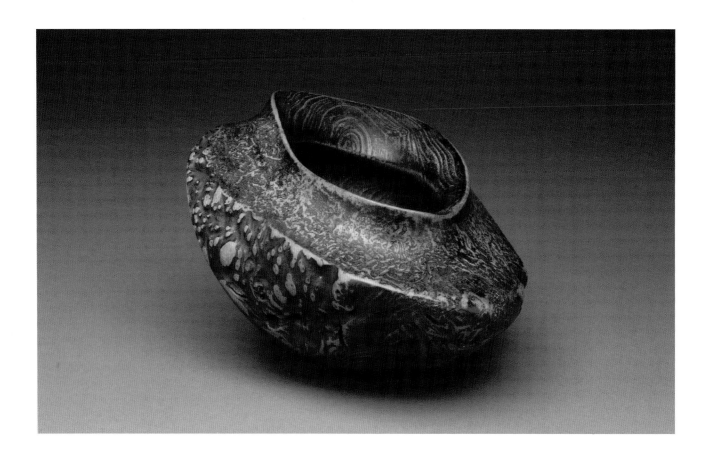

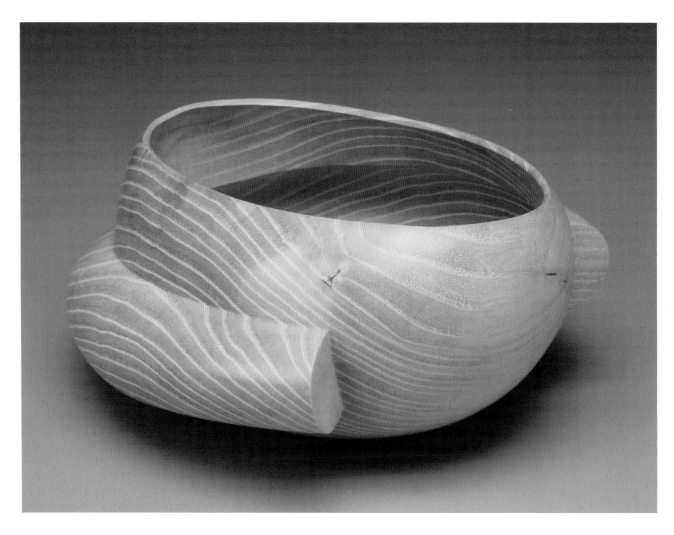

OBJ-639 | **Michael Peterson**, United States | *Clam Shell*, 1994 | Madrone burl | 3 ½ x 5 ½ x 6″ | Donated by Bruce Kaiser | 2008.05.07.001.44G

OBJ-662 | **Hunt Clark**, United States | *ON7/08*, 2008 ITE | Osage orange | 5 x 9 ¼ x 11″ | Donated by the Artist | 2008.08.01.001G

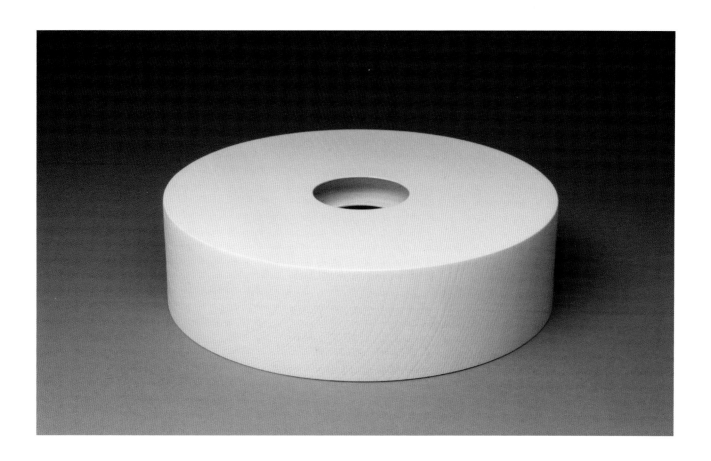

OBJ-661 | **Maria van Kesteren**, Netherlands | Lidded Vessel, 1997 | Elm. 2 ¼ x Dia. 8 ¾₆" | Donated by Bruce Kaiser | 2008.05.07.001.66G

OBJ-666 | **Satoshi Fujinuma**, Japan | *Journey of Will*, 2000 | Cherry, lignitized cedar | 6 ¾ x 4 ⅞ x 3 ½" | Donated by the Artist | 2008.08.01.004.02G

Wonjoo Park, South Korea. *Smoothing - Turning 03*, 2010 ITE. Slumped glass, wood. 21 x 17 x 6". Donated by the Artist. 2010.08.06.003G

Karl Seifert, United States. *ITE 2010 Pennsylvania Avenue Washington DC*, 2010 ITE. Pigment print on Hahnemühle paper. 9 x 13". Donated by the Artist. 2010.08.06.004.01G

Karl Seifert, United States. *Derek Weidman*, 2010 ITE. Pigment print on Hahnemühle paper. 9 x 13". Donated by the Artist. 2010.08.06.004.02G

Karl Seifert, United States. *Luc De Roo*, 2010 ITE. Pigment print on Hahnemühle paper. 9 x 13". Donated by the Artist. 2010.08.06.004.03G

Heidi West, United States. *Karl Seifert*, 2010 ITE. Pigment print on Hahnemühle paper. 9 x 13". Donated by the Artist. 2010.08.06.004.04G

Karl Seifert, United States. *Jay Heryet*, 2010 ITE. Pigment print on Hahnemühle paper. 9 x 13". Donated by the Artist. 2010.08.06.004.05G

Karl Seifert, United States. *David Huntley*, 2010 ITE. Pigment print on Hahnemühle paper. 9 x 13". Donated by the Artist. 2010.08.06.004.06G

Karl Seifert, United States. *Wonjoo Park*, 2010 ITE. Pigment print on Hahnemühle paper. 9 x 13". Donated by the Artist. 2010.08.06.004.07G

Karl Seifert, United States. *ITE Book*, 2010 ITE. Various materials. 10 ½ x 16 ½". Donated by the Artist. 2010.08.06.004.08G

Derek Weidman, United States. *Mandrill*, 2010 ITE. Box elder, paint. 7 x 6 ½ x 9 ½". Donated by the Artist. 2010.08.06.005G

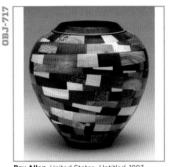

Ray Allen, United States. *Untitled*, 1993. Various woods. 6 x Dia. 6". Donated by Neil & Susan Kaye. 2010.08.06.006.01G

Ray Allen, United States. *Untitled*, 1995. Poison sumac. 10 x Dia. 6". Donated by Neil & Susan Kaye. 2010.08.06.006.02G

Galen Carpenter, United States. *Untitled*, 1995. Chipboard, belize rosewood, zircote. 8 x Dia. 9". Donated by Neil & Susan Kaye. 2010.08.06.006.03G. (plate 44)

Galen Carpenter, United States. *Untitled*, 1995. Black palm, zircote, antler. 7 x Dia. 5". Donated by Neil & Susan Kaye. 2010.08.06.006.04G

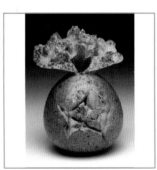

Rod Cronkite, United States. *Untitled*, 1991. Western maple burl. 5 ½ x Dia. 8". Donated by Neil & Susan Kaye. 2010.08.06.006.05G

Michael Mode, United States. *Fan topped vessel*, 1998. Ebony, holly. 10 x 20 x 8". Donated by Neil & Susan Kaye. 2010.08.06.006.06G

Gary Stevens, United States. *Emerging Flowers Series, #83*, 2000. Maple. 20 x 19 x 11". Donated by Neil & Susan Kaye. 2010.08.06.006.07G

Sequoia National Park, United States. *Untitled*, ca. 1930. Sequoia. 5 x Dia. 5 ½". Donated by Neil & Susan Kaye. 2010.08.06.006.08G

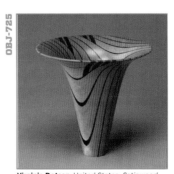

Virginia Dotson, United States. *Satinwood Vessel*, ca. 1990. Satinwood, ebony, wenge. 5 x Dia. 5". Donated by Neil & Susan Kaye. 2010.08.06.006.09G

Melvyn Firmager, United Kingdom. *Eucalyptus Vessel*, ca. 1995. Eucalyptus gunnli. 4 x Dia. 6". Donated by Neil & Susan Kaye. 2010.08.06.006.10G

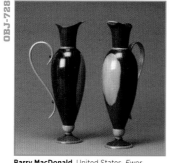

Bud Latven, United States. *Tulipwood Vessel*, 1988. Tulipwood, holly, ebony. 4 x Dia. 3 ¾". Donated by Neil & Susan Kaye. 2010.08.06.006.11G

Barry MacDonald, United States. *Ewer Forms*, 1996. Lignum vitae. 9 ½ x 3" each. Donated by Neil & Susan Kaye. 2010.08.06.006.12a–bG

Bruce Mitchell, United States. *Hovercraft for Gnomes #4*, 1996. Spalted tan oak burl. 8 x 22 x 18". Donated by Neil & Susan Kaye. 2010.08.06.006.13G

Bob Stocksdale, United States. *Redwood Burl from California*, 1970. Redwood burl. 4 x Dia. 18". Donated by Neil & Susan Kaye. 2010.08.06.006.14G

Steve Madsen, United States. *Grapefruit to the Moon*, 1976. Ebony, ash, vermillion, tulipwood, plexiglas, light base with oil finish. 14 x Dia. 16". Donated by the Sally Janpol. 2010.08.06.007G

Eli Avisera, Israel. *Dreidel box*, 2003. Various woods. 3 x Dia. 2". Donated by the Artist. 2010.08.06.008.01G

Eli Avisera, Israel. *Pair of Candlesticks*, 2001. Various woods. 6 ¼ x Dia. 2 ¼" each. Donated by the Artist. 2010.08.06.008.02a–bG

David Huntley, United States. *Shavings*, 2010 ITE. Video, DVD. Donated by the Artist. 2010.08.06.009G

David Lory, United States. *Black Cherry Burl*, 2009. Black cherry. 5 ¾ x Dia. 14 ½". 2010.08.06.010P

Fred Armbruster, United States. *Small Round Box with Lid*, ca. 1990. African blackwood 3 ¼ x Dia. 2". Donated by Walter Balliet. 2010.08.07.001.001G

Walter Balliet, United States. *Salt & Pepper Shaker*, 1988. Cataleta. 8 x Dia. 2 ½", 12 x Dia. 2 ½". Donated by the Artist. 2010.08.07.001.002a–bG

Walter Balliet, United States. *Lidded Bowl*, 1988. Norway maple. 7 ½ x Dia. 6". Donated by the Artist. 2010.08.07.001.003G

Walter Balliet, United States. *Space Needle*, 2001. Norway maple, snakewood, African blackwood. 10 x Dia. 4 ½". Donated by the Artist. 2010.08.07.001.004G

Walter Balliet, United States. *Large Bowl*, 1985. American black walnut, ivory medallions. 7 ¾ x Dia. 8 ½". Donated by the Artist. 2010.08.07.001.005G

Walter Balliet & Lew Wackler, United States. *Washington Monument*, 1993. Shagbark hickory, dessert iron wood, glazed silver medallions. 9 ½ x Dia. 5 ¼". Donated by Walter Balliet. 2010.08.07.001.006G

Walter Balliet, United States. *Vase*, 1987. Padauk, cypress pine. 8 ¼ x Dia. 3 ½". Donated by the Artist. 2010.08.07.001.007G

Walter Balliet, United States. *Turn Lidded Box*, 1993. Apricot, dogwood, African blackwood. 9 x Dia. 1 ⅛". Donated by the Artist. 2010.08.07.001.008G

Walter Balliet, United States. *Crystal Stem*, 1992. African blackwood. 8 ½ x 3 x 3". Donated by the Artist. 2010.08.07.001.009G

Walter Balliet, United States. *Urn*, 1985. American black walnut, Norway maple. 14 x Dia. 3 ⅝". Donated by the Artist. 2010.08.07.001.010G

Walter Balliet, United States. *Chalice*, 1998 Purple heart. 6 ½ x Dia. 3 ¾". Donated by the Artist. 2010.08.07.001.011G

OBJ-747

Walter Balliet, United States. *Volcanish*, 2002. Leadwood, spalted maple, blackwood. 8 x Dia. 4 ½". Donated by the Artist. 2010.08.07.001.012G

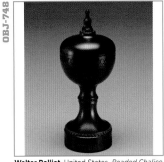

OBJ-748

Walter Balliet, United States. *Beaded Chalice*, 2001. African blackwood. 7 ½ x Dia. 3 ⅛". Donated by the Artist. 2010.08.07.001.013G

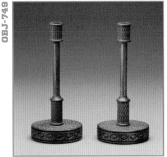

OBJ-749

Walter Balliet, United States. *Candle Holders*, 1983. Maple (hundred-year-old bedposts), metal insert, glass, candle. 10 x Dia. 4 ½" each. Donated by the Artist. 2010.08.07.001.014a–bG

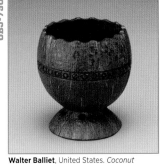

OBJ-750

Walter Balliet, United States. *Coconut Chalice*, 1985. Coconut. 4 ½ x Dia. 4 ¼". Donated by the Artist. 2010.08.07.001.015G

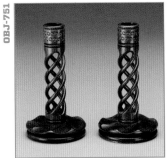

OBJ-751

Walter Balliet, United States. *Candle Holders*, ca. 1982. Maple, votive glass holder. 9 ½ x Dia. 3 ¾" each. Donated by the Artist. 2010.08.07.001.016a–bG

OBJ-752

Walter Balliet, United States. *Serving Bowl*, 1984. Black walnut. 3 ¾ x Dia. 8 ½". Donated by the Artist. 2010.08.07.001.017G

OBJ-753

Walter Balliet, United States. *Serving Bowl*, 1983. Norway maple. 3 ½ x Dia. 7 ¾". Donated by the Artist. 2010.08.07.001.018G

OBJ-754

Walter Balliet, United States. *Bisselon Bowl with Lid*, 1991. Bisselon, spalted maple. 2 ¼ x Dia. 7 ½". Donated by the Artist. 2010.08.07.001.019G

OBJ-755

Walter Balliet, United States. *Large Bowl with 3 Eggs*, 1985. Norway maple, eggs-purple heart, dogwood. 2 ½ x Dia. 9". Donated by the Artist. 2010.08.07.001.020G

OBJ-756

Walter Balliet, United States. *Bocote Bowl with Lid*, 1991. Bocote, spalted maple. 2 ¾ x Dia. 6". Donated by the Artist. 2010.08.07.001.021G

OBJ-757

Walter Balliet, United States. *Bowl with Lid*, 1986. Spalted maple, black walnut, 1974 Winston Churchill coin. 5 x Dia. 7 ½". Donated by the Artist. 2010.08.07.001.022G

OBJ-758

Walter Balliet, United States. *Bowl with Lid*, 1983. Maple, padauk. 6 x Dia. 5 ⅝". Donated by the Artist. 2010.08.07.001.023G

OBJ-759

Walter Balliet, United States. *Bowl with Lid*, 1983. Maple. 6 x Dia. 6 ½". Donated by the Artist. 2010.08.07.001.024G

OBJ-760

Walter Balliet, **M. Dale Chase**, & **Lew Wackler**, United States. *Box with Lid*, 1991. Maple, stone. 5 ½ x Dia. 5". Donated by Walter Balliet. 2010.08.07.001.025G

OBJ-761

Walter Balliet, United States. *Bowl with Lid*, 1986. Wild cherry, lignum vitae. 5 ½ x Dia. 4 ½". Donated by the Artist. 2010.08.07.001.026G

OBJ-762

Walter Balliet, United States. *Flower Pot*, 1998. Olive wood, Swash decorate. 5 x Dia. 3 ⅞". Donated by the Artist. 2010.08.07.001.027G

OBJ-763

Walter Balliet, United States. *Pierced Bowl*, 1992. Pacific yew wood. 3 ¼ x Dia. 6 ¾". Donated by the Artist. 2010.08.07.001.028G

OBJ-764

Walter Balliet, United States. *Pencil Cup*, 1998. Dogwood. 4 x Dia. 3 ½". Donated by the Artist. 2010.08.07.001.029G

OBJ-765

Walter Balliet, United States. *Nut Bowl*, 1999. Claro walnut. 2 ⅝ x Dia. 7 ½". Donated by the Artist. 2010.08.07.001.030G

OBJ-766

Walter Balliet, United States. *Footed Bowl*, 1990. Dawn redwood. 2 ⅞ x Dia. 6". Donated by the Artist. 2010.08.07.001.031G

OBJ-767

Walter Balliet, United States. *Small Bowl*, 1987. Silver yellow pine. 1 ¾ x Dia. 5 ¼". Donated by the Artist. 2010.08.07.001.032G

OBJ-768

Walter Balliet, United States. *Nut Bowl*, 1988. Blood wood, silver dollar medallion. 2 ¼ x Dia. 5 ¾". Donated by the Artist. 2010.08.07.001.033G

OBJ-769

Walter Balliet, United States. *Potpourri Bowl*, 1984. Ivory, Brazilian tulip, Australian silky oak, American black walnut. 4 ½ x Dia. 4 ¼". Donated by the Artist. 2010.08.07.001.034G

OBJ-770

Walter Balliet & M. Dale Chase, United States. *Potpourri Bowl*, 1996. Kingwood, box wood. 3 ½ x Dia. 2 ¾". Donated by Walter Balliet. 2010.08.07.001.035G

OBJ-771

Walter Balliet, United States. *Oval Compote*, 1989. Maple, purpleheart. 4 ½ x Dia. 5 ½". Donated by the Artist. 2010.08.07.001.036G

OBJ-772

Walter Balliet, United States. *Oval Compote*, 1989. Maple, African blackwood medallion. 3 x 4 ¾ x 4 ¼". Donated by the Artist. 2010.08.07.001.037G

OBJ-773

Walter Balliet, United States. *Oval Box*, 1988 Purpleheart. 2 ¾ x 5 ½ x 4". Donated by the Artist. 2010.08.07.001.038G

OBJ-774

Walter Balliet, United States. *Shell Bowl*, 1989. Guanacaste wood (Mexico). 2 ¼ x Dia. 5 ½". Donated by the Artist. 2010.08.07.001.039G

OBJ-775

Walter Balliet, United States. *Pencil Cup*, 1990. Maple. 3 ½ x Dia. 2 ¼". Donated by the Artist. 2010.08.07.001.040G

OBJ-776

Walter Balliet, United States. *Barrel Cup*, 1991. Spalted maple. 3 ⅜ x Dia. 3 ½". Donated by the Artist. 2010.08.07.001.041G

OBJ-777

Walter Balliet, United States. *Dish*, 1985. Guanacaste wood (Mexico). 1 ¼ x 7 x 5 ½". Donated by the Artist. 2010.08.07.001.042G

OBJ-778

Walter Balliet, United States. *Hexagonal Box*, 1992. Apricot wood. 4 x 4 x 4". Donated by the Artist. 2010.08.07.001.043G

OBJ-779

Walter Balliet, United States. *Small Dish*, 1986. Tulip wood. 1 ½ x Dia. 3 ½". Donated by the Artist. 2010.08.07.001.044G

OBJ-780

Walter Balliet, United States. *Round Box with Lid*, 1986. Wood. 3 ½ x Dia. 3 ½". Donated by the Artist. 2010.08.07.001.045aG

OBJ-781

Walter Balliet, United States. *Round Box with Lid*, 1986. Wood. 3 ¾ x Dia. 3 ½". Donated by the Artist. 2010.08.07.001.045bG

OBJ-782

Walter Balliet, United States. *Pickle Barrel Vase*, 1991. Maple. 3 ¼ x Dia. 3 ⅛". Donated by the Artist. 2010.08.07.001.046G

OBJ-783

Walter Balliet, United States. *Small Vase*, 1986. Magnolia, African black walnut. 3 x Dia. 3". Donated by the Artist. 2010.08.07.001.047G

OBJ-784

Walter Balliet, United States. *Fluted Box*, 1999. Pink ivory, mokume medallions. 3 x Dia. 2 ¾". Donated by the Artist. 2010.08.07.001.048G

OBJ-785

Walter Balliet & M. Dale Chase, United States. *Small Rounded Container*, 1999. Sterling silver medallions, ivory medallions, African blackwood. 2 ½ x Dia. 3". Donated by Walter Balliet. 2010.08.07.001.049G

OBJ-786

Walter Balliet, United States. *Small Ball*, ca. 1996. African blackwood, king wood. 3 ¼ x Dia. 2 ⅜". Donated by the Artist. 2010.08.07.001.050G

Walter Balliet, United States. *Miniature Chalice*, ca. 1984. King wood. 1 ½ x Dia. 1 ⅞". Donated by the Artist. 2010.08.07.001.051G

Walter Balliet, United States. *Blizzad Bowl with Lid*, 1993. Wild cherry, greenheart, desert ironwood. 7 ½ x 7 x 5". Donated by the Artist. 2010.08.07.001.052G

Walter Balliet, United States. *Three Tier Decorative Piece*, 1998. Boxwood. 3 ¼ x Dia. 2 ½". Donated by the Artist. 2010.08.07.001.053G

Walter Balliet, United States. *Ash Tray*, ca. 1984. Maple. 1 x Dia. 5". Donated by the Artist. 2010.08.07.001.054G

Walter Balliet, United States. *Lidded Box*, 1986. Argot Marble, maple, holly medallions. 6 x 6 ¼". Donated by the Artist. 2010.08.07.001.055G

Walter Balliet, United States. *Safety Pin Box*, 1926. 4 ¼ x Dia. 3 ½". Donated by the Artist. 2010.08.07.001.056G

Walter Balliet, United States. *Gavel*, 1926. Maple. 10 x 3 x 2". Donated by the Artist. 2010.08.07.001.057G

Walter Balliet, United States. *Lidded Goblet*, 1991. African blackwood, silver and pink ivory medallions. 6 x Dia. 3". Donated by the Artist. 2010.08.07.001.058G

Walter Balliet, United States. *Lidded Chalice*, 1999. African blackwood. 6 x Dia. 3". Donated by the Artist. 2010.08.07.001.059G

Walter Balliet, United States. *Small Chalice*, ca. 1998. African blackwood, silver medallions. 4 ¾ x Dia. 3". Donated by the Artist. 2010.08.07.001.060G

Walter Balliet, United States. *Oval Shell Bowl*, 1989. Norway maple. 2 ¼ x 3 ½ x 3 ¼". Donated by the Artist. 2010.08.07.001.061G

Walter Balliet, United States. *Plate*, 1986. American black walnut. 1 x Dia. 6 ½". Donated by the Artist. 2010.08.07.001.062aG

Walter Balliet, United States. *Plate*, 1986. American black walnut. 1 x Dia. 6 ¼". Donated by the Artist. 2010.08.07.001.062bG

Walter Balliet, United States. *Shell Dish*, 1988. Norway Maple. 2 ¼ x Dia. 5 ¼". Donated by the Artist. 2010.08.07.001.063G

Walter Balliet, United States. *Napkin Rings*, 1988. Maple (stained). 2 x Dia. 2" each. Donated by the Artist. 2010.08.07.001.064a-bG

Walter Balliet, United States. *Footed Vase*, 1990. Maple. 3 x Dia. 4 ⅛". Donated by the Artist. 2010.08.07.001.065G

Walter Balliet, United States. *Little Bowl*, 1984. Cocobolo. 1 ¼ x Dia. 3 ½". Donated by the Artist. 2010.08.07.001.066G

Walter Balliet, United States. *Shell Tray*, 1988. Bubinga. 1 x Dia. 4". Donated by the Artist. 2010.08.07.001.067G

Walter Balliet & **M. Dale Chase**, United States. *Paper Weight*, 1996. Comprag, paduak. 1 x Dia. 3 ½". Donated by Walter Balliet. 2010.08.07.001.068G

Walter Balliet, United States. *Paper Weight*, ca. 2000. African blackwood. ¾ x Dia. 3". Donated by the Artist. 2010.08.07.001.069G

Walter Balliet, United States. *Needle Container*, 1983. Lignum vitae. 2 ½ x Dia. 1 ¼". Donated by the Artist. 2010.08.07.001.070G

Walter Balliet, United States. *Decorative Lidded Container*, ca. 1989. Corian, African blackwood. 4 x Dia. 2 ⅞". Donated by the Artist. 2010.08.07.001.071G

Walter Balliet & **Kushon**, United States. *Rounded Lidded Container*, ca. 1998. African blackwood, silver medallions. 2 ½ x Dia. 2 ¼". Donated by Walter Balliet. 2010.08.07.001.072G

M. Dale Chase, United States. *Rounded Lidded Bowl*, ca. 1999. African blackwood. 2 ¼ x Dia. 3 ¾". Donated by Walter Balliet. 2010.08.07.001.073G

Walter Balliet, United States. *Box with Finial*, 1999. Copula, ivory. 2 ¼ x Dia. 2". Donated by the Artist. 2010.08.07.001.074G

Walter Balliet, United States. *Shot Glass*, 1993. Mesquite, silver medallion. 1 ⅜ x Dia. 2". Donated by the Artist. 2010.08.07.001.075G

Walter Balliet, United States. *Small Lidded Cup*, ca. 1977. Pink ivory, African blackwood medallion. 1 ¾ x Dia. 1 ⅞". Donated by the Artist. 2010.08.07.001.076G

Walter Balliet, United States. *Executive Toy*, 1991. Maple, metal spheres. 1 ¾ x Dia. 4". Donated by the Artist. 2010.08.07.001.077G

Walter Balliet, United States. *Oval Candle Base*, 1982. Mahogany. 3 ¾ x 6 ¾ x 9 ¾". Donated by the Artist. 2010.08.07.001.078G

Walter Balliet, United States. *Daisy Box*, 1989. Norway maple, African blackwood. 5 x Dia. 3 ¼". Donated by the Artist. 2010.08.07.001.079G

Walter Balliet, United States. *Small Bowl*, 1984. Mahogany. 1 ¾ x Dia. 3 ⅛". Donated by the Artist. 2010.08.07.001.080G

Walter Balliet, United States. *Old Candle Lanterns*, 1988. Catinguerra, monkey wood, brazilian rosewood, glass lantern with wick. 6 ½ x Dia. 5 ½" each. Donated by the Artist. 2010.08.07.001.081a–bG

Walter Balliet & **Lew Wackler**, United States. *Serving Plate*, 1993. Amoora wood, silver medallion. 1 x Dia. 7 ½". Donated by Walter Balliet. 2010.08.07.001.082G

Walter Balliet, United States. *Constitution Plate*, 1987. Swiss pearwood, macassar ebony, various coins. 1 ¼ x Dia. 10 ⅝". Donated by the Artist. 2010.08.07.001.083G

Walter Balliet, United States. *Plate*, 1985. Ipe, Corian, engraving stock. 1 ¼ x Dia. 11 ¼". Donated by the Artist. 2010.08.07.001.084G

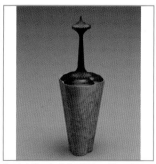

Walter Balliet, United States. *Presentation Plate*, 1988. Cocobolo, rosewood. 1 ⅛ x Dia. 10 ⅞". Donated by the Artist. 2010.08.07.001.085G

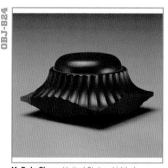

Gorst duPlessis, United States. *Triangular Vase with Lid*, ca. 1985. African blackwood 7 ⅜ x Dia. 2 ⅜". Donated by Walter Balliet. 2010.08.07.001.086G

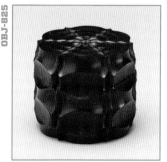

M. Dale Chase, United States. *Lidded Container, fluted edge*, ca. 1991. African blackwood. 2 x 3 ⅛ x 3 ⅛". Donated by Walter Balliet. 2010.08.07.001.087G

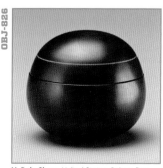

M. Dale Chase, United States. *Lidded Box*, ca. 1992. African Blackwood. 1 ½ x Dia. 1 ¾". Donated by Walter Balliet. 2010.08.07.001.088G

M. Dale Chase, United States. *Sphere Box*, ca. 1998. African blackwood, boxwood. 1 ¾ x Dia. 2 ⅛". Donated by Walter Balliet. 2010.08.07.001.089G

OBJ-827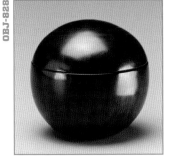

M. Dale Chase, United States. *Lidded Box, with secret compartment*, ca. 1998. African blackwood, boxwood. 2 x Dia. 3 ¼". Donated by Walter Balliet. 2010.08.07.001.090G

OBJ-828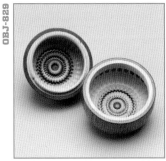

M. Dale Chase, United States. *Sphere Box*, ca. 1992. African blackwood. 2 ¾ x Dia. 3". Donated by Walter Balliet. 2010.08.07.001.091G

OBJ-829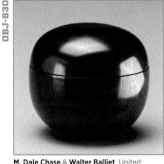

M. Dale Chase, United States. *Box*, ca. 2001. Various woods. 2 ½ x Dia. 2 ¾". Donated by Walter Balliet. 2010.08.07.001.092G

OBJ-830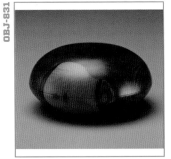

M. Dale Chase & **Walter Balliet**, United States. *Sphere Box*, ca. 1997. African blackwood, silver and pink Ivory. 2 ½ x Dia. 3". Donated by Walter Balliet. 2010.08.07.001.093G

OBJ-831

M. Dale Chase, United States. *Box*, ca. 1996. King wood. 2 ½ x Dia. 4 ⅝". Donated by Walter Balliet. 2010.08.07.001.094G

OBJ-832

M. Dale Chase, United States. *Box*, ca. 1994. African blackwood. 1 ½ x Dia. 1 ⅞". Donated by Walter Balliet. 2010.08.07.001.095G

OBJ-833

M. Dale Chase, United States. *Box*, ca. 2000. Ligma vita, gold medallions. 1 ¾ x Dia. 3 ½". Donated by Walter Balliet. 2010.08.07.001.096G

OBJ-834

M. Dale Chase, United States. *Box*, 1988. African blackwood. 1 ½ x Dia. 1 ⅝". Donated by Walter Balliet. 2010.08.07.001.097G

OBJ-835

M. Dale Chase, United States. *Sphere Box*, ca. 1997. Pink ivory, gold medallion. 2 ½ x Dia. 4 ½". Donated by Walter Balliet. 2010.08.07.001.098G

OBJ-836

M. Dale Chase, United States. *Sphere Box*, ca. 1997. Black wood medallions, pink ivory. 1 ⅜ x Dia. 3 ⅜". Donated by Walter Balliet. 2010.08.07.001.099G

OBJ-837

M. Dale Chase, United States. *Box*, ca. 1993. African blackwood. 2 ¼ x Dia. 2 ¼". Donated by Walter Balliet. 2010.08.07.001.100G

OBJ-838

M. Dale Chase, United States. *Saucer*, ca. 1994. African blackwood, pink ivory. ½ x Dia. 2 ½". Donated by Walter Balliet. 2010.08.07.001.101G

OBJ-839

M. Dale Chase, United States. *Saucer*, ca. 1994. African blackwood, pink ivory. 1 ½ x Dia. 2 ¾". Donated by Walter Balliet. 2010.08.07.001.102G

OBJ-840

M. Dale Chase, United States. *Saucer*, ca. 1994. African blackwood, pink ivory. ½ x Dia. 2 ½". Donated by Walter Balliet. 2010.08.07.001.103G

OBJ-841

M. Dale Chase, United States. *Saucer*, ca. 1994. African blackwood, pink ivory. 1 ⅜ x Dia. 3 ¼". Donated by Walter Balliet. 2010.08.07.001.104G

OBJ-842

M. Dale Chase, United States. *Box*, ca. 2000. Pink ivory, blackwood medallions. 2 x Dia. 2 ¼". Donated by Walter Balliet. 2010.08.07.001.105G

OBJ-843

M. Dale Chase, United States. *Box*, ca. 2000. Pink ivory, boxwood. 1 ¾ x Dia. 2 ½". Donated by Walter Balliet. 2010.08.07.001.106G

OBJ-844

M. Dale Chase, United States. *Box*, ca. 1996. African blackwood. 2 ¾ x Dia. 2 ½". Donated by Walter Balliet. 2010.08.07.001.107G

OBJ-845

M. Dale Chase, United States. *Box*, ca. 1996. King wood. 1 ¼ x Dia. 1 ¾". Donated by Walter Balliet. 2010.08.07.001.108G

OBJ-846

M. Dale Chase, United States. *Kagambuta*, ca. 1996. African blackwood, metal laminated. ¾ x Dia. 1 ⅞". Donated by Walter Balliet. 2010.08.07.001.109G

M. Dale Chase, United States. *Prune Box*, ca. 1992. African blackwood. 1 ½ x Dia. 1 ¾". Donated by Walter Balliet. 2010.08.07.001.110G

M. Dale Chase, United States. *Cricket box*, ca. 1995. Boxwood. ¾ x Dia. 1 ½". Donated by Walter Balliet. 2010.08.07.001.111G

M. Dale Chase, United States. *Little Bowl*, ca. 1992. Wood. 2 x Dia. 2 ¾". Donated by Walter Balliet. 2010.08.07.001.112G

M. Dale Chase, United States. *Box,* ca. 2002. Compressed wood. 1 ½ x Dia. 2". Donated by Walter Balliet. 2010.08.07.001.113G

M. Dale Chase, United States. *Box*, ca. 2002. Compressed wood. 1 ¾ x Dia. 2 ¾". Donated by Walter Balliet. 2010.08.07.001.114G

M. Dale Chase, United States. *Mini Saucer*, ca. 2002. Compressed wood. ⅝ x Dia. 1 ¾". Donated by Walter Balliet. 2010.08.07.001.115G

M. Dale Chase, United States. *Box*, ca. 1998. African blackwood. 2 x Dia. 2 ½". Donated by Walter Balliet. 2010.08.07.001.116G

M. Dale Chase, United States. *Large Saucer*, ca. 2000. Elephant ivory, gold medallions. ½ x Dia. 2 ½". Donated by Walter Balliet. 2010.08.07.001.117G

M. Dale Chase, United States. *Medium Saucer*, ca. 2000. Elephant ivory, gold medallions. ⅝ x Dia. 1 ¾". Donated by Walter Balliet. 2010.08.07.001.118G

M. Dale Chase, United States. *Small Saucer*, ca. 2000. Elephant ivory, gold medallions. ¾ x Dia. 1 ½". Donated by Walter Balliet. 2010.08.07.001.119G

M. Dale Chase, United States. *Box*, ca. 2001. African blackwood, boxwood. 2 x Dia. 2 ¼". Donated by Walter Balliet. 2010.08.07.001.120G

M. Dale Chase, United States. *Box*, ca. 2001. African blackwood, boxwood. 1 ¾ x Dia. 2 ¼". Donated by Walter Balliet. 2010.08.07.001.121G

M. Dale Chase, United States. *Large Saucer*, ca. 1999. African blackwood, pink ivory medallions. 1 ¾ x Dia. 3 ⅝". Donated by Walter Balliet. 2010.08.07.001.122G

M. Dale Chase, United States. *Box*, ca. 1995. African blackwood. 3 x Dia. 3 ¼". Donated by Walter Balliet. 2010.08.07.001.123G

M. Dale Chase, United States. *Box*, ca. 1994. Pink Ivory, African blackwood. 2 ½ x Dia. 2 ⅞". Donated by Walter Balliet. 2010.08.07.001.124G

M. Dale Chase, United States. *Saucer*, ca. 1994. African blackwood, gold medallions. ¾ x Dia. 2 ¼". Donated by Walter Balliet. 2010.08.07.001.125G

M. Dale Chase, United States. *Saucer*, ca. 1994. African blackwood. 1 x Dia. 2 ¾". Donated by Walter Balliet. 2010.08.07.001.126G

M. Dale Chase, United States. *Box*, ca. 2001. Boxwood, African blackwood. 2 ¼ x Dia. 2 ¼". Donated by Walter Balliet. 2010.08.07.001.127G

M. Dale Chase, United States. *Bowl- sample piece*, ca. 1992. African blackwood. ¼ x Dia. 1 ¼". Donated by Walter Balliet. 2010.08.07.001.128G

M. Dale Chase, United States. *Saucer*, ca. 2000. Pink Ivory, African blackwood. 1 ¾ x Dia. 3 ¼". Donated by Walter Balliet. 2010.08.07.001.129G

OBJ-966 | **Hans Joachim Weissflog**, Germany | *3rd Rocking Bowl*, 2009 | African blackwood, boxwood | 1 ⅝ x 3 ¼ x 2″ | Donated by the Artist | 2011.06.04.008.01G

OBJ-959 | **Jakob Weissflog**, Germany | *3 Long Points*, 2010 | African blackwood | 4 ⅝ x 2 ½ x 2″ | Donated by Albert & Tina LeCoff | 2011.06.04.005.03G

OBJ-827 | **M. Dale Chase**, United States | *Lidded Box, with secret compartment*, ca. 1998 | African blackwood, boxwood. 2 x Dia. 3 ¼″ | Donated by Walter Balliet | 2010.08.07.001.090G

OBJ-980 | **John Grass Wood Turning Company**, United States | *Bundle of Balusters*, ca. 1997 | Redwood | 13 x 20 ½ x 13″ |
Donated by Albert & Tina LeCoff | 2011.09.02.001G

OBJ-957 | **Patrick** & **Mieke Senior-Loncin (Indeco)**, Australia | *Ladle Set*, ca. 1995 | Black heart sassafras, ebony pin | 17 x Dia. 4 1/2″ | 14 x Dia. 3 3/4″ | 13 x Dia. 3″ |
Donated by Albert & Tina LeCoff | 2011.06.04.005.01a–cG

OBJ-867

M. Dale Chase, United States. *Box*, ca. 2000. African blackwood, gold medallions. 1 ½ x Dia. 2 ¼". Donated by Walter Balliet. 2010.08.07.001.130G

OBJ-868

M. Dale Chase, United States. *Box*, ca. 2000. African blackwood, pink ivory. 2 x Dia. 3". Donated by Walter Balliet. 2010.08.07.001.131G

OBJ-869

M. Dale Chase, United States. *Box*, ca. 2000. Pink Ivory, African blackwood. 2 ½ x Dia. 2 ¾". Donated by Walter Balliet. 2010.08.07.001.132G

OBJ-870

M. Dale Chase, United States. *Box*, ca. 2003. Pink Ivory, African blackwood. 2 x Dia. 3". Donated by Walter Balliet. 2010.08.07.001.133G

OBJ-871

M. Dale Chase, United States. *Box*, ca. 2001. African blackwood. 1 ½ x Dia. 2 ¾". Donated by Walter Balliet. 2010.08.07.001.134G

OBJ-872

M. Dale Chase, United States. *Box*, ca. 2000. Pink Ivory, African blackwood. 1 ¼ x Dia. 1 ½". Donated by Walter Balliet. 2010.08.07.001.135G

OBJ-873

M. Dale Chase, United States. *Box*, ca. 2003. Pink Ivory, African blackwood. 2 x Dia. 2". Donated by Walter Balliet. 2010.08.07.001.136G

OBJ-874

M. Dale Chase, United States. *Saucer*, ca. 2001. Pink Ivory, African blackwood. 1 x Dia. 2 ½". Donated by Walter Balliet. 2010.08.07.001.137G

OBJ-875

M. Dale Chase, United States. *Box*, ca. 2003. African blackwood, snakewood. 2 ¼ x Dia. 2 ½". Donated by Walter Balliet. 2010.08.07.001.138G

OBJ-876

M. Dale Chase, United States. *Box*, ca. 2003. Boxwood, African blackwood. 2 x Dia. 2 ⅜". Donated by Walter Balliet. 2010.08.07.001.139G

OBJ-877

M. Dale Chase, United States. *Box*, 2006. African blackwood, boxwood. 2 x Dia. 3". Donated by Walter Balliet. 2010.08.07.001.140G

OBJ-878

M. Dale Chase, United States. *Box*, 2004. Pink ivory, boxwood. 2 x Dia. 2 ½" Donated by Walter Balliet 2010.08.07.001.141G

OBJ-879

M. Dale Chase, United States. *Box*, 2005. African blackwood. 1 ⅜ x Dia. 1 ¼". Donated by Walter Balliet.. 2010.08.07.001.142G

OBJ-880

M. Dale Chase, United States. *Box*, ca. 2000. Pink ivory. 1 x Dia. 1 ¾". Donated by Walter Balliet. 2010.08.07.001.143G

OBJ-881

M. Dale Chase, United States. *Box*, ca. 2000. Pink Ivory, African blackwood. 1 ½ x Dia. 2 ¾". Donated by Walter Balliet. 2010.08.07.001.144G

OBJ-882

M. Dale Chase, United States. *Box*, ca. 2000. Boxwood. 1 x Dia. 2 ¼". Donated by Walter Balliet. 2010.08.07.001.145G

OBJ-883

M. Dale Chase, United States. *Box*, ca. 2003. African blackwood, boxwood. 1 ¾ x Dia. 2". Donated by Walter Balliet. 2010.08.07.001.146G

OBJ-884

M. Dale Chase, United States. *Box*, ca. 1997. African blackwood. ⅞ x Dia. 1 ¾". Donated by Walter Balliet. 2010.08.07.001.147G

OBJ-885

M. Dale Chase, United States. *Saucer*, ca. 1997. African blackwood. 1 x Dia. 2 ⅞". Donated by Walter Balliet. 2010.08.07.001.148G

OBJ-886

M. Dale Chase, United States. *Saucer*, ca. 1997. African blackwood, pink ivory. ⅞ x Dia. 3". Donated by Walter Balliet. 2010.08.07.001.149G

M. Dale Chase, United States. *Box*, ca. 1998. Boxwood, gold medallions. 1 x Dia. 2 ⅛". Donated by Walter Balliet. 2010.08.07.001.150G

M. Dale Chase, United States. *Bowl*, ca. 1992. Lignum vitae. 1 ¾ x Dia. 3 ½". Donated by Walter Balliet. 2010.08.07.001.151G

M. Dale Chase, United States. *Box*, ca. 1993. Lignum vitae, gold medallions. 1 ½ x Dia. 2 ¼". Donated by Walter Balliet. 2010.08.07.001.152G

M. Dale Chase, United States. *Box*, ca. 1993. Snakewood. 1 ½ x Dia. 3". Donated by Walter Balliet. 2010.08.07.001.153G

M. Dale Chase, United States. *Box*, ca. 2007. Jade. 2 x Dia. 2 ⅜". Donated by Walter Balliet. 2010.08.07.001.154G

M. Dale Chase, United States. *Box*, ca. 2007. Cortez Crystal. 1 ¾ x Dia. 2 ½". Donated by Walter Balliet. 2010.08.07.001.155G

M. Dale Chase, United States. *Box*, ca. 2006. Plexiglas. ¾ x Dia. 2". Donated by Walter Balliet. 2010.08.07.001.156G

M. Dale Chase, United States. *Box*, ca. 2006. Plexiglas. 1 ¾ x Dia. 2". Donated by Walter Balliet. 2010.08.07.001.157G

M. Dale Chase, United States. *Box*, ca. 2006. Plexiglas. 1 ¼ x Dia. 2". Donated by Walter Balliet. 2010.08.07.001.158G

M. Dale Chase, United States. *Cube*, ca. 1994. Plexiglas. 1 x 1 x 1". Donated by Walter Balliet. 2010.08.07.001.159G

GB Cillcosky, United States. *Log with Saw and Axe*, 1990. Cherry. 3 ¾ x 4 ¾ x 6 ¼". Donated by Walter Balliet. 2010.08.07.001.160G

Paul Cler, United States. *Small Pot*, ca. 1986. Corian. 2 x Dia. 3 ¼". Donated by Walter Balliet. 2010.08.07.001.161G

Paul Cler, United States. *Small Pot*, ca. 1986. Corian. 2 ⅞ x Dia. 2 ½". Donated by Walter Balliet. 2010.08.07.001.162G

Paul Cler, United States. *Small Dish*, ca. 1984. Kingwood. 1 x Dia. 3 ¾". Donated by Walter Balliet. 2010.08.07.001.163G

Paul Cler, United States. *Small Box with Turned Lid*, ca. 1986. African blacwood, pink ivory. 1 ½ x Dia. 2 ⅜". Donated by Walter Balliet. 2010.08.07.001.164G

Charles Wilcoxon, United States. *Chalice*, 1992. Pear wood. 5 ½ x Dia. 3 ½". Donated by Walter Balliet. 2010.08.07.001.165G

Charles Wilcoxon, United States. *Boot*, 1991. Apple wood, leather lace. 3 x 4 ½ x 2". Donated by Walter Balliet. 2010.08.07.001.166G

Dave Hardy, United States. *Santa Clause*, 1991. Wood, paint. 6 x 1 ½ x 2". Donated by Walter Balliet. 2010.08.07.001.167G

Dave Hardy, Mark Krick & **Ken Wurtzel**, United States. *Paper Weight*, 1992. Plexiglas ⅞ x Dia. 3". Donated by Walter Balliet. 2010.08.07.001.168G

Bonnie Klein, United States. *Mushroom*, 1986. Wood. 1 ¾ x Dia. 1 ½". Donated by Walter Balliet. 2010.08.07.001.169G

OBJ-907

Frank Knox, United States. *Greek Urn*, 1973. Lignum Vitae. 12 ¼ x 4 ½ x 3 ¼". Donated by Walter Balliet. 2010.08.07.001.170G

OBJ-908

Frank Knox, United States. *Box with Pointed Lid*, 1984. Elephant ivory, pink ivory, African blackwood. 5 x Dia. 3 ⅜". Donated by Walter Balliet. 2010.08.07.001.171G

OBJ-909

Frank Knox, United States. *Little Box*, 1983. Totara burl, elephant ivory. 3 ¼ x Dia. 2 ¾". Donated by Walter Balliet. 2010.08.07.001.172G

OBJ-910

Frank Knox, United States. *Round Box*, 1982. Satin wood. 2 x Dia. 3 ⅛". Donated by Walter Balliet. 2010.08.07.001.173G

OBJ-911

Frank Knox, United States. *The Wood Rose*, ca. 2000. Mexican laurel tree, lignum vitae. 13 x 7 ¼ x 7". Donated by Walter Balliet. 2010.08.07.001.174G

OBJ-912

Frank Knox, United States. *Medallion*, 1985. Pink ivory. ¼ x Dia. 4 ⅞". Donated by Walter Balliet. 2010.08.07.001.175G

OBJ-913

Kenneth Molitor, United States. *Candle Holders*, 1965-66. Myrtle wood. 10 x Dia. 3 ¼" each. Donated by Walter Balliet. 2010.08.07.001.176a–bG

OBJ-914

Kenneth Molitor, United States. *Serving Dish*, 1965-66. Myrtle wood. 3 ½ x Dia. 7 ¼". Donated by Walter Balliet. 2010.08.07.001.177G

OBJ-915

Kenneth Molitor, United States. *Small Candle Holder*, 1965-66. Myrtle wood. 4 x Dia. 4 ¼". Donated by Walter Balliet. 2010.08.07.001.178G

OBJ-916

Alfred Schwarz, United States. *Coaster*, ca. 1990. Wood. ¼ x 3 x 3 ¼". Donated by Walter Balliet. 2010.08.07.001.179G

OBJ-917

Lew Wackler, United States. *Small Box*, ca. 1985. Elephant Ivory, glass green engraved lid. 1 ⅜ x Dia. 1 ¼". Donated by Walter Balliet. 2010.08.07.001.180G

OBJ-918

Steve White & **David Lindow**, United States. *Christmas tree ornaments*, 2007–08. Brass. Dia. 2" each. Donated by Walter Balliet. 2010.08.07.001.181a–bG

OBJ-919

Fred Yaxley Jr., United States. *Candle Holder*, 1988. Orange wood. 2 x Dia. 2 ¾". Donated by Walter Balliet. 2010.08.07.001.182G

OBJ-920

Unknown Artist, United States. *Elephant*, ca. 1990. Wood. 5 ¼ x 6 ¾ x 3 ½". Donated by Walter Balliet. 2010.08.07.001.183G

OBJ-921

Unknown Artist, India. *Kogul*, ca. 1990. Guri Lacquer. 1 x 2 ⅜ x 2 ⅜". Donated by Walter Balliet. 2010.08.07.001.184G

OBJ-922

Unknown Artist, United States. *Lidded Dish*, ca. 1990. Mulberry. ¾ x Dia. 2 ¾". Donated by Walter Balliet. 2010.08.07.001.185G

OBJ-923

R.C.D., United States. *Small Vase* , ca. 1997. Wood. 4 x Dia. 2". Donated by Walter Balliet. 2010.08.07.001.186G

OBJ-924

Unknown Artist, United States. *Untitled*, ca. 1990. Aluminum. 1 x 1 x 1". Donated by Walter Balliet. 2010.08.07.001.187G

OBJ-925

S.C., United States. *Skinny Bird*, 1989. Spalted maple. 10 x 1 ½ x 2". Donated by Walter Balliet. 2010.08.07.001.188G

OBJ-926

Unknown Artist. *Lidded Box with Lady Engraved*, ca. 20th Century. Wood. 1 ½ x Dia. 2 ½". Donated by Walter Balliet. 2010.08.07.001.189G

OBJ-927

M. Dale Chase, United States. *Rounded Case*, ca. 2002. African Blackwood, silver medallions. 1 ½ x Dia. 2 ¾". Donated by Walter Balliet. 2010.08.07.001.190G

OBJ-928

M. Dale Chase, United States. *Rounded Case*, ca. 2002. African Blackwood, gold medallions. 1 ¼ x Dia. 2 ¾". Donated by Walter Balliet. 2010.08.07.001.191G

OBJ-929

M. Dale Chase, United States. *Rounded Case*, ca. 2001. African blackwood, pink ivory. 2 x Dia. 4 ½". Donated by Walter Balliet. 2010.08.07.001.192G

OBJ-930

M. Dale Chase, United States. *Box*, ca. 1998. African blackwood. 2 x Dia. 2 ½". Donated by Walter Balliet. 2010.08.07.001.193G

OBJ-931

M. Dale Chase, United States. *Rounded Case*, ca. 1998. Pink ivory, African blackwood. 1 x Dia. 3". Donated by Walter Balliet. 2010.08.07.001.194G

OBJ-932

M. Dale Chase, United States. *Blued, Gunmetal Box*, ca. 2003. Blued gunmetal, gold layers. 1 x Dia. 1 ¾, ⅜ x Dia. ½". Donated by Walter Balliet. 2010.08.07.001.195G, 2010.08.07.001.198G

OBJ-933

M. Dale Chase, United States. *Stainless Steel Box*, ca. 2003. Stainless steel. ⅜ x Dia. 1, ⅜ x Dia. ¾". Donated by Walter Balliet. 2010.08.07.001.196G, 2010.08.07.001.197G

OBJ-934

M. Dale Chase, United States. *Untitled*, ca. 1993. Lignum vitae. 1 ¼ x Dia. 2 ½". Donated by Walter Balliet. 2010.08.07.001.199G

OBJ-935

Bonnie Klein, United States. *Untitled*, ca. 1994. Wood. 2 ½ x ⅝ x ⅝". Donated by Walter Balliet. 2010.08.07.001.200G

OBJ-936

Jason Romblad, Sweden. *Vertical Vessel*, ca. 2002. Various woods. 7 ½ x 3 ¼ x 2". Donated by Walter Balliet. 2010.08.07.001.201G

2011

»

OBJ-937

Alan Stirt, United States. *White Ash Bowl*, 1995. White ash burl. 15 ½ x Dia. 7 ½". Donated by Neil & Susan Kaye. 2011.06.04.001.01G

OBJ-938

Tony Boase, United Kingdom & **Stephen Hogbin**, Canada. *Bleached Maple Bowl*, 1997. Maple. 3 x Dia. 8". Donated by Neil & Susan Kaye. 2011.06.04.001.02G

OBJ-939

M. Dale Chase, United States. *Quadrispheric Box*, 1999. Maple. 1 ¼ x 1 ¾ x 1 ¾". Donated by Neil & Susan Kaye. 2011.06.04.001.03G

OBJ-940

David Ellsworth, United States. *Vessel*, 1990. Grecian briar burl. 2 x Dia. 2". Donated by Neil & Susan Kaye. 2011.06.04.001.04G

OBJ-941

David Ellsworth, United States. *Vessel*, 1991. African blackwood. 1 x Dia. 1". Donated by Neil & Susan Kaye. 2011.06.04.001.05G

OBJ-942

David Ellsworth, United States. *Vessel*, 1992. Silver maple. 1 x Dia. 2 ½". Donated by Neil & Susan Kaye. 2011.06.04.001.06G

OBJ-943

Craig Lossing, United States. *Toothpick Top*, 1995. Maple, ebony. 3 ½ x Dia. 3 ½". Donated by Neil & Susan Kaye. 2011.06.04.001.07G

OBJ-944

Bret Marsh, United Kingdom. *Cocobolo Bowl*, ca. 1990. Cocobolo. 2 x Dia. 3 ¾". Donated by Neil & Susan Kaye. 2011.06.04.001.08G

OBJ-945

Philip Moulthrop, United States. *Vessel*, 1994. Ash leaf maple. 5 x Dia. 12". Donated by Neil & Susan Kaye. 2011.06.04.001.09G

OBJ-946

Rude Osolnik, United States. *Vase*, 1993. Box elder. 9 x Dia. 8". Donated by Neil & Susan Kaye. 2011.06.04.001.10G

OBJ-947

Graeme Priddle, New Zealand. *Against the Tide*, 2000. Maple, stain. 2 x 10 x 9 ½". Donated by Neil & Susan Kaye. 2011.06.04.001.11G

OBJ-948

Jon Sauer, United States. *Wave Box*, 1994. Blackwood, dymondwood. 6 x Dia. 1 ½". Donated by Neil & Susan Kaye. 2011.06.04.001.12G

OBJ-949
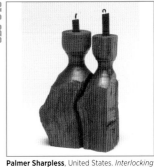
Palmer Sharpless, United States. *Interlocking Candlesticks*, 2001. Wood. 6 x Dia. 4". Donated by Neil & Susan Kaye. 2011.06.04.001.13a–bG

OBJ-950

Michael Shuler, United States. *Bowl*, 1994. Brazilian tulipwood, holly, cocobolo. 3 ⅝ x Dia. 4 ½". Donated by Neil & Susan Kaye. 2011.06.04.001.14G

OBJ-951

Bob Stocksdale, United States. *English Walnut Bowl*, 1972. English Walnut. 8 x Dia. 24". Donated by Neil & Susan Kaye. 2011.06.04.001.15G

OBJ-952

Len Scherock, United States. *Endless Wave*, 2007. African blackwood, shagreen. 3 ¼ x Dia. 3". Donated by Len Scherok. 2011.06.04.002.01G

OBJ-953

M. Dale Chase, United States. *Bowl*, 2006. African blackwood, pink ivory, boxwood. 1 ¾ x Dia. 2 ½". Donated by Charlene Chase. 2011.06.04.003.01G

OBJ-954

M. Dale Chase, United States. *Bowl*, 2006. African blackwood, boxwood. 1 ⅛ x Dia. 3 ¾". Donated by Charlene Chase. 2011.06.04.003.02G

OBJ-955

M. Dale Chase, United States. *Kagamibutae*, ca. 1985. African blackwood, metal. ¾ x Dia. 1 ½". Donated by Charlene Chase. 2011.06.04.003.03G

OBJ-956

David Pye, United Kingdom. *Bowl*, ca. 1985. Wood. 2 ¾ x 13 ¼ x Dia. 8". 2011.06.04.004.01P

OBJ-957

Patrick & Mieke Senior-Loncin (Indeco), Australia. *Ladle Set*, ca. 1995. Black heart sassafras, ebony pin. 13–17 x Dia. 3–4 ½". Donated by Albert & Tina LeCoff. 2011.06.04.005.01a–cG. (see p. 263)

OBJ-958

Dewey Garrett & Wheaton Arts Artists, United States. *OT Bottle Set*, 2008. Apricot, African blackwood. 4 x Dia. 1", 4 x 5 ¼ x 1 ¼". Donated by Albert & Tina LeCoff. 2011.06.04.005.02a–bG

OBJ-959

Jakob Weissflog, Germany. *3 Long Points*, 2010. African blackwood. 4 ⅝ x 2 ½ x 2". Donated by Albert & Tina LeCoff. 2011.06.04.005.03G. (see p. 262)

OBJ-960

Harry Nohr, United States. *Red Elm Burl Bowl*, ca. 1970. Red elm burl. 3 x Dia. 8 ¾". Donated by Albert & Tina LeCoff. 2011.06.04.005.04G

OBJ-961

Rude Osolnik, United States. *Laminated Birch Vessel*, 1989. Birch. 7 ½ x Dia. 9". Donated by Ed Bosley. 2011.06.04.006.01G

OBJ-962

Dan Saal, United States. *Book*, 2010. Silk screened prints framed, hand embossed. 30 x 22". Donated by the Artist. 2011.06.04.007G. (see pp. 264–265)

OBJ-963

Dan Saal, United States. *Book*, 2010. Silk screened prints framed, hand embossed. 30 x 22". Donated by the Artist. 2011.06.04.007G. (see pp. 264–265)

OBJ-964

Dan Saal, United States. *Book*, 2010. Silk screened prints framed, hand embossed. 30 x 22". Donated by the Artist. 2011.06.04.007G. (see pp. 264–265)

OBJ-965

Dan Saal, United States. *Book*, 2010. Silk screened prints framed, hand embossed. 30 x 22". Donated by the Artist. 2011.06.04.007G. (see pp. 264–265)

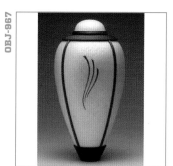

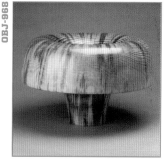

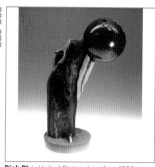

OBJ-966

Hans Joachim Weissflog, Germany. *3rd Rocking Bowl*, 2009. African blackwood, boxwood. 1 ⅝ x 3 ¼ x 2". Donated by the Artist. 2011.06.04.008.01G. (see p. 262)

OBJ-967

Giles Gilson, United States. *Fiberglass Vase*, 1988. Fiberglass, walnut. 15 x 7 ⅝". Donated by Fleur Bresler. 2011.06.04.009.01G

OBJ-968

Ed Moulthrop, United States. *Rolled Edge Bowl*, 1988. Georgia pine. 9 x Dia. 14". Donated by Fleur Bresler. 2011.06.04.009.02G. (plate 35)

OBJ-969

Binh Pho, United States. *I am free*, 1998. African blackwood, lilac burl, acrylic paint, slate. 16 x 9 x 7". Donated by the Artist. 2011.07.29.001G

OBJ-970

Jérôme Blanc, Switzerland. *Premiere Dance, #1*, 2009 ITE. Red & black ink, watercolor paper. 22 ⅛ x 30". 2011.06.25.001.01P. (plate 81)

OBJ-971

Jérôme Blanc, Switzerland. *Untitled, #5*, 2009 ITE. Red & black ink, watercolor paper 22 ⅛ x 30". 2011.06.25.001.02P. (plate 82)

OBJ-972

Jérôme Blanc, Switzerland. *Dance Souterraine*, 2009 ITE. Red & black ink, watercolor paper. 22 ⅛ x 30". 2011.06.25.001.03P. (plate 83)

OBJ-973

Jérôme Blanc, Switzerland. *Dance Final*, 2009 ITE. Red & black ink, watercolor paper. 22 ⅛ x 30". 2011.06.25.001.04P. (plate 79)

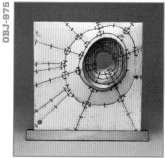

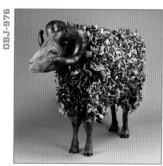

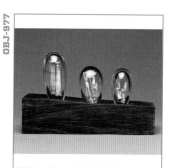

OBJ-974

Noah Addis, United States. *Gus Jardin at the wood dump*, 2011 ITE. Pigment Inkjet print. 50 x 40". Donated by the Artist. 2011.08.05.001G

OBJ-975

Michael de Forest, United States. *Concave/Convex*, 2011 ITE. Various woods, milk paint, waxed linen line. 12 ¾ x 12 ¾ x 1 ¾". Donated by the Artist. 2011.08.05.002G

OBJ-976

Daniel Forest Hoffman, United States. *Ram*, 2011 ITE. Poplar, basswood, felt, glass, dye. 36 x 24 x 48". Donated by the Artist. 2011.08.05.003G

OBJ-977

Beth Ireland, United States. *Reliquary*, 2011 ITE. Cherry, holly, glass. 8 x 13 x 3 ¼". Donated by the Artist. 2011.08.05.004G

OBJ-978

Carl R. Pittman, United States. *Welcome to the New Paradigm*, 2011 ITE. Silver Maple, white milk paint, waxed linen, steel, wax. 7 x 36 x 36". Donated by the Artist. 2011.08.05.005G

OBJ-979

Kimberly Winkle, United States. *Expanse*, 2011 ITE. Polychrome cherry and mahogany. 10 x 46 x 2". Donated by the Artist. 2011.08.05.006G

OBJ-980

John Grass Wood Turning Company, United States. *Bundle of Balusters*, ca. 1997. Redwood. 13 x 20 ½ x 13". Donated by Albert & Tina LeCoff. 2011.09.02.001G. (see p. 263)

BACK MATTER

Board Member History

Board, Staff, and Committes—2011

Chronological List of Exhibitions & Publications

Exhibitions in *italics* were accompanied by publications.

Title of exhibition catalogue is listed with its details.

Visit the Center's website for a list of artists, work, and catalogue essays. www.centerforatinwood.org

Turned Objects: The First North American Turned Object Show, 10th Symposium, Bucks County Community College, Newtown, PA, September 11–13, 1981. Coordinating curator: Albert LeCoff. Jurors: David Ellsworth, Rude Osolnik. Past symposia instructors were invited.

PUBLICATION: *Gallery of Turned Objects: The First North American Turned Object Show*. Editor: Albert LeCoff. Photographer: Bobby Hanson

TOUR: Works Craft Gallery and Richard Kagan Studio and Gallery, Philadelphia. Netsky Gallery, Inc., South Miami, FL. Squires Student Center, Virginia Polytechnic & State University, Blacksburg, VA. Greenville County Museum of Art, Greenville, SC. Kipp Gallery, Indiana University of Pennsylvania, Indiana, PA

Works off the Lathe: Old and New Faces, Craft Alliance Gallery, St Louis, MO, July 5–August 8, 1987. Curator: Albert LeCoff

Works off the Lathe: Old and New Faces II, Craft Alliance Gallery, St Louis, MO, July 10–August 16, 1988. Curator: Albert LeCoff

International Turned Objects Show (ITOS), Port of History Museum, Philadelphia, September 17–November 13, 1988. Invitational Section: David Ellsworth, Albert LeCoff, Rude Osolnik. Juried Section: Jonathan Fairbanks, Lloyd Herman, Rude Osolnik. Coordinating curator: Albert LeCoff

PUBLICATION: *Lathe-Turned Objects: An International Exhibition*. Coordinating curator: Albert B. LeCoff. Photographer: Eric Mitchell. Editor: Eileen Silver

TOUR: Arkansas Art Center, Little Rock, AR. Canton Art Institution, N. Canton, OH. Delaware Art Museum, Wilmington, DE. Lexington Civic Center, Lexington, KY. Madison-Morgan Cultural Center, Madison, GA. North Carolina State University, Raleigh, NC. Southern Highland Handicraft Guild, Asheville, NC. The Brunnier Gallery and Museum, Ames, IA. Anchorage Museum of History and Art, Anchorage, AK. Lee Hall Gallery, Northern Michigan University, Marquette, MI.

Turners Challenge III, Craft Alliance Gallery, St Louis, MO, July 7–August 12, 1989. Curator: Albert LeCoff. Panel discussion and paper: The Purpose of the Object: Why we create, Why we collect. Organized by the Wood Turning Center. Panelists: Michelle Holzapfel, Bruce Mitchell, James Prestini

Pennsylvania Lathe-Turned Objects: Trends, Traditions, Transitions 1700–1990, Woodmere Art Museum, Philadelphia, March 20–July 15, 1990. Curator: Albert LeCoff. Brochure with essay by Albert LeCoff and Tina Van Dyke

Revolving Techniques: Thrown, Blown, Spun, and Turned, James A. Michener Art Center, Doylestown, PA, May 5–June 24, 1990. Curators: Albert LeCoff, Amy Sarner Williams and John Clark

Challenge IV: International Lathe-Turned Objects, Port of History Museum, Philadelphia, May 17–August 4, 1991. Curators: Ned Cooke, Stephen Hogbin, Rudolf Staffel

TOUR: Arizona State University Art Museum, Tempe, AZ. Northern Arizona University, Flagstaff, AR. Craft & Folk Art Museum, Los Angeles

Revolving Techniques: Clay, Glass, Metal, Wood, James A. Michener Art Museum, Doylestown, PA, March 28–May 24, 1992. Curators and essayists: Diane M. Douglas, Mark Richard Leach

TOUR: Art Gallery at Kutztown University, Sharadin Art Gallery, Kutztown, PA. Worcester Craft Center, Worcester, MA

Art from the Lathe, Hagley Museum, Wilmington, DE, June 15–November 30, 1993. Curator: Dan Muir, Deputy Director, Hagley Museum exhibit from Wood Turning Center's permanent collection, and developed interpretive and educational materials. Held in conjunction with the 1993 World Turning Conference

Challenge V: International Lathe-Turned Objects, Philip & Muriel Berman Museum of Art, Ursinus College, Collegeville, PA, January 29–April 4, 1994. Curators and essayists: Michael Monroe, Davira Taragin. Essayists: William Daley, Albert LeCoff

TOUR: Fine Arts Museum of the South, Mobile, AL. California Crafts Museum, Los Angeles, CA. Leigh Yawkey Woodson Art Museum, Wausau, WI. Southern Ohio Museum & Cultural Center, Portsmouth, OH. Huntsville Museum of Art, Huntsville, AL. Philharmonic Center for the Arts, Naples, FL. Arkansas Art Center, Little Rock, AR. Paine Art Center and Arboretum, Oshkosh, WI. Ella Sharpe Museum, Jackson, MI. Knoxville Museum of Art, Knoxville, TN. Wichita Center for the Arts, Wichita, KA. Dane G. Hansen Memorial Museum, Logan, KS

allTURNatives: Form + Spirit 1995, Philip & Muriel Berman Museum of Art, Ursinus College, Collegeville, PA, August 3–August 31, 1995

allTURNatives: Form + Spirit 1996, Philip & Muriel Berman Museum of Art, Ursinus College, Collegeville, PA, August 8–September 29, 1996

allTURNatives: Form + Spirit 1997, Philip & Muriel Berman Museum of Art, Ursinus College, Collegeville, PA, August 8–September 14, 1997

TOUR: Wallingford Community Arts Center, Wallingford, PA

Curators' Focus: Turning in Context: Physical, Emotional, Spiritual and Intellectual, Philip & Muriel Berman Museum of Art, Ursinus College, Collegeville, PA, September 25–November 30, 1997. Curators and essayists: Mark Richard Leach, David McFadden, Bruce Metcalf Maria van Kesteren. Photographer: John Carlano

TOUR: Art Museum of South Texas, Corpus Christi, TX. Albuquerque Museum of Art, Albuquerque, NM. Lee Hall Gallery, Northern Michigan University Marquette, MI. Ella Sharpe Museum, Jackson, MI. Dane G. Hansen Memorial Museum, Logan, KA

allTURNatives: Form + Spirit 1998, Philip & Muriel Berman Museum of Art, Ursinus College, Collegeville, PA, August 8–September 13, 1998

Turned Multiples, co-organized with Craft Alliance, St. Louis, MO, March 5–April 15, 1999

Turned on the Lathe: From the Collection of the Wood Turning Center, Philadelphia International Airport, Philadelphia, July 15–November 1, 1999

allTURNatives: Form + Spirit 1999, Philip & Muriel Berman Museum of Art, Ursinus College, Collegeville, PA, August 7–November 30, 1999

TOUR: Ben Shahn Galleries, William Patterson Museum

allTURNatives: Form + Spirit 2000, Philip & Muriel Berman Museum of Art, Ursinus College, Collegeville, PA, July 25–September 1, 2000

TOUR: Wood Turning Center, Philadelphia

Challenge VI—Roots: Insights & Inspirations in Contemporary Turned Objects, Philip & Muriel Berman Museum of Art, Collegeville, PA, September 8–November 11, 2001. Curators and essayists: Michelle Holzapfel, Christopher D. Tyler. Essayist: Robin Rice. Editor: Judson Randall. Photographer: John Carlano

TOUR: Susquehanna Art Museum, Harrisburg, PA. Indianapolis Museum of Art, Columbus Gallery, Columbus, Indiana. Museum of Art, Washington State University, Pullman, WA. Houston Center for Contemporary Craft, Houston, TX. Arkansas Arts Center, Decorative Arts Museum, Little Rock, AR. Leigh Yawkey Woodson Art Museum, Wausau, WI. The Schneider Museum of Art of Southern, Oregon University, Ashland, OR. Wood Turning Center, Wexler Gallery and The Mills at East Falls, Philadelphia

Turned Multiples II, Staged simultaneously at Craft Alliance, St. Louis, MO; Saskatchewan Craft Council, Saskatoon, Sk, Canada, Wood Turning Center, Philadelphia, March 2–April 30, 2001. Curators: Michael Hosaluk, Merryll Saylan, Hans Joachim Weissflog

Board's Choice: Selections from the Wood Turning Center's Collection, Wood Turning Center, June 1–July 31, 2001

allTURNatives: Form + Spirit 2001, Wood Turning Center, August 3–November 2, 2001

TOUR: Ben Shahn Galleries, William Patterson Museum, Wayne, NJ

Wood Turning in North America Since 1930, The Minneapolis Institute of Arts, Minneapolis, MN, October 21–December 30, 2001. Curators: Glenn Adamson, Edward S. Cooke, Jr, Charles Hummel, Patricia Kane, Albert LeCoff. Essayists: Glenn Adamson, Edward S. Cooke, Patricia Kane, Albert LeCoff, Graeme P. Berlyn, Andrew D. Richardson. Photographer: John Carlano

TOUR: Renwick Gallery of the Smithsonian American Art Museum, Washington, DC. Yale University Art Gallery, New Haven, CT

ReTurnings, Wood Turning Center, February 1–March 29, 2002

Furniture Primavera, Wood Turning Center, April 5–May 31, 2002

allTURNatives: Form + Spirit 2002, Wood Turning Center, July 26–October 25, 2002

Serious Play: The Work of Michael Brolly, January 10–March 1, 2003. Curator: Gail M. Brown

Turned Multiples III, Wood Turning Center, March 7–April 26, 2003. Co-organized with Craft Alliance, St. Louis, MO. Curators: Michael Hosaluk, Thomas Loeser

Cabinets of Curiosities, Wood Turning Center, May 2–July 25, 2003. Curators and essayists: Diane Douglas, Ursula Ilse-Neuman, Brock Jobe, Tom Loeser, Rick Mastelli. Editor: Judson Randall. Photographer: John Carlano. 2003 participating Philadelphia venues: Academy of Natural Sciences, Albert M. Greenfield School, The Clay Studio, The Franklin Institute of Science, Free Library of Philadelphia, Independence Visitor's Center

TOUR: Southern Alleghenies Museum of Art, Ligonier, PA. Southern Alleghenies Museum of Art, Loretto, PA. Houston Center for Contemporary Craft, Houston TX. Leigh Yawkey Woodson Art Museum, Wausau, WI. Turtle Bay Exploration Park, Redding, CA. Anchorage Museum of History and Art, Anchorage, AK. Erie Art Museum, Erie, PA. The Society for Contemporary Craft, Pittsburgh, PA

allTURNatives: Form + Spirit 2003, Wood Turning Center, August 1–November 24, 2003

Mark Lindquist: Millennial Mysteries 1990–2000, Wood Turning Center, October 3–November 27, 2003

Lincoln Seitzman: Illusions in Wood 1984–2004, Wood Turning Center, May 7–July 23, 2004. Curator: Robin Rice

allTURNatives: Form + Spirit 2004, Wood Turning Center, August 6–November 23, 2004

Artists' Reflections: Selections from the Wood Turning Center's Museum Collection, Wood Turning Center, February 4–March 19, 2005

TOUR: Presented in lobby gallery at 1105 N. Market Street, Wilmington, DE

Designing with Nature: Ron and Patti Fleming 1975–2005, Wood Turning Center, April 1–June 18, 2005

Innovations: Perspectives in Turning, Wood Turning Center, July 1–August 20, 2005. Co-organized with Brookfield Craft Center, Brookfield, CT

Carnival, the Work of C.R. "Skip" Johnson, Wood Turning Center, September 2–November 15, 2005

Another View: Garry Knox Bennett and Gord Peteran, Wood Turning Center, September 23–December 31, 2005

Connections Plus, Wood Turning Center, September 2–December 31, 2005

Connections: International Turning Exchange 1995–2005, Presented at Philip & Muriel Berman Museum of Art, Ursinus College, Collegeville, PA in conjunction with WOOD 2005 and the Center's World Turning Conference (September 22–24) and the Collectors of Wood Art 2005 Forum (September 21–25), September 13–October 30, 2005. Curator: Glenn Adamson. Essayists: Robert Bell, Senior Curator, Decorative Arts and Design, National Gallery of Australia; Agnes Bruno, Curator/Director, Musee des Pays de L'Ain; Tanya Harrod; Terry Martin; Glenn Adamson; Judson Randall; Robin Rice; Albert LeCoff. Editor: Judson Randall. Photographer: John Carlano

TOUR: Philip & Muriel Berman Museum of Art, Ursinus College, Collegeville, PA. Noyes Museum, Oceanville, NJ. Embassy of Australia, Washington, DC. Fort Wayne Museum of Art, Fort Wayne, IN. Dane G. Hansen Memorial Museum, Logan, KA. Arkansas Arts Center, Little Rock, AR. Mobile Museum of Art, Mobile, AL

The Bowl: A Classic Shape, Wood Turning Center, May 1–August 31, 2006

Two Views of Wood Art, Presented in lobby gallery at 919 N. Market Street, Wilmington, DE, January 20–July 14, 2006

Round 2: Wood Turning from the 1970's to 1980's, Wood Turning Center, February 3–May 20, 2006

Selections from the Wood Turning Center, Peters Valley Craft Center, Layton, NJ, 2006

Art in Motion: Work by Siegfried Schreiber, Wood Turning Center, February 3–May 20, 2006

Work by Hunt Clark, Wood Turning Center, May 5–August 30, 2006

WOOD NOW, Craft Alliance, St. Louis, MO, June 2–July 15, 2006. Curator: Mark Leach

TOUR: Wood Turning Center, Philadelphia

Bowls, 919 N. Market Street, Wilmington, Delaware, 2006

International Turning Exchange, 1105 N. Market Street, Wilmington, Delaware, July 1, 2006–April 1, 2007

allTURNatives: Form + Spirit 2006, Wood Turning Center, August 4–November 21, 2006

Coming of Age: Emerging and Established Wood Artists, Wood Turning Center, February 16–May 19, 2007

TOUR: Ohio Craft Museum, Columbus, OH

ROLL CALL: Work from Current Teachers and Graduate Students, Wood Turning Center, June 1–July 15, 2007. Jurors: Participating faculty members

allTURNatives: Form + Spirit 2007, Wood Turning Center, August 3–September 22, 2007

Transforming Vision: The Wood Sculpture of William Hunter, 1970–2005, November 6–December 8, 2007. Organized by the Long Beach Museum of Art, Long Beach, CA. Curator: Kevin Wallace

Cocktails with Skip Johnson, Wood Turning Center, December 15, 2007–January 19, 2008

Rose-Engines and Kings: Contemporary Ornamental Turning, Wood Turning Center, February 1–March 22, 2008

7 Visions: Wood as Fiber, Wood Turning Center, March 7–May 17, 2008

Civilization as They Knew It: Work by Stephen Paulsen, 1963–2008, Wood Turning Center, April 4–July 19, 2008

Collaborations at the Echo Lake Conferences: The First Ten Years, Wood Turning Center, June 6–July 19, 2008

allTURNatives: Form + Spirit 2008, Wood Turning Center, August 1–September 13, 2008

TOUR: University of the Arts, Philadelphia

Challenge VII: dysFUNctional, Wood Turning Center, October 3, 2008–January 17, 2009. Jurors: Cecil Baker, Marsha Moss, Richard Torchia, Ricardo Viera. Essayist: Robin Rice. Editor: Judson Randall. Photographer: John Carlano

TOUR: Houston Center for Contemporary Craft, Houston, TX. Lehigh University Art Galleries, Zoellner Art Center, Bethlehem, PA. Fine Arts Center Gallery, Montgomery County Community College, Blue Bell, PA. Southern Alleghenies Museum of Art, Loretto, PA. Bucks County Community College, Newtown, PA. Erie Art Museum, Erie, PA

Selections From The Collection: Donations by Bruce Kaiser & Joe Seltzer, Wood Turning Center, March 6–April 11, 2009

The Art of Opening: Bottles & Their Toppers, Wood Turning Center, May 1–July 18, 2009. In collaboration with WheatonArts Glass Center. Curators: Boris Bally, Michael Hosaluk

In Balance: Wood & Metal, Wood Turning Center, May 1–July 18, 2009

allTURNatives: Form + Spirit 2009, Wood Turning Center, August 7–September 19, 2009

Steve Madsen: A World in Wood, Wood Turning Center, October 9, 2009–January 23, 2010. Organized by Grounds for Sculpture, Hamilton, NJ

Contemporary Wood Art: Collectors' Selections, Wood Turning Center, February 5–March 20, 2010. Curators: Stephen Keeble, Karen Depew, Dr. Jeffrey Bernstein, Dr. Judith Chernoff

Magic Realism: Material Illusions, Wood Turning Center, April 2–July 17, 2010. Curator: Robin Rice. Editor: Judson Randall.

allTURNatives: Form + Spirit 2010, Wood Turning Center, August 6–November 16, 2010

Michael Peterson: EVOLUTION | REVOLUTION, Wood Turning Center, November 5, 2010–February 19, 2011. Organized by the Bellevue Art Museum. Curators: Michael Monroe and Stefano Catalani.

Exotic Woods Metal Cutters and Dale Chase: Ornamental Turnings From The Walter Balliet Collection, Wood Turning Center, March 4–July 23, 2011

allTURNatives: Form + Spirit 2011, Philadelphia Art Alliance, Philadelphia, August 5–28, 2011

Turning to Art in Wood: A Creative Journey, The Center for Art in Wood, November 4, 2011–April 21, 2012. Curator: Gerard Brown. Essayists: Glenn Adamson, Elisabeth Agro, Gerard Brown, Richard T. Goldberg, Albert LeCoff, Robin Rice. Editor: Judson Randall. Photographer: John Carlano

OTHER PUBLICATIONS

The Purpose of the Object: Why we create, Why we collect, July 8, 1989. Essayists: Michelle Holzapfel, Bruce Mitchell, James Prestini

A Sampling of Papers from the 1993 World Turning Conference

Papers from the 1997 World Turning Conference

Enter the World of Lathe-Turned Objects, 1997. Editor: Judson Randall. Photographer: John Carlano

DVDS

Connections: Sweet Possibilities and Grave Self Doubts, 2005. Ron Kanter, videographer. Pig Iron Theatre actors

2006 ITE, Vince Romanelli, videographer

Shavings, 2010. David Huntley, videographer

TURNING POINTS

Turning Points: Volume 1, No. 1: Spring 1988

Turning Points: Volume 1, No. 2: Summer 1988

Turning Points: Volume 1, No. 3: Fall 1988

Turning Points: Volume 2, No. 3: Summer 1989

Turning Points: Volume 2, No. 4: Fall 1989

Turning Points: Volume 3, No. 2: Spring/Summer 1990

Turning Points: Volume 3, No. 1: Spring/Summer 1990

Turning Points: Volume 3, No. 2: 1990

Turning Points: Volume 3, No. 3: Summer/Fall 1990

Turning Points: Volume 3, No. 4: 1990

Turning Points: Volume 4, No. 1: Winter/Spring 1991

Turning Points: Volume 4, No. 2: Summer/Fall 1991

Turning Points: Volume 5, No. 1: Winter 1992

Turning Points: Volume 5, No. 2: Winter 1992

Turning Points: Volume 5, No. 3: Summer/Fall 1992

Turning Points: Volume 6, No. 1: Fall 1992/
Winter 1993

Turning Points: Volume 6, No. 2: 1993

Turning Points: Volume 6, No. 3: 1993

Turning Points: Volume 6, No. 4: 1993

Turning Points: Volume 7, No. 1: Summer 1994

Turning Points: Volume 7, No. 2: Fall 1994

Turning Points: Volume 8, No. 1: Winter 1995

Turning Points: Volume 8, No. 2: Spring 1995

Turning Points: Volume 8, No. 3: Fall 1995

Turning Points: Volume 8, No. 4: Fall 1995

Turning Points: Volume 9, No. 1: Summer 1996

Turning Points: Volume 9, No. 2: Winter 1996

Turning Points: Volume 10, No. 1: Spring 1997

Turning Points: Volume 10, No. 2: Summer 1997

Turning Points: Volume 10, No. 3: Fall 1997

Turning Points: Volume 10, No. 4: Winter 1997

Turning Points: Volume 11, No. 1: Winter 1998

Turning Points: Volume 11, No. 2: Summer 1998

Turning Points: Volume 11, No. 3: Fall 1998

Turning Points: Volume 12, No. 1: Summer 1999

Turning Points: Volume 12, No. 2: Summer 1999

Turning Points: Volume 12, No. 3: Winter 1999

Turning Points: Volume 13, No. 1: 2000

Turning Points: Volume 13, No. 2: 2000

Turning Points: Volume 13, No. 3: 2000

Turning Points: Volume 14, No. 1: Spring 2001

Turning Points: Volume 14, No. 2: Summer 2001

Turning Points: Volume 14, No. 3: Fall 2001

Turning Points: Volume 14, No. 4: Winter 2001

Turning Points: Volume 15, No. 1: Spring 2002

Turning Points: Volume 15, No. 2: Summer 2002

Turning Points: Volume 15, No. 3: Fall 2002

Turning Points: Volume 15, No. 4: Winter 2002

Turning Points: Volume 16, No. 1: 2003

Turning Points: Volume 16, No. 2: 2003

Turning Points: Volume 16, No. 3: Winter 2003

Turning Points: Volume 16, No. 3: 2004

Turning Points: Volume 16, No. 4: 2004

Turning Points: Volume 17, No. 1: Fall 2004

Turning Points: Volume 17, No. 2: Winter 2005

Turning Points: Volume 17, No. 4: 2005

Turning Points: Volume 18, No. 1: Fall 2005

Turning Points: Volume 18, No. 2: Winter 2006

Online Turning Points Editions

Issue 01, March, 200/

Issue 02, May, 2007

Issue 03, June/July, 2007

Issue 04, September/October 2007

Issue 05, January–March, 2008

Issue 06, April–June, 2008

Issue 07, July–August, 2008

Issue 08, October/Sept, 2008

Issue 09, June, 2009

Issue 10, September, 2009

Issue 11, October, 2009

Issue 12, December, 2009

Issue 13, April, 2010

Issue 14, July, 2010

Issue 15, October, 2010

Issue 16, February, 2011

Issue 17, May, 2011

Index

Italicized page references indicate figure and small color illustrations.

Boldface page references indicate large color plates.

Schiffer Books are available at special discounts for bulk purchases for sales promotions or premiums. Special editions, including personalized covers, corporate imprints, and excerpts can be created in large quantities for special needs. For more information contact the publisher:

Published by Schiffer Publishing, Ltd. and The Center for Art in Wood

Schiffer Publishing, Ltd.
4880 Lower Valley Road | Atglen, PA 19310
610.593.1777 | www.schifferbooks.com

The Center for Art in Wood
141 N. 3rd Street | Philadelphia, PA 19106
215.923.8000 | www.centerforartinwood.org

For the largest selection of fine reference books on this and related subjects, please visit our website at **www.schifferbooks.com**
We are always looking for people to write books on new and related subjects. If you have an idea for a book, please contact us at **proposals@schifferbooks.com**

This book may be purchased from the publisher.
Please try your bookstore first.
You may write for a free catalog.

In Europe, Schiffer books are distributed by
Bushwood Books
6 Marksbury Ave.
Kew Gardens
Surrey TW9 4JF England
Phone: 44 (0) 20 8392 8585; Fax: 44 (0) 20 8392 9876
E-mail: info@bushwoodbooks.co.uk
Website: www.bushwoodbooks.co.uk

There is a signed Limited Edition of 250 of this publication which is beautifully presented in a museum-quality clam shell portfolio box and is available through The Center for Art in Wood. All permission requests in connection with the Limited Edition and this edition must be addressed to The Center for Art in Wood. Contact The Center for Art in Wood for information about purchasing the Limited Edition.

Every reasonable attempt has been made to identify owners of copyright. Errors or omissions will be corrected in subsequent editions.

Publication of this volume was organized at The Center for Art in Wood.

Editor: Judson Randall, Portland, Oregon

Designer: Dan Saal, StudioSaal Corporation, Milwaukee, Wisconsin

Photographer: John Carlano, Philadelphia, Pennsylvania

Photographer: Karl Seifert, Philadelphia, Pennsylvania

The Center for Art in Wood, formerly the Wood Turning Center, is an arts and educational institution whose mission is leading the growth, awareness, appreciation and promotion of artists and their creation and design of art in wood and wood in combination with other materials.

The exhibition and publication are produced by The Center for Art in Wood. Contact the Center for more information about this publication and exhibition, other publications produced by the Center, or about the art of wood.

COLOPHON

Typeset in Gotham Narrow, HTF Didot, and Vitesse—all designed by Hoefler & Frere-Jones.

PHOTOGRAPHY CREDITS

Fig. 1, p. 12: Michelle Holzapfel, David Holzapfel, Donna C. Hawes, Dan MacArthur, Kim Thayer, Steve Smith, and Brown & Roberts Hardware, *Story Book*, 2002. American walnut, wild cherry, basswood, curly maple, sugar maple, baltic birch plywood, parchment, leather, linen, silk, paper, pencil, and ink. 15 ½ x 23 ¼ x 21 ¼". Collection of the Museum of Arts & Design (MAD), NY. Museum purchase with funds provided by the MAD Collection Committee and an anonymous foundation, 2004.

Fig. 12, p. 56: Michael Chinn, *TRI - 1000*, 1986. Purpleheart, Indian ebony, aluminum. 3 ½ x 12 x 6". From the collection of John and Robyn Horn.

John Carlano (in addition to the photographs of the collection): fig. 29, p. 44

David Ellsworth: fig. 2, p. 80

Leslie Silk Eslinger: fig. 2, p. 32

Stephen Hogbin: fig. 1, p. 79

David Holzapfel: fig. 2, p. 13; figs. 20 & 21, p. 41

Isabelle Lacey: fig. 13, p.37; figs. 9–11, p. 55

Jesse LeCoff: fig. 1, p. 31

Tina LeCoff: fig. 11, p. 36; fig. 14, p. 37; figs. 24 & 25, p. 42

Jet Lowe, HAER: figs 15 & 16, p. 38

Terry Martin: fig. 12, p. 191

Gord Peteran: fig. 3, p. 80

Karl Seifert: fig. 4, p. 80

Rick Sniffin: fig. 1, p. 19; fig. 3, p. 32; figs. 4 & 5, p. 33; figs. 6, 7, 8 & 9, p. 34; fig. 10, p. 35; fig. 28, p. 44; figs. 1 & 2, p. 46; figs. 3 & 4, p. 47; figs. 5 & 6, p. 48

Lynne Yamaguchi: fig 1, p. 26